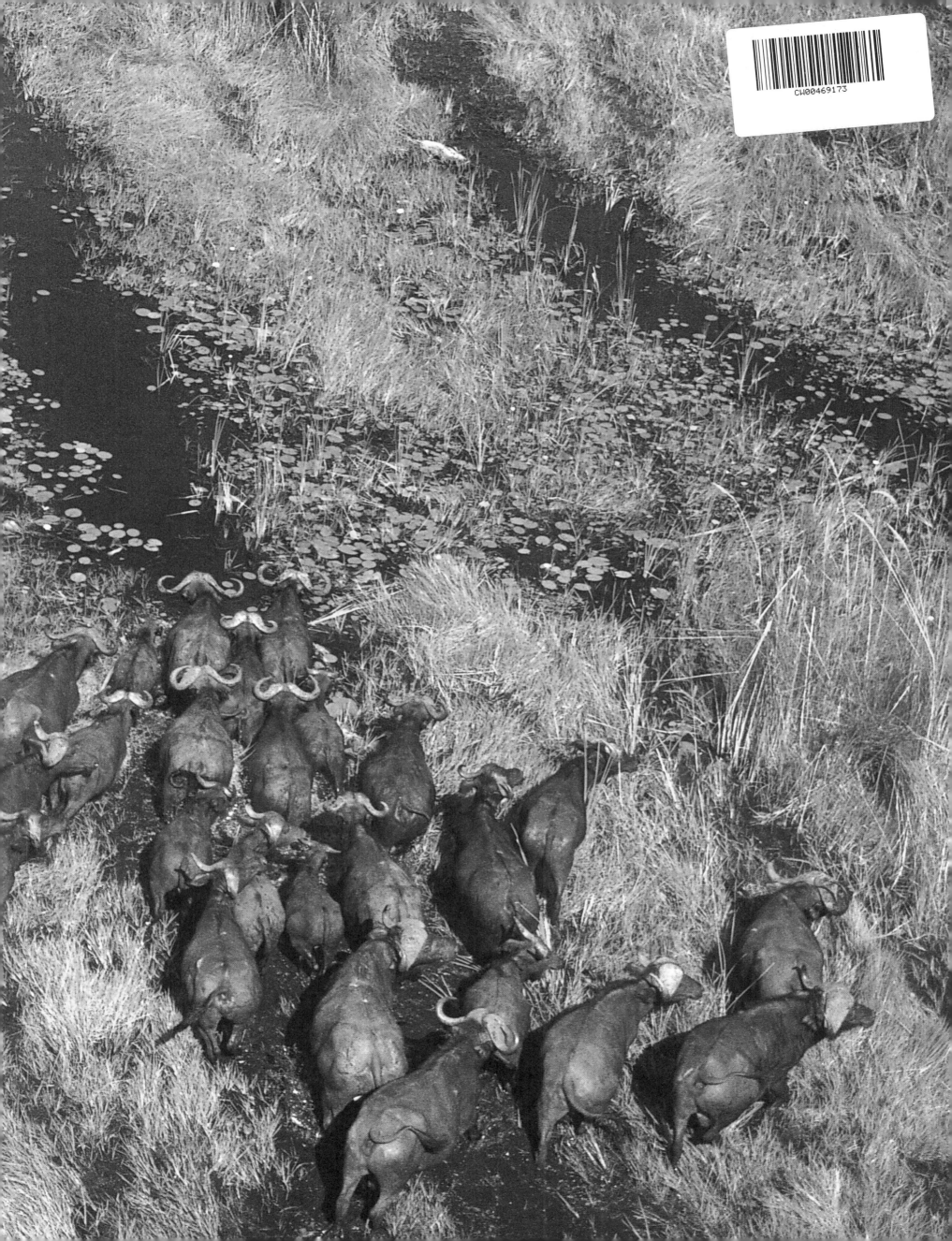

AFRICAN *Wildlife*

A Visual Celebration

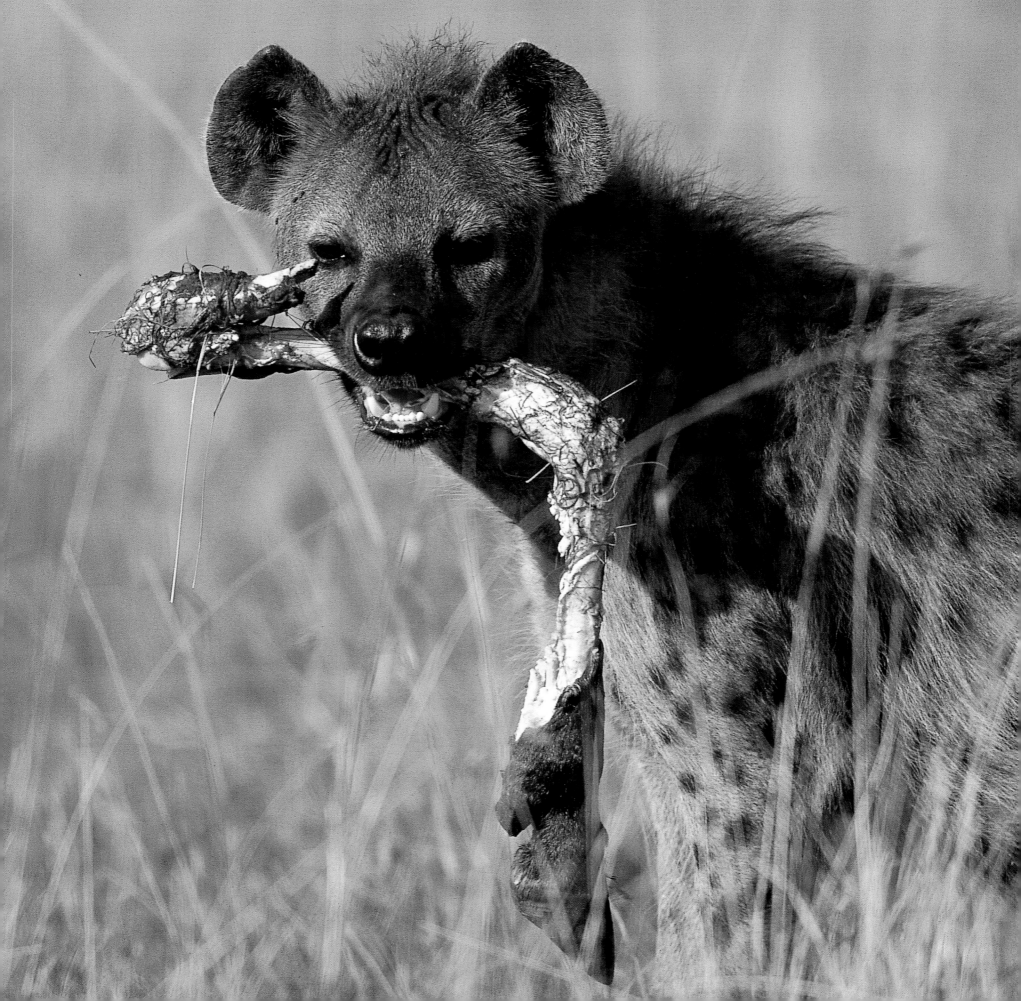

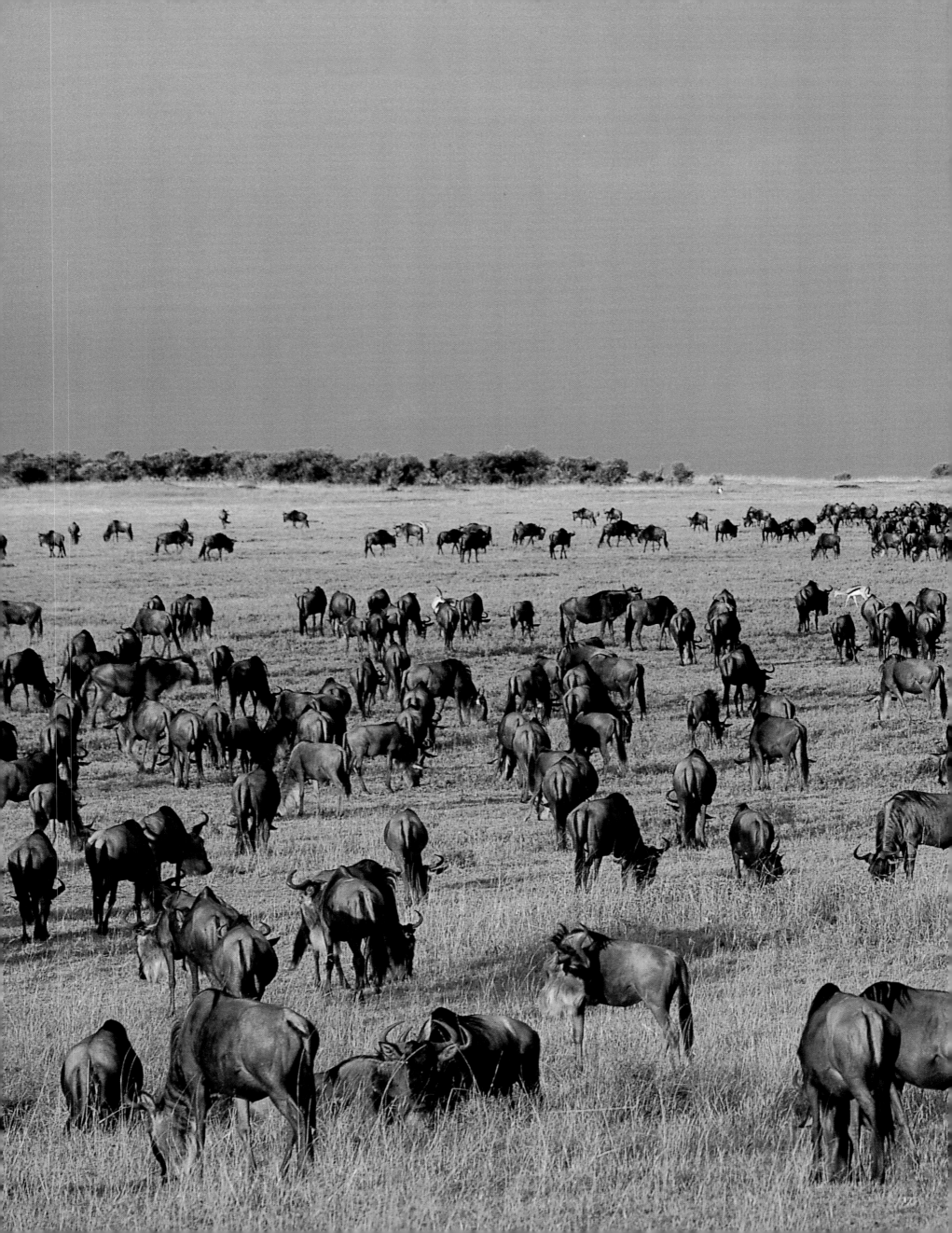

AFRICAN
Wildlife
A Visual Celebration

TEXT BY PETER JOYCE

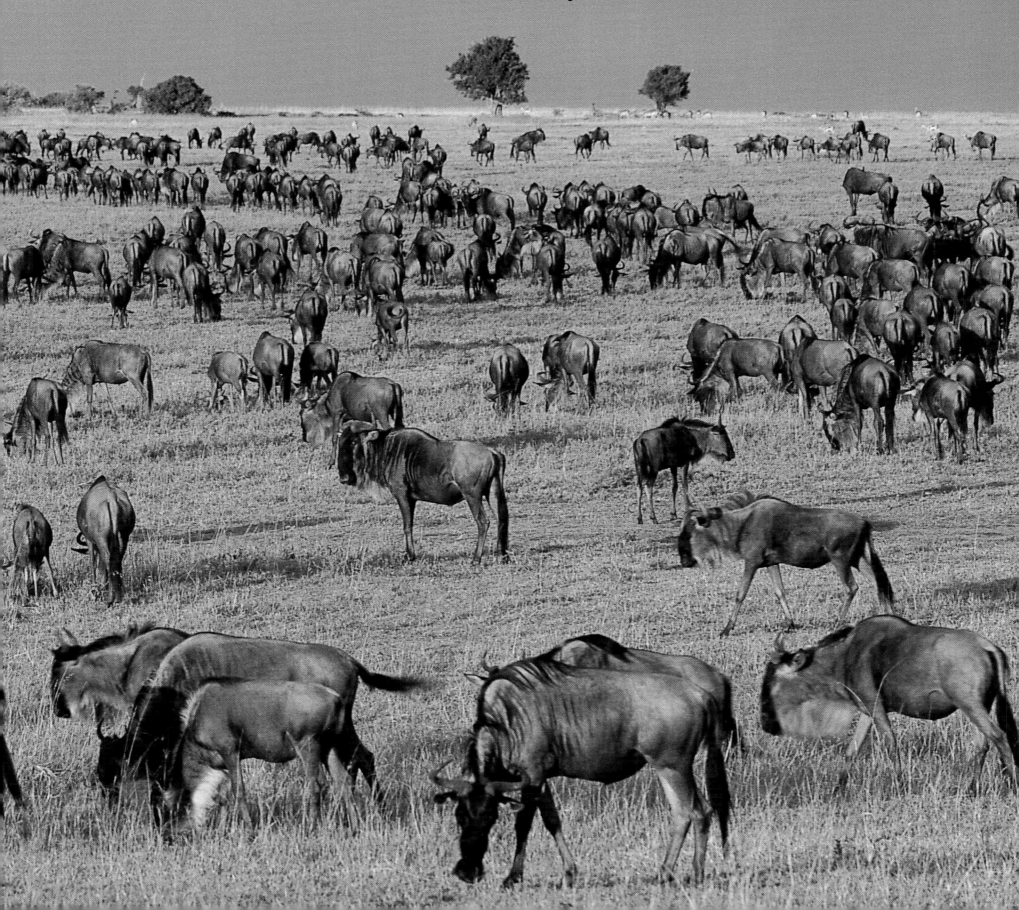

Struik Publishers

(A division of New Holland Publishing

(South Africa) (Pty) Ltd)

Cornelis Struik House, 80 McKenzie Street, Cape Town, 8001

New Holland Publishing is a member of the

Johnnic Publishing Group.

WWW.STRUIK.CO.ZA

Log on to our photographic website

WWW.IMAGESOFAFRICA.CO.ZA for an African experience.

First published in 1998

10 9 8 7 6 5 4

Designer Janice Evans

Managing editor Pippa Parker

Editor Helena Reid

Design assistant Lellyn Creamer

Picture researcher Carmen Swanepoel

Cartographer Desireé Oosterberg

Using Mountain High Maps™

Copyright © Digital Wisdom

Reproduction by Hirt & Carter, Cape (Pty) Ltd

Printed and bound by Tien Wah Press (Pte) Ltd, Singapore

ISBN 1 86872 161 2

Front cover: Lioness *Panthera leo* with cub.

Spine: A gerenuk reaching for young acacia leaves.

Back cover: Reticulated giraffes, residents of the Samburu Reserve.

Front flap: Elephant mother and calf.

Back flap: Verreaux's sifaka performing its curious dance-step.

Endpapers: Buffalo *Syncerus caffer* move en masse through the wetland terrain of Botswana's Okavango Delta.

Half-title page: The spotted hyaena *Crocuta crocuta* is noted for its immensely strong jaws. This one has hold of a wildebeest's leg-bone.

Title page: Wildebeest *Connochaetes taurinus* on the broad grassland plains of Kenya's Masai Mara National Reserve.

Contents page: Hippo *Hippopotamus amphibius* yawning.

Right: Normally placid, two white rhinos *Ceratotherium simum* square up to each other in South Africa's Hluhluwe-Umfolozi Park.

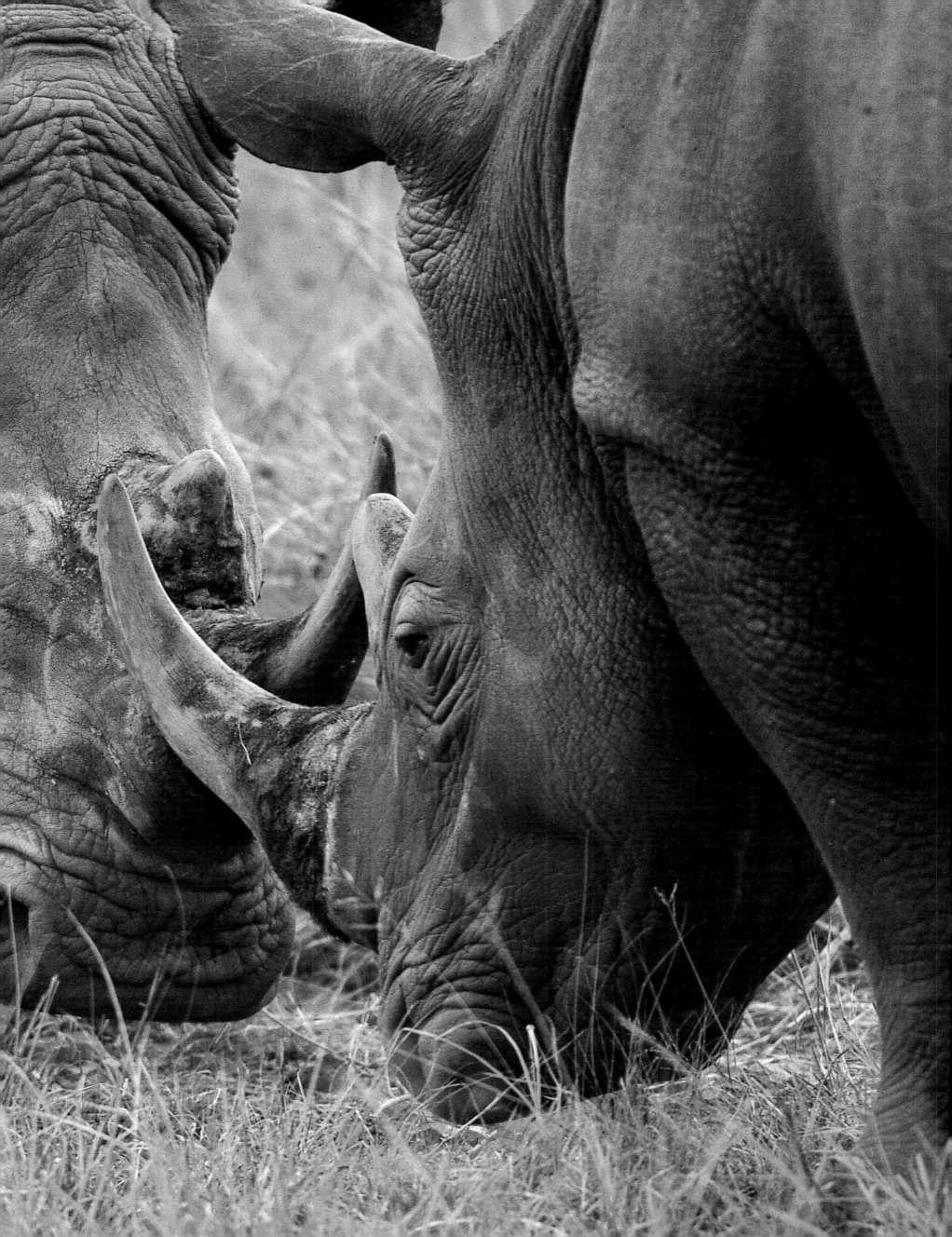

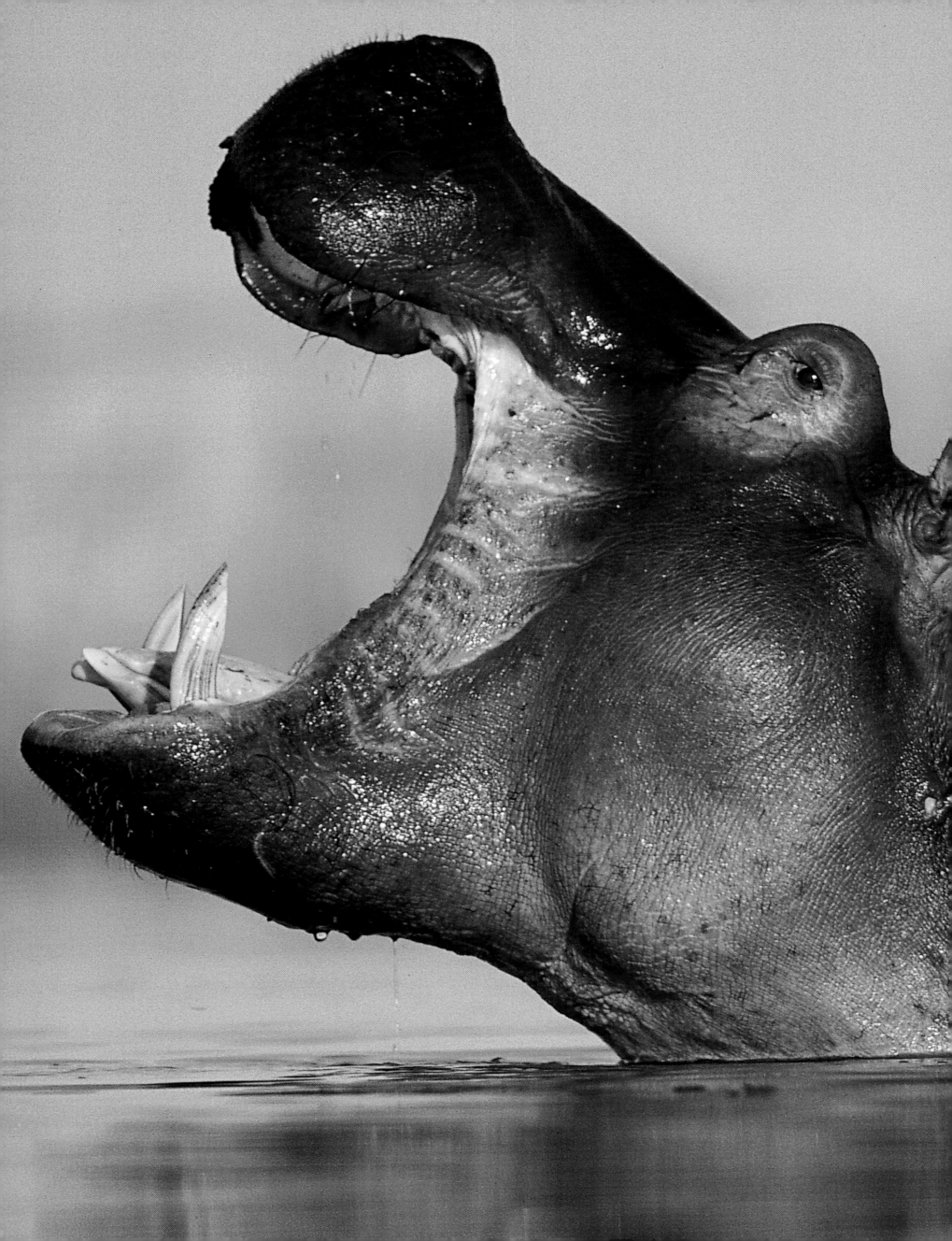

CONTENTS

INTRODUCTION

In none of the world's regions can you see so much wild-life, and see it in such awe-inspiring of natural settings, as on the African continent.

Cross the great, golden grasslands of Kenya's Masai Mara, the plains of Tanzania's Serengeti and the Ngoro-ngoro Crater and breathtaking panoramas, landscapes teeming with living forms, unfold before you. Each season more than a million black wildebeest, together with lesser but still substantial numbers of gazelle and zebra, set off on a migration to fresh pastures that takes them across the swollen Mara River in huge, close-packed, jostling cavalcades that stretch 40 kilometres and more behind the leaders. Many of the animals, impelled by an instinctive and irresistible urge to move forward, regardless of hazard, are drowned in the turbulent flow.

Arguably the most beautiful, and elusive, of Africa's larger carnivores is the leopard *Panthera pardus* (right), a solitary animal that hunts mainly at night, lying up in the tall grass or among the rocks of an outcrop during the hot daylight hours.

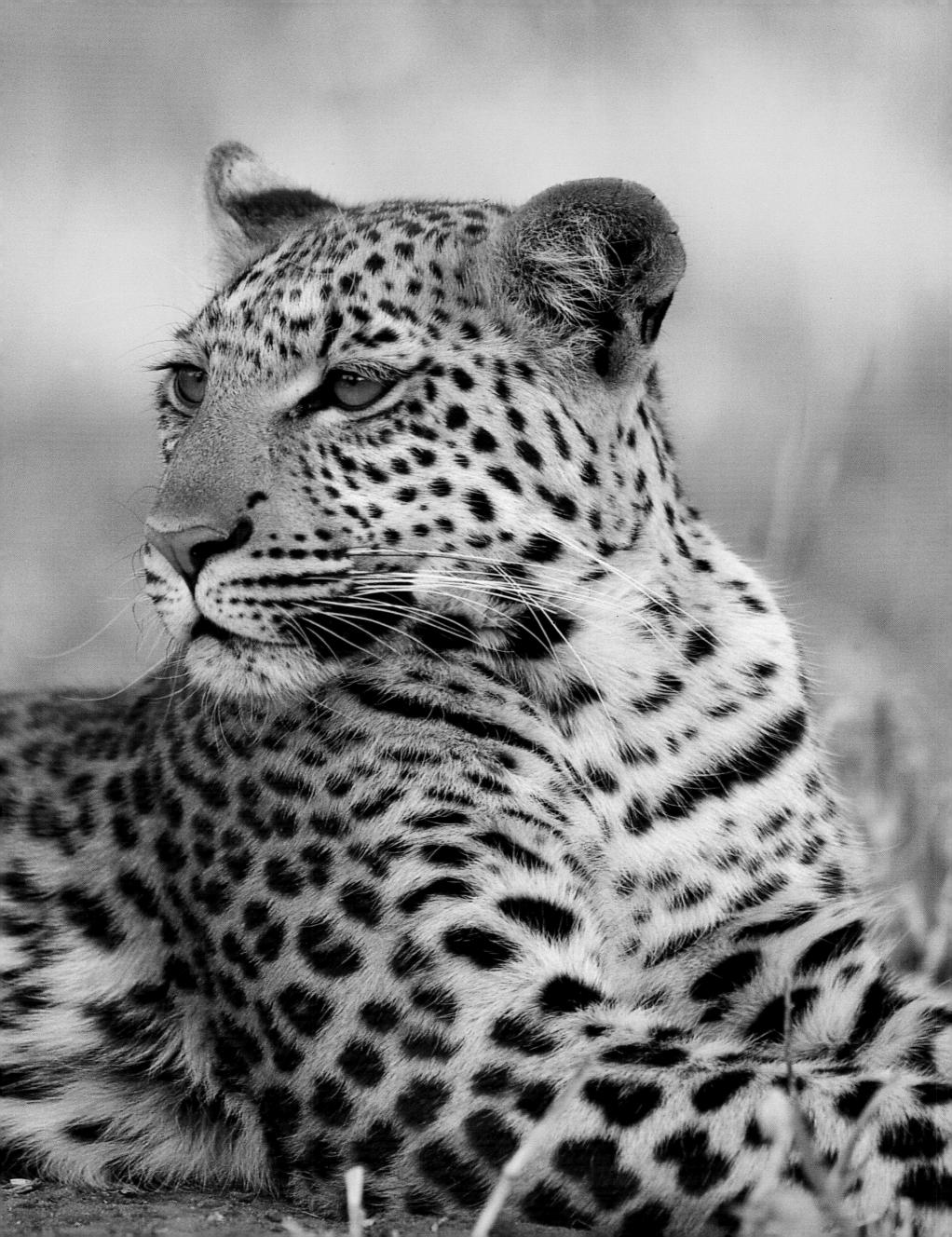

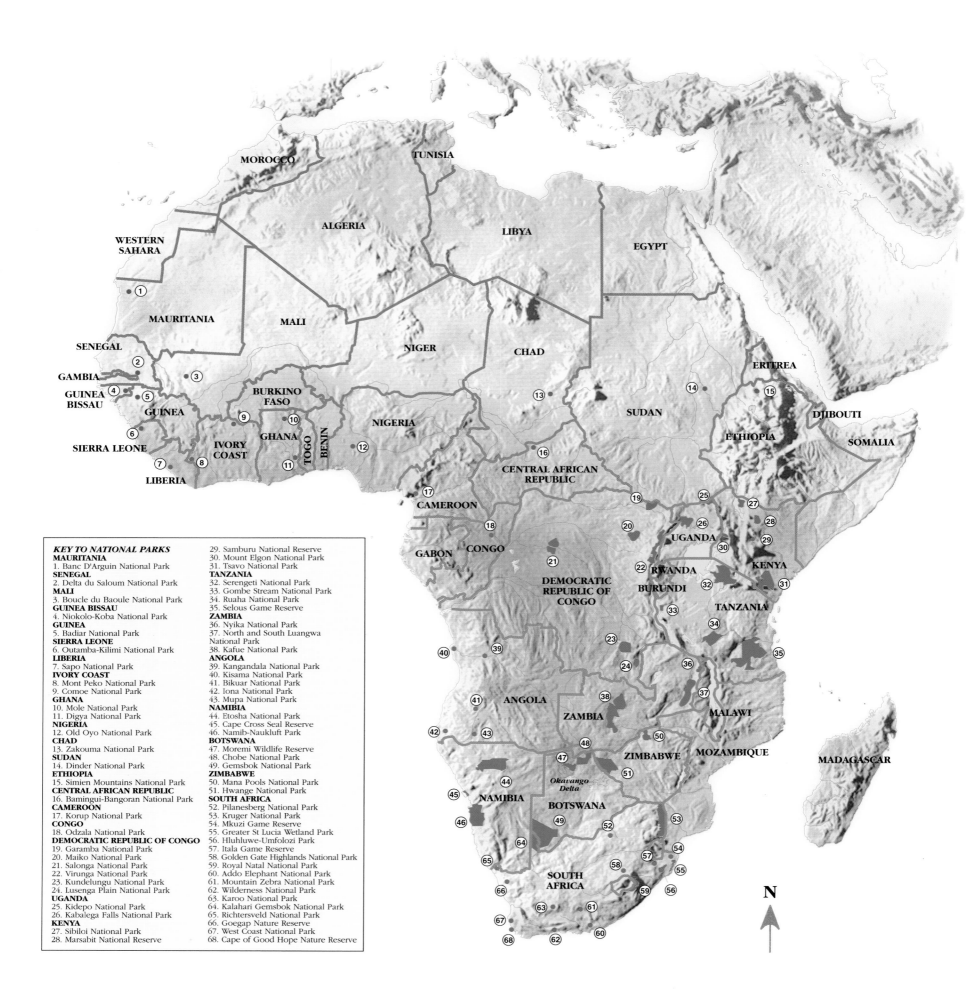

MOROCCO
TUNISIA
WESTERN SAHARA
ALGERIA
LIBYA
EGYPT
MAURITANIA
MALI
NIGER
CHAD
SUDAN
ERITREA
SENEGAL
GAMBIA
GUINEA BISSAU
GUINEA
SIERRA LEONE
LIBERIA
IVORY COAST
GHANA
TOGO
BENIN
BURKINO FASO
NIGERIA
CENTRAL AFRICAN REPUBLIC
CAMEROON
DJIBOUTI
ETHIOPIA
SOMALIA
GABON
CONGO
DEMOCRATIC REPUBLIC OF CONGO
UGANDA
KENYA
RWANDA
BURUNDI
TANZANIA
ANGOLA
ZAMBIA
MALAWI
MOZAMBIQUE
MADAGASCAR
NAMIBIA
Okavango Delta
BOTSWANA
ZIMBABWE
SOUTH AFRICA
N

KEY TO NATIONAL PARKS

MAURITANIA
1. Banc D'Arguin National Park
SENEGAL
2. Delta du Saloum National Park
MALI
3. Boucle du Baoule National Park
GUINEA BISSAU
4. Niokolo-Koba National Park
GUINEA
5. Badiar National Park
SIERRA LEONE
6. Outamba-Kilimi National Park
LIBERIA
7. Sapo National Park
IVORY COAST
8. Mont Peko National Park
9. Comoe National Park
GHANA
10. Mole National Park
11. Digya National Park
NIGERIA
12. Old Oyo National Park
CHAD
13. Zakouma National Park
SUDAN
14. Dinder National Park
ETHIOPIA
15. Simien Mountains National Park
CENTRAL AFRICAN REPUBLIC
16. Bamingui-Bangoran National Park
CAMEROON
17. Korup National Park
CONGO
18. Odzala National Park
DEMOCRATIC REPUBLIC OF CONGO
19. Garamba National Park
20. Maiko National Park
21. Salonga National Park
22. Virunga National Park
23. Kundelungu National Park
24. Lusenga Plain National Park
UGANDA
25. Kidepo National Park
26. Kabalega Falls National Park
KENYA
27. Sibiloi National Park
28. Marsabit National Reserve

29. Samburu National Reserve
30. Mount Elgon National Park
31. Tsavo National Park
TANZANIA
32. Serengeti National Park
33. Gombe Stream National Park
34. Ruaha National Park
35. Selous Game Reserve
ZAMBIA
36. Nyika National Park
37. North and South Luangwa National Park
38. Kafue National Park
ANGOLA
39. Kangandala National Park
40. Kisama National Park
41. Bikuar National Park
42. Iona National Park
43. Mupa National Park
NAMIBIA
44. Etosha National Park
45. Cape Cross Seal Reserve
46. Namib-Naukluft Park
BOTSWANA
47. Moremi Wildlife Reserve
48. Chobe National Park
49. Gemsbok National Park
ZIMBABWE
50. Mana Pools National Park
51. Hwange National Park
SOUTH AFRICA
52. Pilanesberg National Park
53. Kruger National Park
54. Mkuzi Game Reserve
55. Greater St Lucia Wetland Park
56. Hluhluwe-Umfolozi Park
57. Itala Game Reserve
58. Golden Gate Highlands National Park
59. Royal Natal National Park
60. Addo Elephant National Park
61. Mountain Zebra National Park
62. Wilderness National Park
63. Karoo National Park
64. Kalahari Gemsbok National Park
65. Richtersveld National Park
66. Goegap Nature Reserve
67. West Coast National Park
68. Cape of Good Hope Nature Reserve

Much farther south, on the border of Zambia and Zimbabwe, the meandering, sluggish middle reaches of the Zambezi are girded by a floodplain of rich alluvial soils and shallow pools that sustain an enormous concourse of wild animals. In the dry months, the game makes its way down from the high flanking escarpment for the life-giving waters of the river and the lush grazing of its

Above: The African continent's major national parks.

A lioness (opposite) in a watchful pose. These regal cats, largest of Africa's predators, have no natural enemies, but the death rate is surprisingly high among the prides. Cubs are vulnerable to adult aggression and, in lean seasons, to parasite-borne disease and starvation.

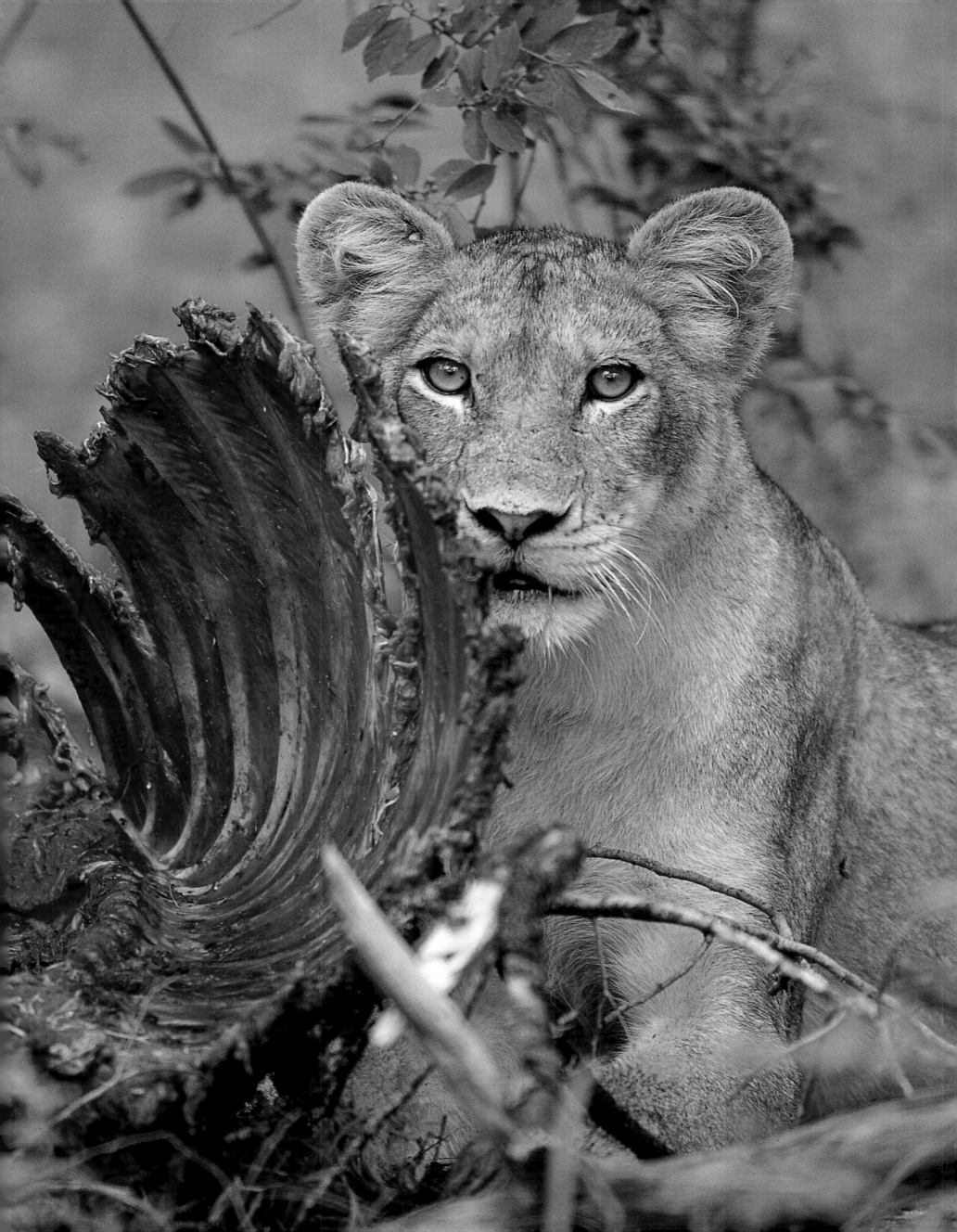

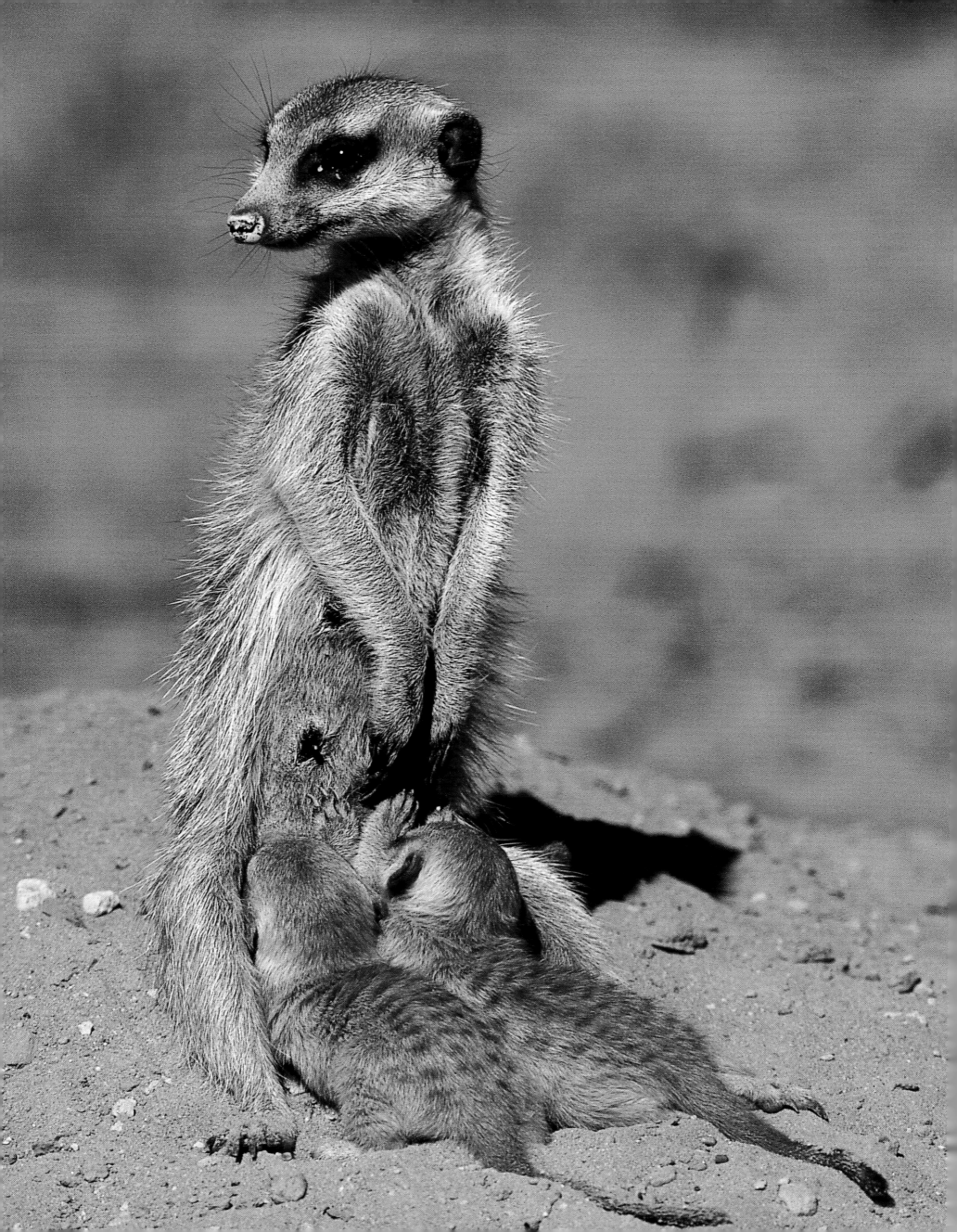

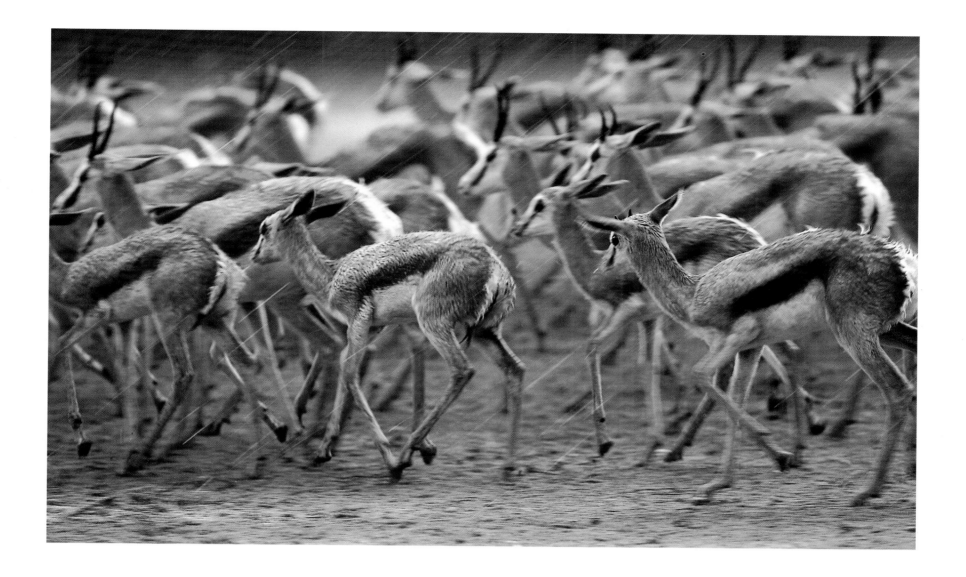

A suricate *Suricata suricatta* mother (opposite) suckles her young at the burrow. These viverrids, known as meerkats in southern Africa, depend heavily for survival on co-operation within the group.

*G*raceful springbok *Antidorcas marsupialis* (above) trek across the hot sands of the Kalahari.

terraces, and to be there just before the coming of the summer rains is to witness a memorable moment in the wilderness cycle. There are so many elephant that, after a while, they appear part of the landscape; buffalo can be seen in herds of 2 000 and more; hippo and baboon are everywhere, and the great predators of the veld congregate for the easy pickings.

The scene is very different in the Namib, far to the west. This is the earth's most ancient desert, a vast and seemingly barren region of hard, bare plains, isolated granite hills and, in the south, a sea of sand where rank upon rank of massive dunes march to distant horizons. Nothing, one feels, can survive in such a desolate place. Yet it too has its life forms, a rich diversity ranging from

conventional (though supremely well adapted) big game down to an intriguing array of small, specialized mammals, reptiles, insects and plants. Some of the species – lizards that 'swim' in the sand, for instance, and the strange and primitive welwitschia (a kind of conifer described by the great Charles Darwin as 'the platypus of the Plant Kingdom') – are unique: here, the long millennia of isolation have given free rein to the evolutionary processes.

Madagascar, in the Indian Ocean to the east, is also home to a marvellously distinctive variety of species, some of them found nowhere else. The island, once part of Africa, broke off and began to drift away from the mainland some 65 million years ago, before primates proper made their appearance on earth, and many of its living organisms, most notably the prosimian lemurs, developed outside the zoological mainstream.

Cheetah hunt in all their beauty and grace on the sandy spaces of the Kalahari; primeval rhino graze and browse in the southern bushveld; buffalo trek en masse across the winter dry-lands, their passage marked by clouds of rising dust that darken the sun; elephants in their thousands migrate seasonally between northern Botswana and Zimbabwe's splendid Hwange Park. Namibia's Etosha Pan, a desolate salt desert of hard, cracked clay,

is incapable of sustaining plant life, but its saline and mineral residues, and the moisture from the summer rains, attract an immense number and variety of game animals, and dense flocks of flamingos are drawn to the short-lived 'lake' by the richness of its micro-organic life. The birds congregate here to breed, and this involves a frantic race against time, for the water evaporates quickly in the scorching sun and the predators will soon move in.

Plains zebra *Equus burchellii* in the rich grasslands of the Masai Mara Reserve in Kenya.

Other species, elsewhere, go to equally risky lengths, and use remarkable gifts, to ensure the future of their kind. Each summer night scores of giant sea turtles crawl from the ocean to lay their eggs on the beaches of Africa's south-eastern seaboard. Some have come from as far away as the Malindi area of Kenya, 3 500 kilometres to the north; others swim the 2 000-odd kilometres from Cape Agulhas, the continent's southernmost point, homing in on that exact stretch of coast on which they themselves were born – which, in some cases, could have been half a century and more before. They mate offshore, and then each female finds her way through the coral reefs and the inter-tidal zone to the sand in search of a scent, a distinctive smell that

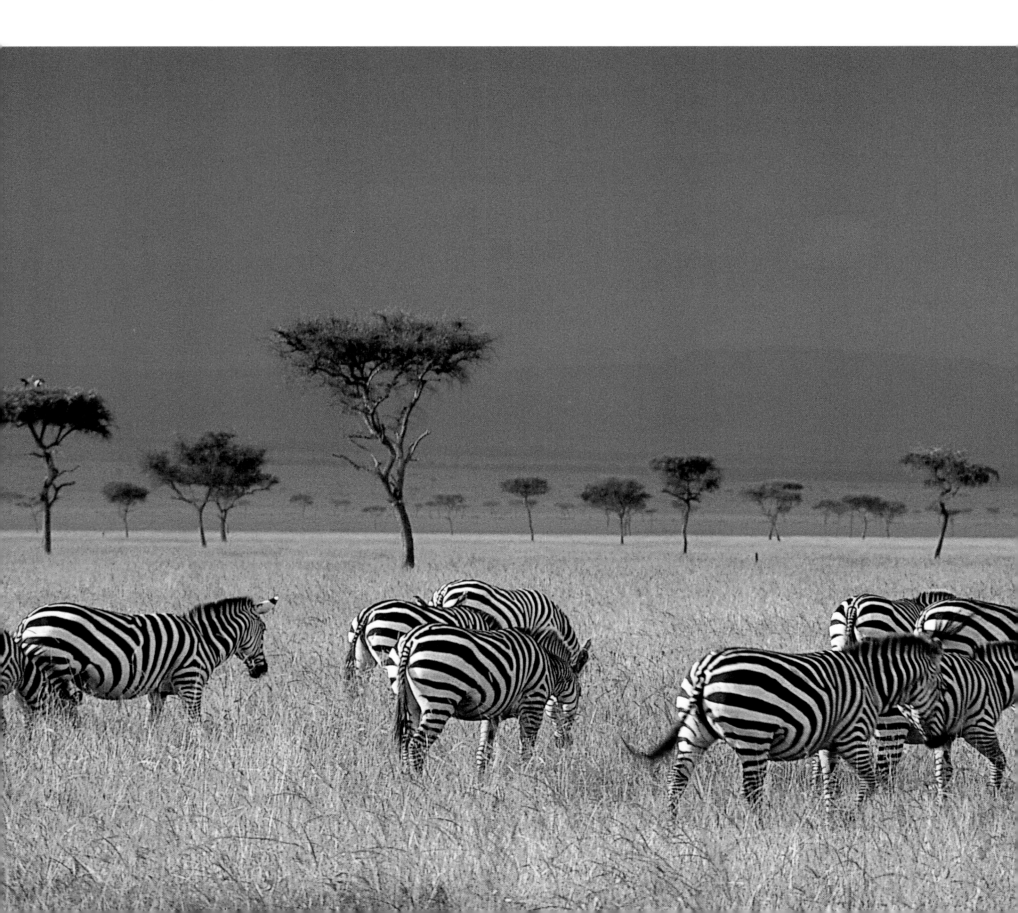

surrounded her when she herself was a hatchling, and which was programmed into her impulse mechanism. She lays her eggs, disguises the nest and, exhausted, retreats back into the sea. The hatchlings eventually emerge, at night-time, to brave the ghost crabs of the beach and plunge into an even more predator-infested ocean; only one in 500 will survive to return as an adult.

This is a tiny cross section of the marvels of the African wild. There are many more. But, tragically, they flatter only to deceive, and it is wrong to deduce from them that the continent and its off-shore islands are some kind of Eden, an unspoilt wilderness in which the dramas of the natural world, the ancient choreography of birth, death and renewal, are played out in pristine splendour.

The harsh realities are that, in Africa, the habitats are shrinking, ecosystems are being destroyed, life forms are disappearing at an alarming rate and many others are under imminent threat.

The lush rainforests of the tropics are still graced by a remarkable diversity of fauna: the Democratic Republic of Congo (formerly Zaire), for instance, is home to more than 400 different kinds of mammal and nearly 1 100 recorded bird species. But the forests, already under pressure from natural forces, are fast retreating before the human onslaught. Each day trees by the hundred are cut down for timber, for charcoal to meet the fuel needs of the expanding urban areas, and to clear the land for subsistence agriculture. In parts of West Africa less than

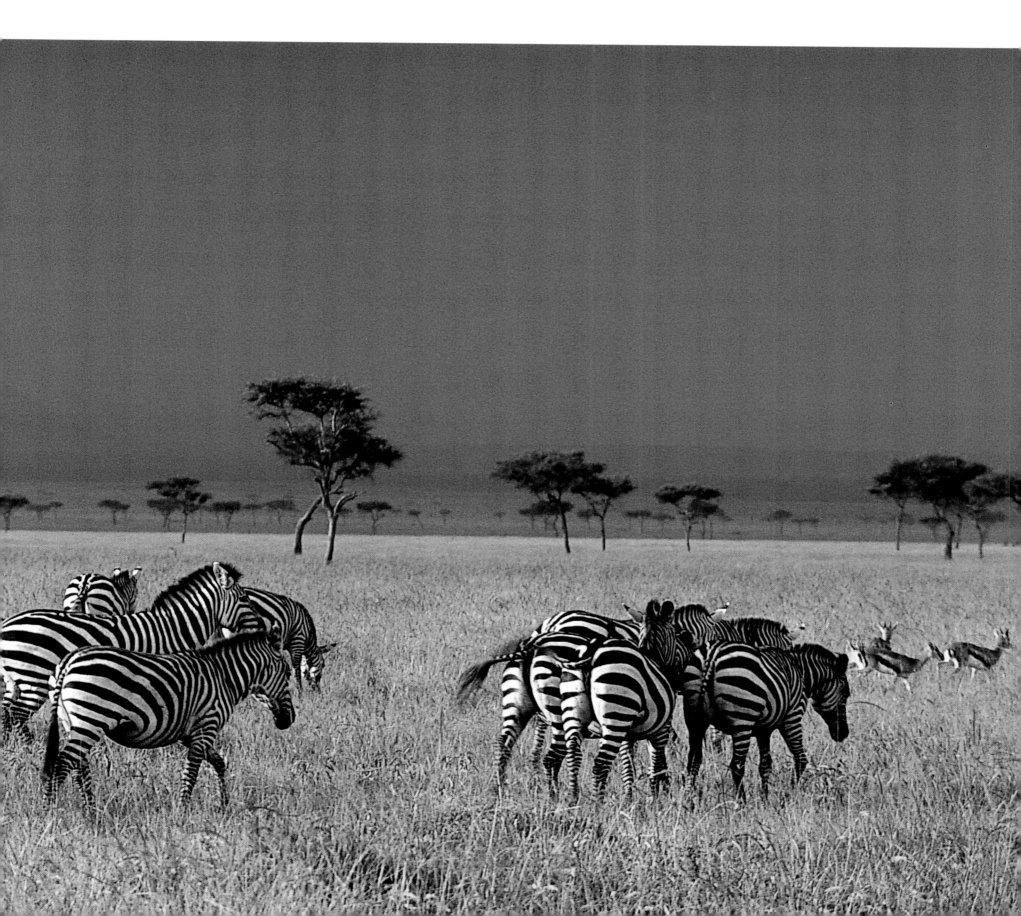

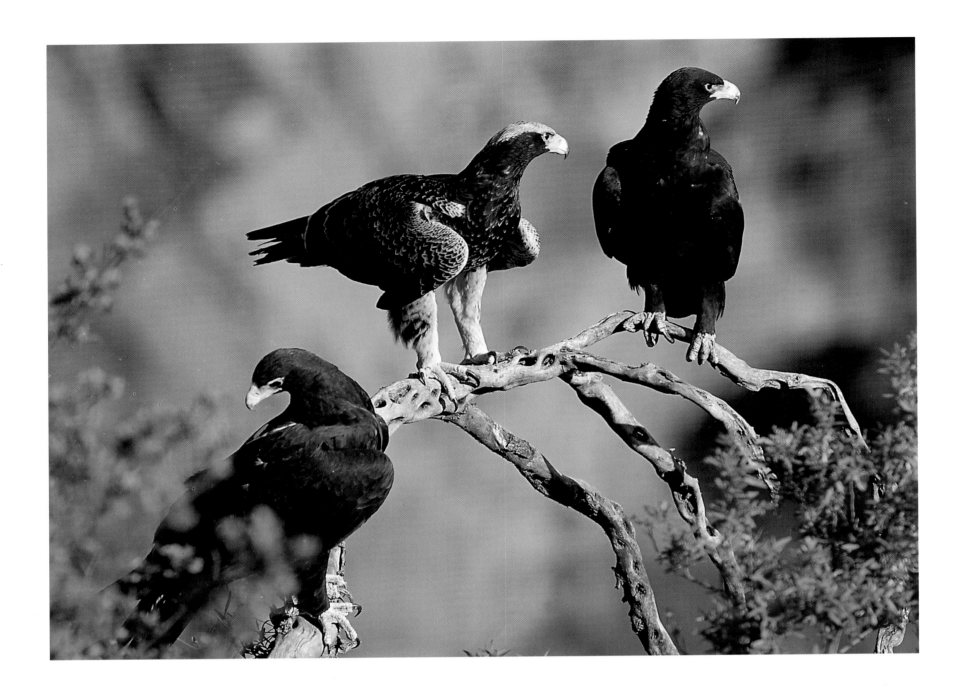

Among the aristocrats of Africa's hillier, rockier regions is *Aquila verreauxii* (above), known as the black eagle in southern Africa and as Verreaux's eagle farther north. Favourite food of this large, powerful bird of prey is the furry, tailless little hyrax or rock dassie.

10 per cent of the original close-canopy forests have survived (those of Nigeria and the Ivory Coast have been hardest hit); overall decline throughout equatorial Africa is estimated to be around 70 per cent, and the degradation rate is accelerating as ever growing numbers of people move south, away from the Sahel region that is becoming increasingly arid.

Many once-fertile swathes of African countryside, in fact, are slowly turning to desert, a process prompted partly by climatic and other irresistible influences but, today, largely the consequence of human activity. At one time the great drylands were able to support pastoralists and their livestock with relative ease because the herders were free to wander where they willed in search of grazing. No longer. Human populations have expanded, permanent settlement has supplanted the nomadic life, and the cattle, sheep and goats, now confined within finite areas, are taking devastating toll of the protective ground cover. Desertification is most pronounced along the southern fringes of the Sahara, but it also afflicts Sudan, Ethiopia, northern Kenya and the southern African interior.

Other, different but in their way equally powerful factors reinforce the assault on Africa's precious and fragile heritage. Habitats are damaged, biodiversity reduced by the large-scale invasion of alien flora: plants brought in, either deliberately or accidentally, find themselves free of their natural controls and they run riot, choking the indigenous vegetation; exotic fish are destroying species native to Africa's freshwater systems (which are vital sources of protein-rich food, especially for the people of

the Great Lakes region); each year significant numbers of domestic animals are returned to the wild to breed feral offspring that play havoc with the environment.

Then there is the deliberate and systematic rape of the continent's wildlife resources. The black rhino has been hunted almost to extinction for its horn, valued in the Far East as a fever suppressant and in the Middle East for ornamentation. Ivory poachers have depleted and, in some countries, virtually

*D*espite appearances, the wild or hunting dog *Lycaon pictus* (below) is not closely related to the domestic animal (it is the sole member of the Canidae family to have four rather than five toes on each forefoot). Relentlessly persecuted by farmers, ranchers and herders, the species has disappeared from most of subSaharan Africa; only a few of the larger southern conservation areas have viable breeding populations.

*L*ionesses and cub (overleaf). The Serengeti-Mara system and the Kruger National Park host the largest populations of these big cats.

annihilated the national elephant herds. The continent-wide population of these gentle giants has plunged from 1,3 million to 600 000 during the past two decades.

These are the charismatic animals, the ones that grab the headlines. But the plunder has larger, less publicized and much more destructive dimensions. Widespread poaching, conducted at the subsistence as well as commercial level, is driving a number of antelope species towards oblivion; chimpanzees are killed for the pot; birds and snakes, prized for either their rarity or beauty or both, are harvested and sold on an illegal but flourishing international market avid for the exotic wealth of Africa; the orchids of the rainforests and the ancient cycads of South Africa's Eastern Cape are picked and sold for astronomical sums to shady middlemen in Brussels and Bangkok, London, Los Angeles and Hong Kong. And so on, right across the spectrum of natural treasures. There is scarcely a living organism, faunal or floral, that is safe from man's predation if it can command any sort of price.

The fundamental dynamic, however, the root cause of Africa's ecological demise, is the relentless pressure created by rapidly expanding human populations. The continental growth rate, at

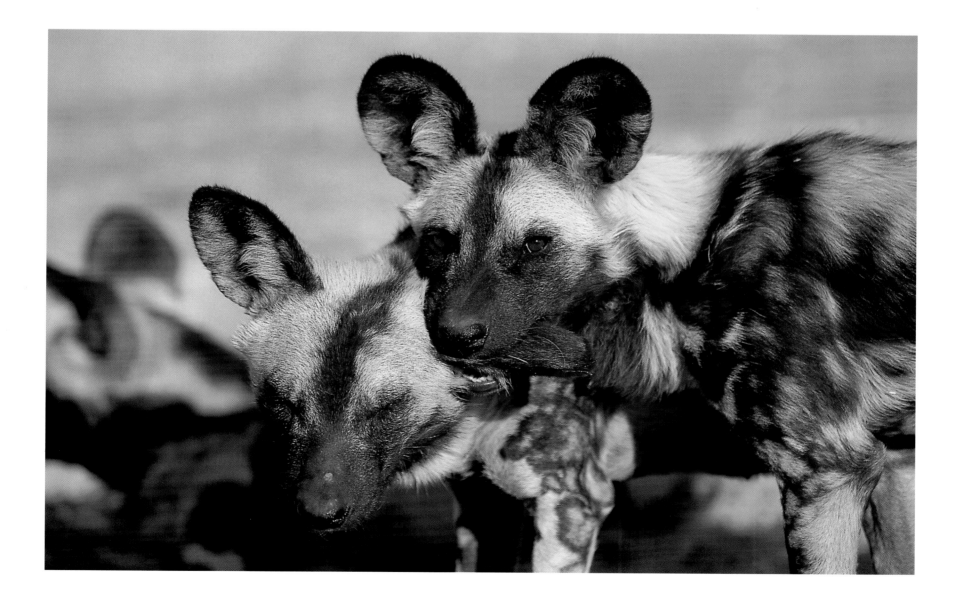

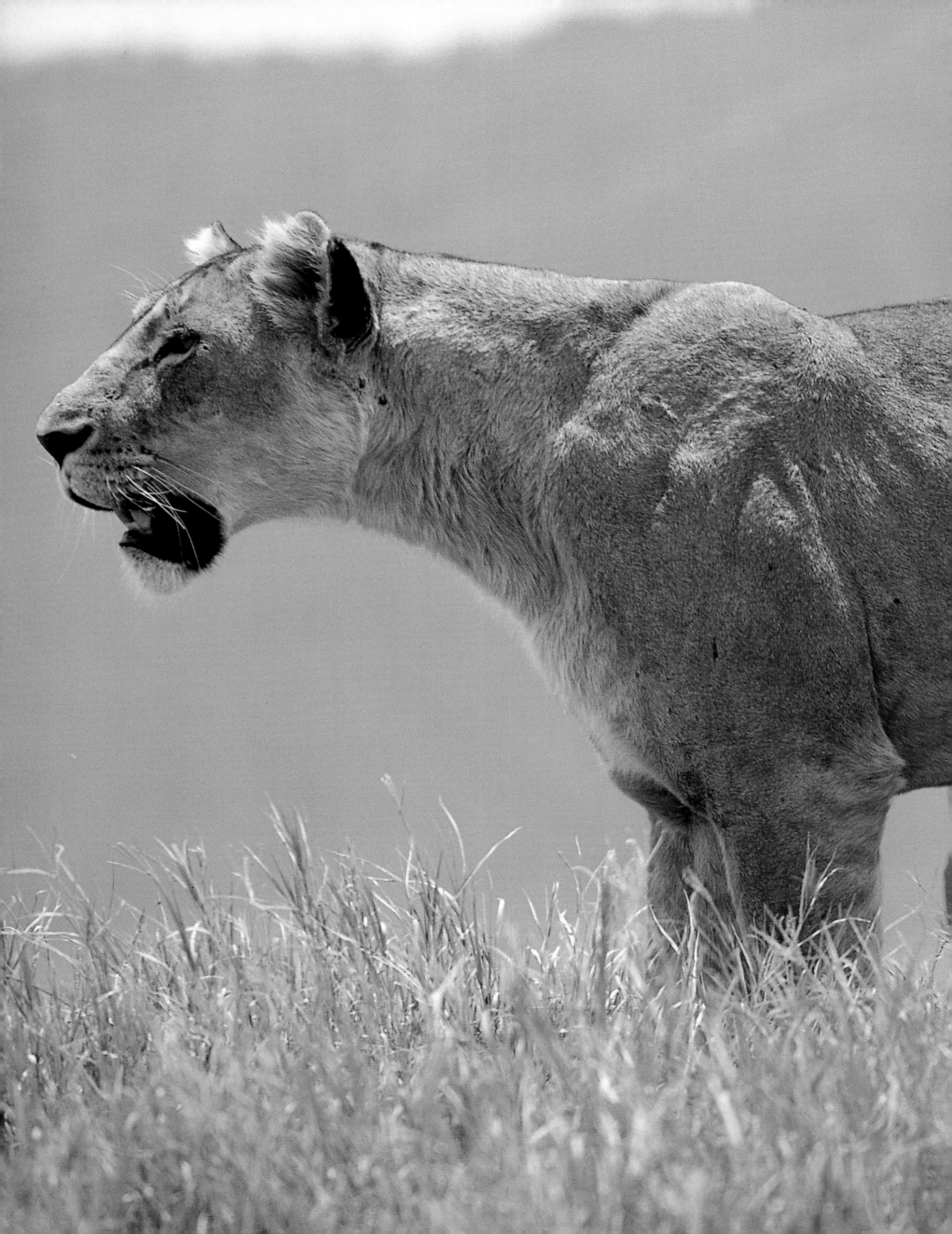

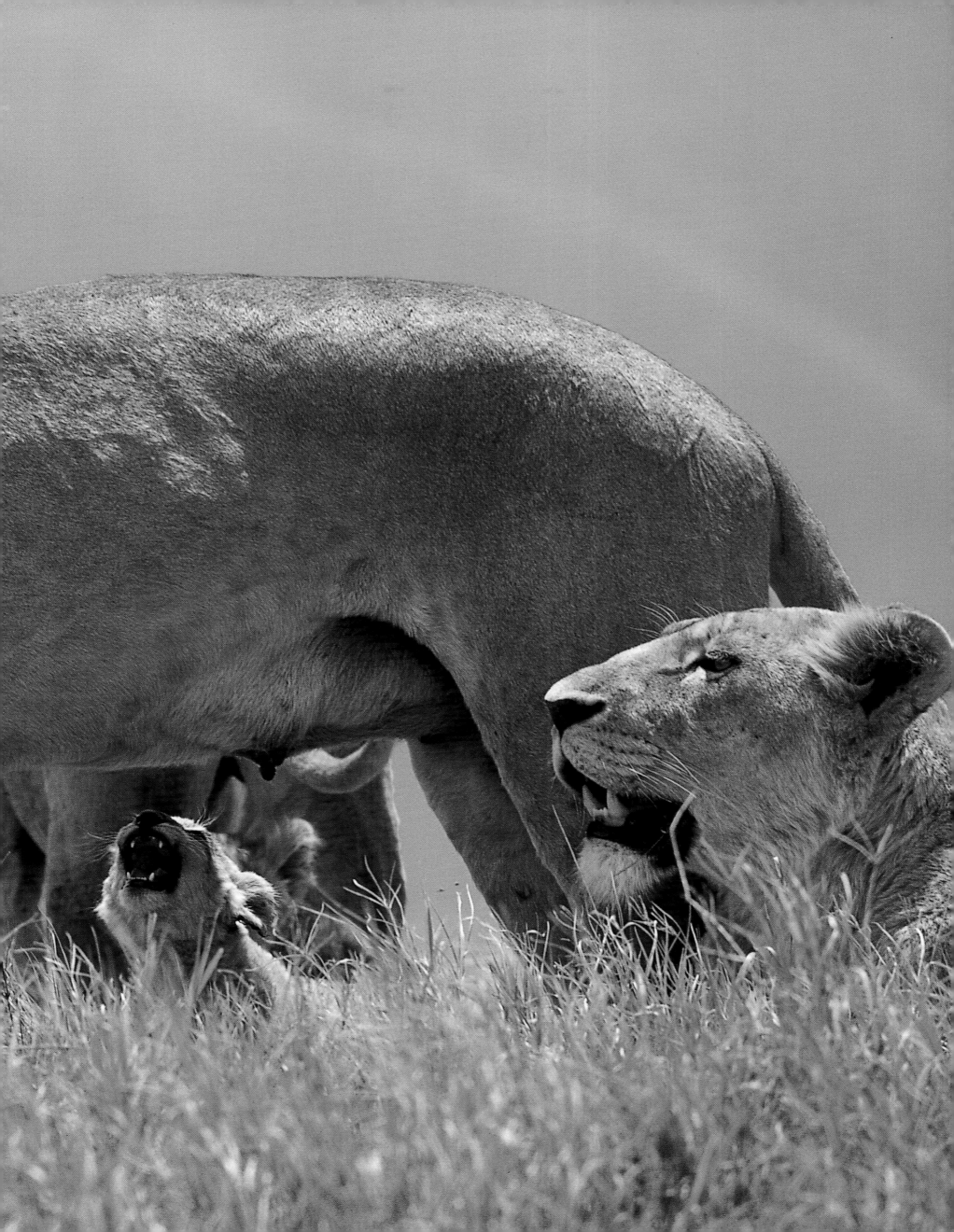

just under 3 per cent, is the highest of the world's major regions; it is making intolerable demands on resources, and unless it is lowered the environmental future is bleak indeed. Unhappily, there seems little prospect of this, certainly in the short term: poverty, illiteracy and traditional taboos inhibit birth control programmes designed to reduce the size of families and raise living standards. The drift from the countryside into the cities and towns, and the concurrent improvement in material circumstances and, above all, in education, hold some promise for the

next century – urbanization does tend to lead to smaller family units. But this is a slow process, probably too slow to make any significant difference to the outcome.

In any event, land is central to the African economy; its importance – more than that, its sanctity – is deeply embedded in the psyche of the continent's people, and the needs and aspirations of human society will continue to take precedence over the integrity of the environment. And quite rightly so: it is neither moral nor practical to ask a poor man to make sacrifices, to deny communities access to their water, pasture, firewood, thatching materials, medicinal plants, game meat, wild fruits, their very living space, for something so intangible and incomprehensible as conservation. An abstraction such as 'biodiversity' simply has no meaning, and therefore no value, for the ordinary person.

Unless, of course, it can be demonstrated that conservation will bring direct benefit to those on the ground. And herein lies a spark of hope: it is now generally appreciated, not only by the environmental lobby but by the politicians as well, that the wellbeing of the wildlife and the interests of the tourism industry need not be in conflict with the demands of rural society.

The spotted hyaena (below) is widely perceived as the 'vacuum cleaner' of the veld, a lowly scavenger that survives on the kills of other carnivores. The animal does scavenge, of course, but essentially it is an opportunist, taking whatever is offered and often doing so with considerable panache (it has been known to rob lions of their kill). It is also one of the most resourceful of hunters. In certain regions – on the plains of East Africa and in the Kalahari – hyaena packs kill up to 60 per cent of their food.

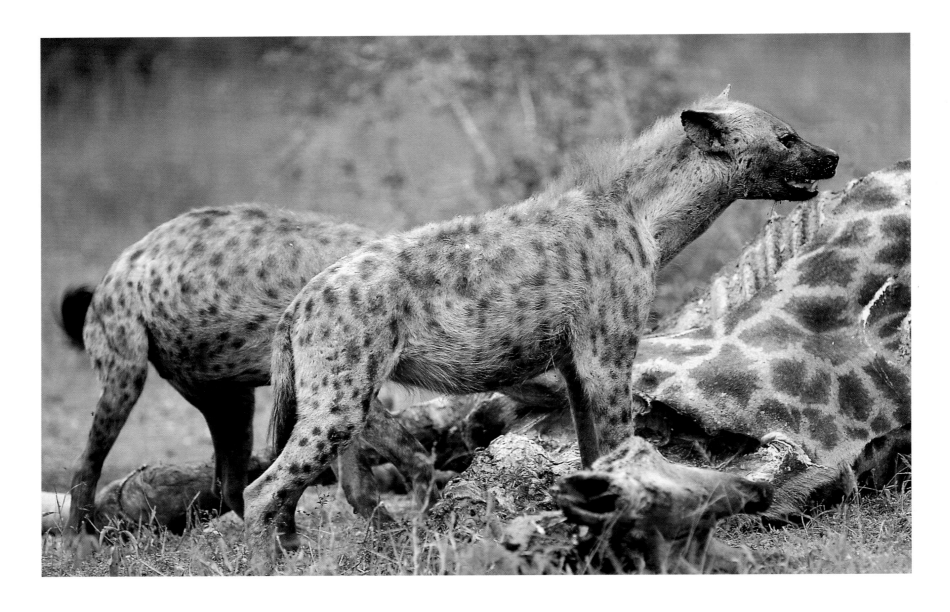

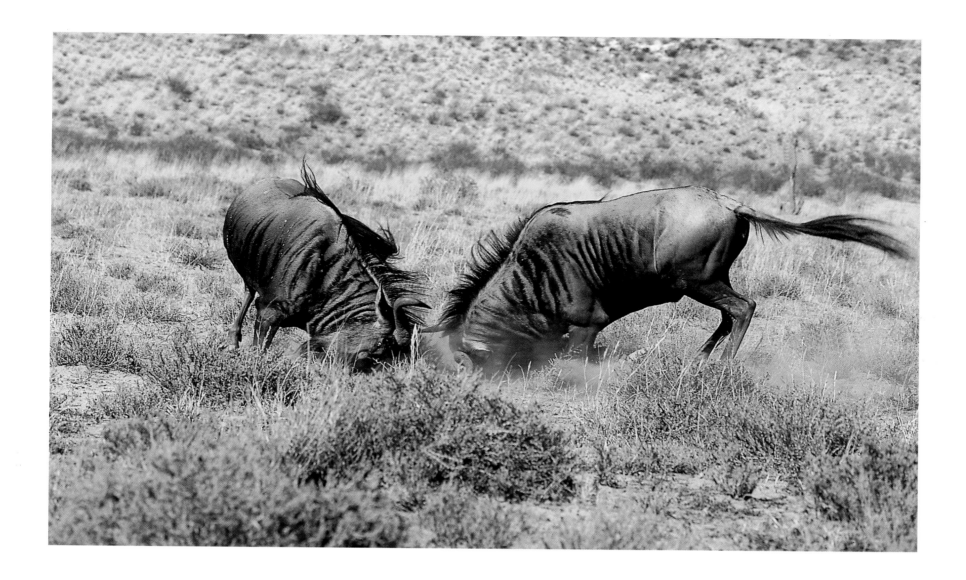

Two blue wildebeest (above) fight for territorial dominance. Also known as brindled gnus, these large bovids are usually found in groups of up to 30 individuals, though they sometimes gather in vast concourses numbering tens and even hundreds of thousands of head. The aggregations are at their most spectacular in East Africa, home to the white-bearded race of the species.

At present, a considerable proportion of Africa's larger fauna and some of its more threatened flora are locked into protected areas of one sort or another. Much, however, remains outside, including many of the most vulnerable animals and plants (notably those of the tropical montane forests). Moreover, a depressing number of the formally proclaimed reserves are barely functional, suffering badly from a lack of funds, lack of management expertise and, indeed, lack of commitment. There are notable exceptions, of course, shining examples of the conservation ethic in efficient practice in countries such as Kenya, Tanzania, Zimbabwe, Namibia, Swaziland and South Africa but, sadly, they are in the minority.

Many of Africa's ecosystems are already doomed. The solution for the remainder, those that may be in decline but are still viable, is not to parcel them up into sanctuaries closed to all but the well-heeled ecotourist – that is unacceptable in regions cursed by poverty and land hunger – but to put them to practical use.

The objectives are, first, to make wildlife pay its way (by charging fees to view it, and through such activities as hunting, and game farming) and, second, to develop reserves in which the people of the countryside, instead of being locked out, have access to and can help preserve the environment in exchange for a share in its resources and in funds generated by ecotourism.

This is a relatively new approach, and one should not underestimate the difficulties: among other things it calls for the understanding, trust, and the active involvement of local communities that are still largely unsophisticated. Nevertheless there has been some progress, most obviously perhaps in the 'resource development' schemes, such as the Richtersveld National Park, launched in recent years by the South African authorities.

Only when conservation creates wealth, and is clearly seen to do so to the benefit of all, will the concept be embraced and the environment treasured as our priceless gift to future generations.

THE RHYTHMS OF LIFE

Like everything else in the wild kingdom, the patterns of breeding – of courtship, mating, feeding and protecting the young until they are able to fend for themselves – are bewildering in their variety. In every instance, however, the sequence has been fashioned over epochs to fulfil a single purpose: the survival of the species.

Many of the larger living forms breed according to the calendar, the precise timing determined by an environmental trigger associated with the weather and what is known as the photoperiod. These conditions change with the seasons, and at the optimum point, established through aeons of trial and error, an animal's glands will respond, releasing a hormone that begins the reproductive cycle.

Other species, especially the smaller ones – those with shorter gestation periods – are more opportunistic, reacting to secondary cues. Thus a marked rise in air temperature, an unusual amount of rain, perhaps a sudden abundance of food will produce proliferations among certain rodents and amphibians, insects, and plants, the expanding biomass nurturing a myriad other creatures in a cycle of birth, growth and interdependence that is as old as life itself.

A spotted hyaena pup (right) plays pensively with a twig. The heart of the spotted hyaena community is the den, often a tunnel-type burrow taken over from another animal. Here the cubs remain, reasonably secure from such predators as lions and jackals, while the adult members of the clan are out finding food.

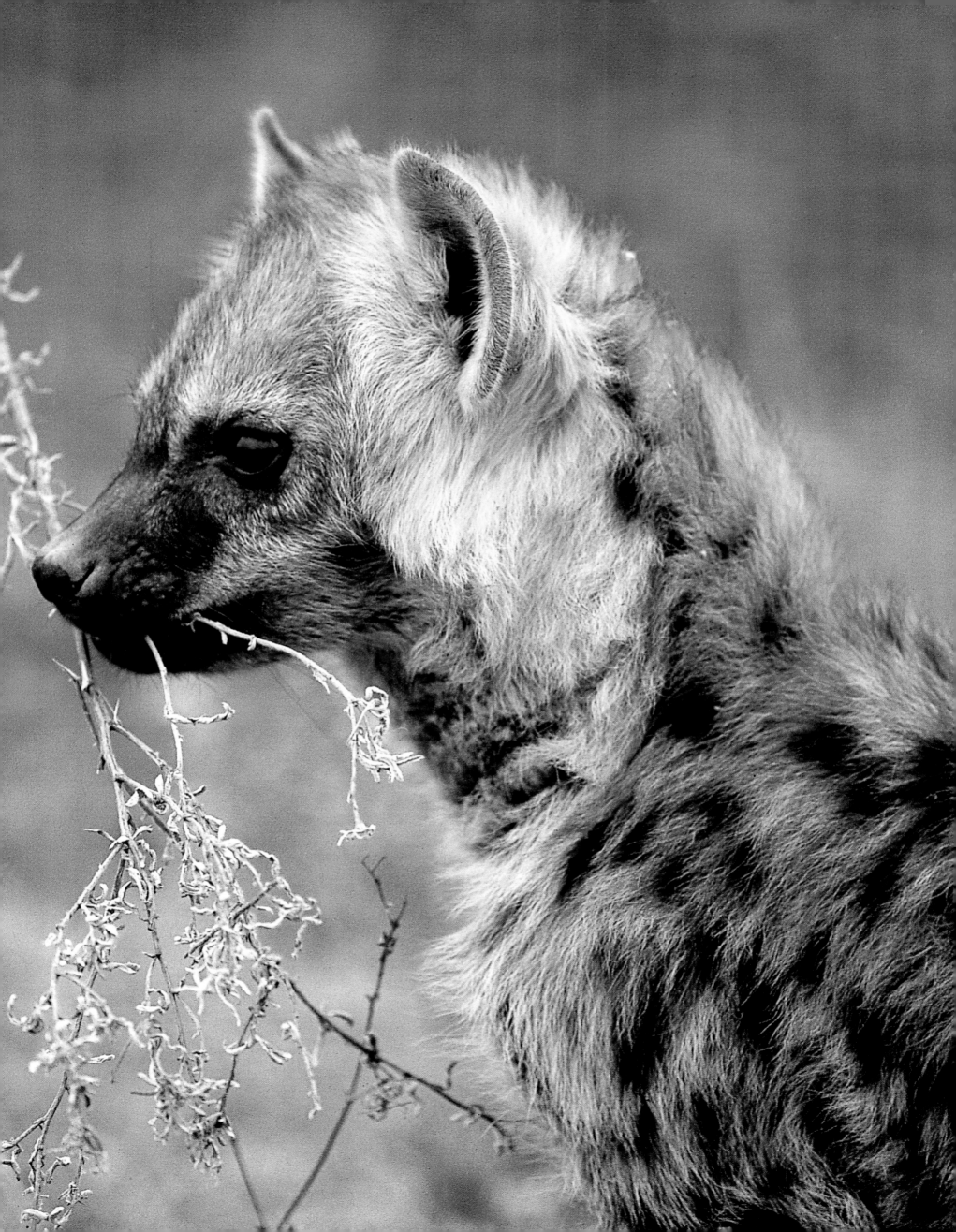

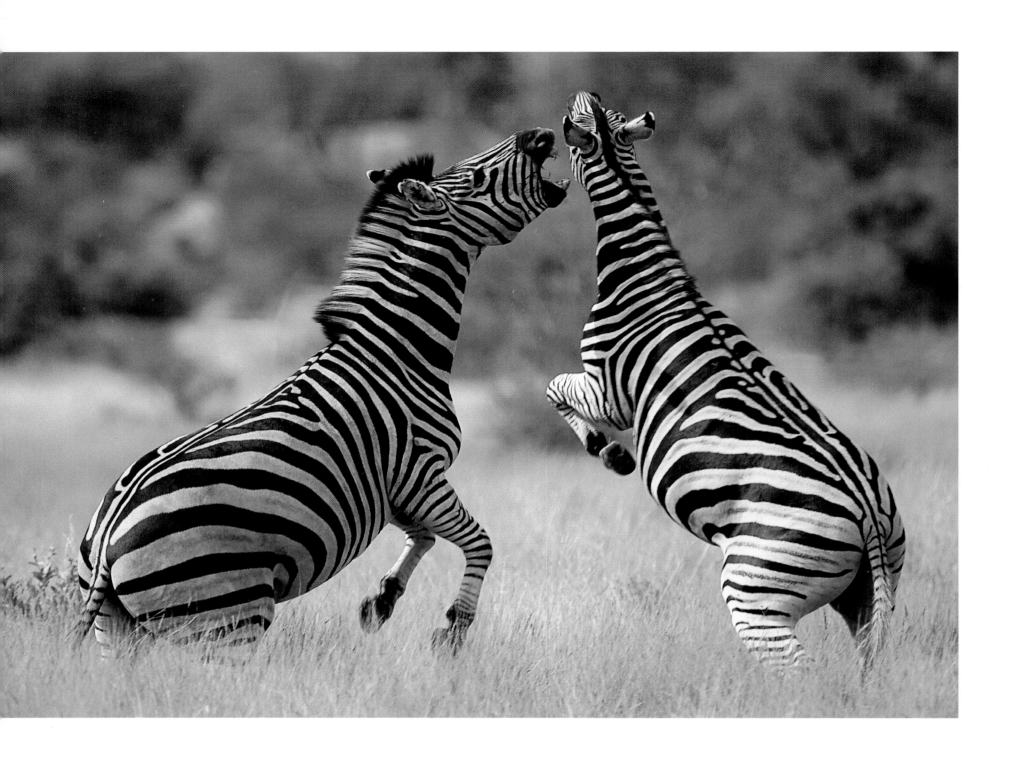

\mathscr{M}ale zebras will fight fiercely to acquire or keep tenure of the mares. Those who lose out either join bachelor herds or remain alone. Family units within the larger herd are small, comprising a single stallion, his females and their young.

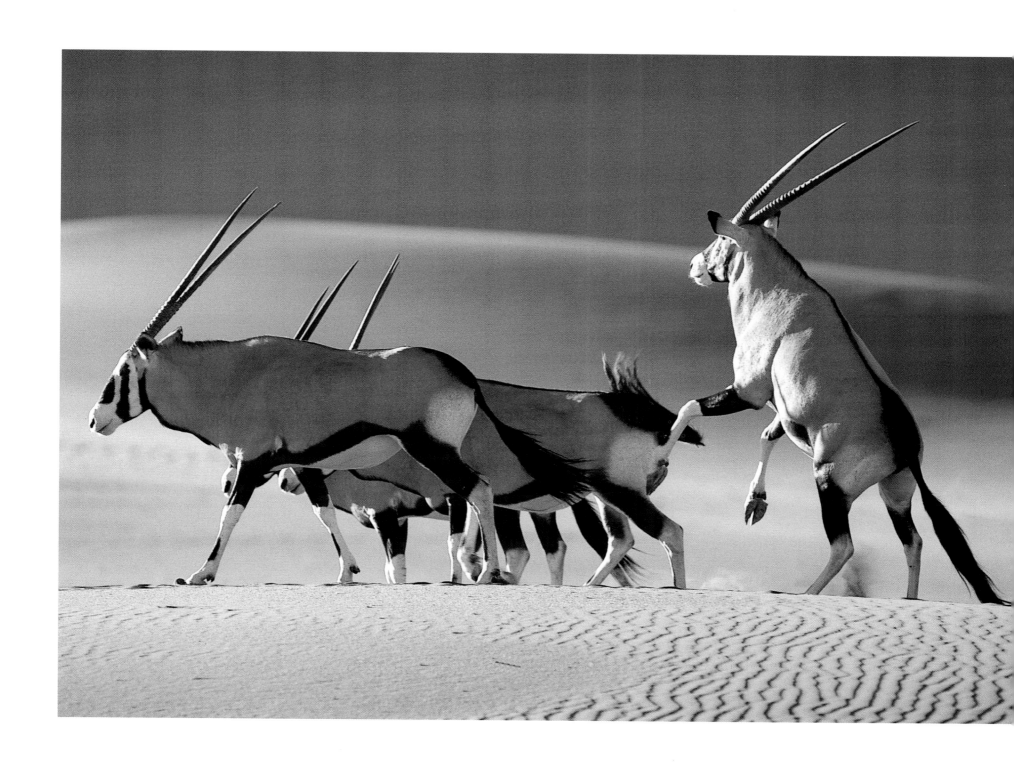

*T*hese gemsbok *Oryx gazella* bulls, superbly adapted to the rigours of the Namib Desert, are manœuvring for dominance over territory. The victor will round up a mixed or nursery herd – perhaps 30 individuals in all – and enjoy sole mating rights for up to three years.

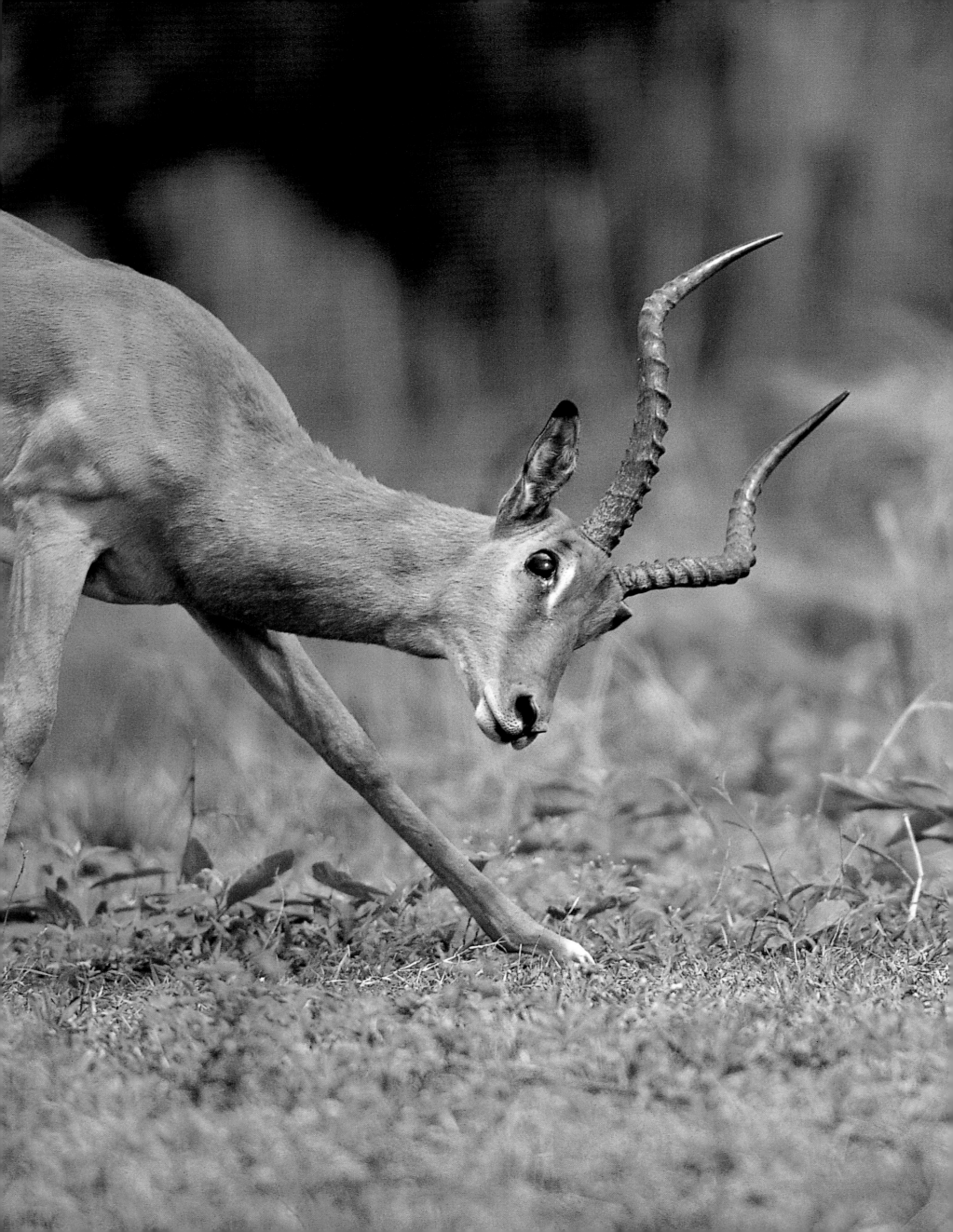

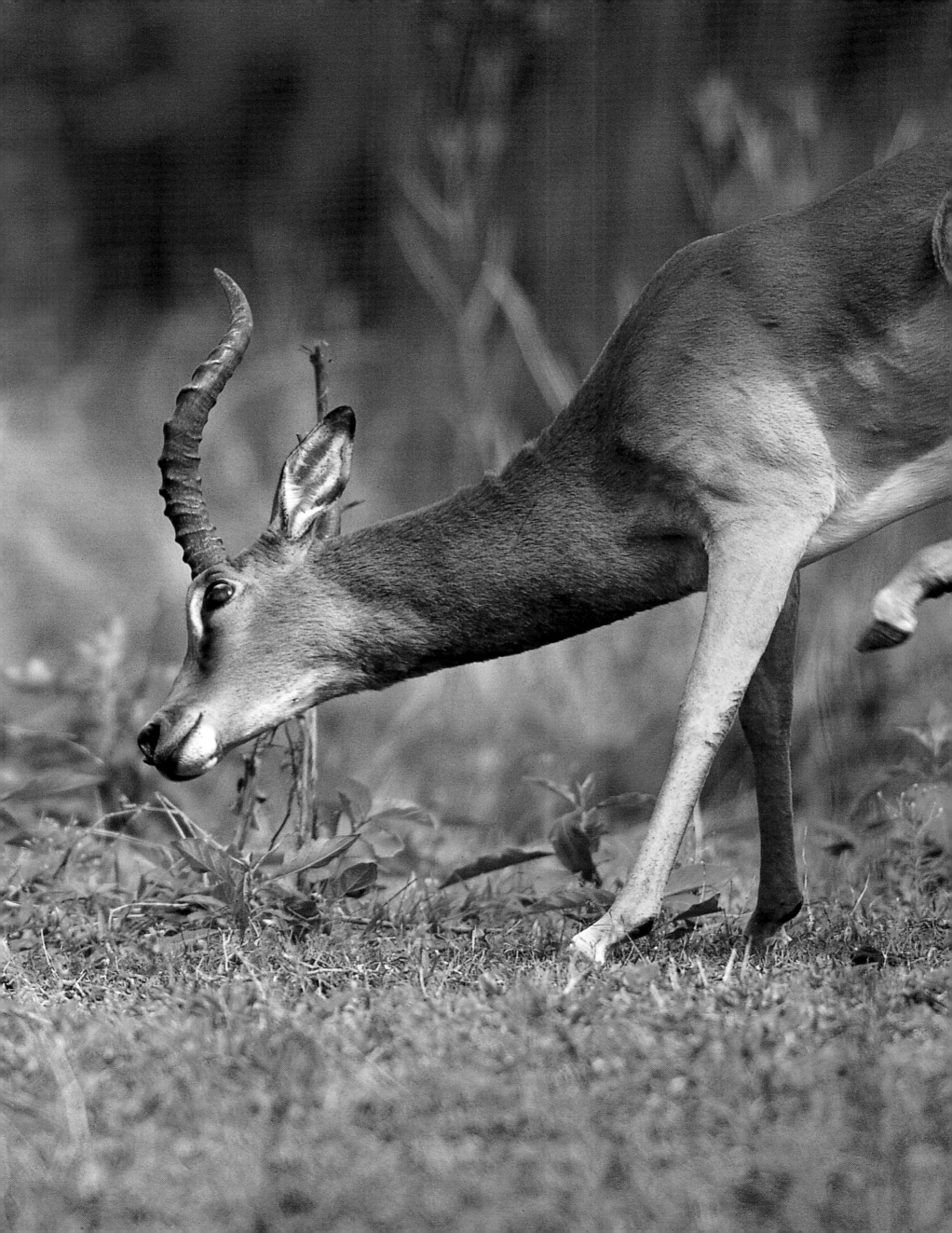

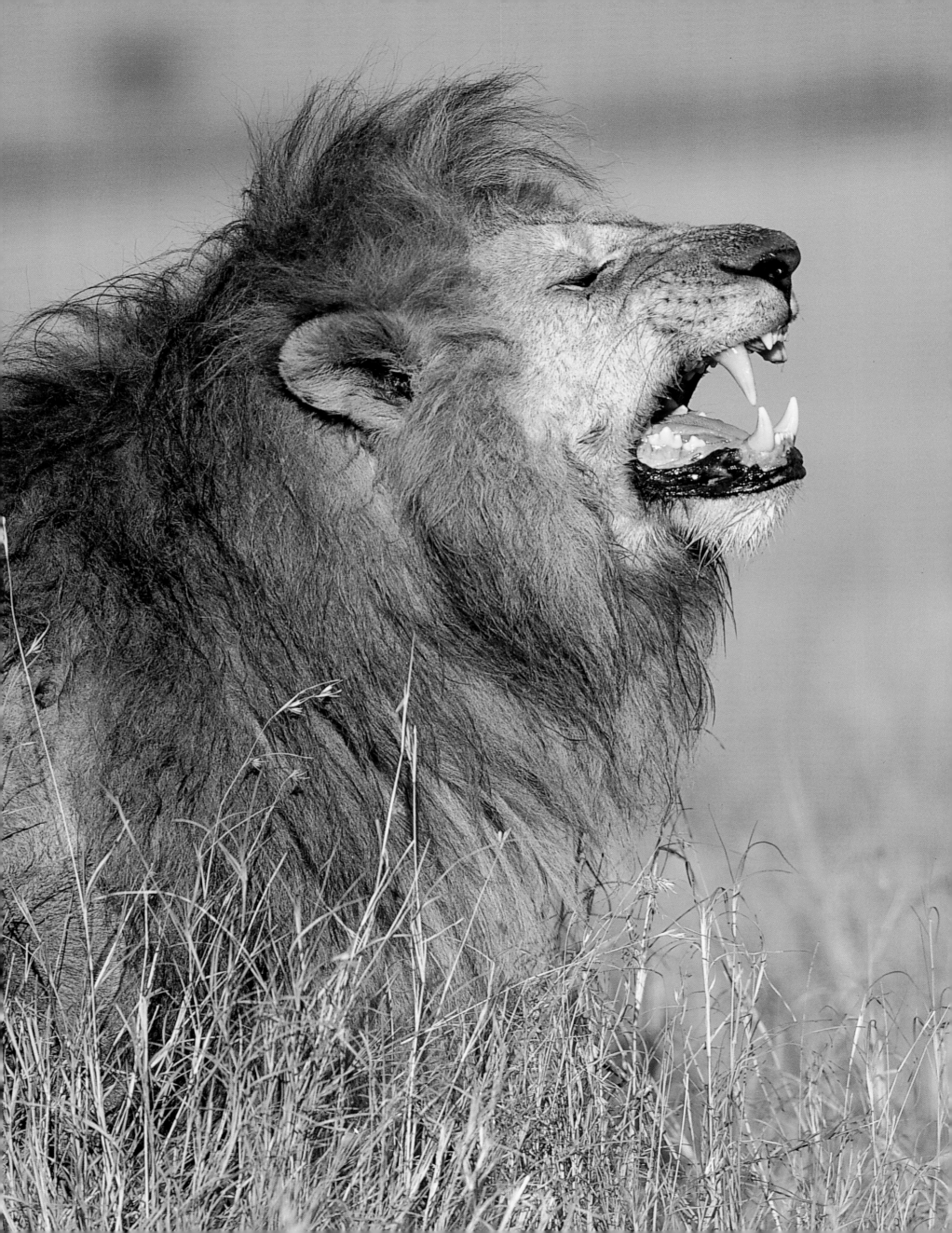

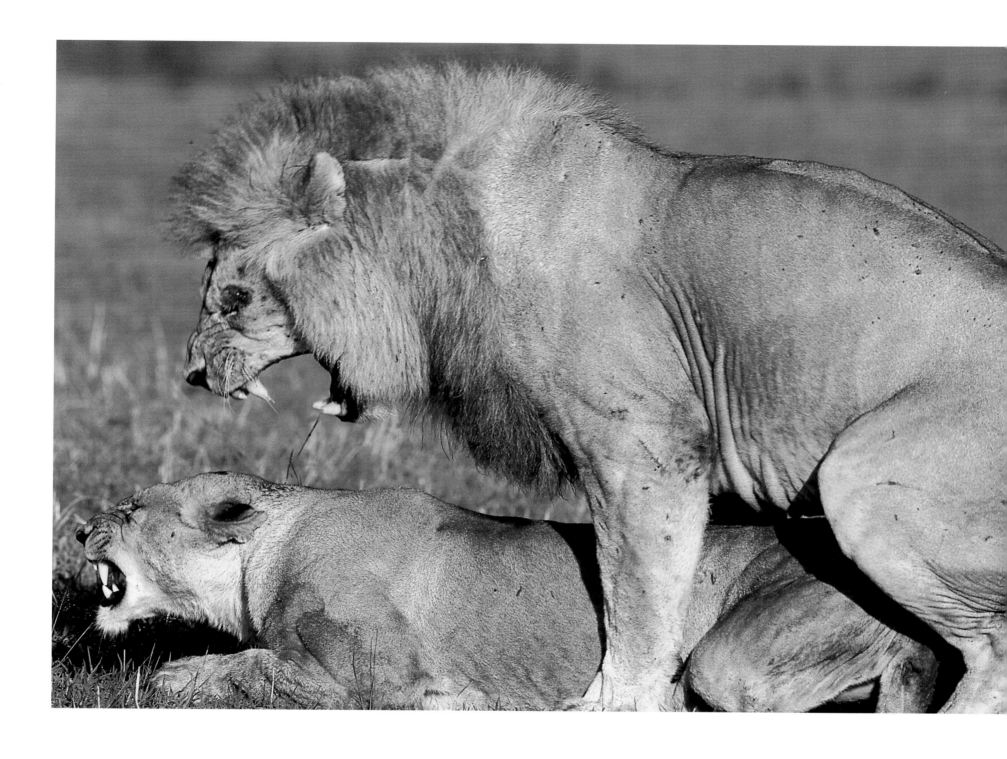

Impala *Aepyceros melampus* rams (previous pages) spend most of the year in bachelor herds, but become territorial, noisy and aggressive during the rut. Mating males usually gather together harem groups of 15 to 20 ewes.

With head raised, mouth open and lip curled – a display of behaviour known as 'flehmen' – a male lion (opposite) captures the scent of a female on heat.

At the height of the relatively short (up to 16 days) mating period, a pair of lions will copulate once every 15 to 20 minutes. The male remains in close attendance throughout this time: to leave the female's side, even briefly, would be an open invitation to rivals. These two (above) belong to a pride in Kenya's Masai Mara Reserve.

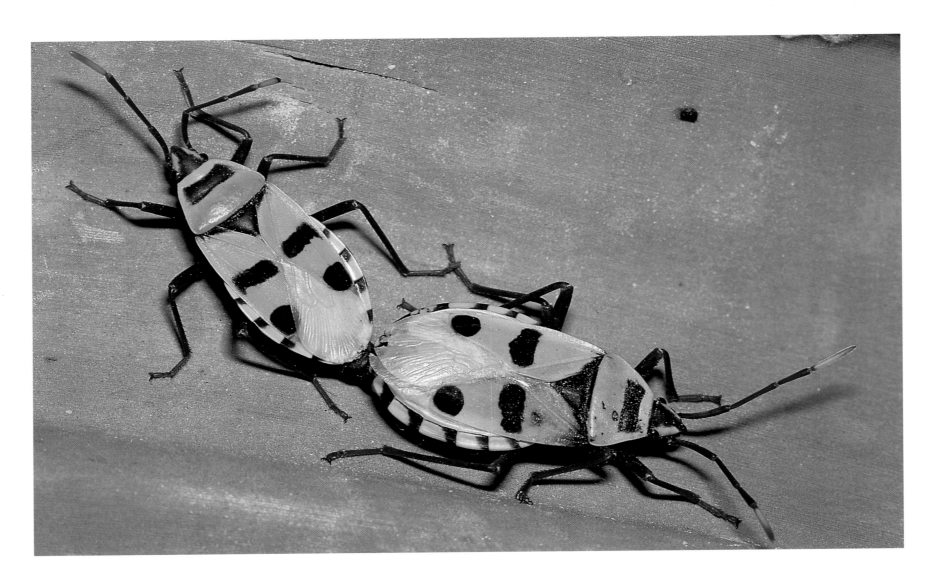

\mathscr{B}reeding rituals within the invertebrate world take numerous forms, many of them elaborate, all of them perfected over the aeons to take optimum advantage of climatic conditions and the availability of food. Some species, including the bugs, give birth to live offspring that are similar to the adults. Others – the ants, wasps, bees, beetles and butterflies – are subject to a complete metamorphosis, where the young go though various stages of development. After a number of moults they become pupae, and then undergo further changes inside a cocoon before emerging as the final product. Seen here, in the mating process, are welwitschia bugs *Probergrothius sexpunctatus* (above), mocker swallowtail butterflies *Papilio dardanus* (right), and day-flying moths (opposite).

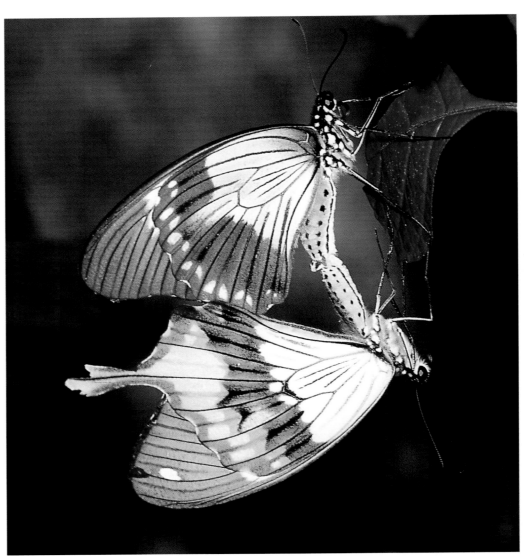

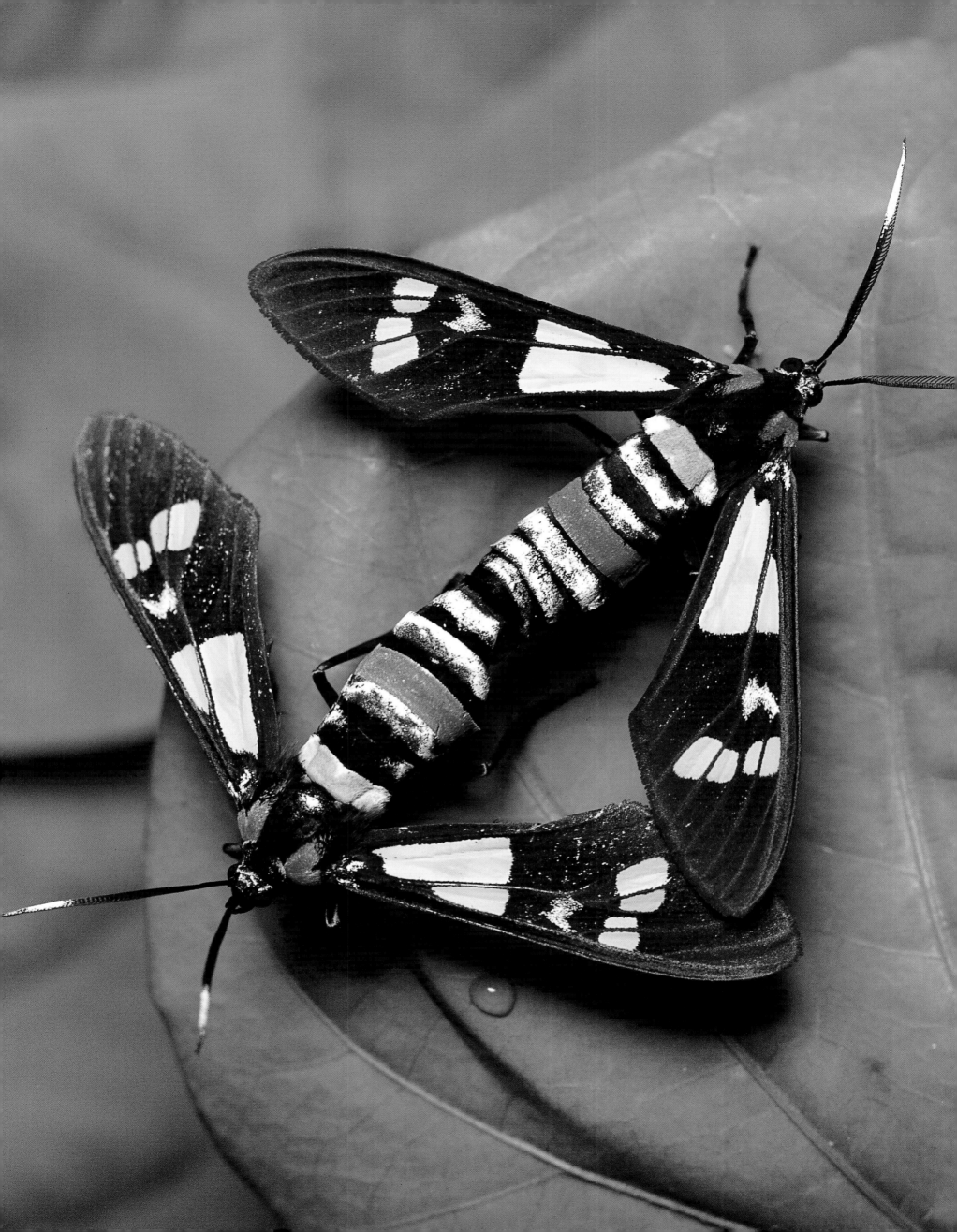

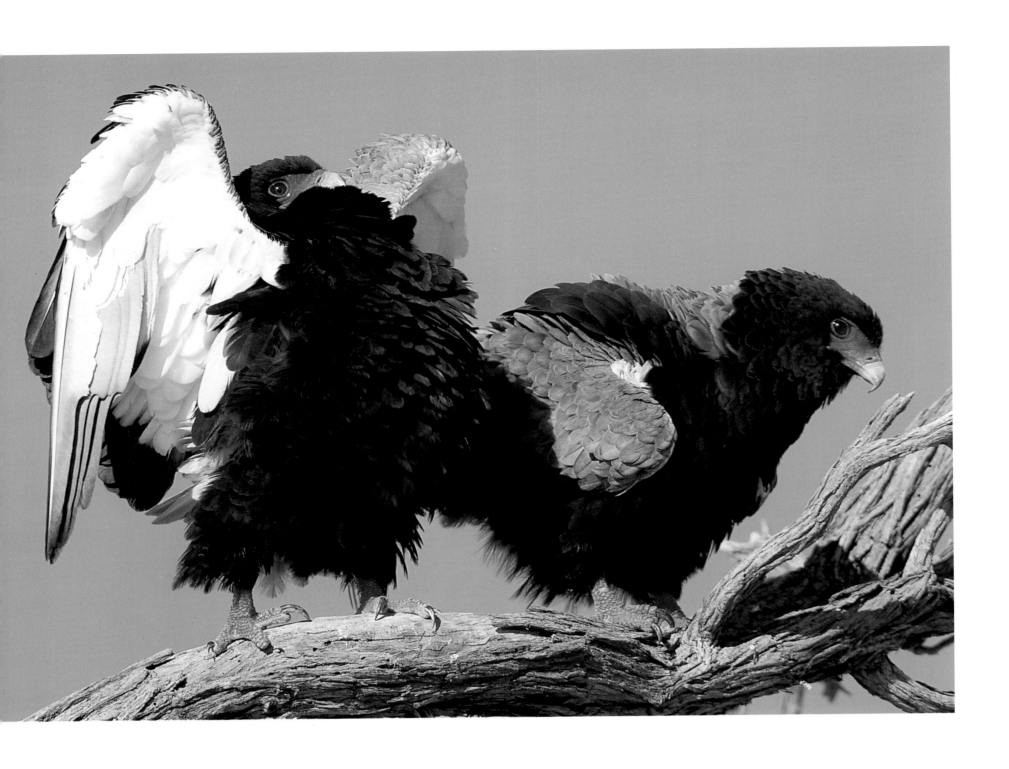

Among the more striking of Africa's birds of prey is the bateleur *Terathopius ecaudatus*, seen here performing part of its courtship display (above) and mating (opposite). The eagle, which occurs in most of the continent south of the Sahara (as well as in parts of the Middle East), has a marked liking for carrion, a dietary preference which partly explains its decline, outside the major protected areas, in the more developed southern part of its range. There, poison bait laid down by stock farmers – to exterminate marauders such as jackals – has taken devastating toll of the bateleur populations.

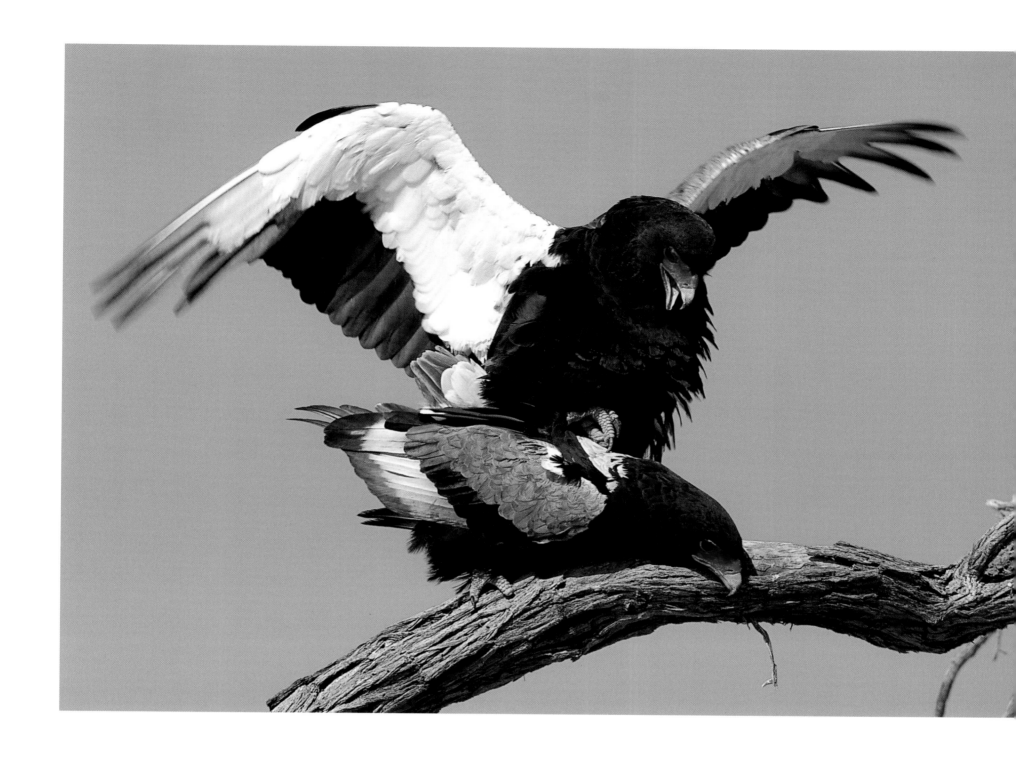

\mathscr{T}hese two bateleurs will produce a single, chocolate-and-cream coloured chick, which will be confined to the nest for between three and six and a half months, and may remain dependent on its parents for a further four. Mother and father share the incubation, brooding and feeding duties. The species is renowned for its aerial prowess: 'bateleur' is French for acrobat or juggler, and it aptly describes the bird's marvellous control of the air as its rolls, tumbles and somersaults in its spectacular display flight. When hunting, it planes along on a straight course, its only bodily movement a gentle rocking from side to side.

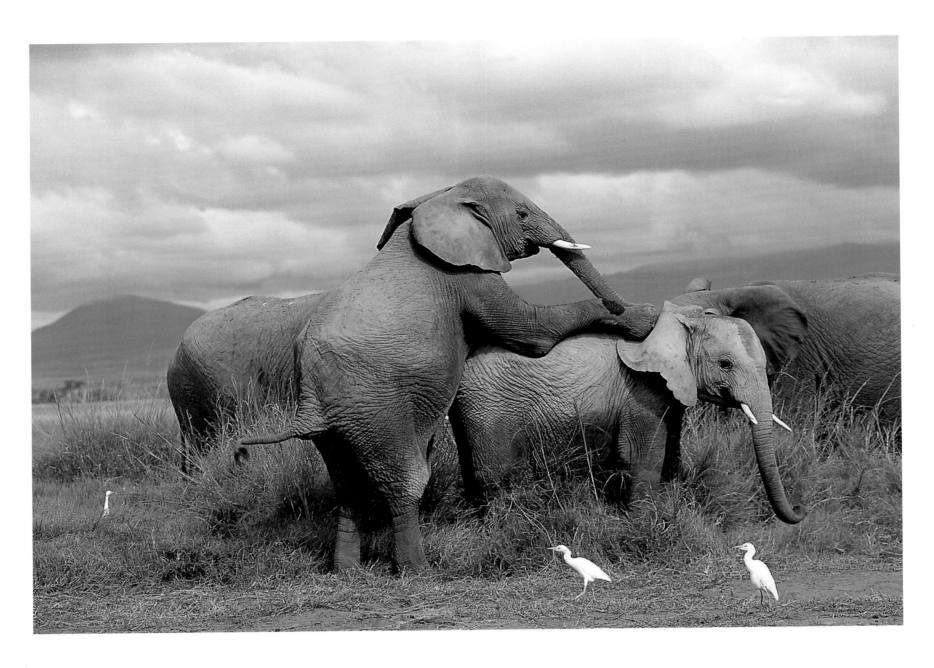

The long-living African bull elephant *Loxodonta africana* (above) seldom mates before his twentieth year – an age at which, though not yet fully mature, he can compete on almost equal terms with the older males. After a 22-month gestation period the cow, accompanied by one or two other females, retires to a quiet place to give birth to her single calf. Mother and child (right) rejoin the matriarchal herd a few days later, when the calf is strong enough to keep up with the adults.

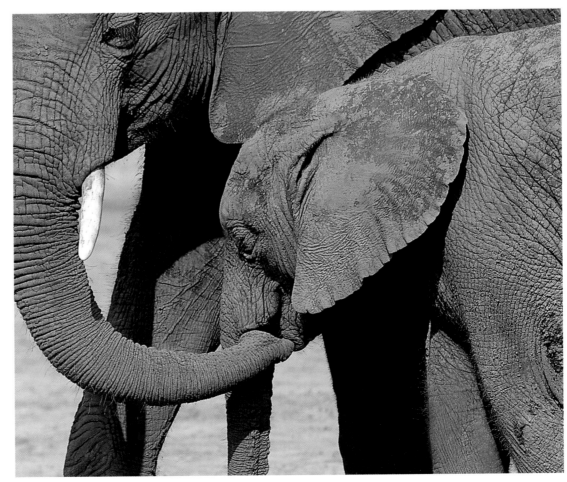

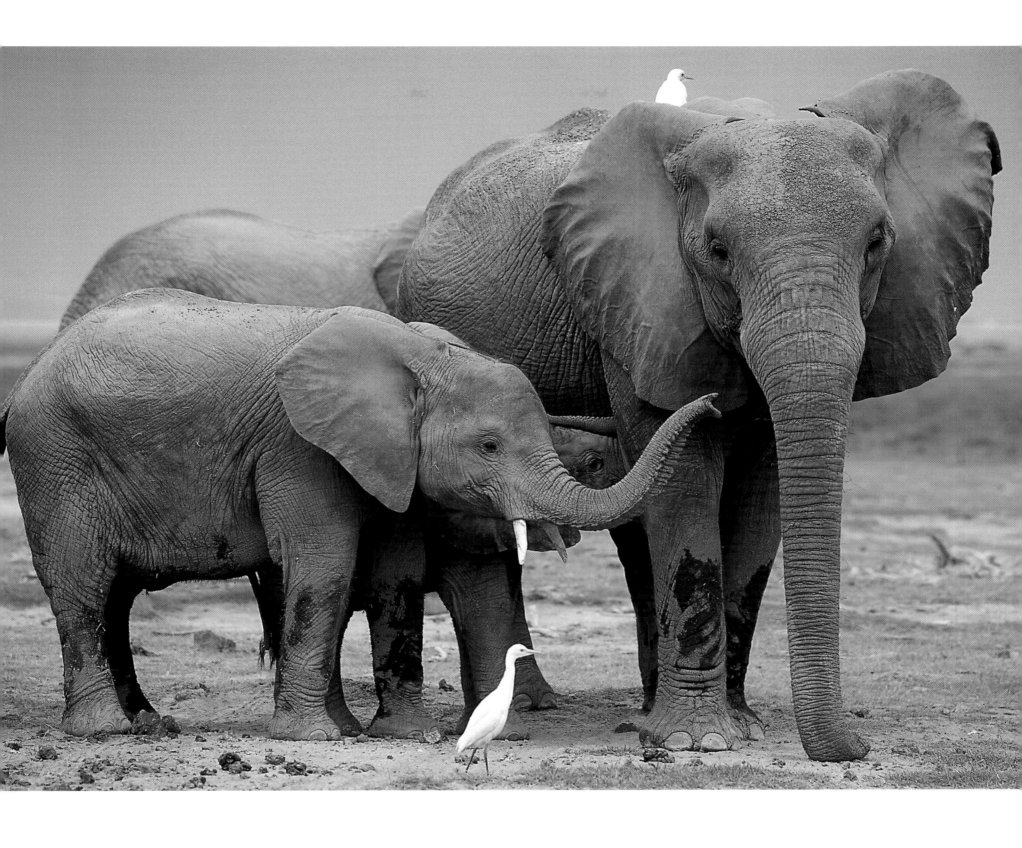

\mathcal{T}he elephant herd can number anything between 10 and 20 individuals comprising a leader cow (the matriarch), related females and their offspring of different ages. Bulls only associate with cows for mating purposes. Several family groups inhabit a clan territory and sometimes the members of different family groups come together to form loose herds of up to several hundred individuals.

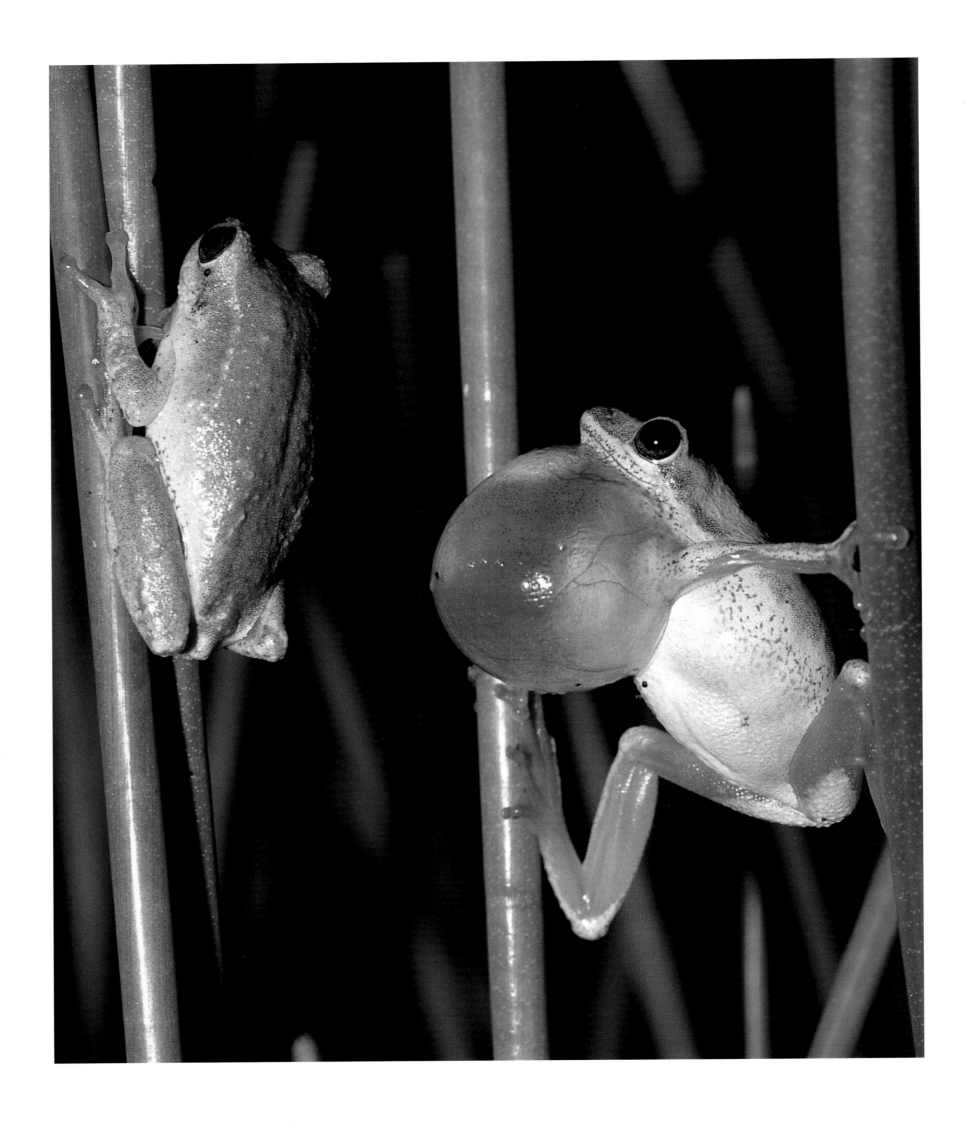

*B*rilliantly coloured *Hyperolius* frogs (above and opposite) breed in
marshlands and on the fringes of pools.

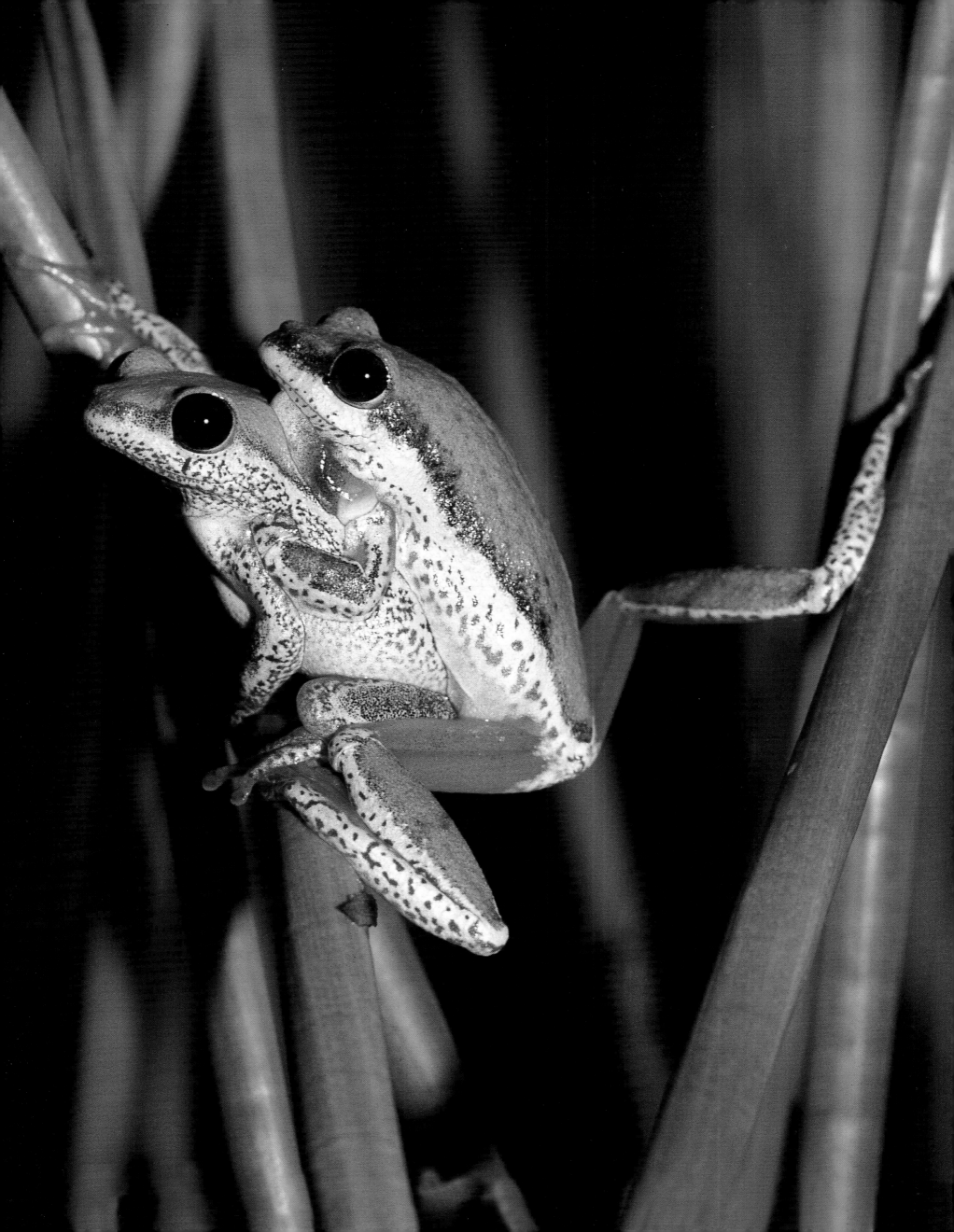

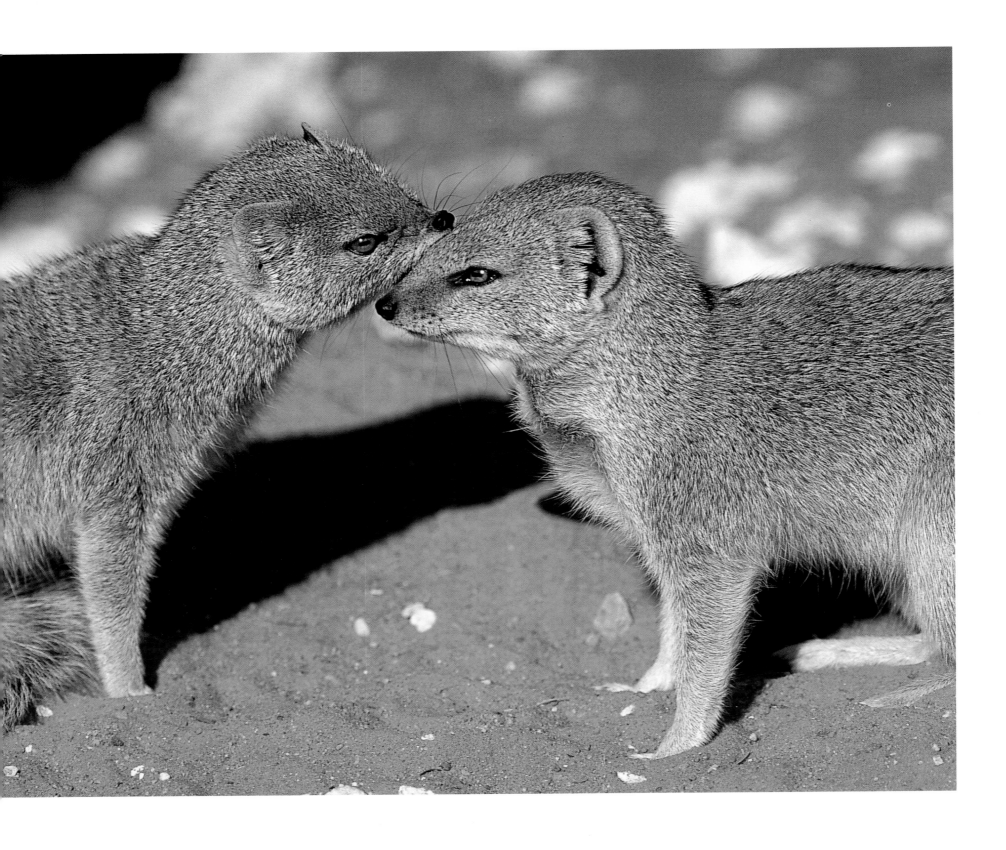

Getting to know you. These yellow mongooses *Cynictis penicillata* will produce between two and five offspring in a warren that they share with their own kind and sometimes, quite amiably, with the suricate and the ground squirrel. Sociable though the species is, it forages alone.

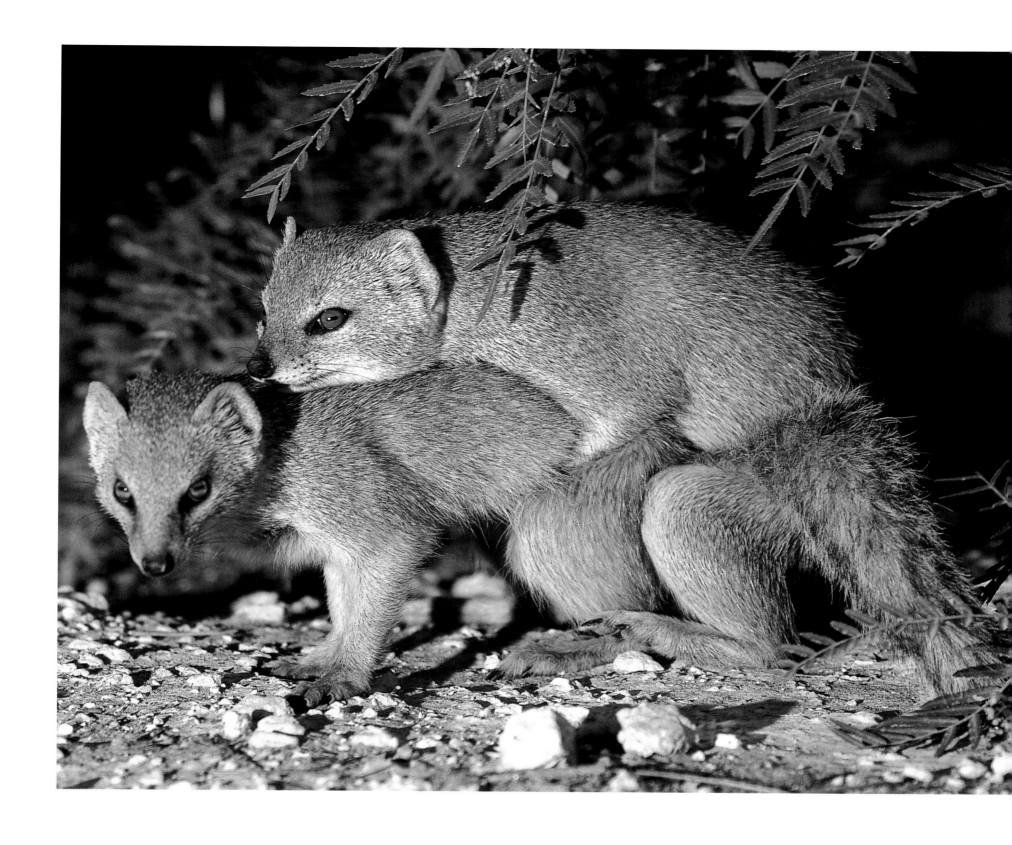

\mathscr{A} pair of yellow mongooses begins the breeding process. The animal's natural habitats are within the more open, drier scrub- and grasslands of the interior, though it is a highly adaptable little creature, encroaching happily and in numbers into crop-farming areas.

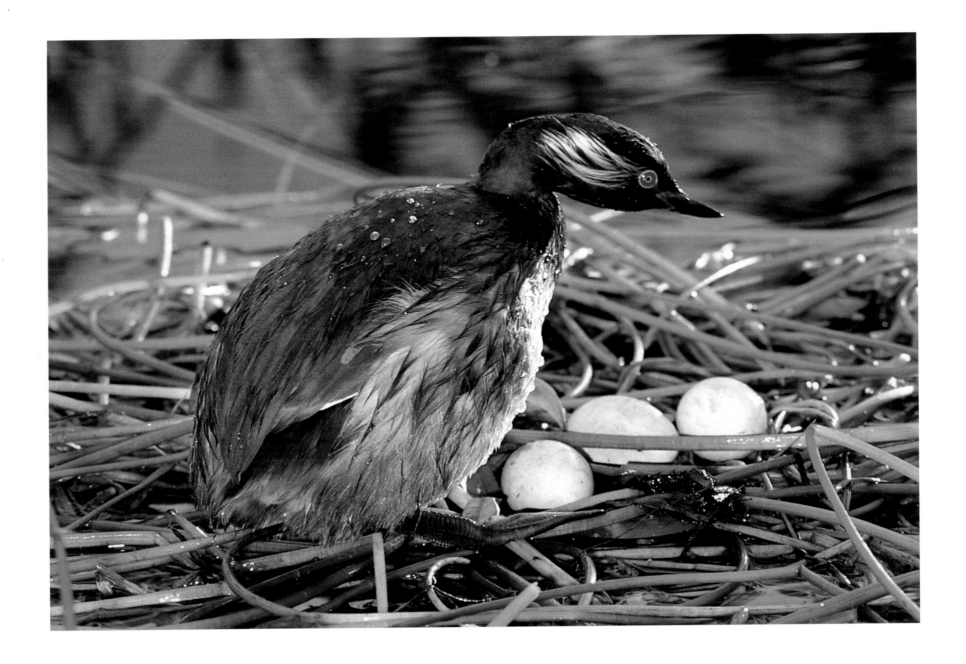

\mathcal{T}he black-necked grebe *Podiceps nigricollis* (above), a small diving bird with lobed toes (as opposed to webbed feet), inhabits open stretches of water in southern Africa, the East African Rift Valley and north-western Africa, its nest a floating tangle of aquatic plants.

\mathcal{S}imilar in habitat preference is the little bittern *Ixobrychus minutus* (opposite), a relative of the heron and a species found in dense reed-beds, marshlands and other freshwater areas. It nests, alone or in small groups, in the rushes just above the waterline.

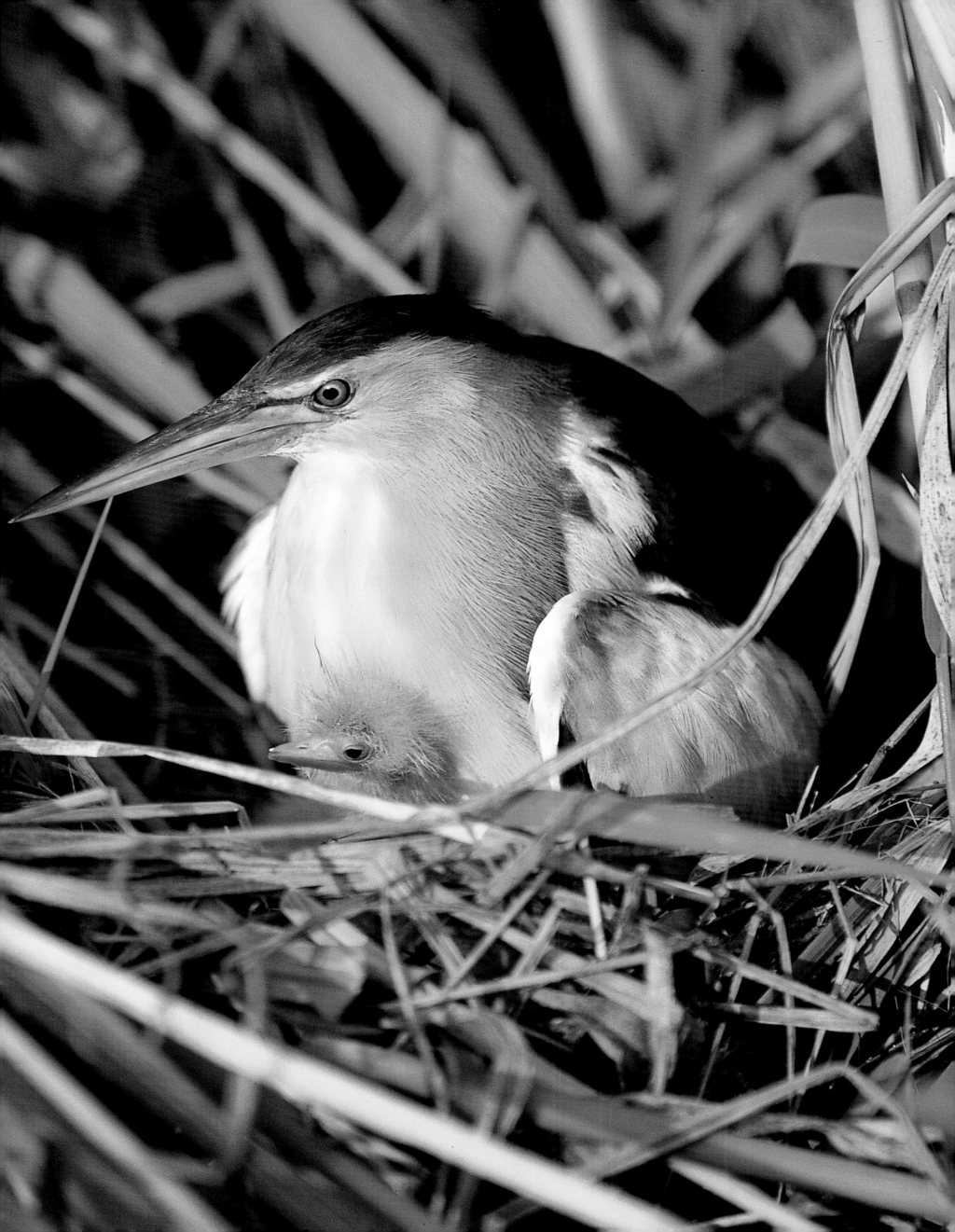

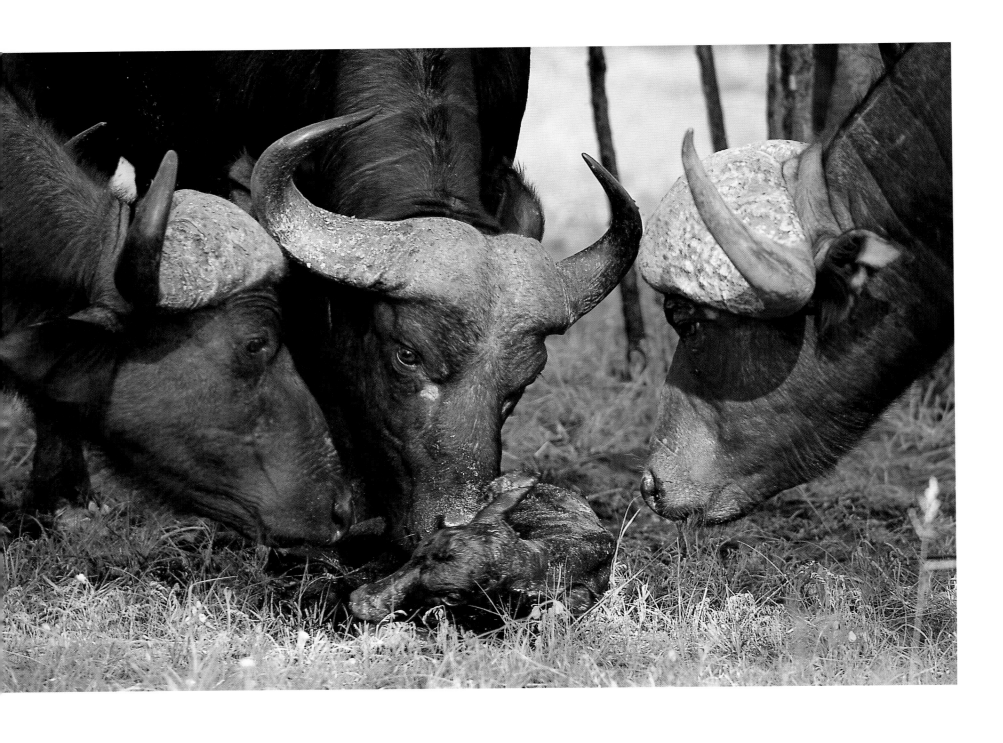

\mathcal{T}oday, few African buffalo (above and opposite), once so prolific in the great savannas and woodlands of subSaharan Africa, can be found outside the larger protected areas. Cows can give birth at any time of the year, though most do so between January and April.

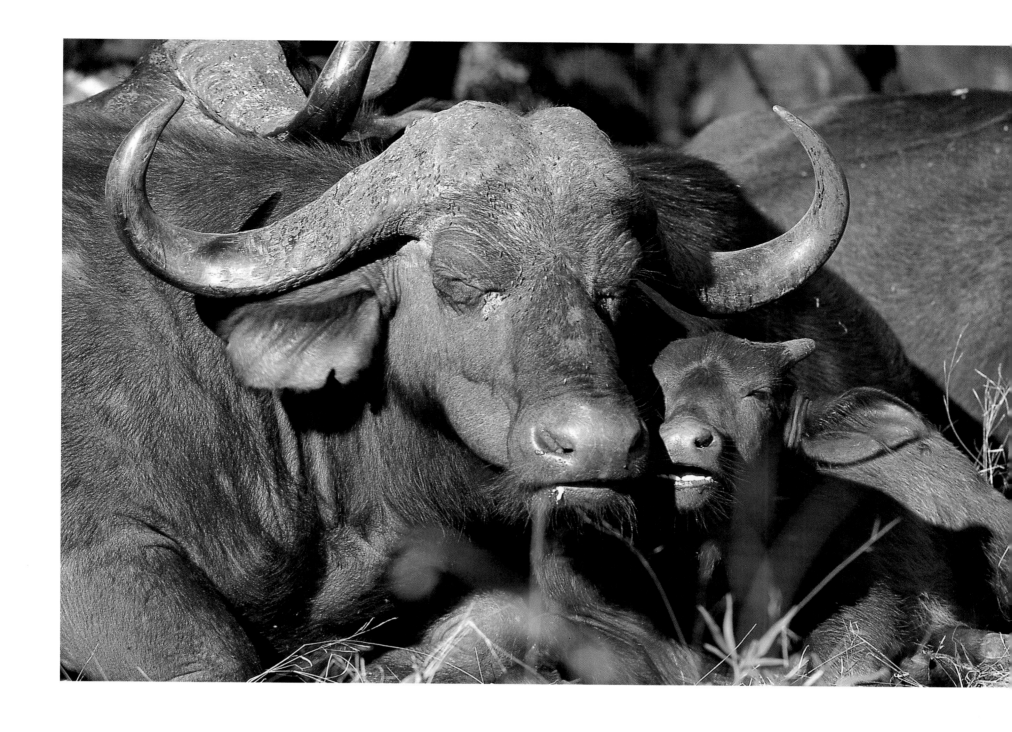

\mathscr{A} buffalo calf has a mass of about 40 kilograms at birth, and is up and running with the herd just a few hours later. All being well, it will grow into a huge animal standing 1,4 metres at the shoulder and weighing up to 800 kilograms.

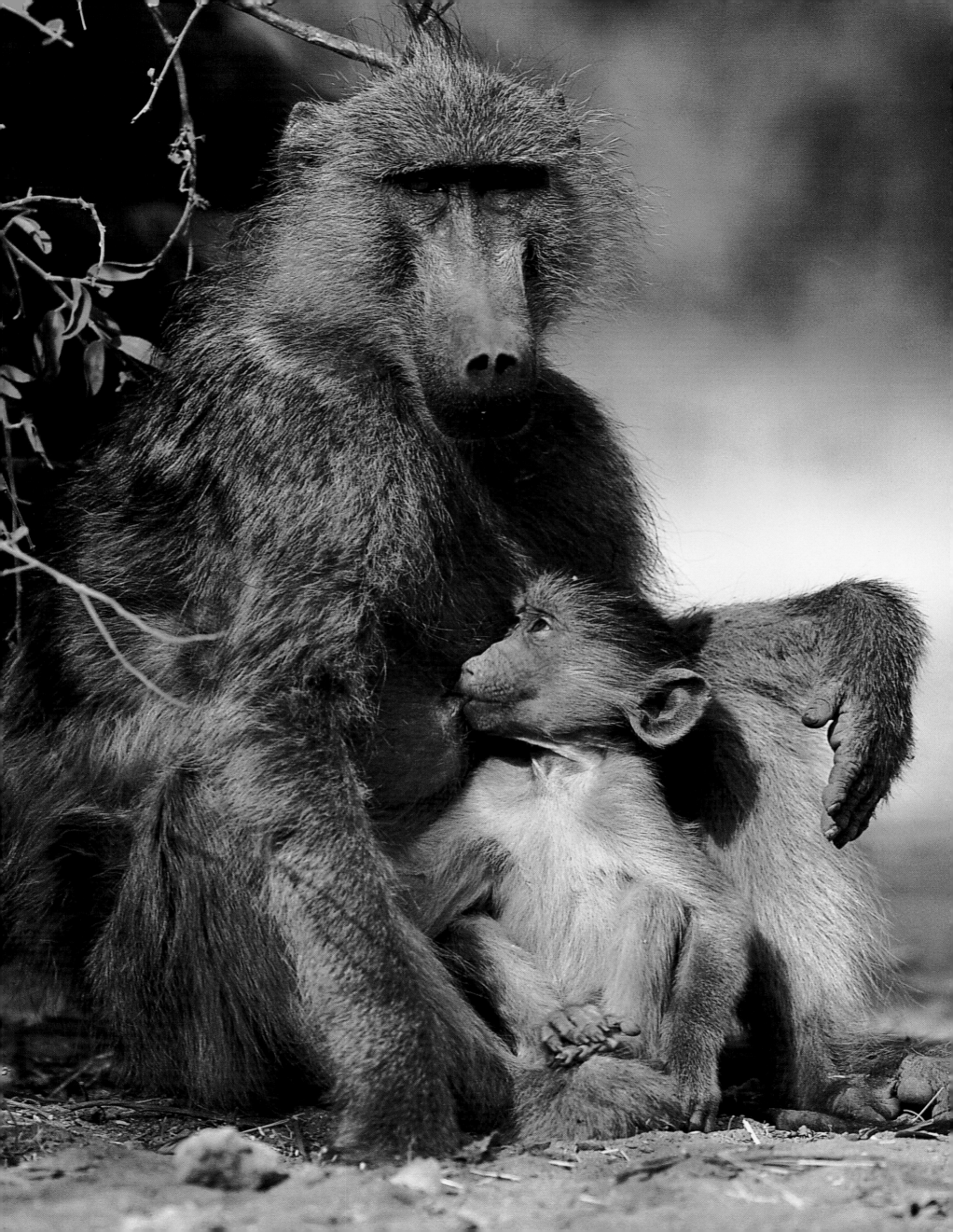

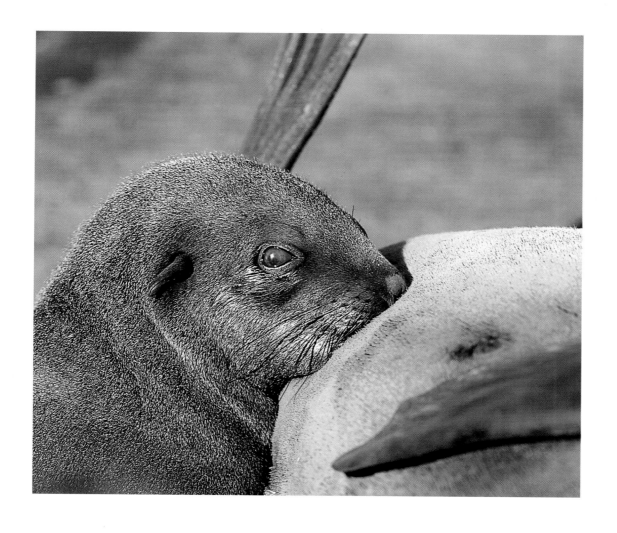

This chacma baboon *Papio cyno-cephalus* mother (opposite) will nurse her solitary child for about six months. When on the move the infant clings to its parent's chest at first, but soon learns to ride her lower back, the tail serving as a back-rest.

A Cape fur seal *Arctocephalus pusillus* mother provides her single pup (left) with a 'shuttle' feeding service, suckling her infant in the intervals between her sea-going hunting forays.

Warthog *Phacochoerus aethiopicus* young (below), of which there are on average three to a litter, are born in burrows and weaned at three months.

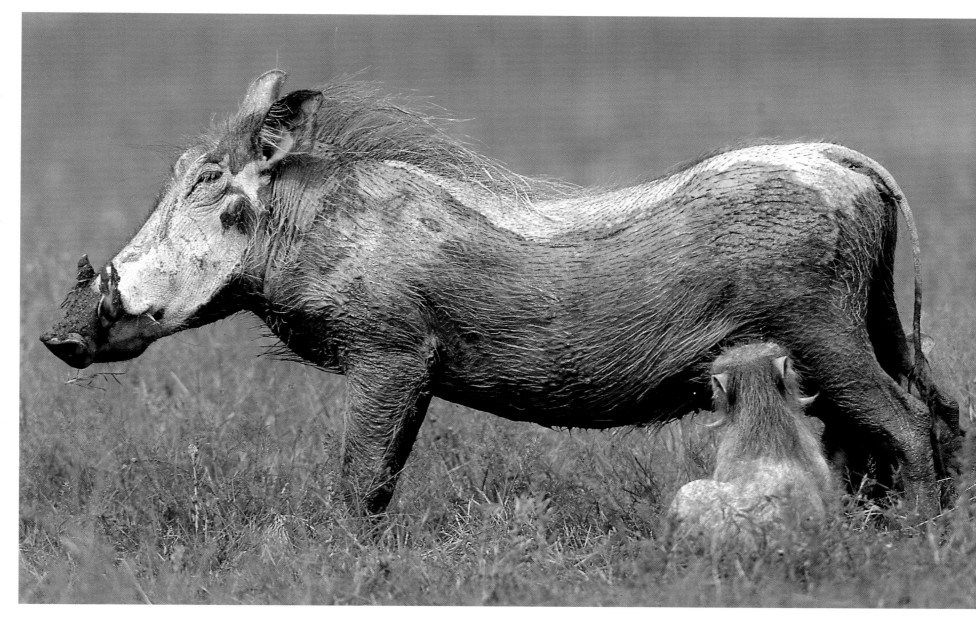

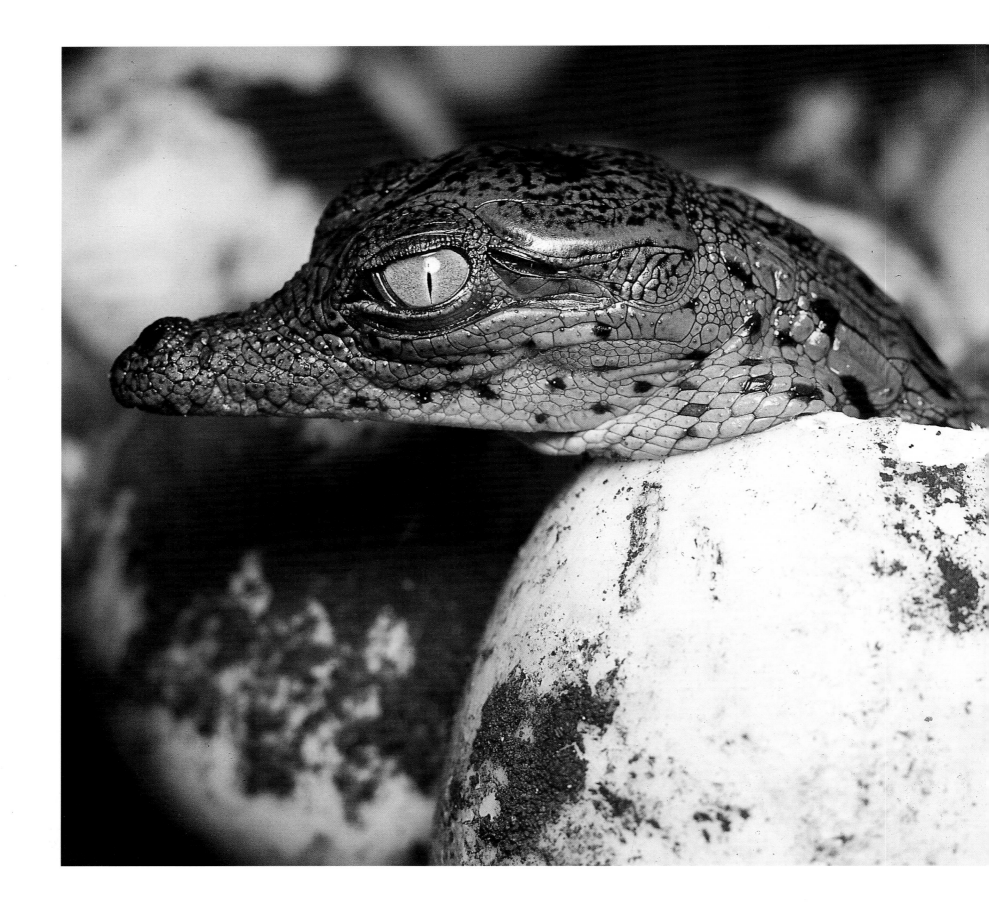

*N*ile crocodiles *Crocodylus niloticus*, awesome carnivores found in most parts of Africa where there's plenty of surface water, make remarkably caring and gentle parents. The female lays up to 90 eggs, and guards them closely throughout the three-month incubation period.

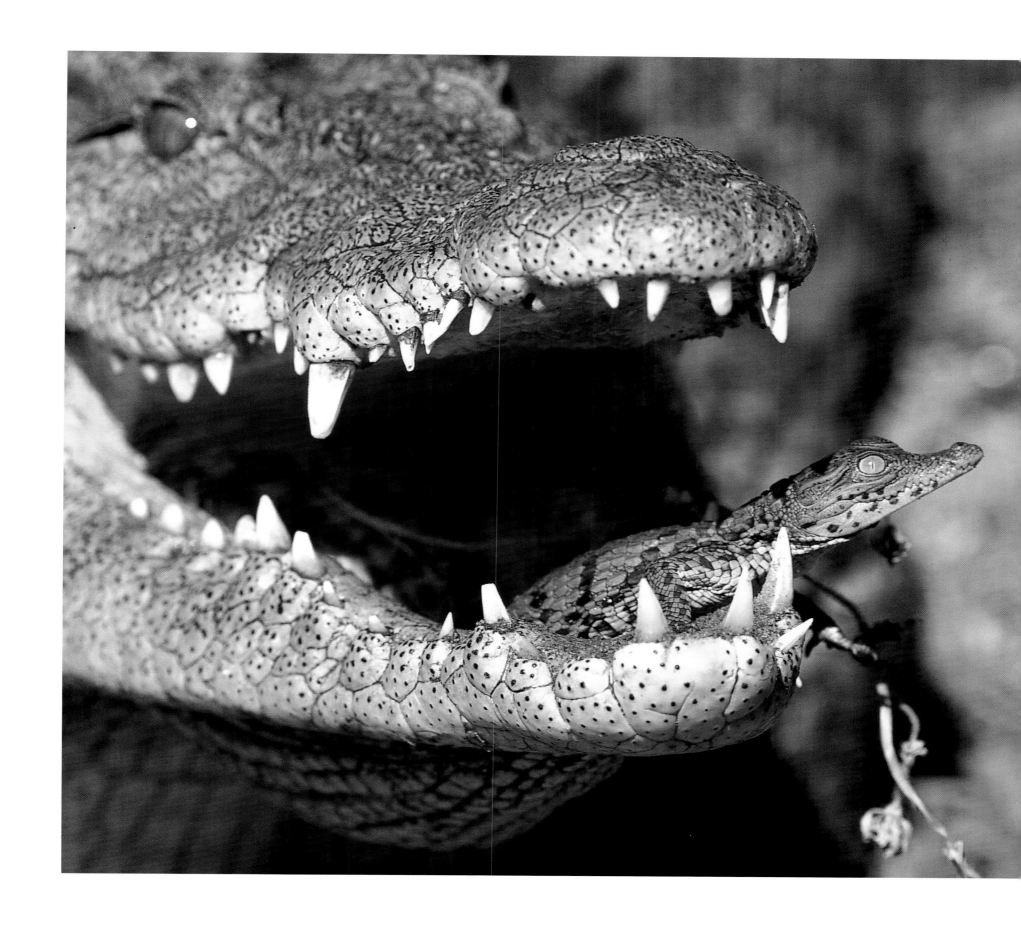

When crocodile young begin to hatch, the mother helps them out of the eggs and carries them to the water in her mouth. Once there, they remain for several weeks in a 'crèche', where they are well protected, and their progress as novice swimmers monitored, by their dutiful parents.

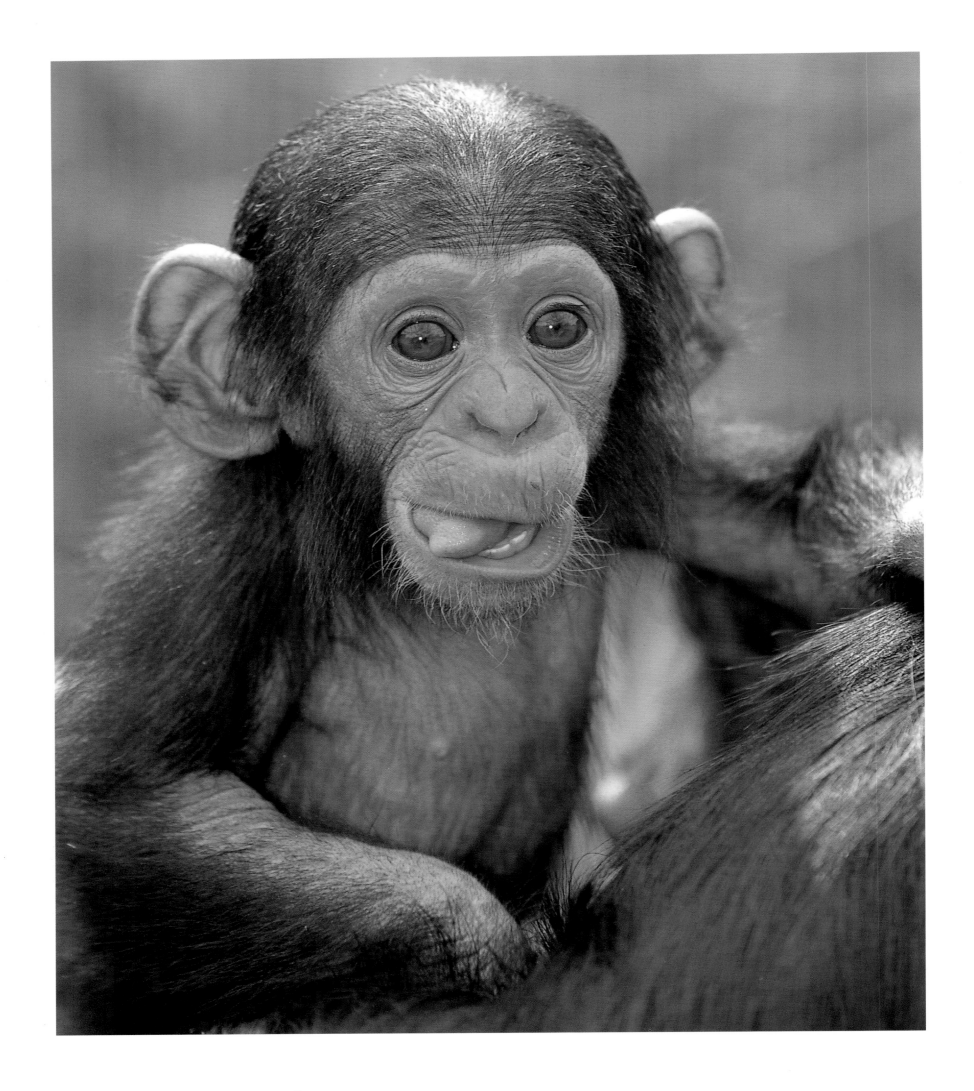

Chimpanzees *Pan troglodytes*, humankind's closest primate relatives,

give birth to a single offspring that is entirely dependent on its mother for

the first five years, and a strong bond between the two persists for life.

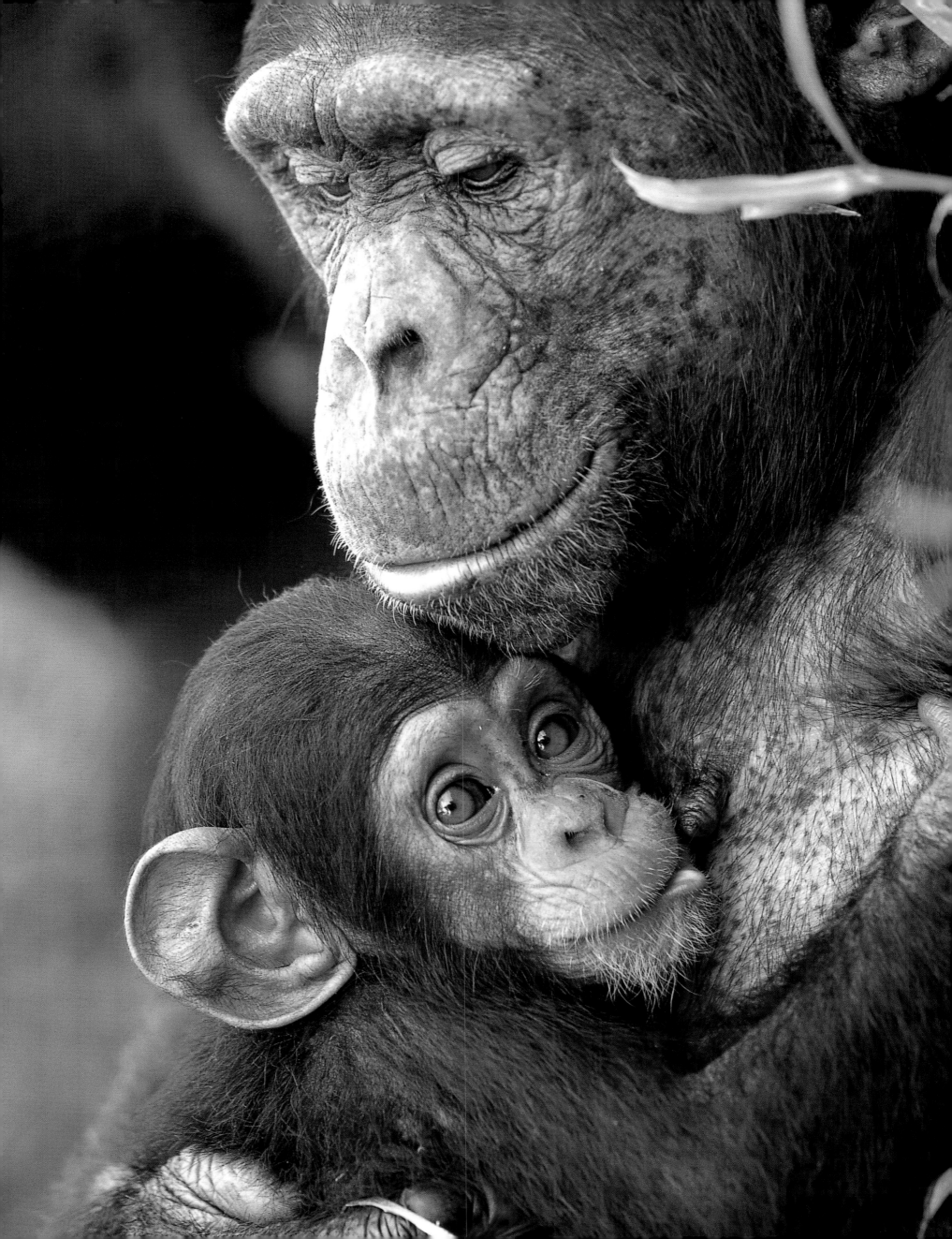

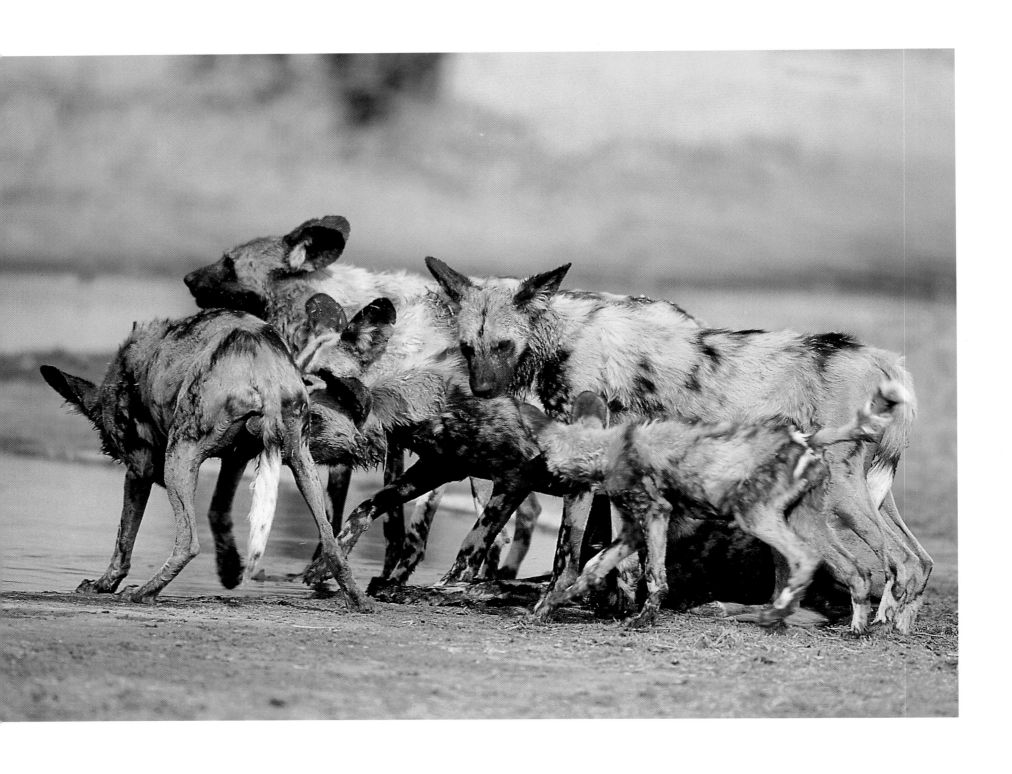

\mathcal{W}ild or Cape hunting dogs share the kill. The species has perhaps the most intricate social order of all the larger predators: each individual's seniority within the pack, its place in the hunt and rights to the spoils are precisely defined. The adults make sure that the juveniles are well fed before they themselves begin eating.

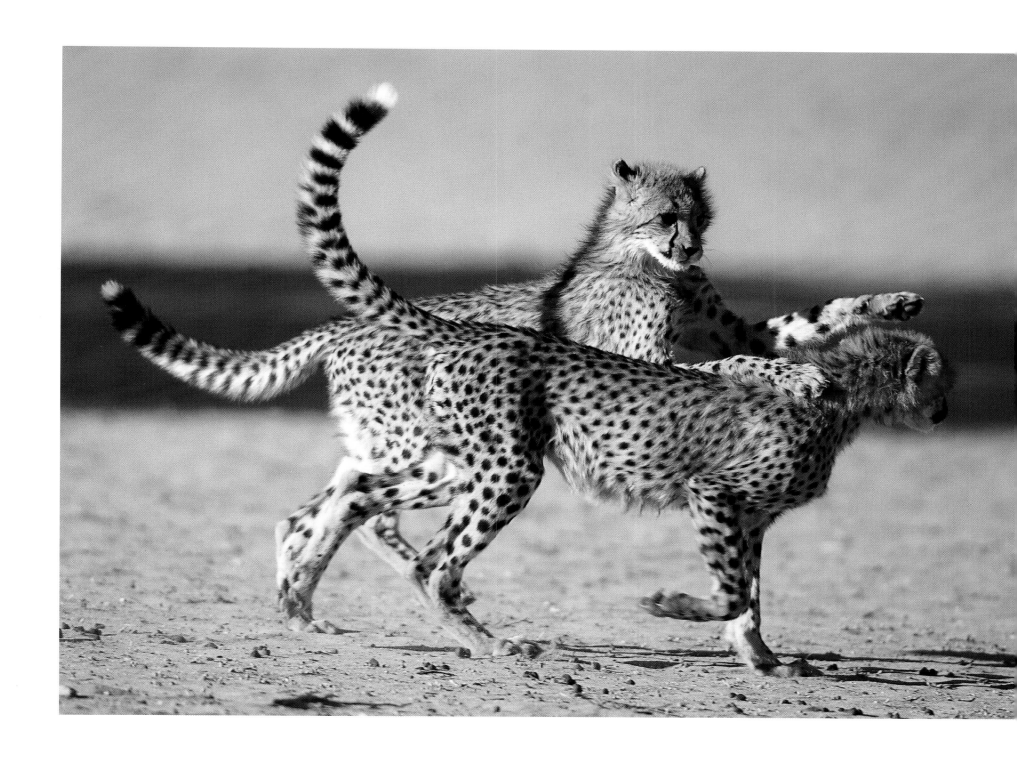

\mathscr{Y}oung cheetahs *Acinonyx jubatus* at play. These animals, swiftest and arguably the most beautiful of mammals, are also among the most vulnerable, for they lack the brute strength and aggressiveness of their carnivore competitors. The females live independent and solitary lives, their only company the latest litter of three or four cubs.

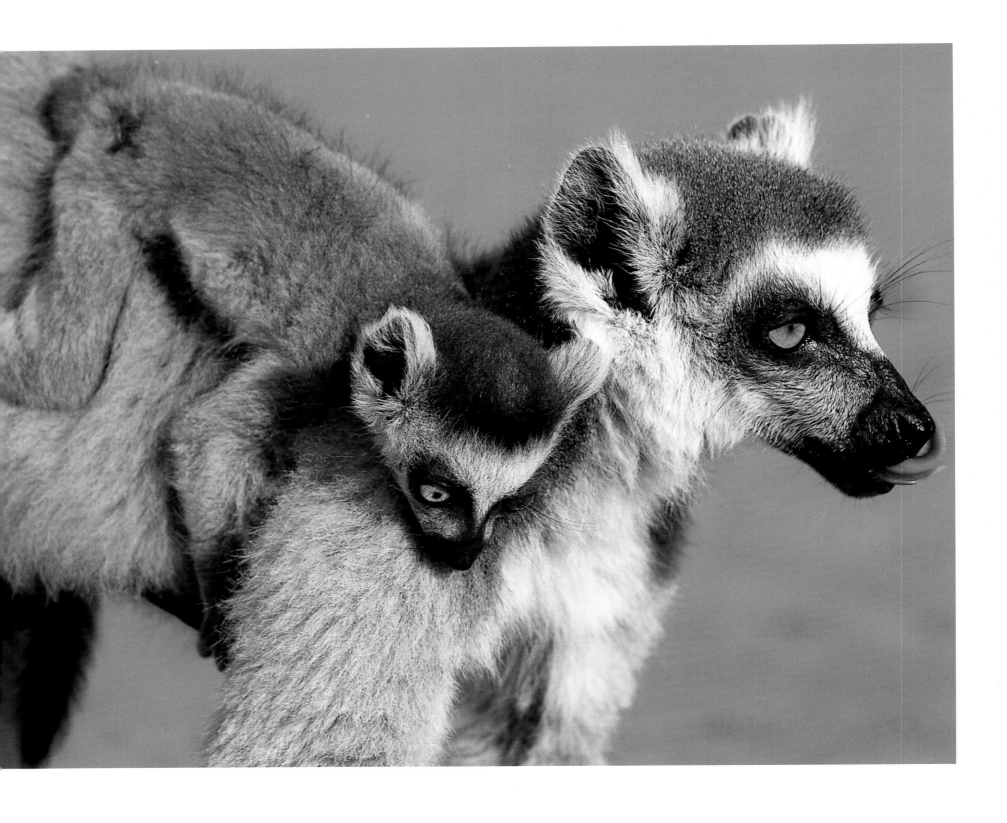

*M*adagascar is famed for its lemurs, prosimian primates that have followed an evolutionary path of their own over the epochs since the island began to drift away from mainland Africa. Seen here is the ring-tailed lemur *Lemur catta* (above and opposite) with its solitary offspring, which started life clinging to its mother's furry underside but soon graduated to a 'seat-with-a-view' astride her back. The infant, though, is highly precocious, often dismounting to join other youngsters in lively and increasingly adventurous playgroups. Ring-tailed lemurs – which, unlike other members of the family, spend most of their time in the coolness of the forest floor – live in mixed groups that are run on strictly matriarchal lines. A group will comprise roughly equal numbers of females and males, but it is the former who make the decisions and enjoy the choicest food items.

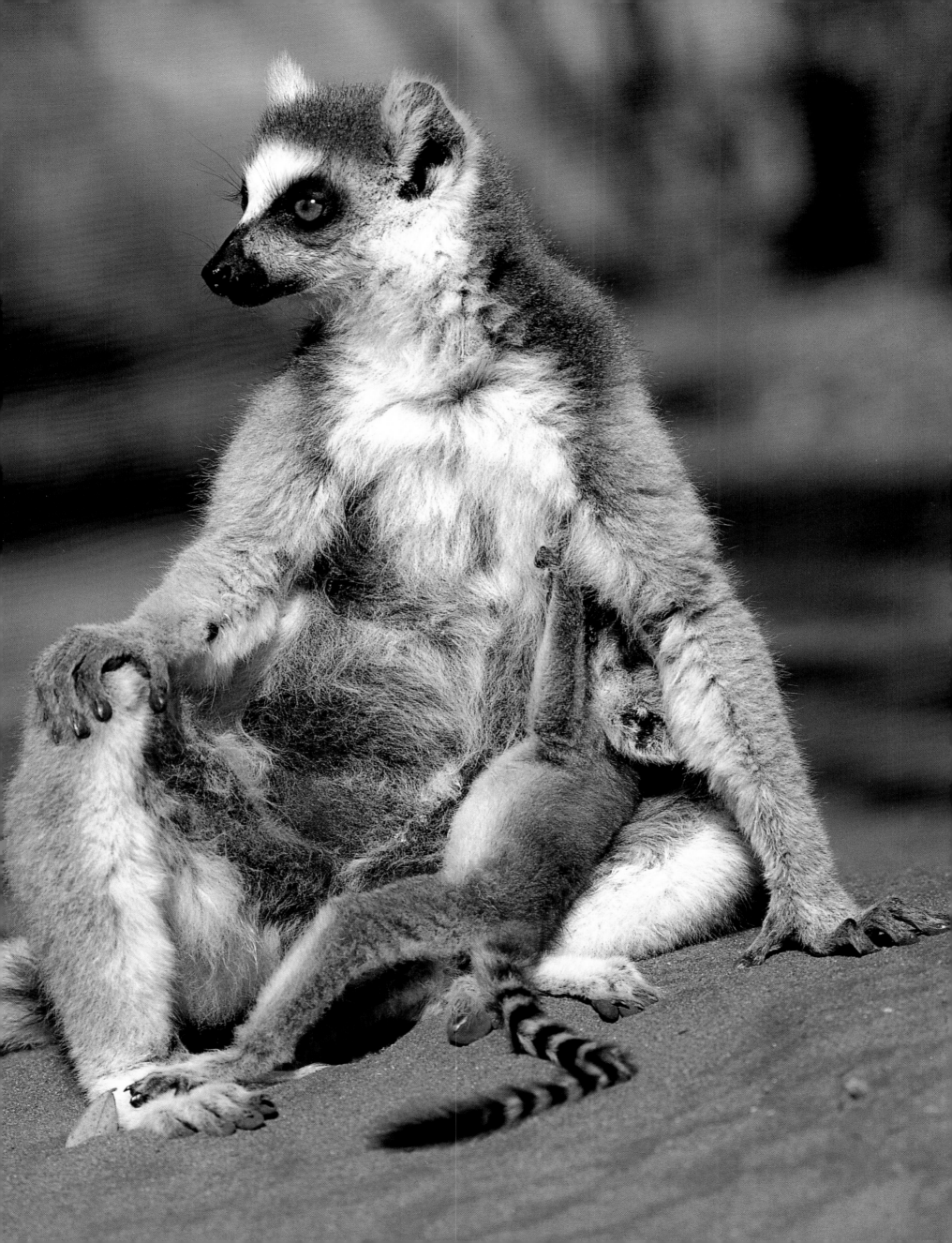

*M*other and child (right). In good times, the cubs of a lion pride are well fed and well looked after. When food is scarce, however, the young suffer, for adults claim first pick of the kill and there is little left over for their young. Such deprivation may offend human sensibilities, but it is simply nature's way of preserving the species, of protecting those who can immediately produce another generation. The core of the pride is a group of anything up to nine females, who are all related to one another and who often split up into sub-prides but continue to defend a common territory. When two or more sets of cubs are born at the same time, the mothers share the suckling duties.

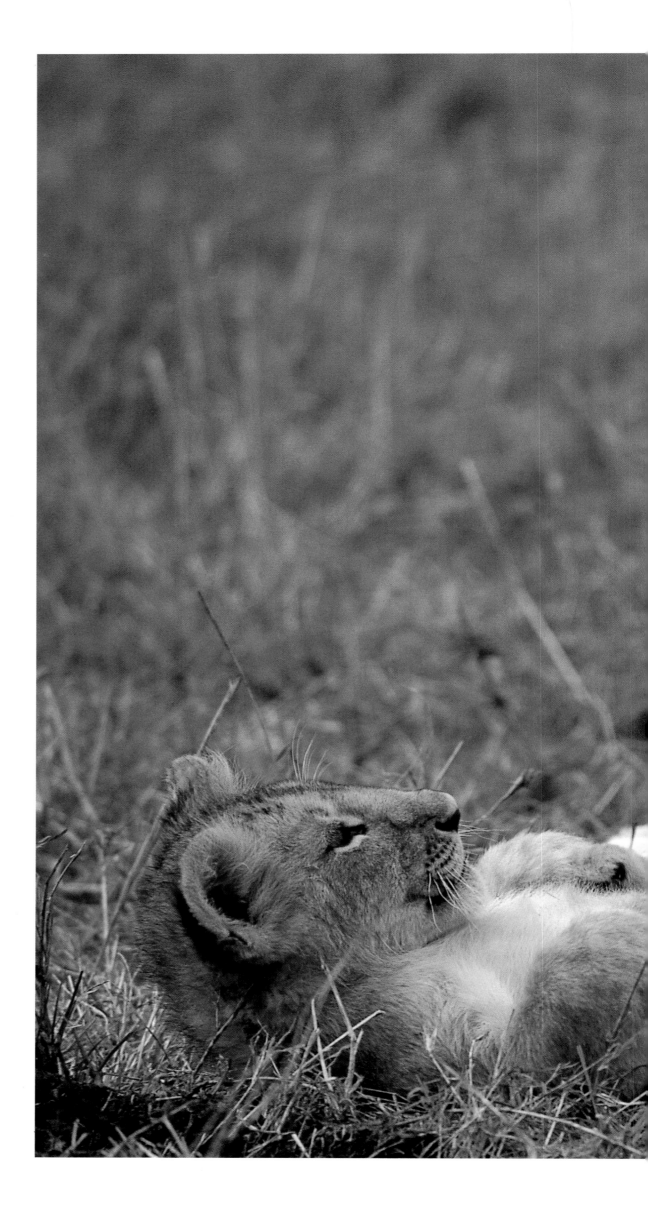

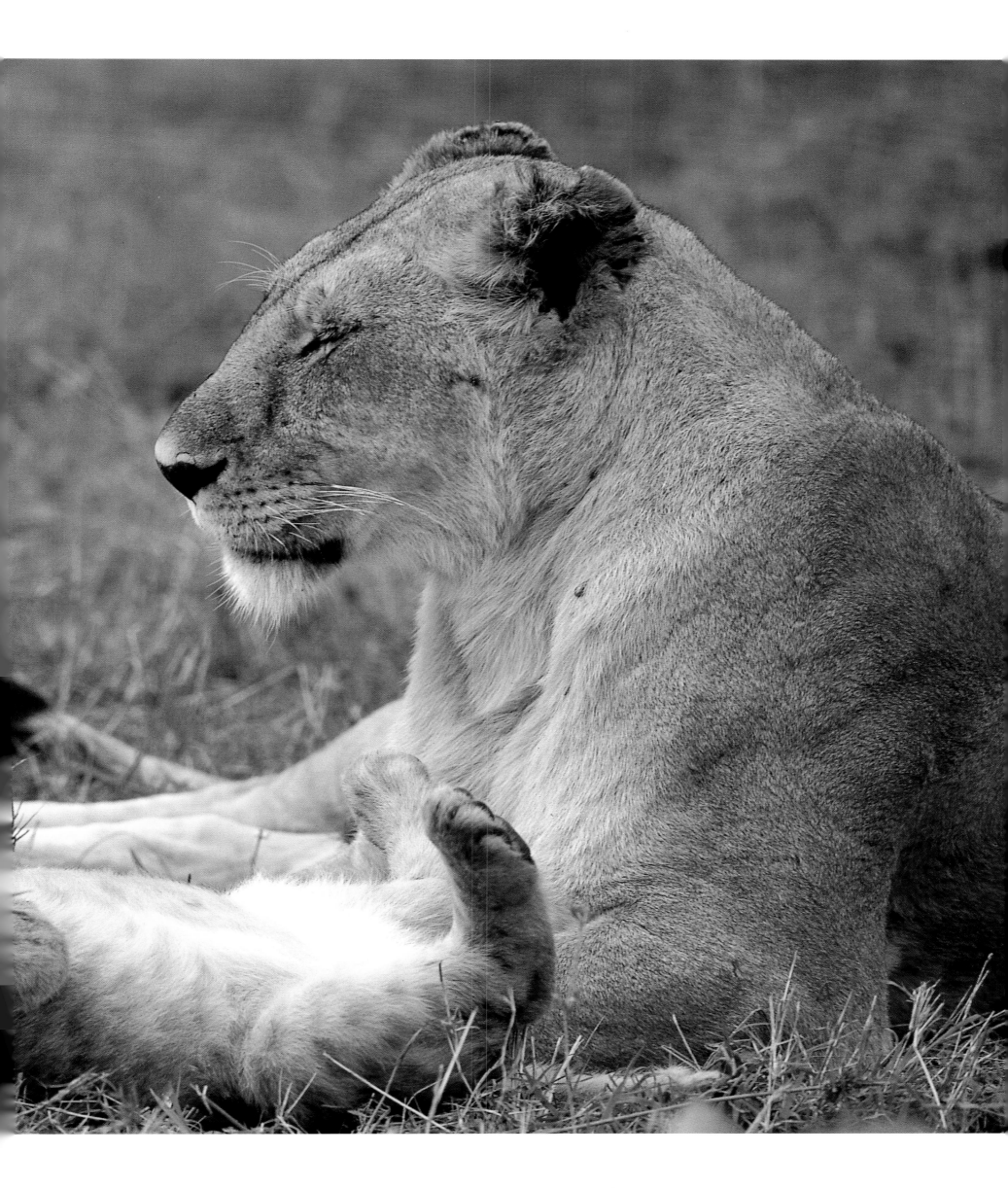

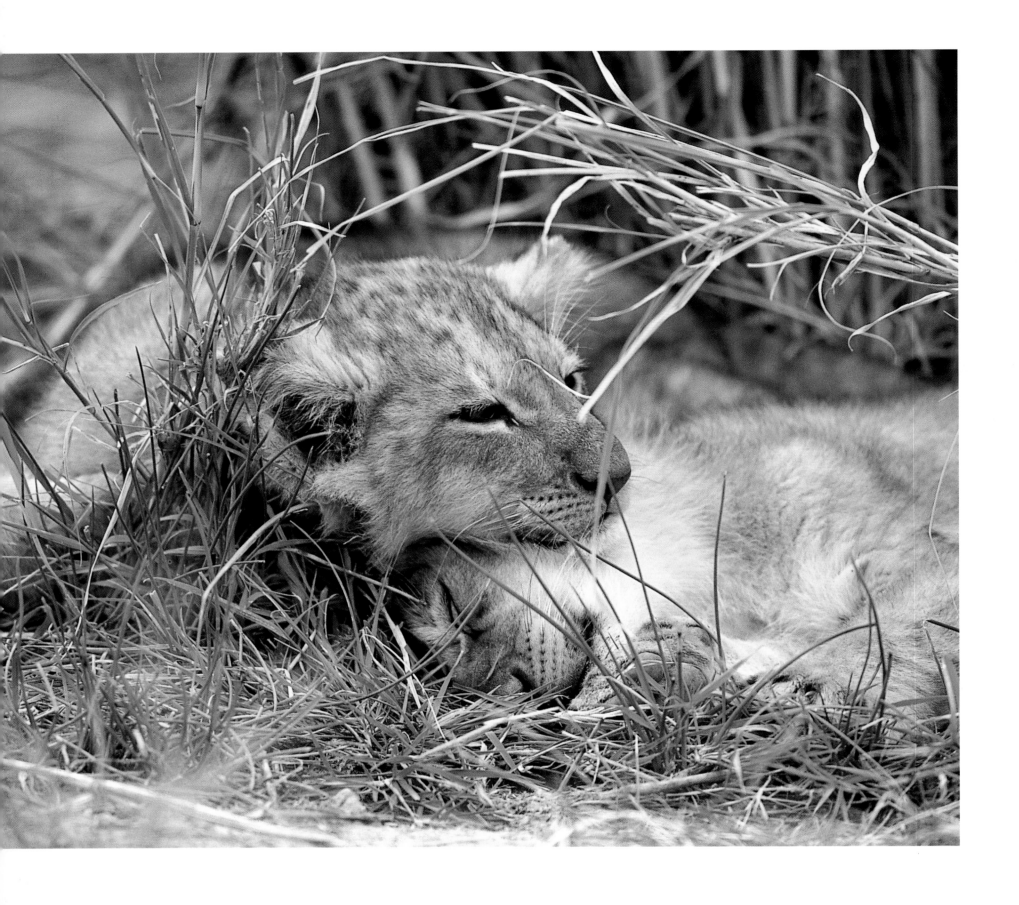

\mathcal{Y}oung female lions remain with the natal pride. The males, however, are evicted when they are about 30 months old, forming either pairs or small groups to live a nomadic life. They are fully mature and ready to challenge for territory at four years of age – a critical time marked by violent and sometimes lethal struggles for dominance.

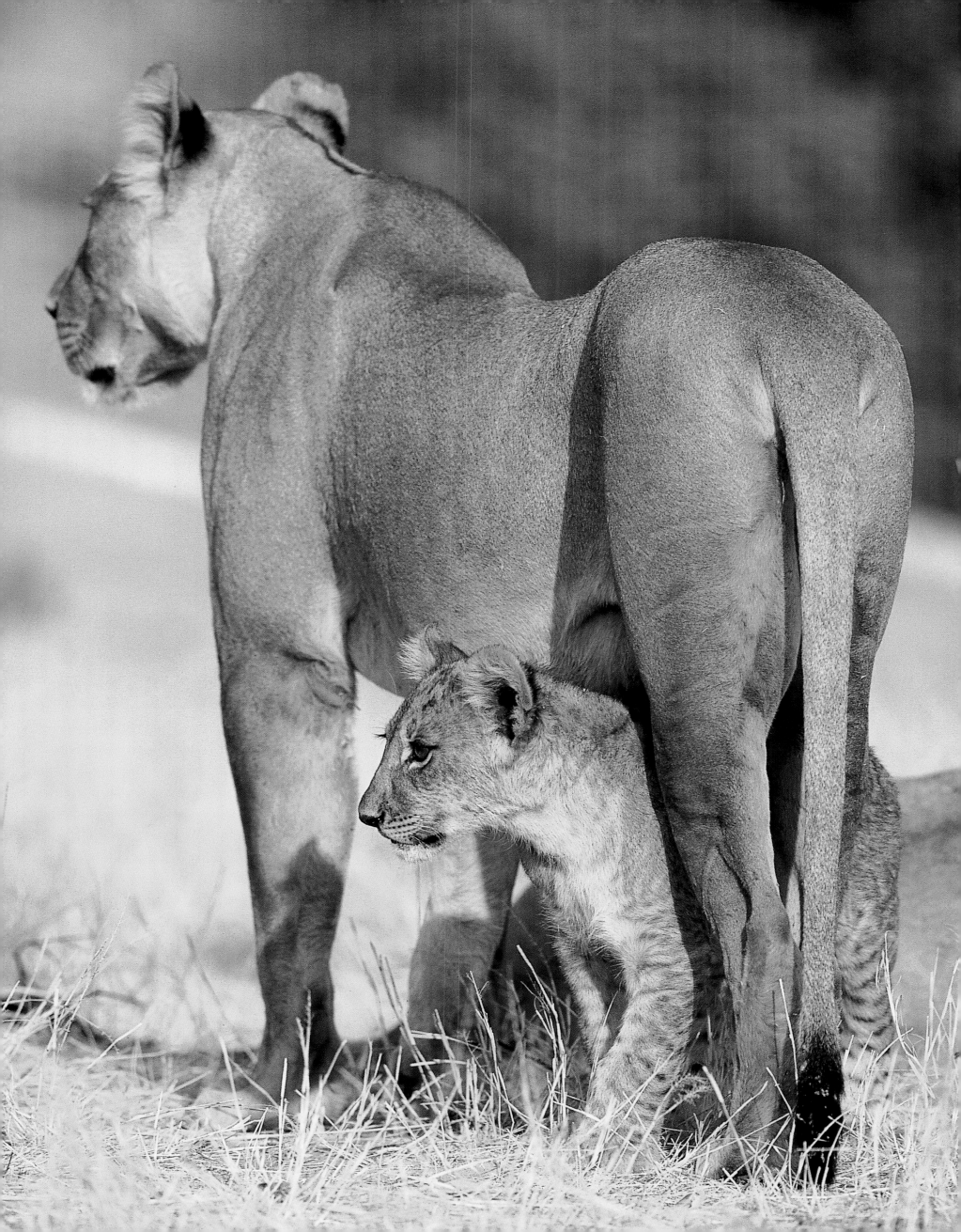

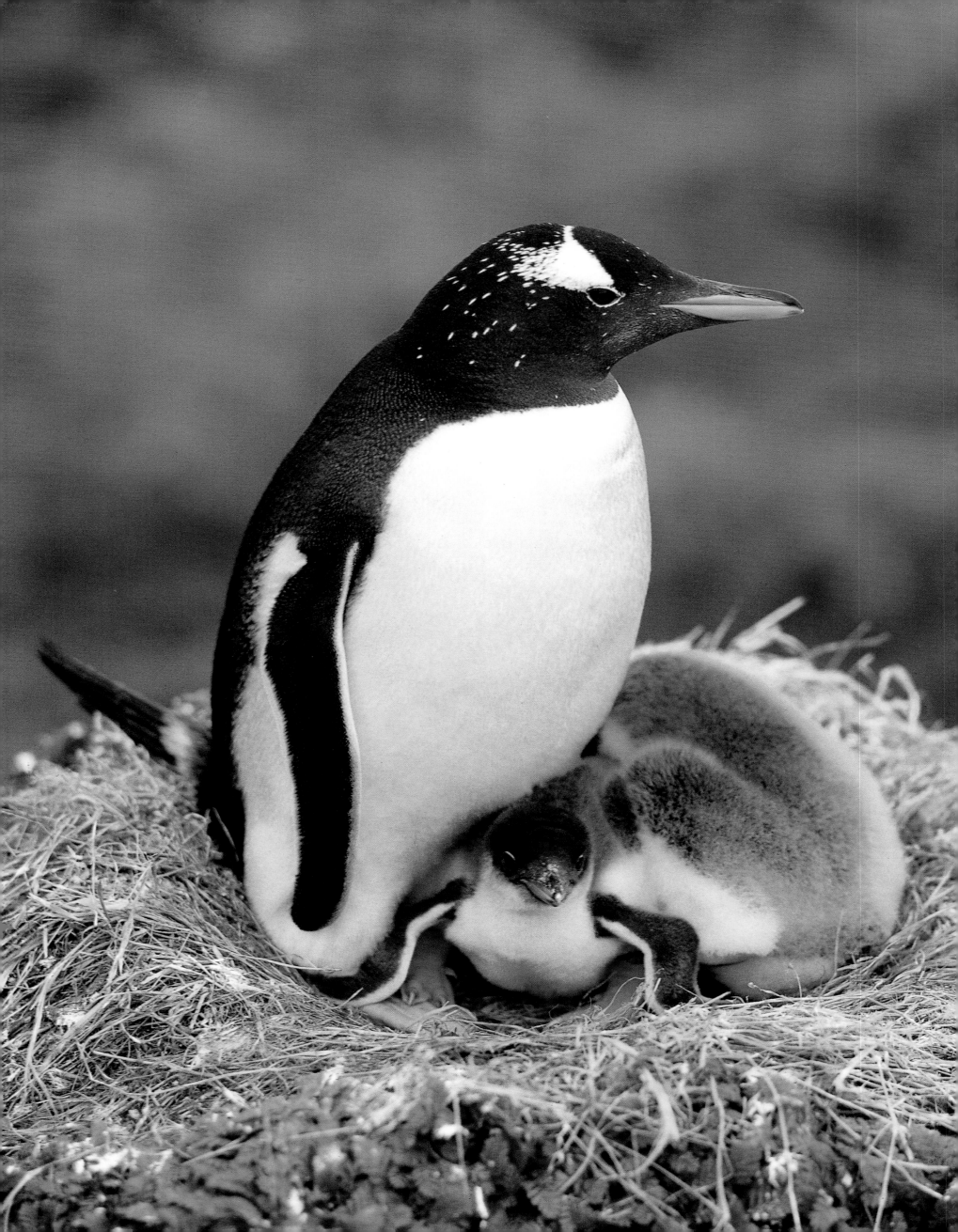

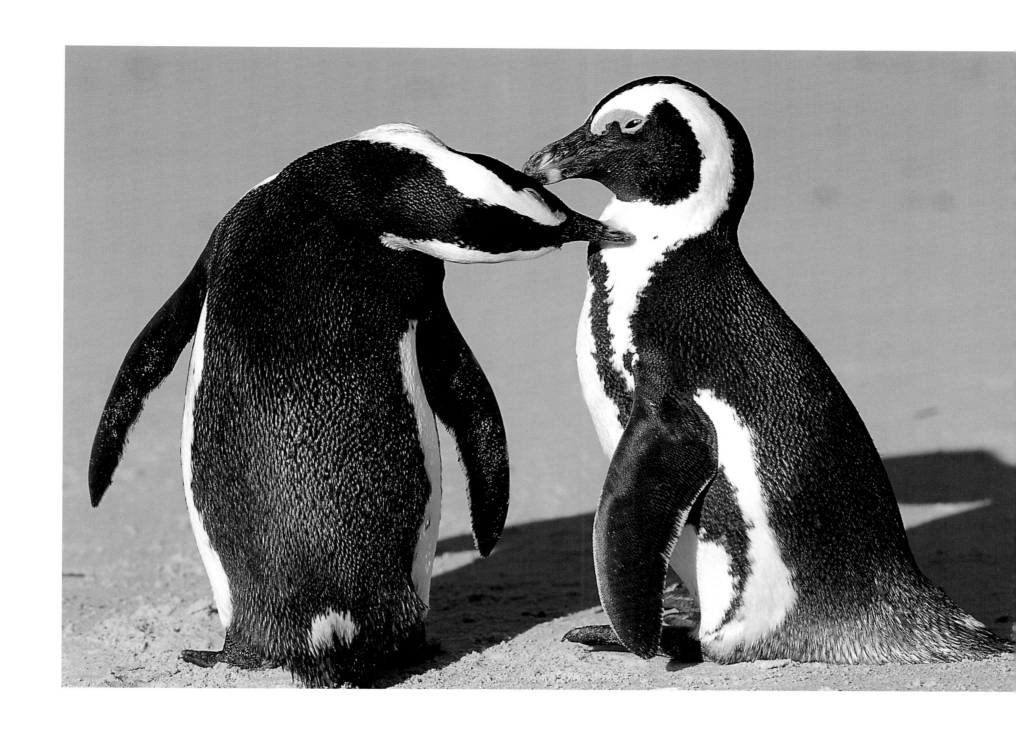

\mathscr{A}frica's only resident penguin is the jackass *Spheniscus demersus* (above), so called for its loud, donkey-like braying calls. The species is endemic to the southern coasts from South Africa's KwaZulu-Natal around to Angola in the west, although human activity – the fishing industry, guano harvesting, commercial egg-gathering and oil spills – have driven it from much of its range, especially the eastern seaboard. The species traditionally roosts and breeds on the offshore islands (though one or two mainland groups have been established), leaving their rocky homes during the daytime to hunt the seas for anchovy, squid and small octopus. The less threatened gentoo penguin *Pygoscelis papua* (opposite) breeds in small colonies on Marion and Prince Edward islands, in the cold Atlantic halfway between South Africa and Antarctica.

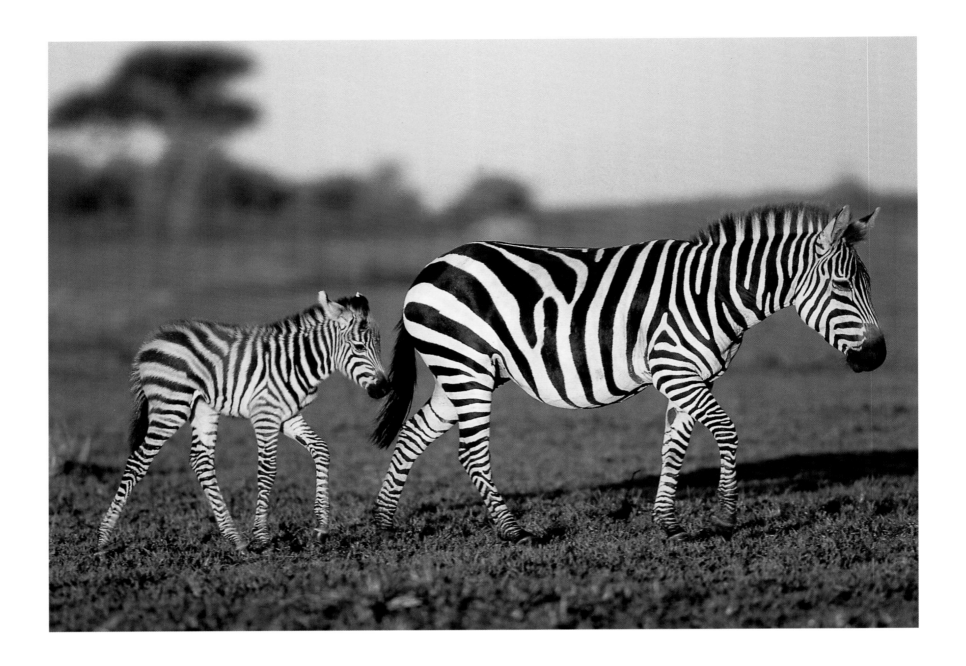

\mathscr{Z}ebra foals (above and opposite) are usually born in summer, just before the onset of the rains to ensure good grazing. Most common of the genus, *Equus*, is the plains or Burchell's zebra, once widely distributed from the Cape north to East Africa (though the southernmost populations, known as quagga, disappeared more than a century ago) and now more or less confined to the bigger conservation areas. The animals live in small family groups, getting together in large aggregations at watering points and in places where there is especially good grazing. In a mutually rewarding arrangement, they will often mix with herds of wildebeest and other bovids: the zebra gains safety in numbers, while the antelope benefit from the zebra's acute eyesight, hearing and sense of smell.

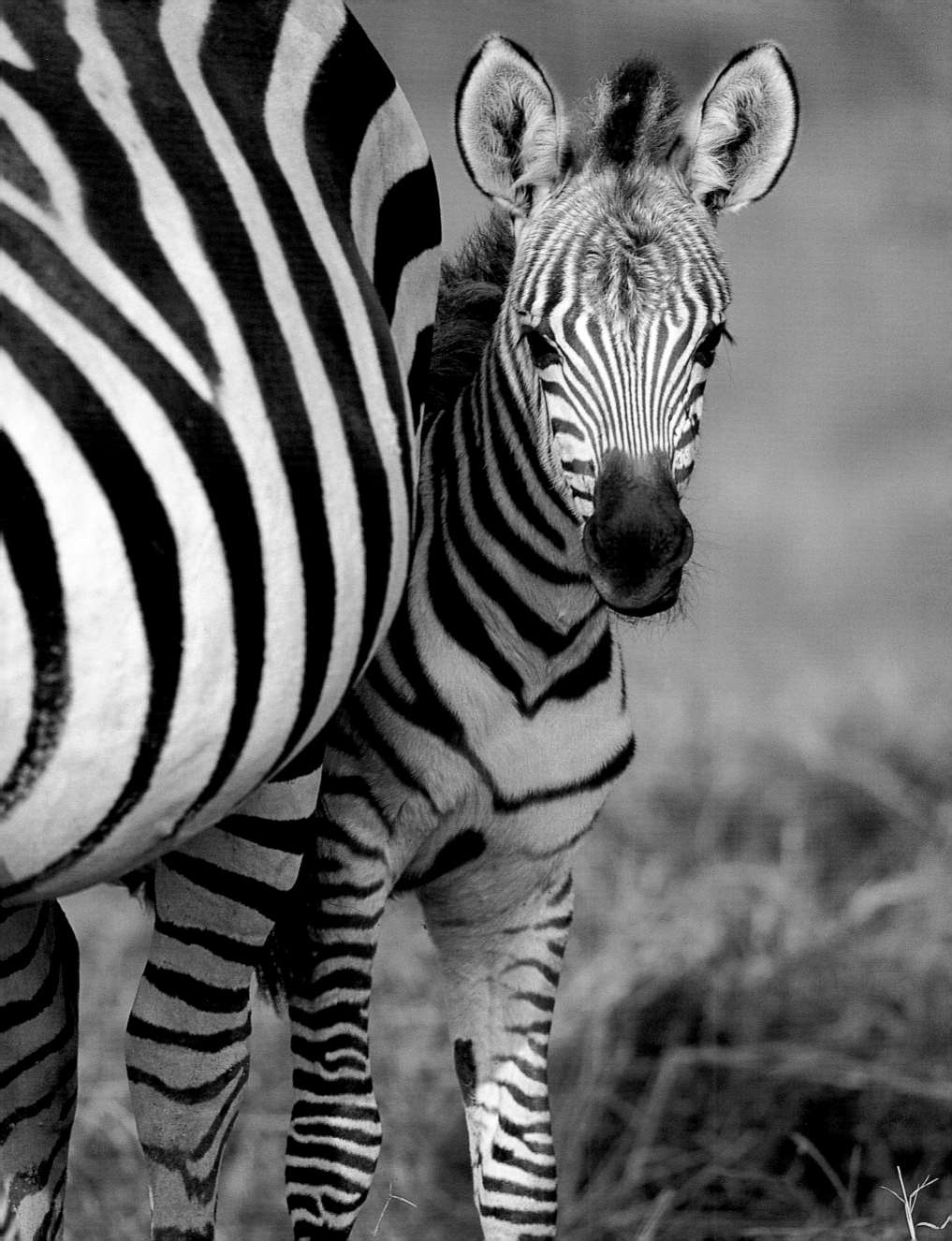

THE QUEST FOR FOOD

Abundance is a rarity in much of the African wilderness. Uncertain rains, and climatic cycles that embrace long periods of drought, more often than not create an environment in which food is scarce – and in which there is fierce competition among the life forms. Many have evolved adroit and proficient ways of obtaining their nutrients.

Just how well one species can compete has a direct bearing on the health of other, quite different kinds of animals. In lean times, when the grazing is poor and the antelope weaken and die off, the predators – lion, hyaena, vulture – will enjoy a brief bonanza, but soon enough all the vulnerable individuals are gone, the stock of available prey has been reduced, and the carnivore populations will suffer and decline.

Eventually, however, the drought must break. There will come a long and generous wet season to green the land, fatten the herds, galvanize the processes of birth and growth and fill the great larders of the wild. The herbivores will increase in number, and so will their hunters, each species playing its part in a drama first conceived in the primordial oceans, and which has as its central theme the interdependence of all living organisms.

The giraffe's *Giraffa camelopardalis* (right) long neck enables it to get to foliage that is out of reach of other browsers. Despite the animal's massive bulk, it is a highly selective feeder, using its elongated muzzle and prehensile tongue to single out and crop tender but often thorn-girded shoots, pods and flowers.

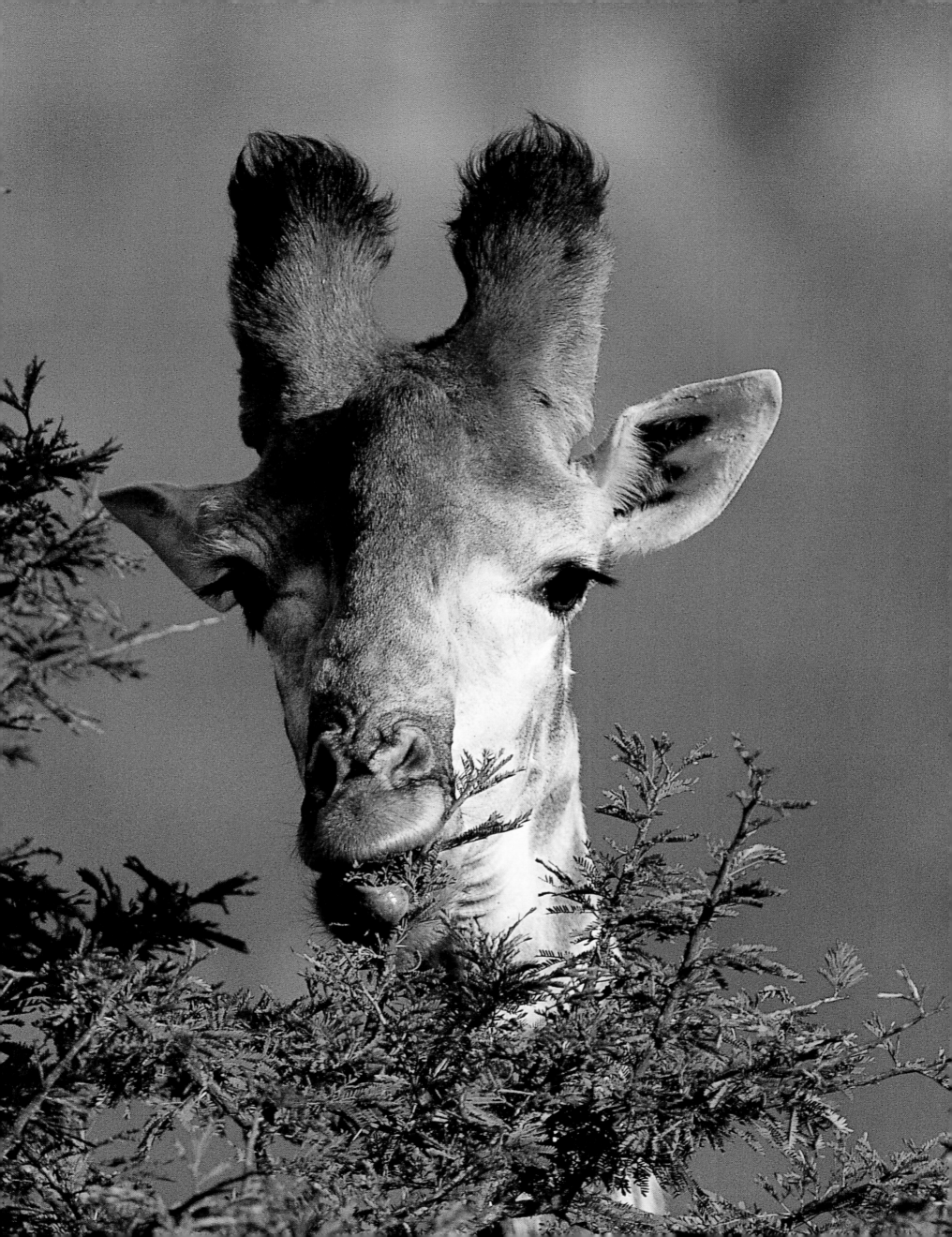

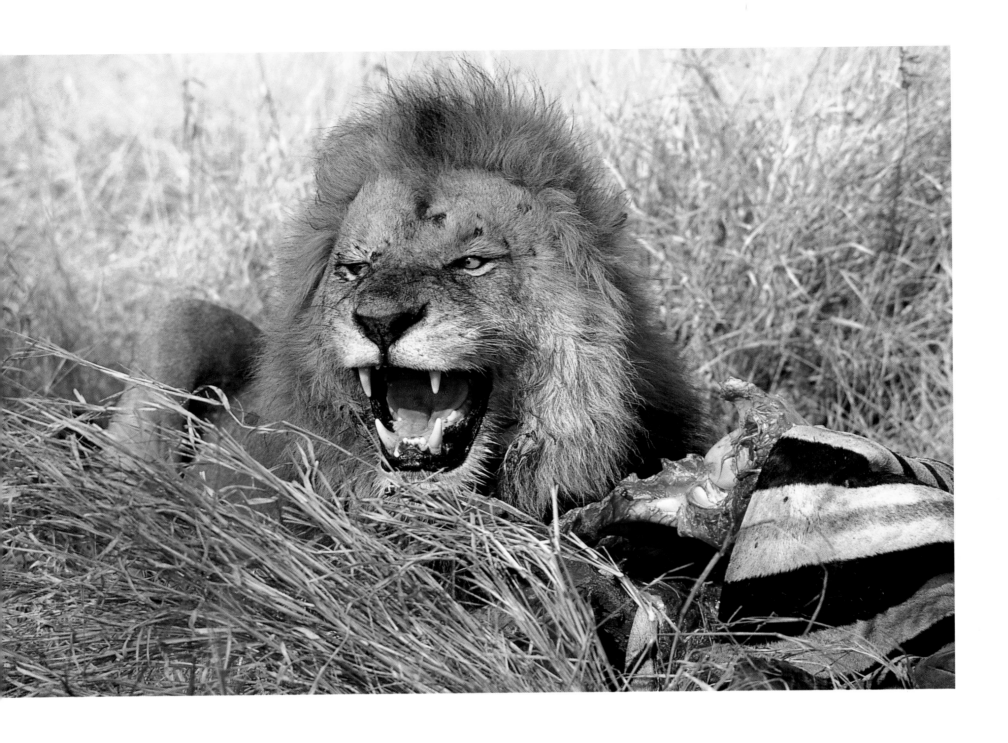

The African lion takes prey ranging from elephant down to the smallest rodent, but the bulk of its food comprises mammals – zebra and various antelope species – in the 100- to 300-kilogram bracket. The hunt, which usually takes place under cover of darkness, is a co-operative effort in which the target is selected, stalked in silence and dispatched after a brief chase. Females invariably play the major role in the sequence but the lord of the pride (above) takes precedence at the kill.

A sick, wounded or weakened elephant will provide lions with a rare feast. Opposite: cubs gorge themselves in the dead animal's body cavity.

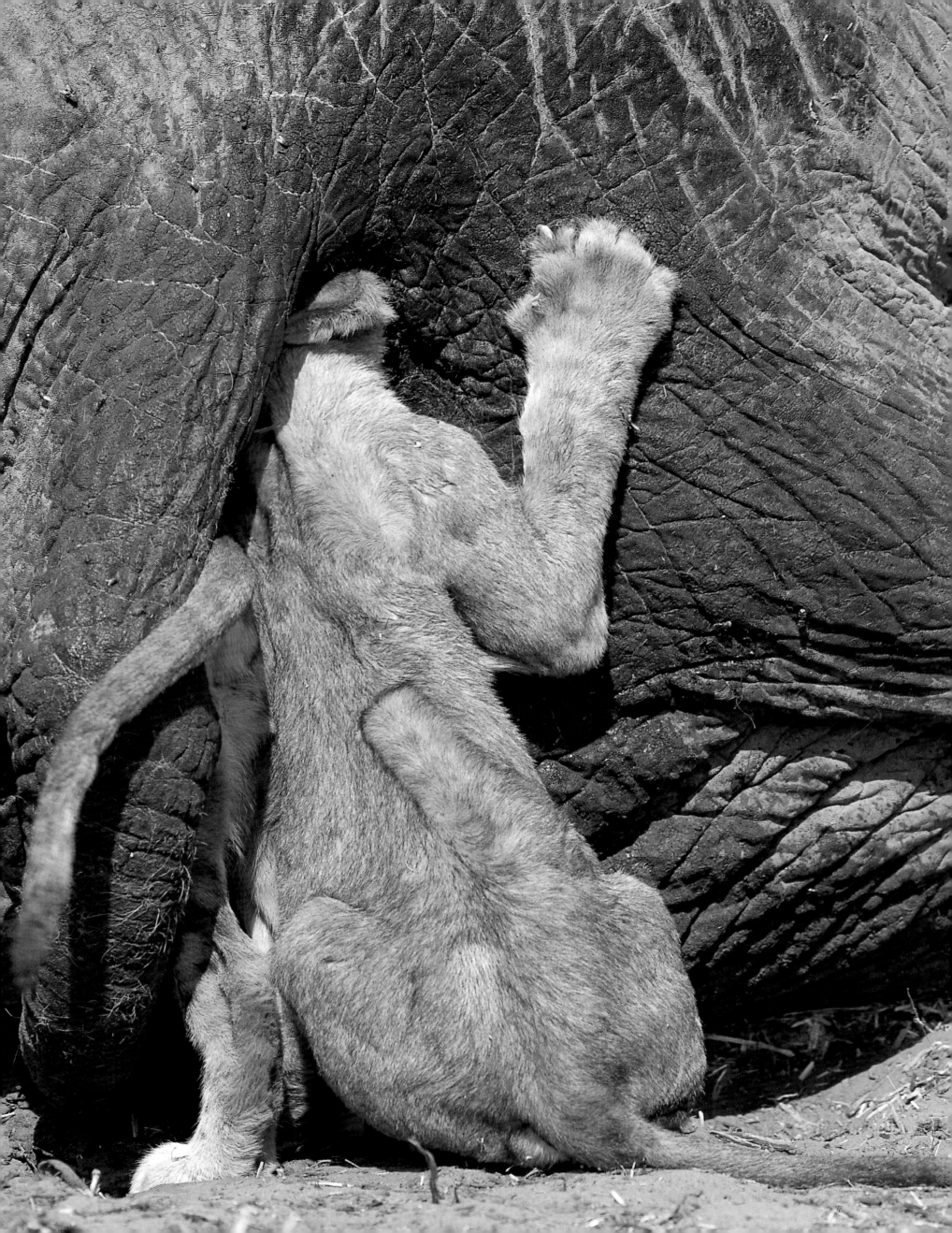

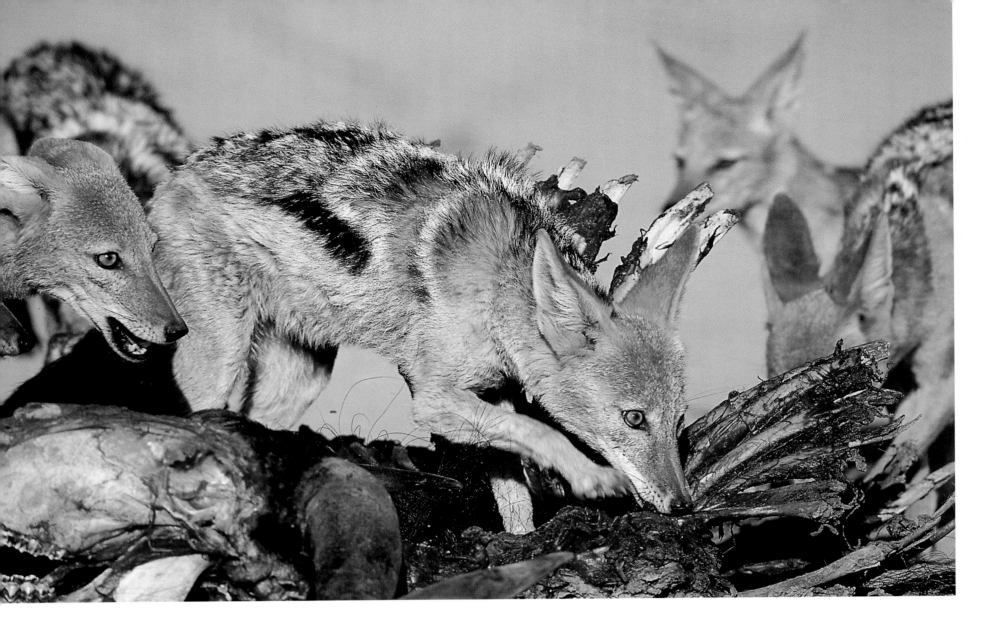

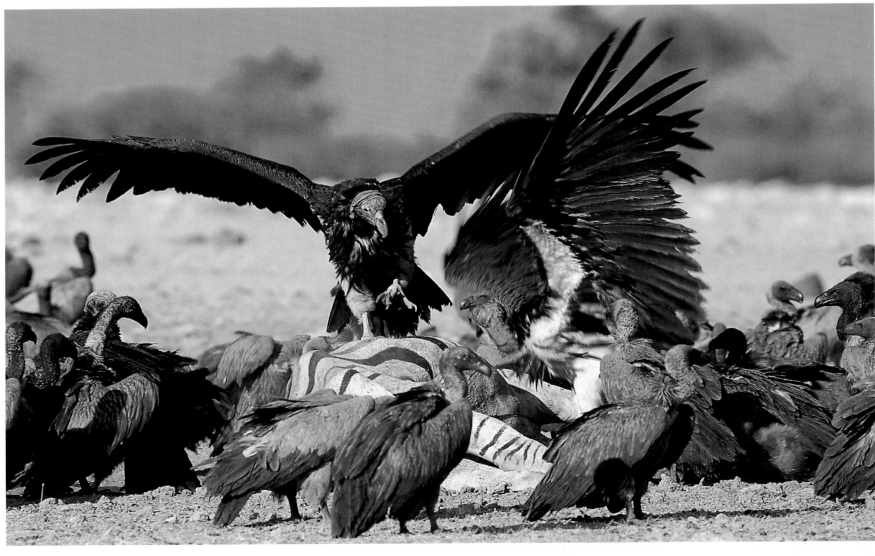

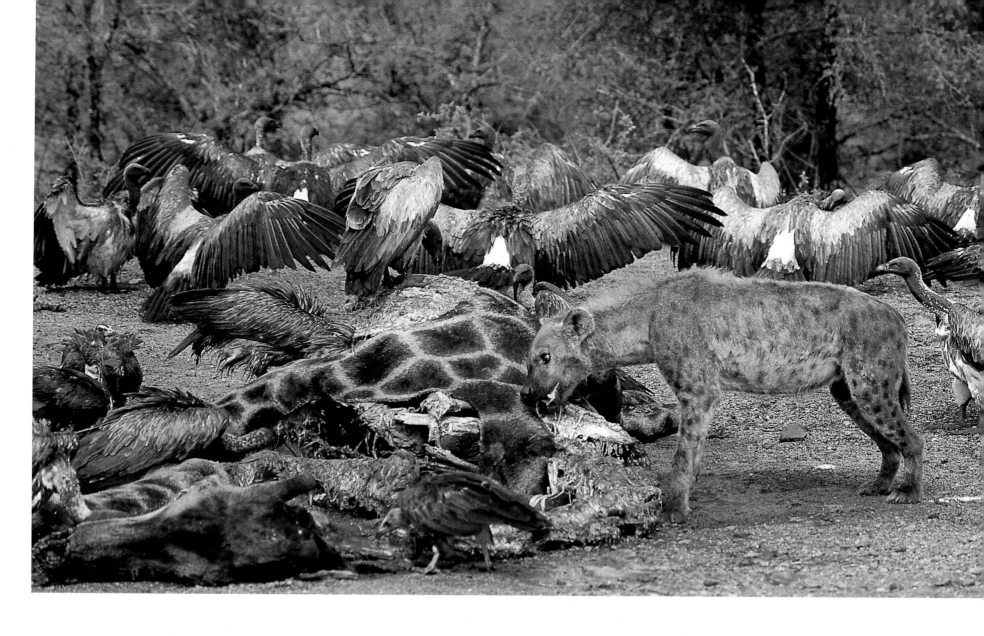

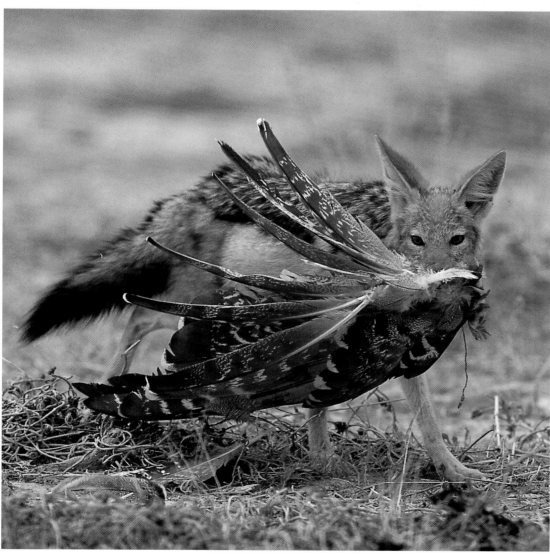

Arrival of the scavengers. Opposite, top: black-backed jackals *Canis mesomelas* feed on the carcass of a dead blue wildebeest. Opposite, bottom: lappet-faced *Torgos tracheliotus* and white-backed vultures *Gyps africanus* make a frenzied meal of zebra. Above: a spotted hyaena joins white-backed vultures feeding on giraffe. It is popularly believed that vultures depend entirely on the kills of carnivores, but this is not so: in many regions such carcasses make up less than half their diet, the remainder comprising animals that have met non-violent deaths.

Jackals (left) are hunters and foragers as well as scavengers, their diet encompassing wild fruits, berries and insects as well as meat. This one has caught himself a kori bustard.

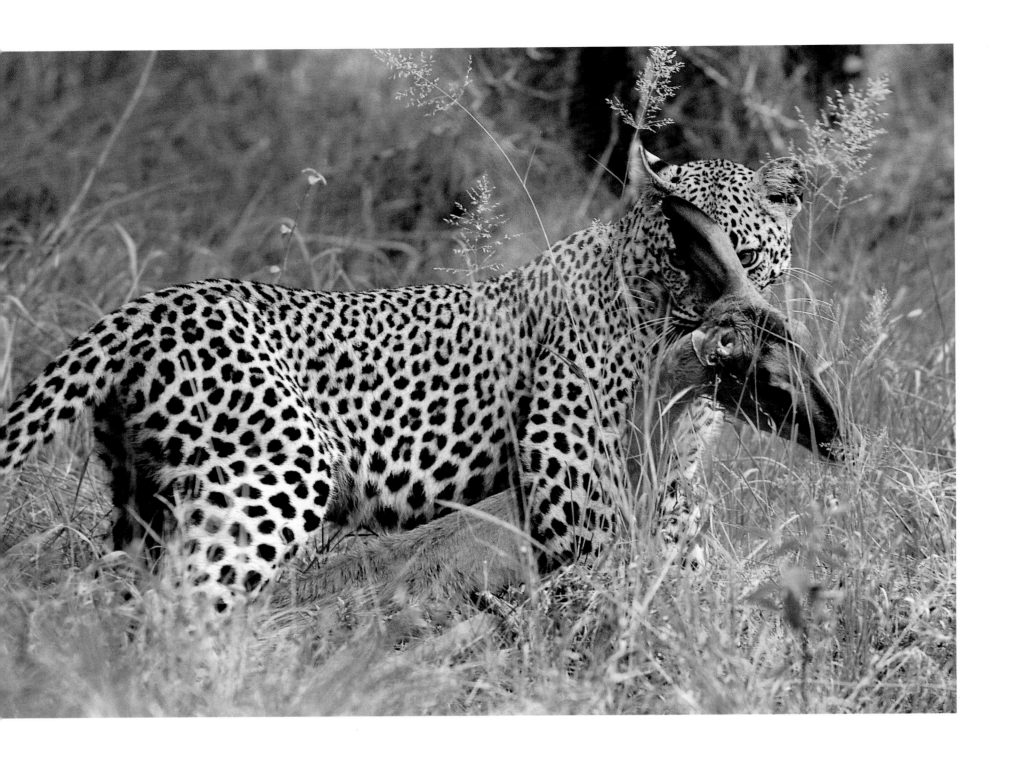

\mathscr{A} female leopard (above) drags her impala kill into dense bush cover in the Londolozi area of South Africa's Lowveld region. Later, she may carry it into the branches of a tree, safe from competing carnivores and the prying eyes of the vultures.

\mathscr{A} cheetah family (opposite) at mealtime. These elegant cats use sheer speed to catch their prey, covering the ground at close to 100 kilometres an hour in pursuit of springbok, impala or other medium-sized bovids.

\mathscr{T}opi antelope *Damaliscus lunatus* (overleaf) keep a watchful eye on passing lions in the Masai Mara Reserve, Kenya.

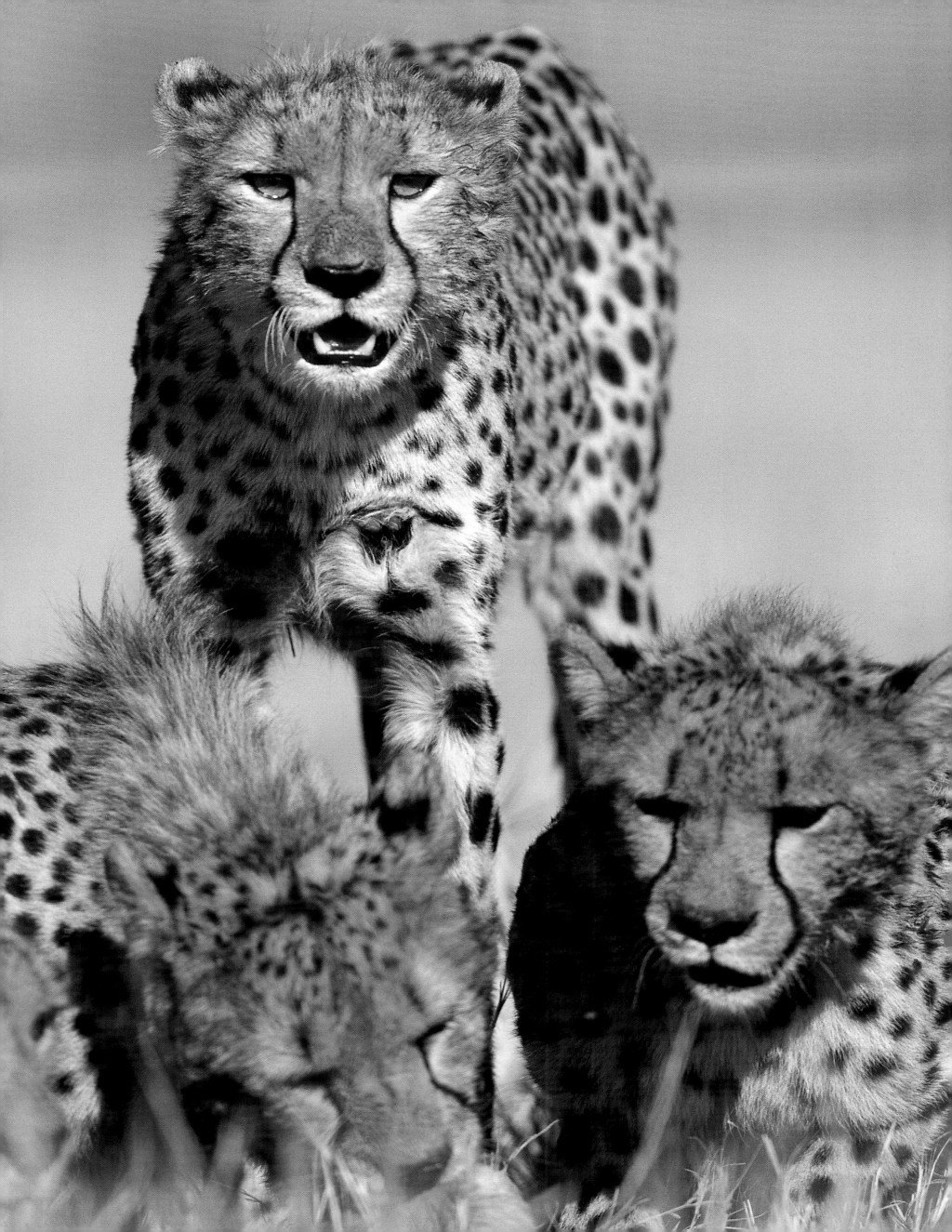

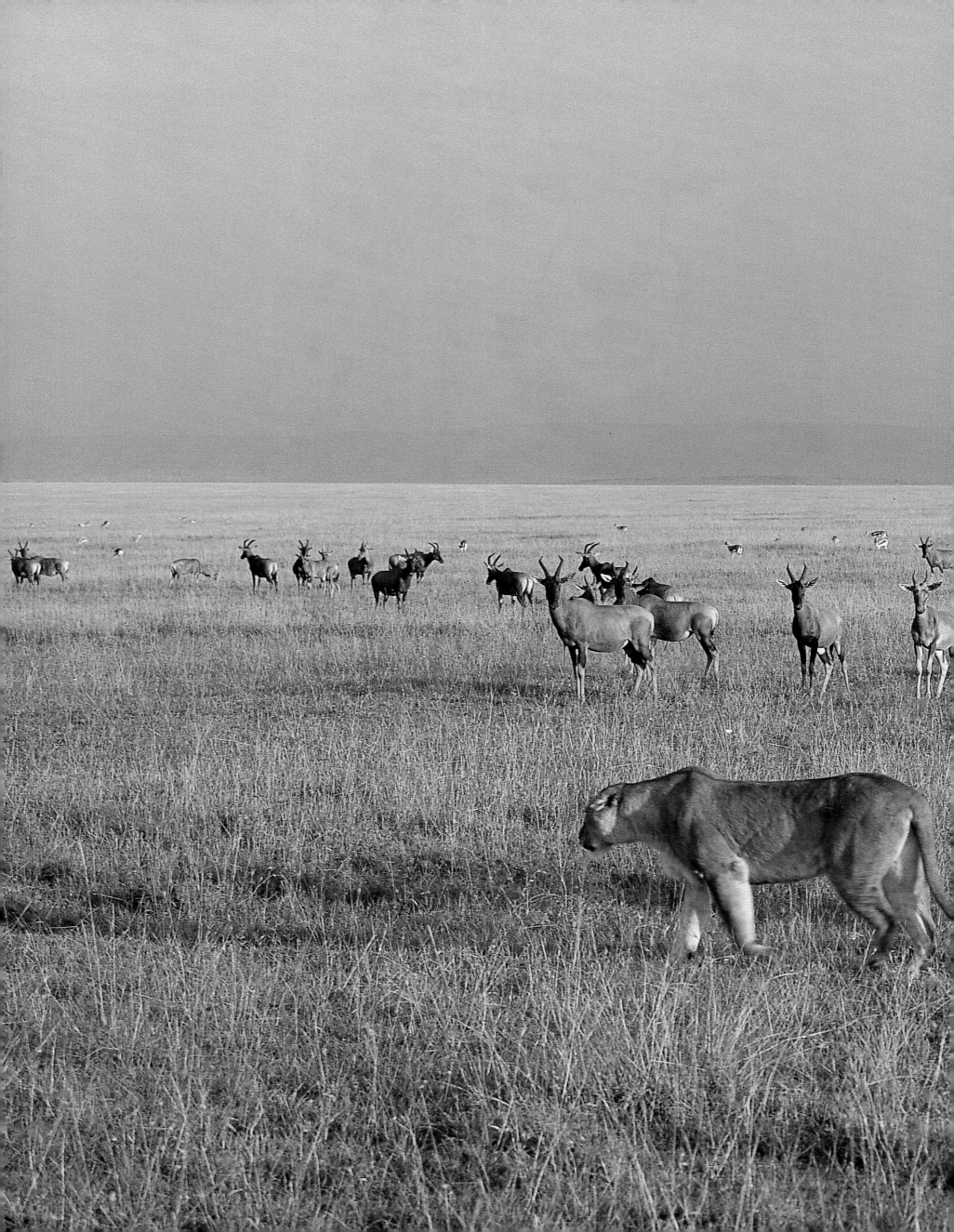

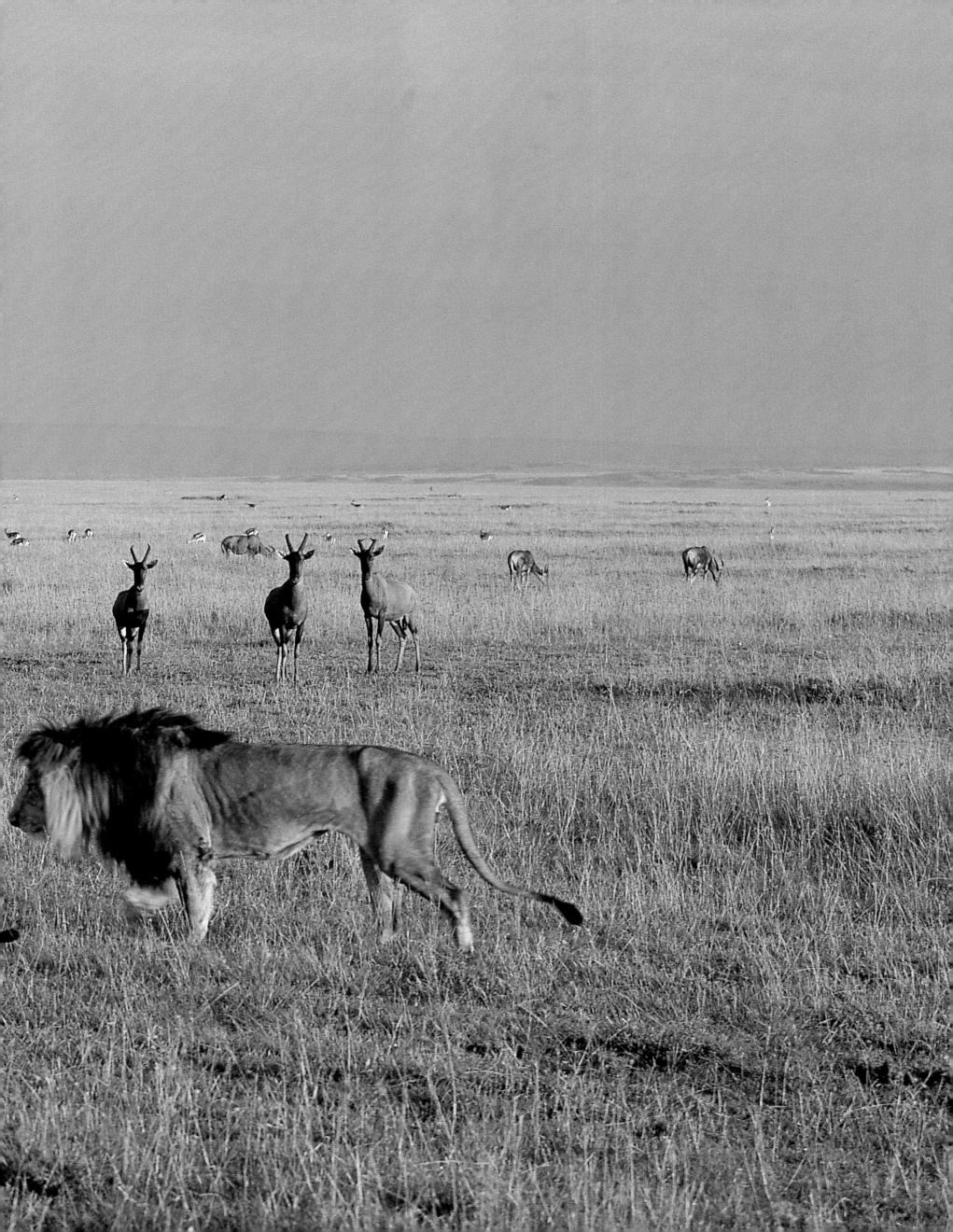

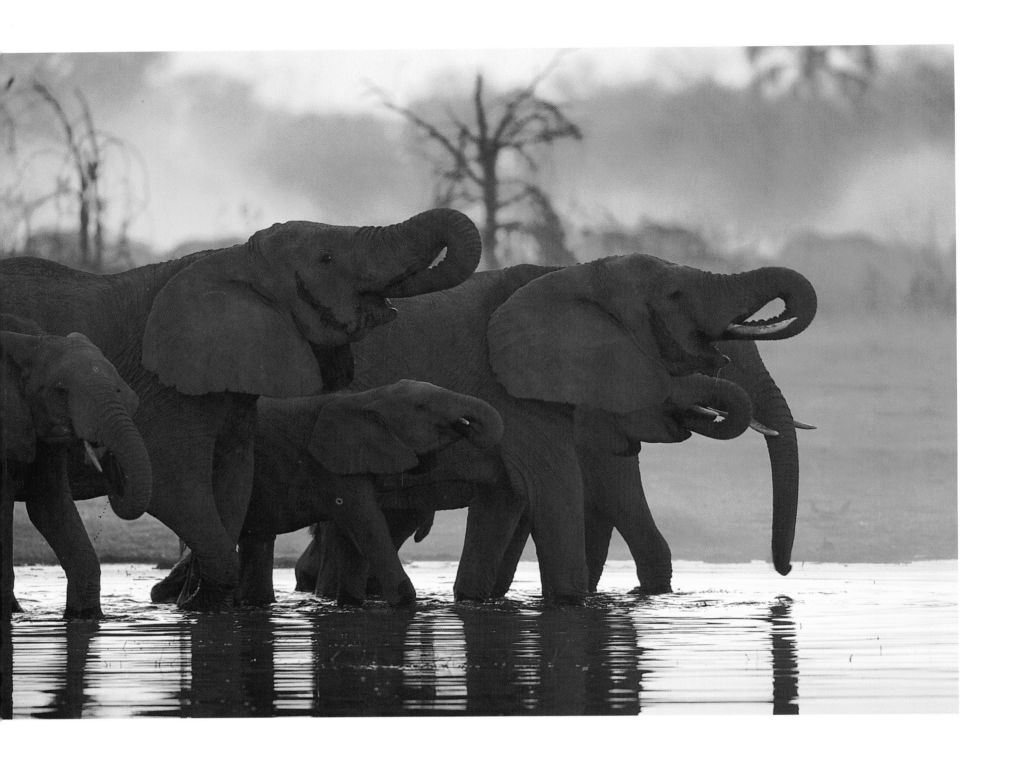

\mathscr{A}n elephant herd makes its ponderous way through a watering hole. These massive animals are voracious and destructive feeders: a single adult can consume up to 300 kilograms of grass, shoots and roots (which it digs up with its tusks) each day, and will sometimes topple an entire tree simply to get at the tender leaves of its crown. Certain flowers and fruits – notably those of the marula tree – are especially favoured.

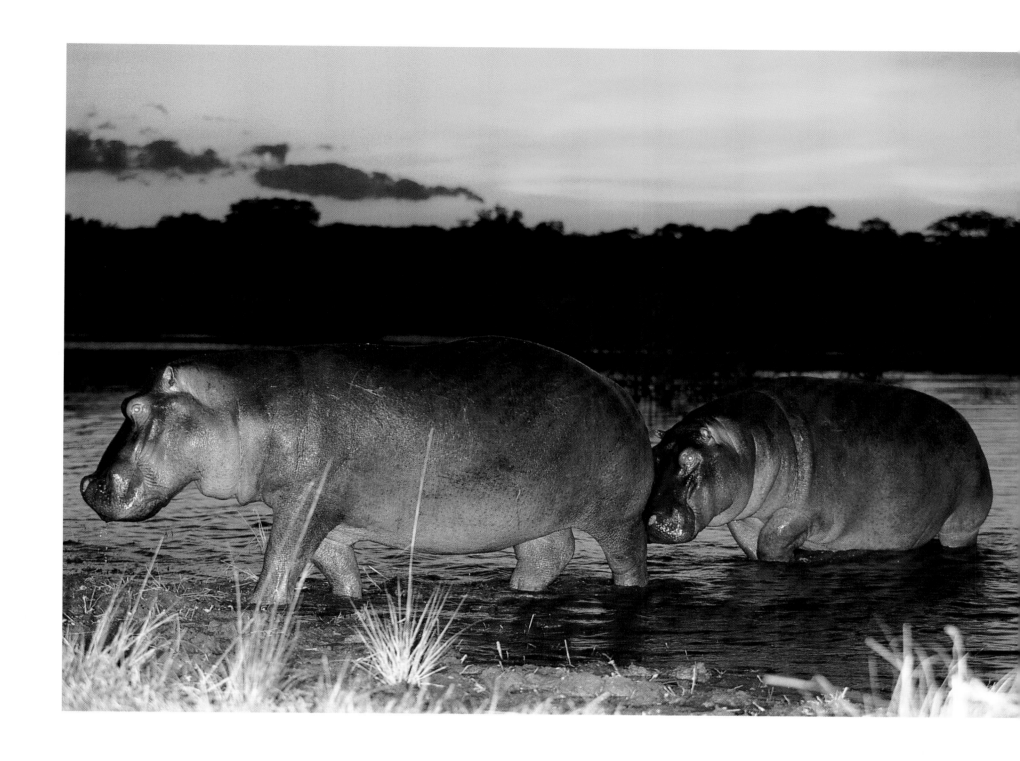

\mathscr{W}ater is the hippo's home. Indeed, this massive herbivore cannot remain on dry land for long during the daytime: its skin, though thick, is surprisingly sensitive to the sun. At night, though, it grazes in the open – preferably near a river or pan, but if needs be it will travel overland for up to 30 kilometres in search of pasture. It has an enormous appetite: a full feed for a single adult weighs around 130 kilograms.

\mathcal{T}he big stretch. The highly adapted gerenuk *Litocranius walleri* (right), endemic to a region extending from the Horn of Africa westwards to Ethiopia, is able to reach leaves, buds and fresh twig-tips denied to its shorter-necked cousins. Its ability to stand on its hind legs confers further advantage. The animal is especially partial to acacia species. The wider region supports about 80 000 gerenuk, most of them concentrated in Kenya's drier protected areas. Opposite: springbok also browse, but enjoy a mixed diet, feeding on grasses, roots (which they dig up with their front hooves) as well as bulbs.

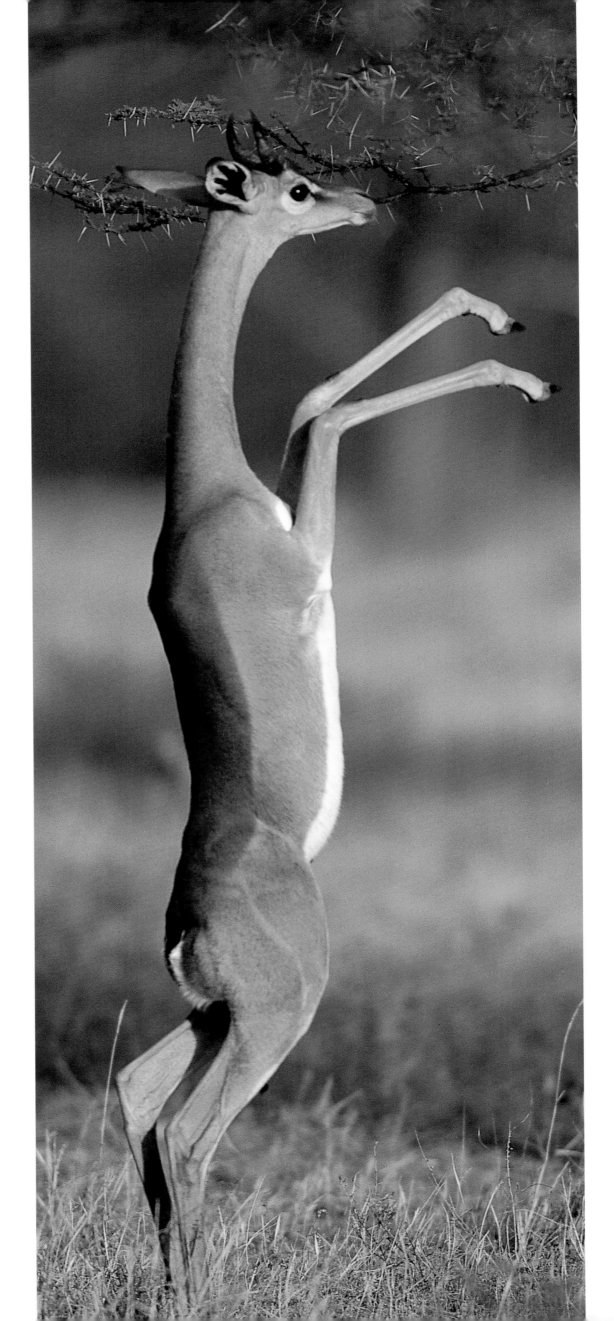

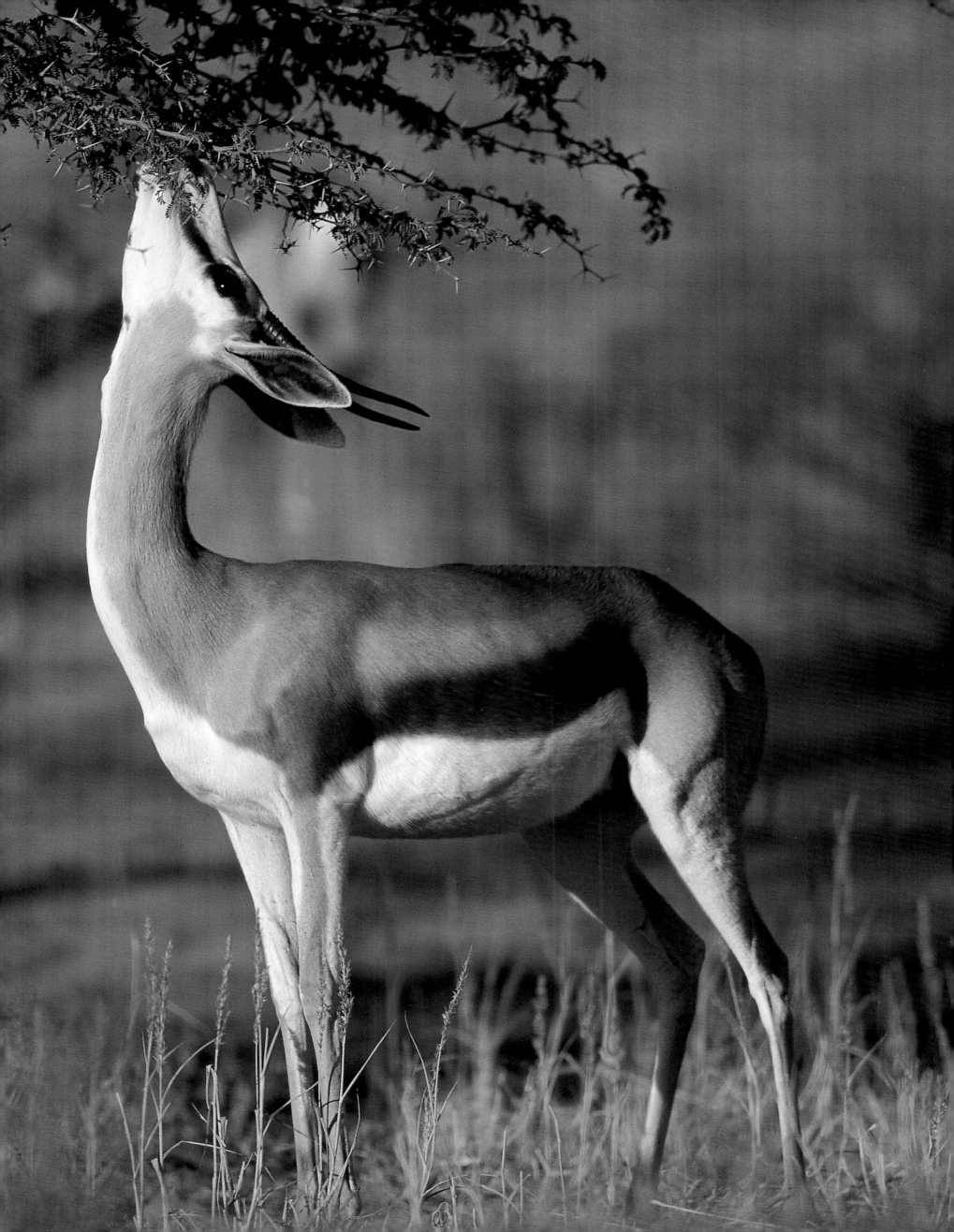

Among the deadliest of Africa's snakes is the gaboon adder *Bitis gabonica* (above and opposite, top), found in the forests of subSaharan Africa. A fat reptile distinguished by its strident colours (perfect camouflage in the leaf-litter of the forest floor), it lies in ambush for the rats, ground birds and toads it feeds on. Sluggish though it may appear, its strike is lightning quick.

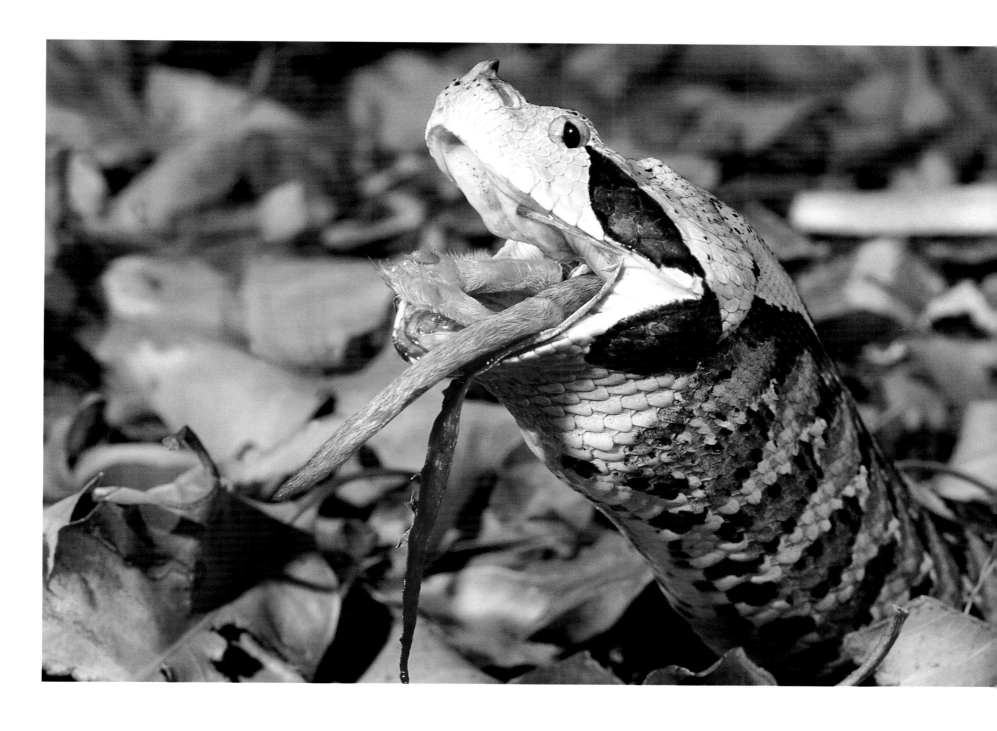

The egg-eater *Dasypeltis* species (opposite, bottom) is adapted to a diet of birds' eggs: it is virtually toothless, the skin surrounding the jaw elastic, enabling the reptile to swallow food items three times the size of its mouth.

This Anchieta's dwarf python *Python anchietae* (right), endemic to the rocky sandveld regions of northern Namibia and southern Angola, makes a meal of a rosy-faced lovebird.

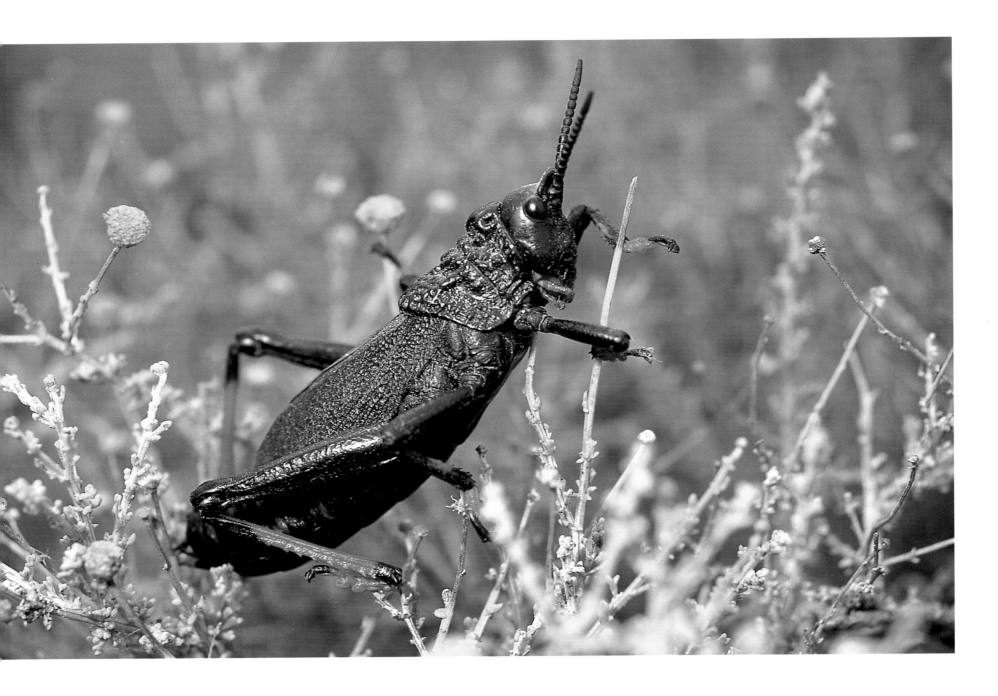

When disturbed, the foam grass-hopper (above) *Dictyophorus spumans* produces a billow of foul-smelling foam to repel the intruder; most predators hastily retire to seek tastier food elsewhere. The species belongs to the insect family Pyrgomorphidae, whose members are distinguished by their striking colours – a clear warning of their toxic potential.

These *Trichostetha* beetles (right) are devouring a *Leucospermum* plant, otherwise known as a pincushion and a member of the protea family.

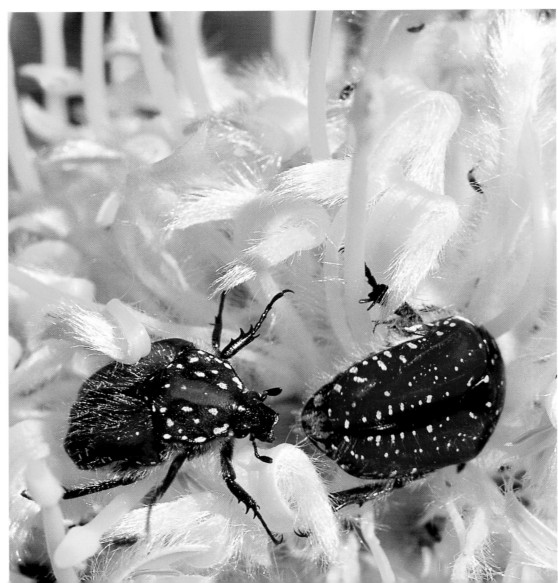

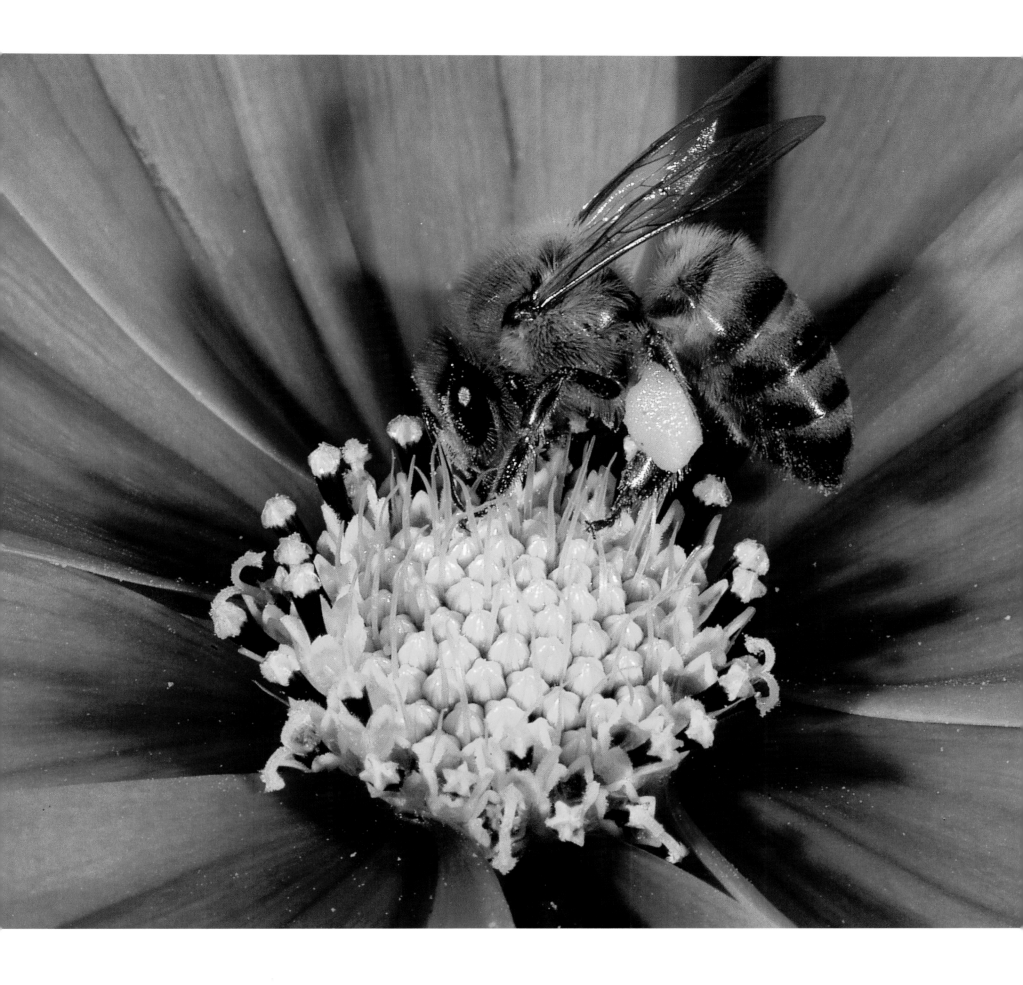

𝒯he honeybee *Apis mellifera* (above), a species indigenous to Africa, forages for pollen among the blooms of a cosmos plant. Worker honeybees spend the first two weeks of their short lives in the hive, feeding the queen and larvae with protein-rich 'royal jelly', and building and repairing the cells. They then undertake a spell of guard duty and, when they are about three weeks old, venture forth to collect nectar.

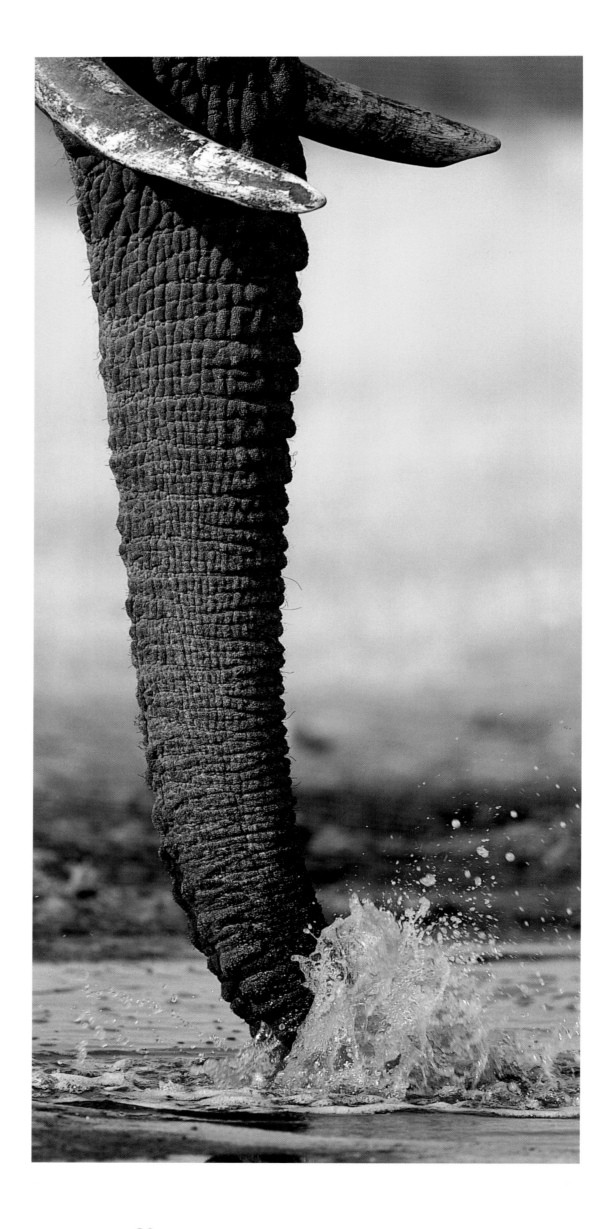

Water is a cherished commodity within the elephant community (right) – both for drinking (an adult's daily intake can be as high as 220 litres) and as an aid in dissipating the heat from its huge body. This it does by wallowing, showering, and spraying moisture over its head and, especially, over the large ears, which are then flapped to enhance the cooling effect. The trunk is remarkably sensitive, enabling the animal to select the choicest of leaves, flowers and fruits (opposite).

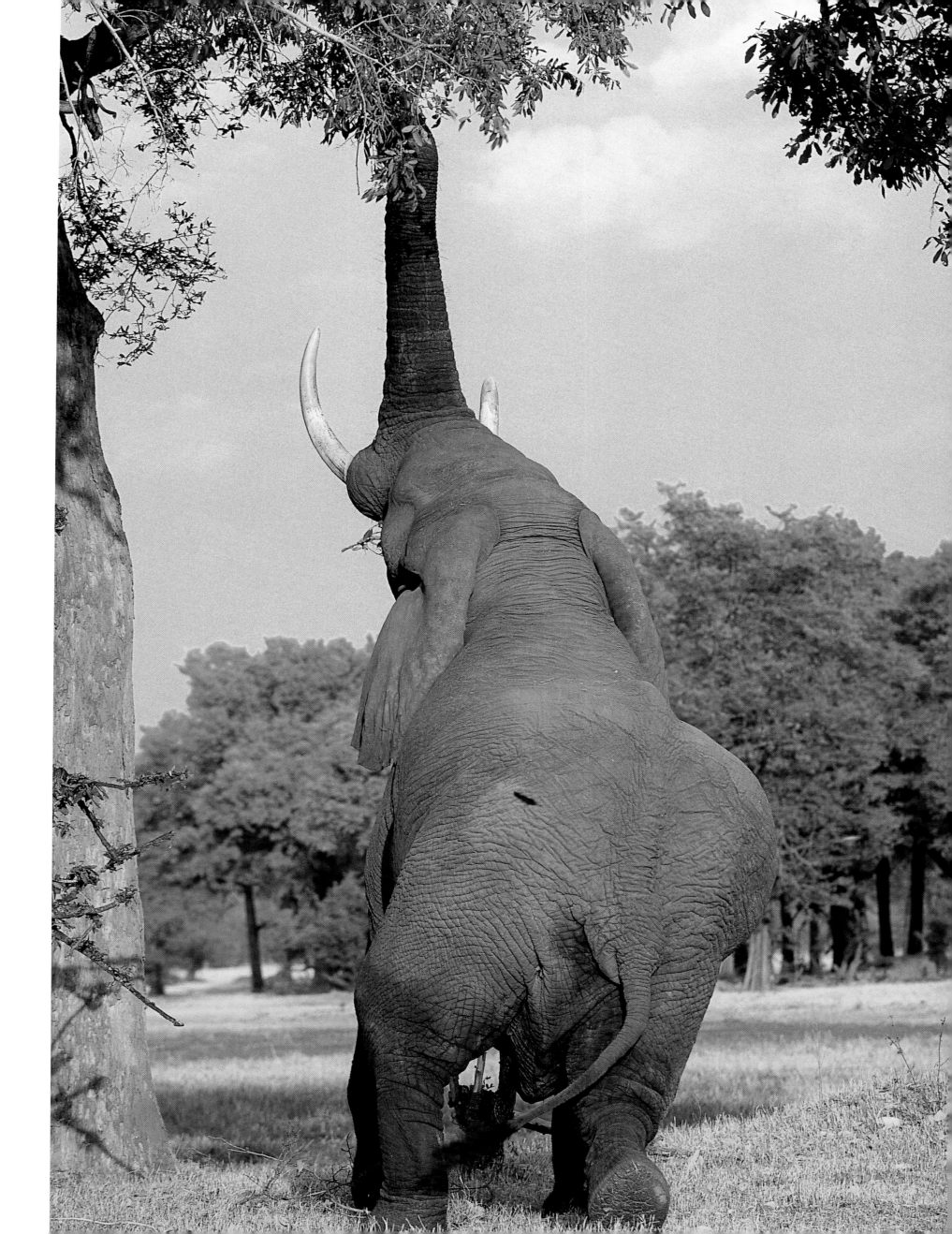

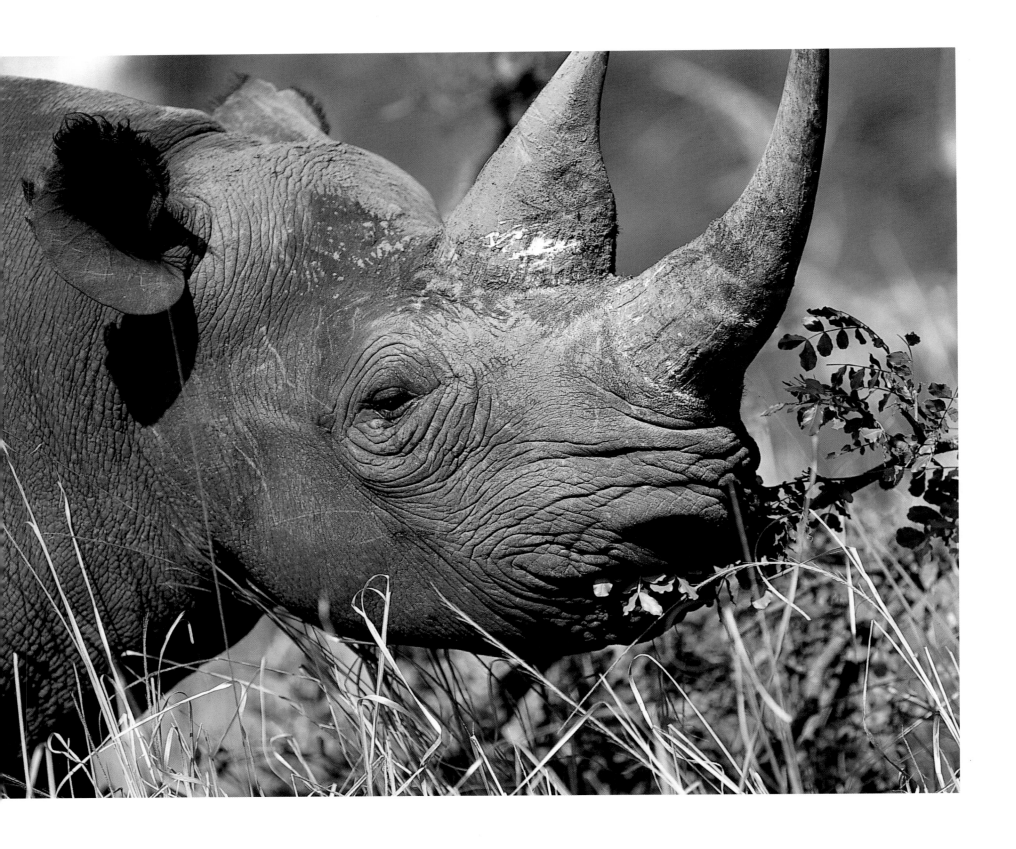

\mathscr{A}mong the most threatened of Africa's large mammals is the black or hook-lipped rhino *Diceros bicornis*, a browser that uses its pointed upper lip to grasp, and its cheek teeth to snap, the twigs and leaves that make up the bulk of its diet. Once a common resident of southern, Central and East Africa (as recently as 1970 the continent-wide population stood at 65 000), poachers have reduced the species to a few, isolated, carefully guarded groups. South Africa's Natal Parks Board has featured in the vanguard of the conservation effort.

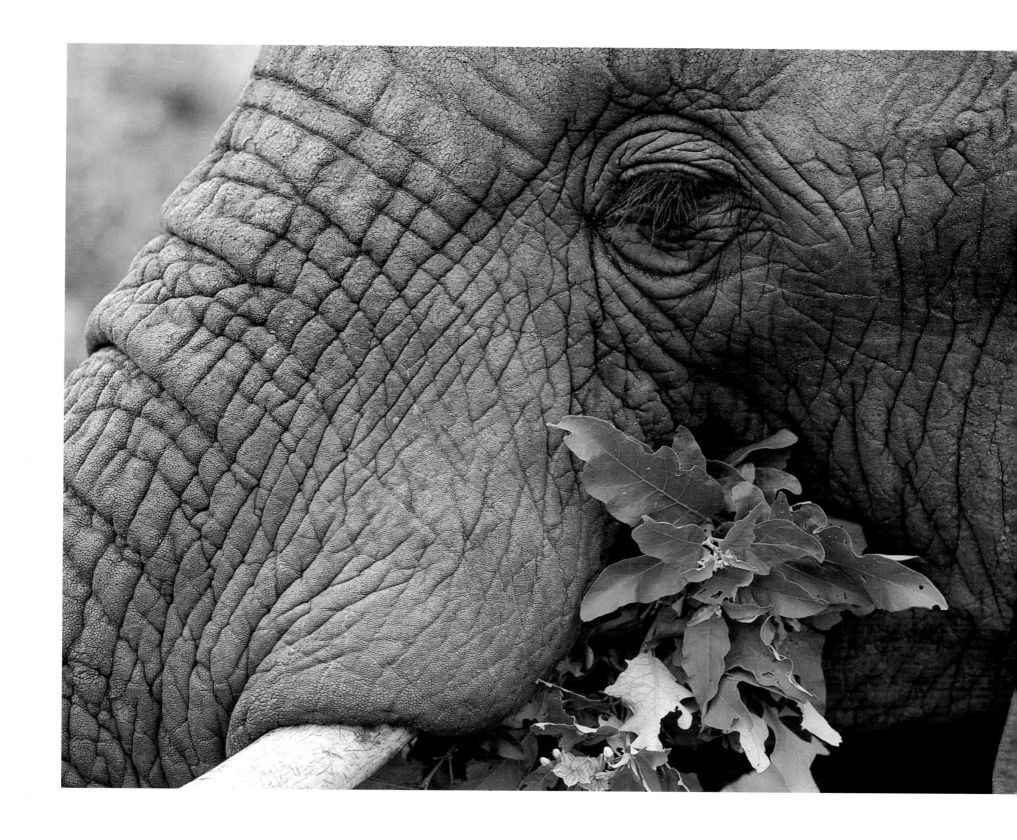

The elephant's prodigious appetite can have a devastating impact on the environment: if the population is allowed to become too large for the area to which it is restricted, the habitat suffers serious degradation – this poses a threat, not only to the animal's wellbeing, but to the very survival of other species. In some parts of Africa elephants, protected within well-managed parks, have thrived to the point where surplus individuals have to be killed off (culled). By contrast, ivory poaching has taken savage toll of the herds in other regions.

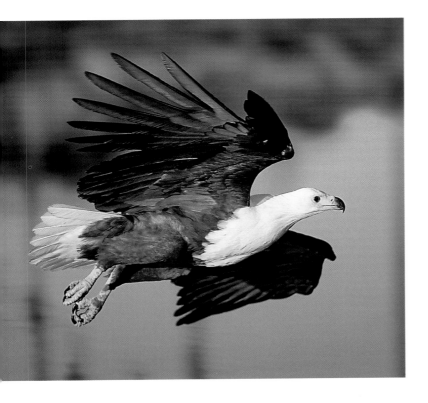

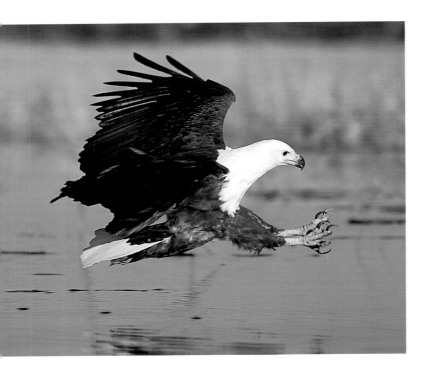

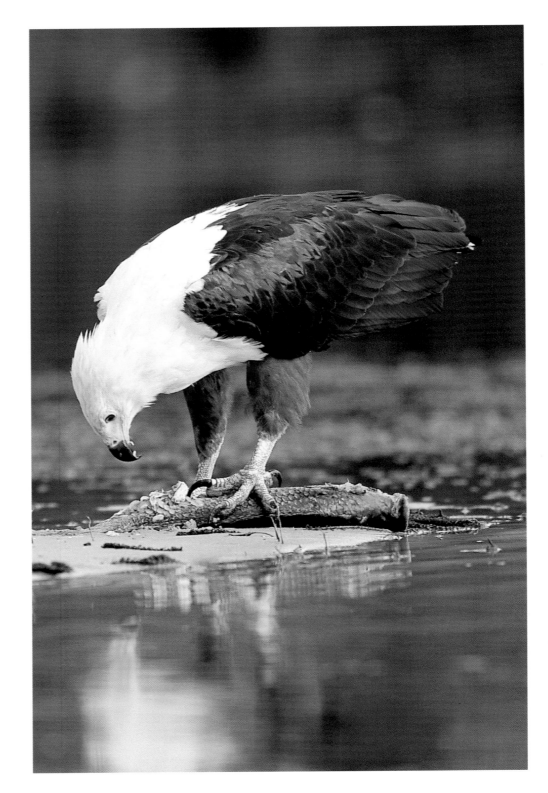

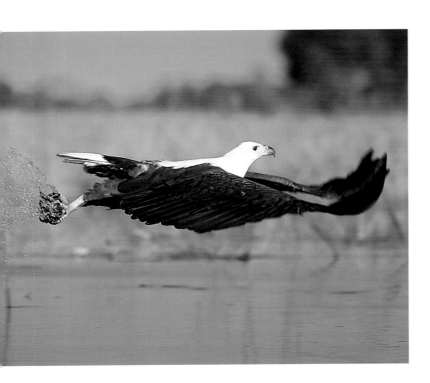

The African fish eagle *Haliaeetus vocifer*, instantly recognizable by its striking plumage, is one of the most spectacular hunters of the continent's wetlands. It is also known for its loud, wailing call. Another familiar water-related bird is the lesser flamingo *Phoenicopterus minor* (opposite); this flock graces the Ngorongoro Crater in Tanzania.

Overleaf: hordes of blue wildebeest cross Kenya's Mara River on their way to fresh pastures. Many drown in the sometimes swift-flowing waters.

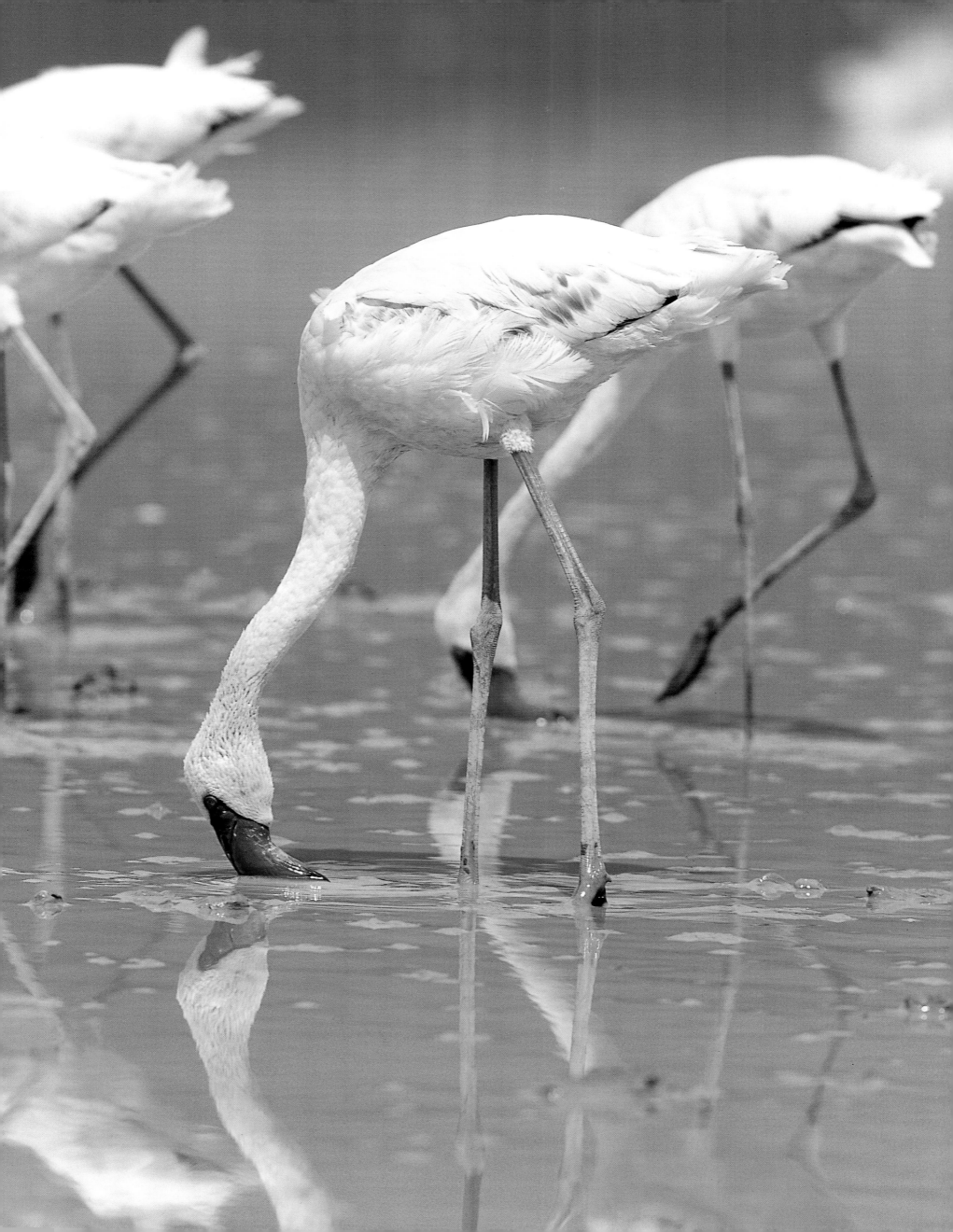

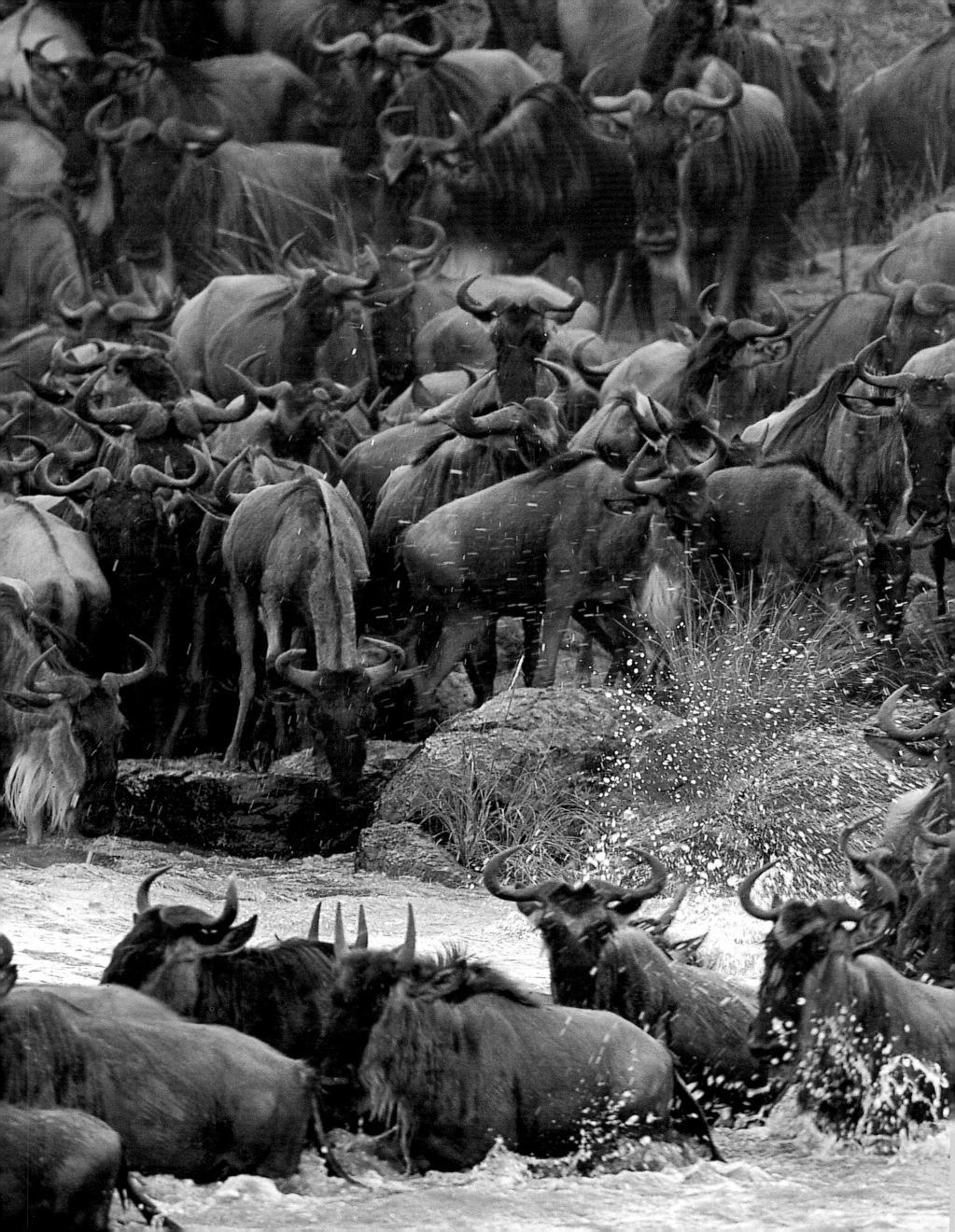

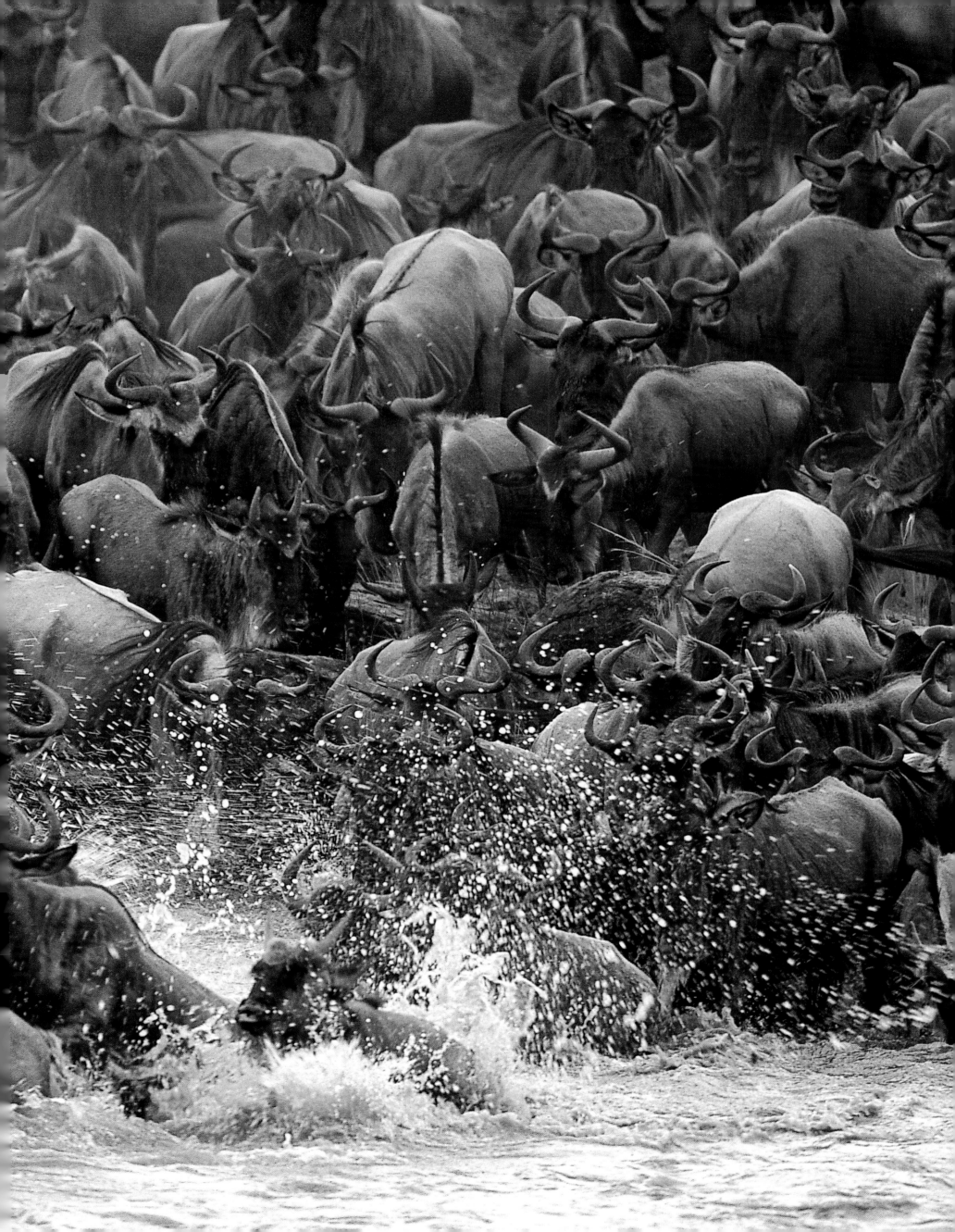

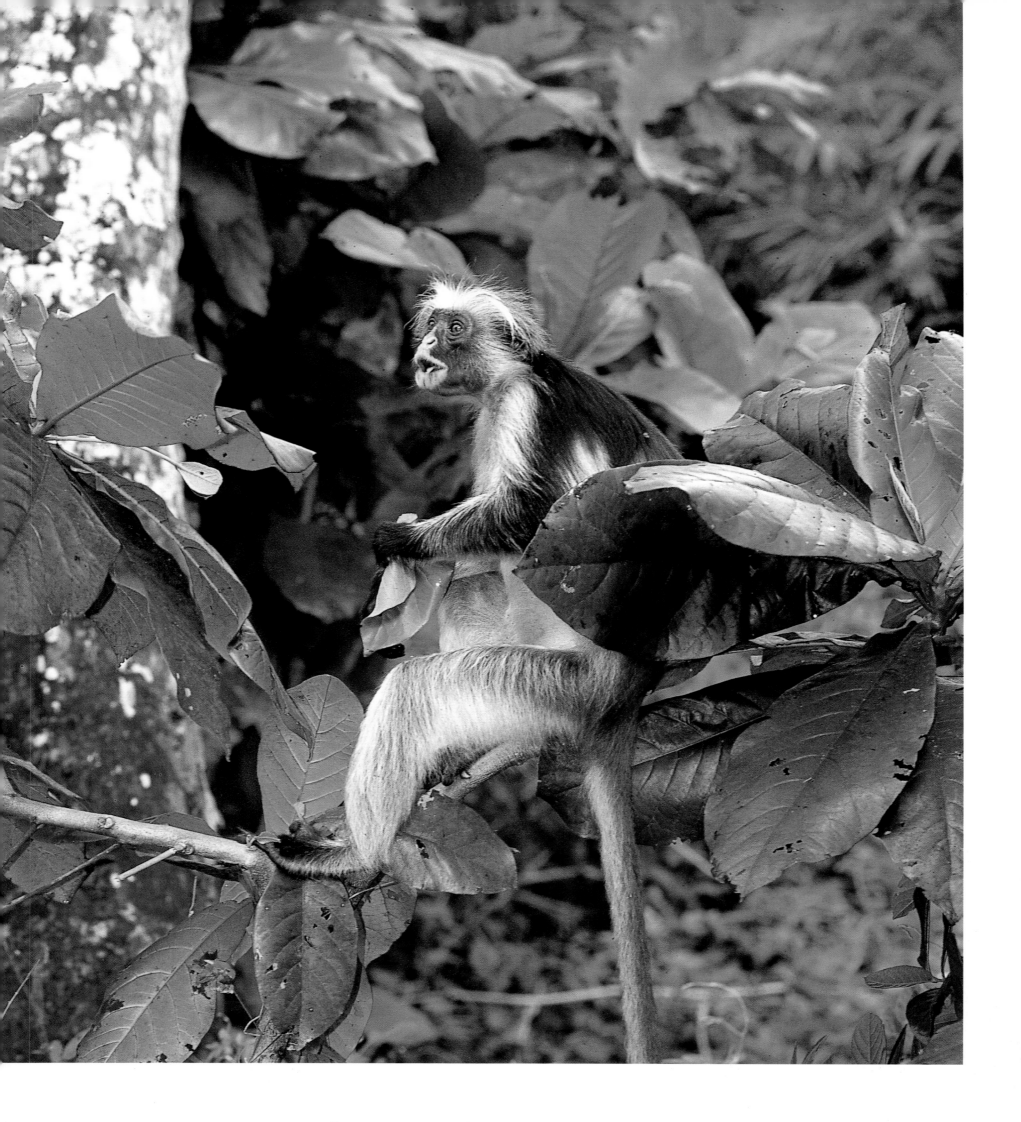

*B*ringing a bright splash of colour to tropical Africa's forests is the colobus monkey, *Procolobus* species (above and opposite). There are five species of the primate, all of which subsist on young leaf growth.

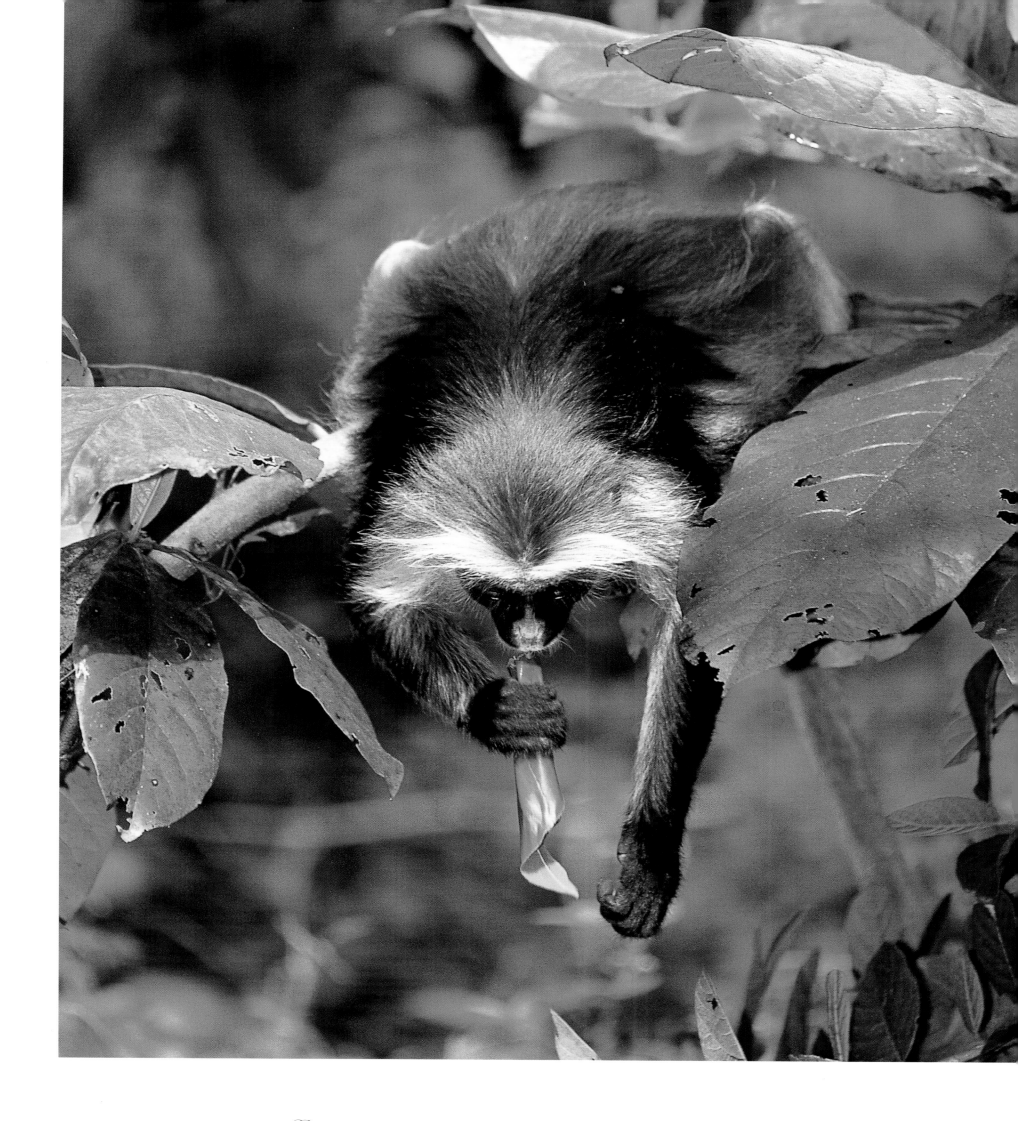

*R*ed colobuses *Procolobus kirkii* have evolved a highly specialized digestive system to process their leaf intake. These monkeys spend virtually all their time in the trees, descending only to cross clearings.

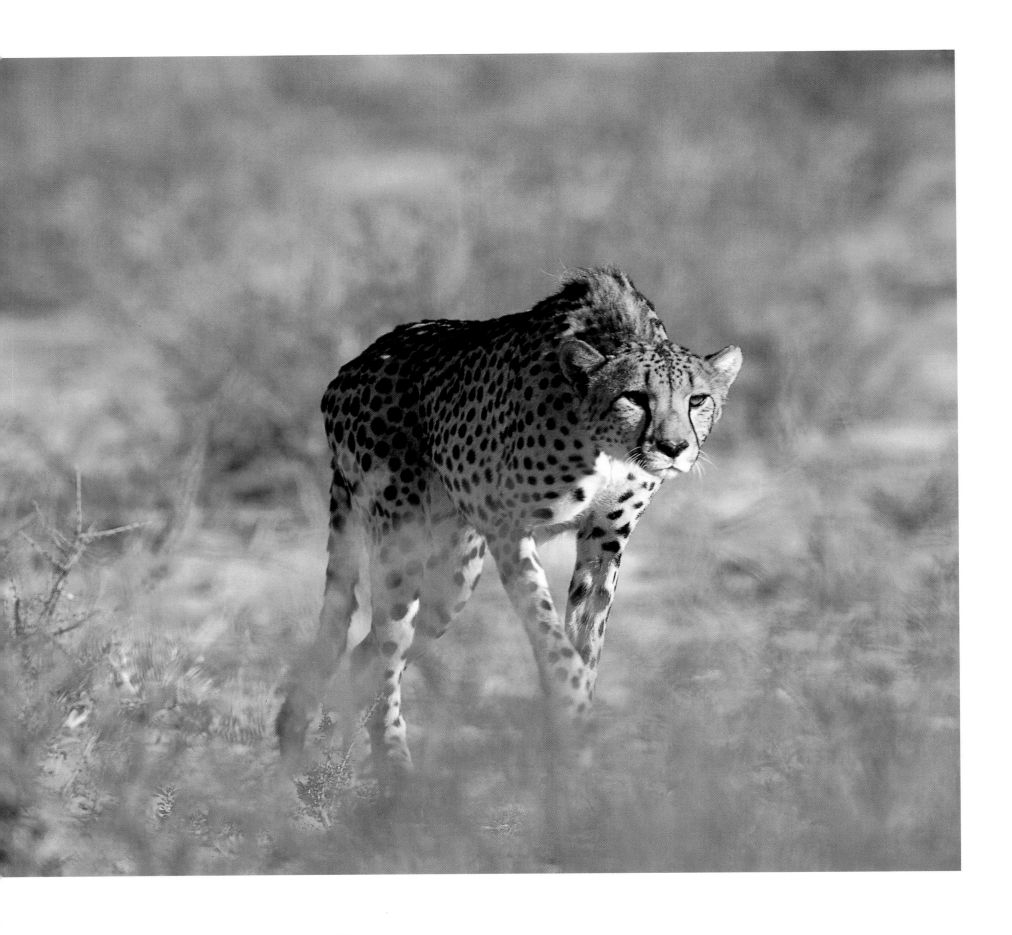

The cheetah (above and opposite) may be phenomenally quick over short distances – it can outrun even the most agile of antelope – but it is blessed with very little stamina. Exhausted after a successful chase, it must rest for a few minutes, which is often time enough for the vultures and other scavengers to move in. Much else, too, has been sacrificed to speed: it lacks retractable claws, for instance, and it cannot rotate the wrists of its forelimbs, an adaptation that stabilizes it during the sprint but also inhibits it when the prey changes direction at the last moment.

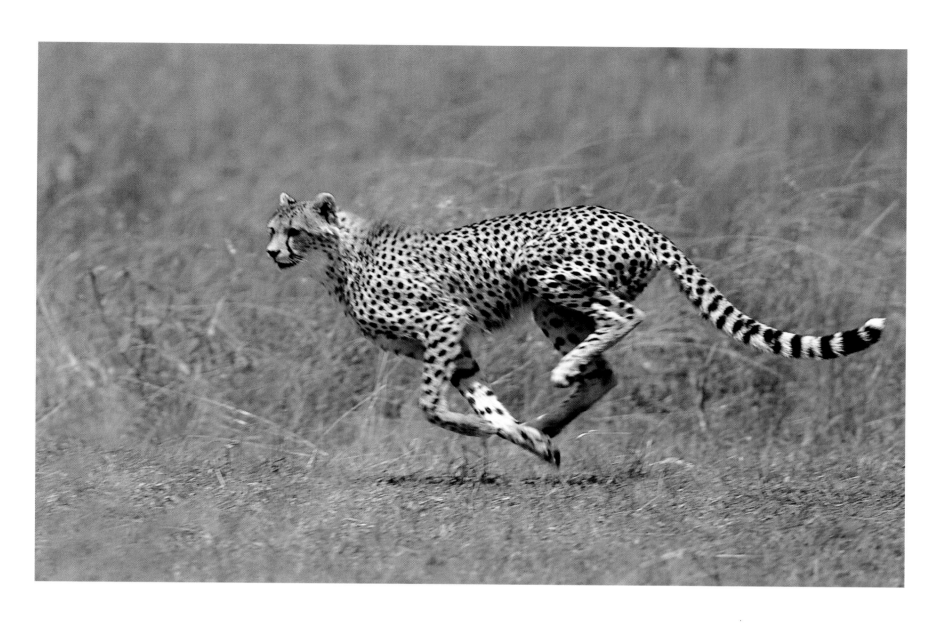

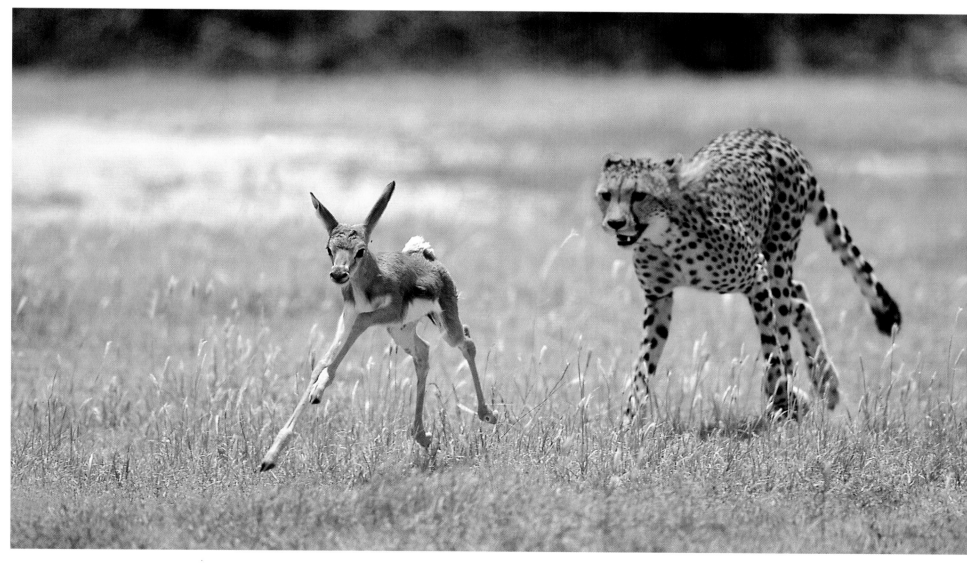

SECRETS OF SURVIVAL

Every one of the African continent's, indeed the earth's, countless life forms has evolved its own, effective means of self-preservation. Many of the mechanisms are unique, some are quite remarkable in their ingenuity.

The armament that enables the larger carnivores to catch and kill – their teeth and powerful jaws, their size, speed and cunning – also provides them with protection. Prey animals on the other hand are obliged to fall back on a variety of passive defences. Some hide away in holes and burrows; others depend on camouflage; still others on chemicals: when threatened, the honey badger, for example, produces miasmic smells that intimidate the most determined of pursuers. Antelope tend to rely on sharp eyesight, keen hearing and fleetness of foot for safety though a few, like the rapier-horned gemsbok, have developed formidable weaponry. The buffalo herd will form a 'laager' against attackers, and the suricate post a sentry to keep watch while the rest of the group forages.

Elusiveness, disguise, bluff, mimicry, freeze behaviour, chemical warfare, flight, fight, armament, co-operation, safety in numbers, sensory acuteness – the strategies for defence are legion in a natural world governed by the quest for species immortality.

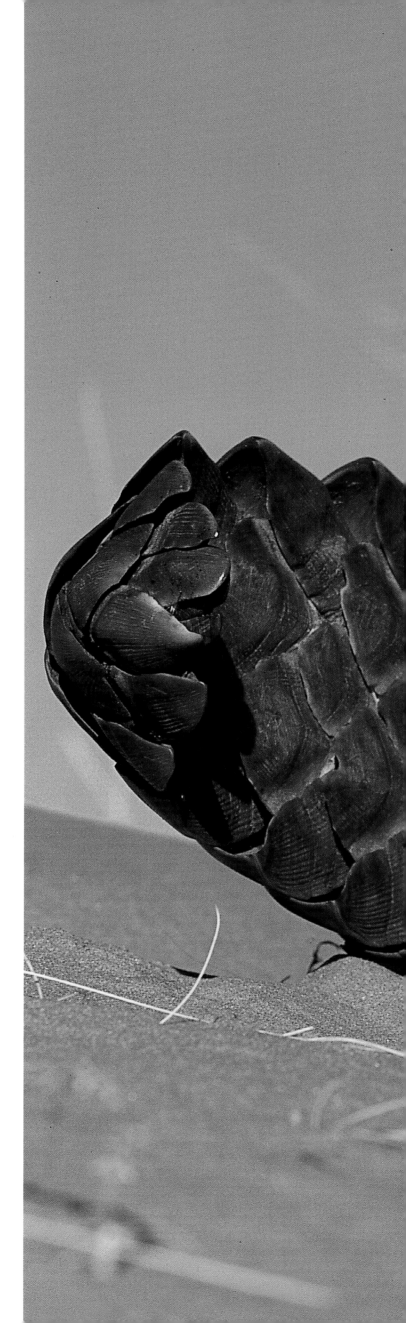

The pangolin's *Manis temmincki* armoured plating (right) has protected this ancient and curious mammal species for close on 40 million years. When threatened, it rolls itself up into a tight little ball and, if molested, will lash out with its sharp-scaled tail.

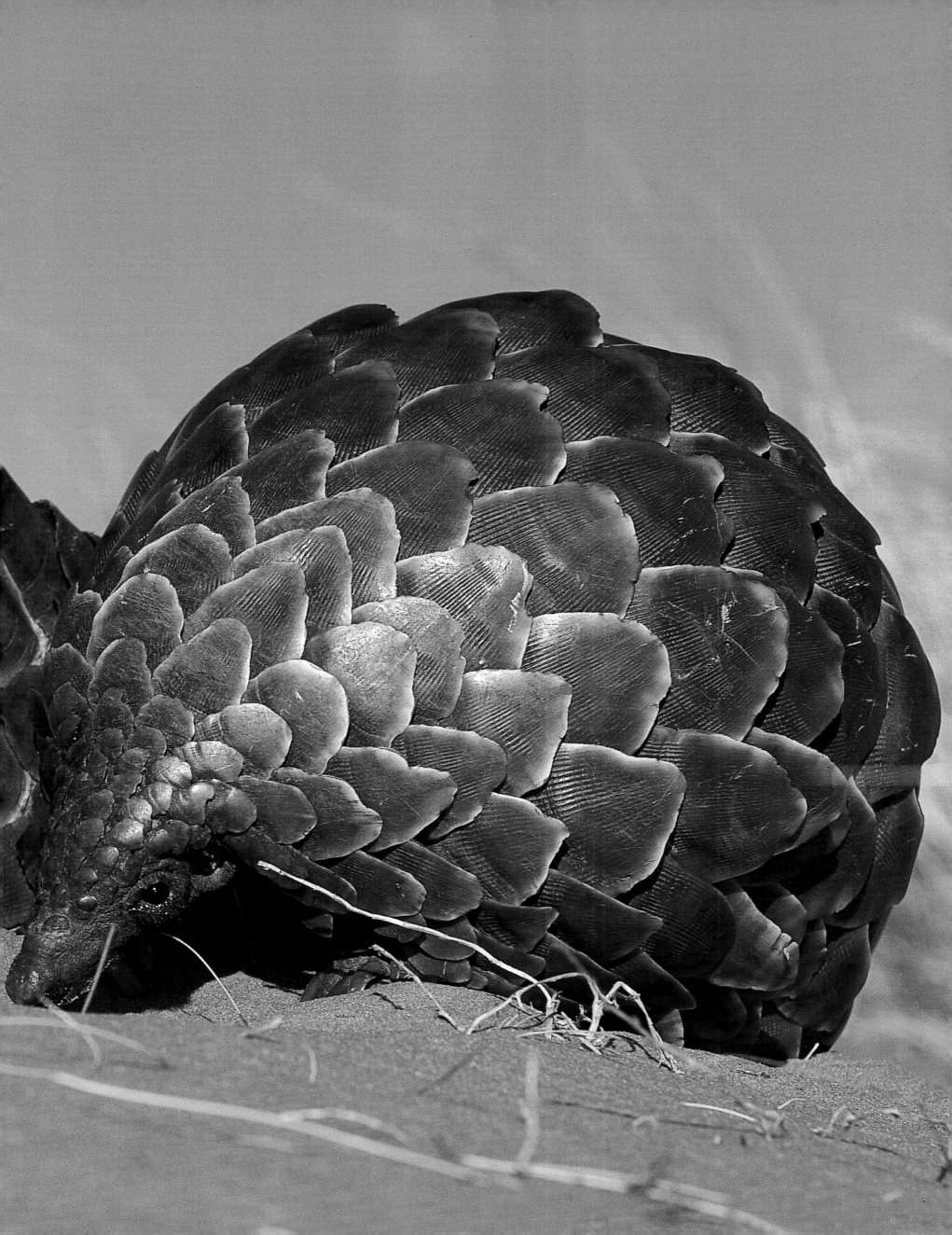

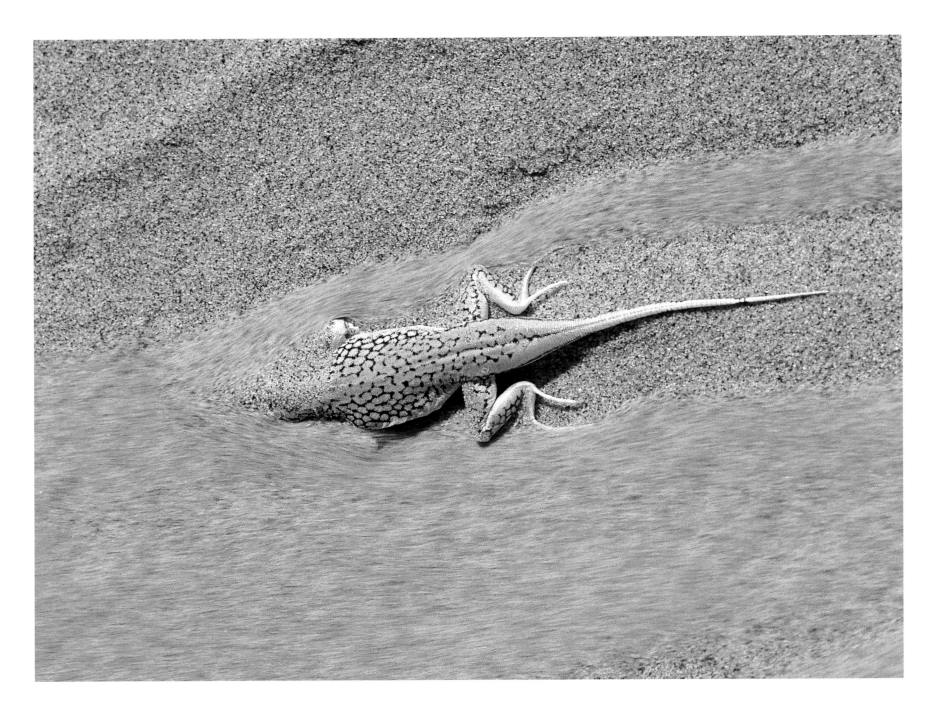

Arid deserts support life forms that are remarkably well adapted to their harsh environment. To escape danger, the shovel-snouted lizard *Aporosaura anchietae* (above) 'swims' through the loose sand of the Namib. The ground agama *Agama aculeata* (right) depends on speed and camouflage for self-preservation. Here, a female is digging a hole in which to lay her eggs. Opposite: a sidewinder snake *Bitis peringueyi* makes its convoluted way across the burning surface of the Namib.

Overleaf: a cheetah stalks its prey at the Okonjima Game Lodge in Namibia.

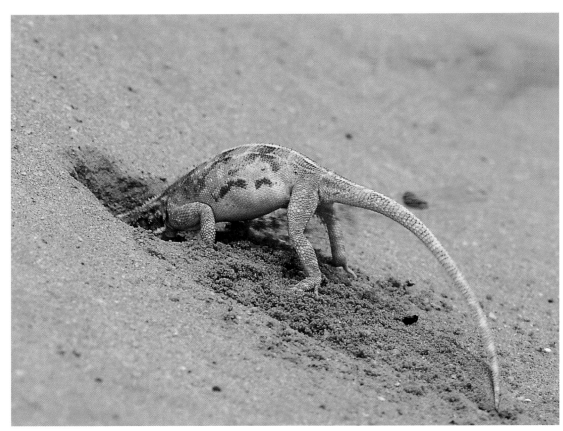

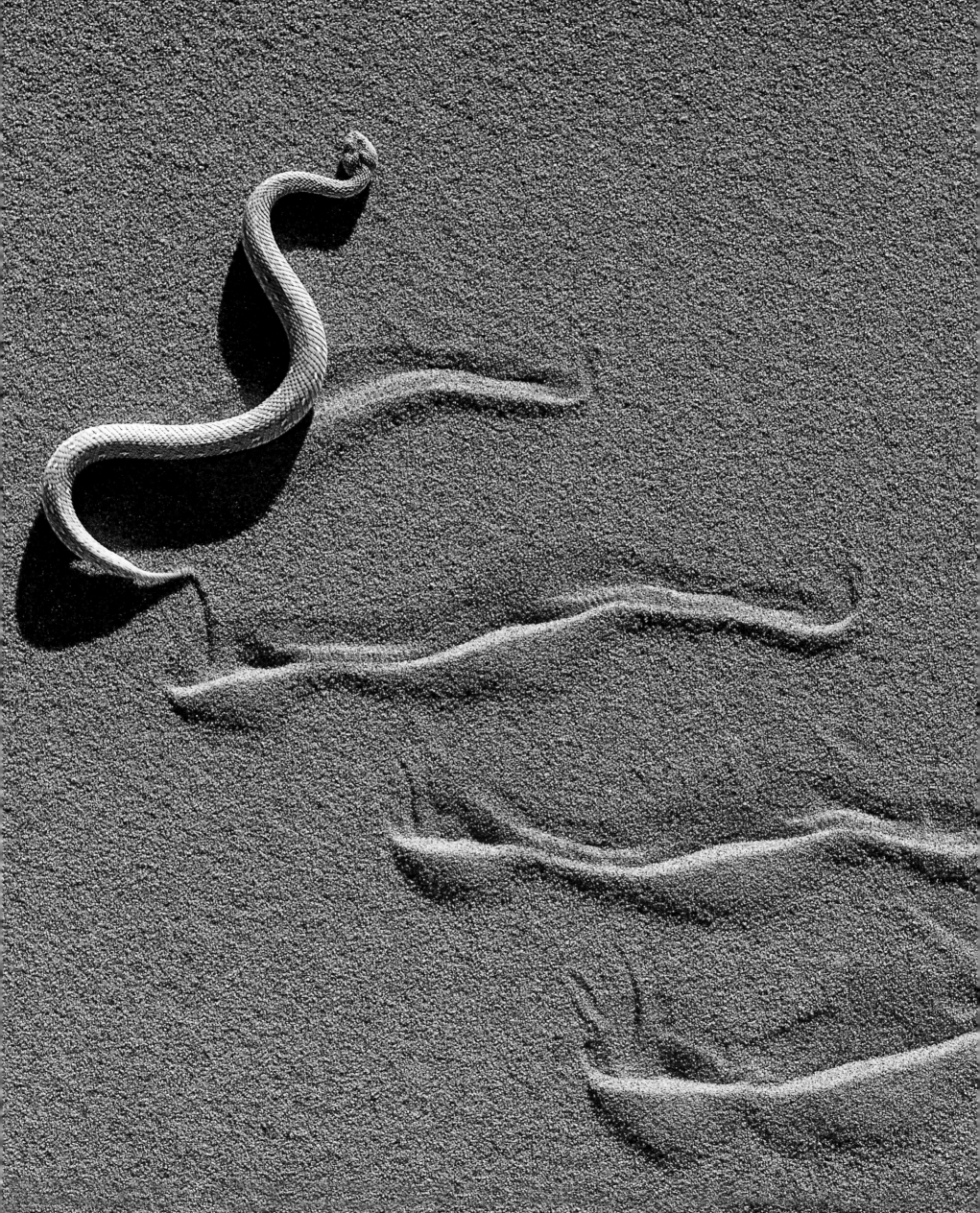

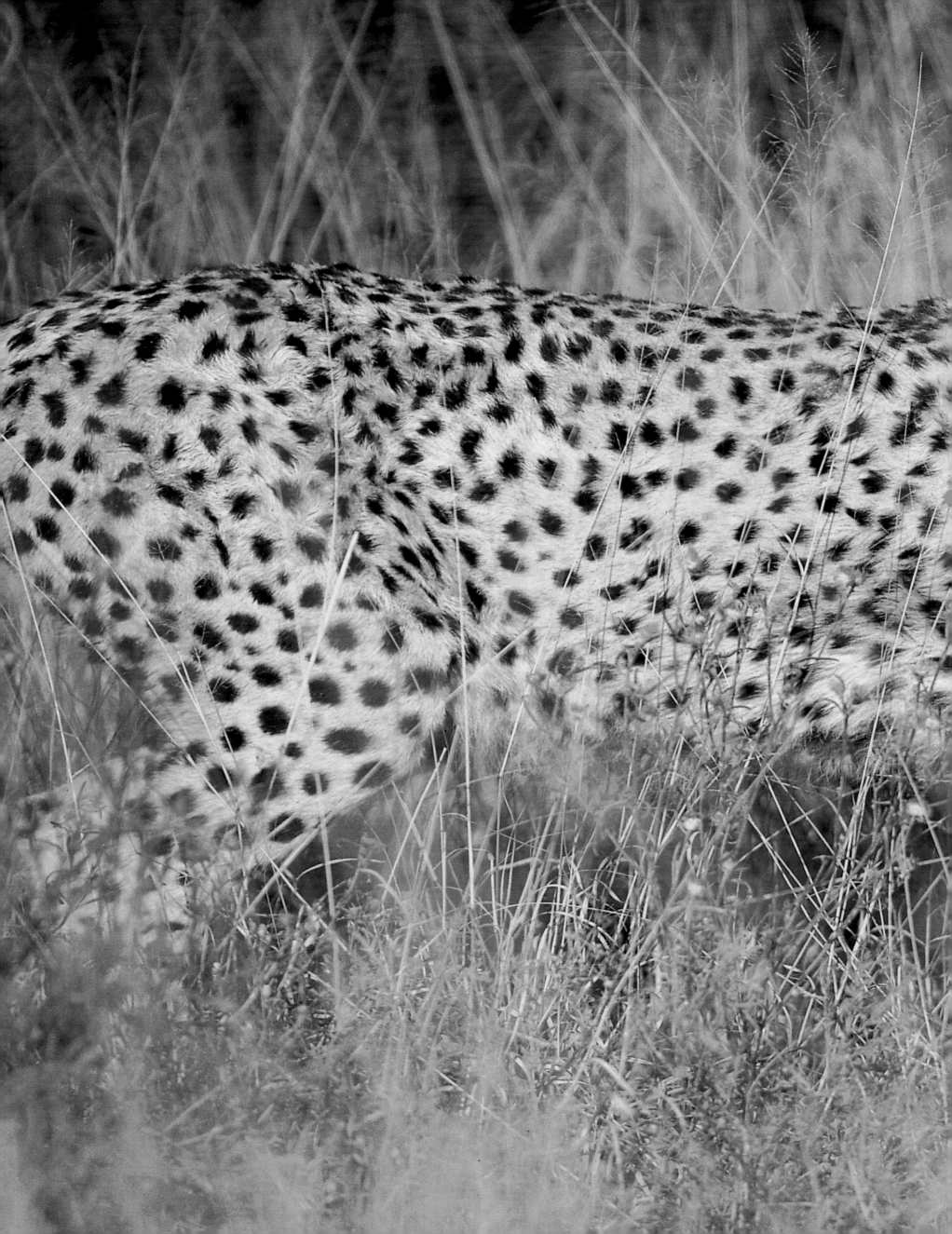

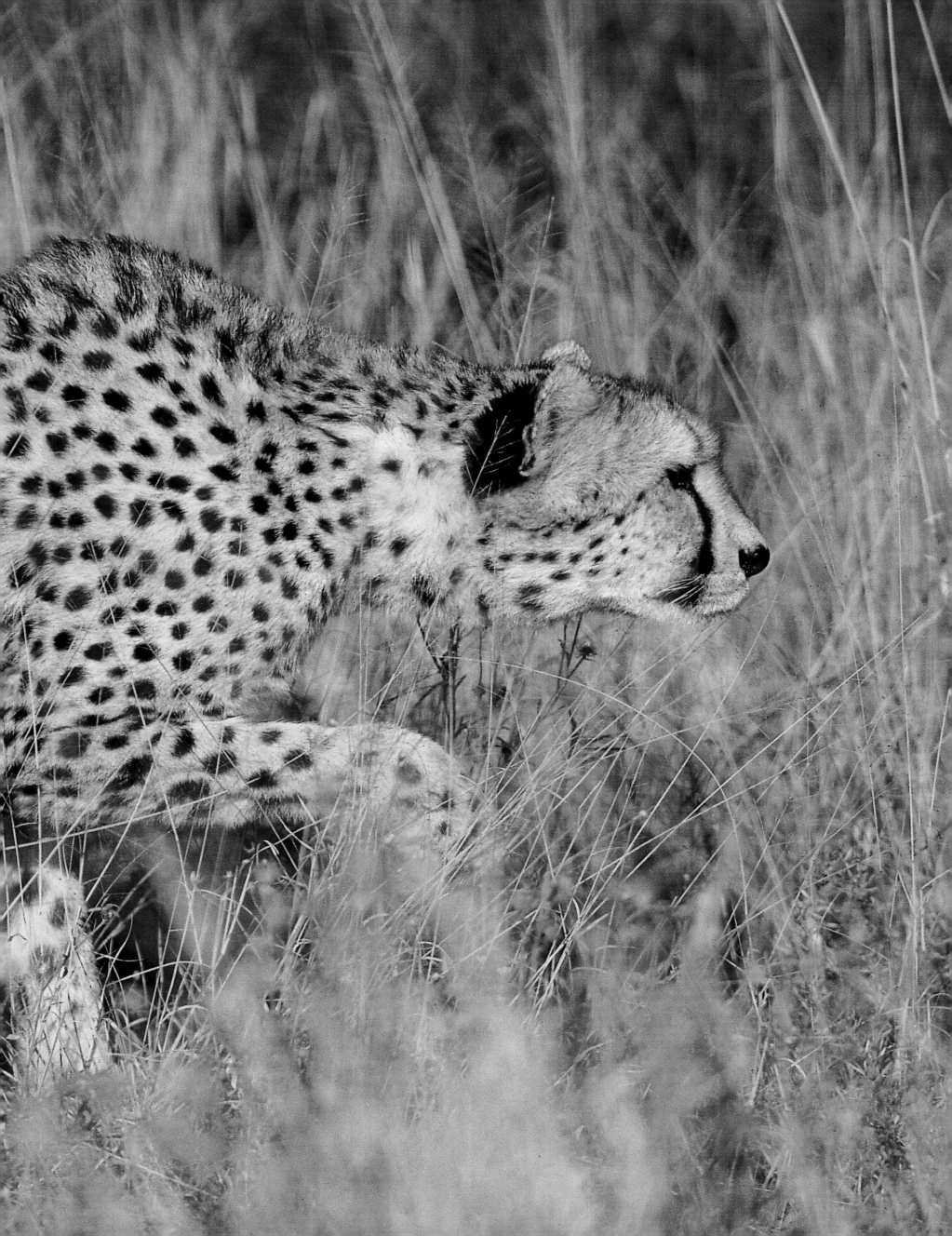

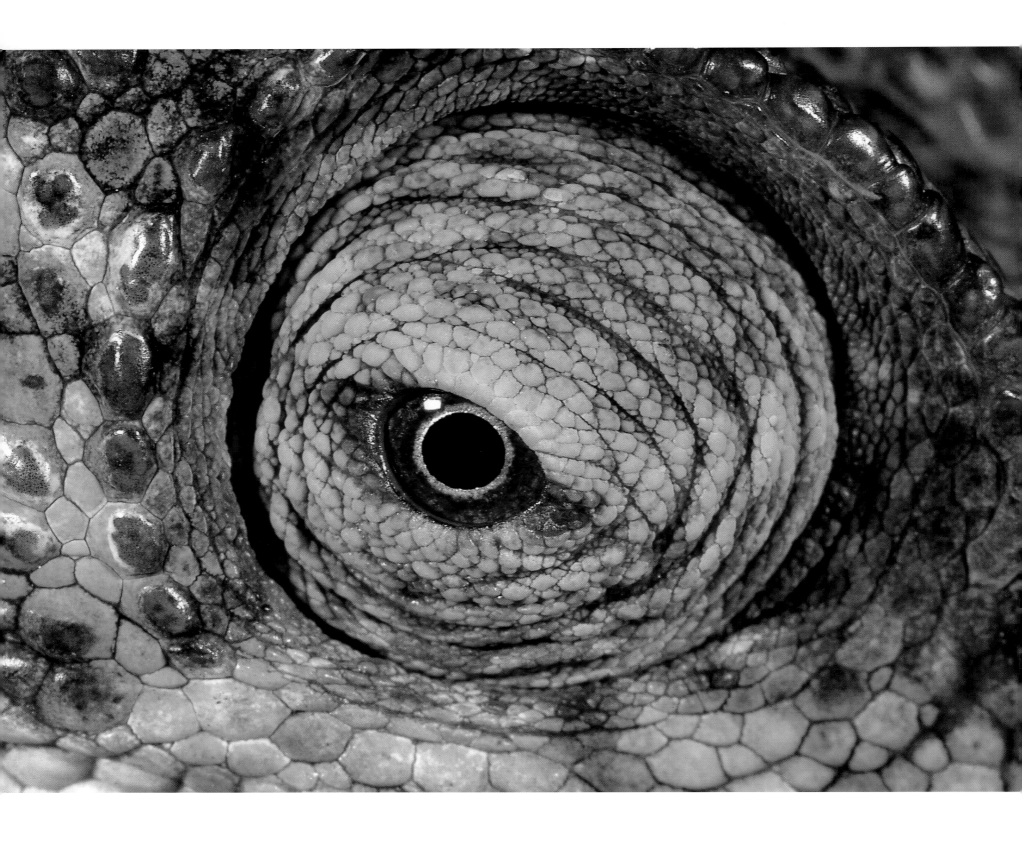

For many life forms, keen eyesight is a major weapon in the armoury, vital not only for defence but also in the feeding process. The chameleon's vision is excellent; its eyes (pictured above is that of *Chamaeleo parsonii*) capable of swivelling independently through almost 180 degrees in both the vertical and horizontal planes while the head stays still.

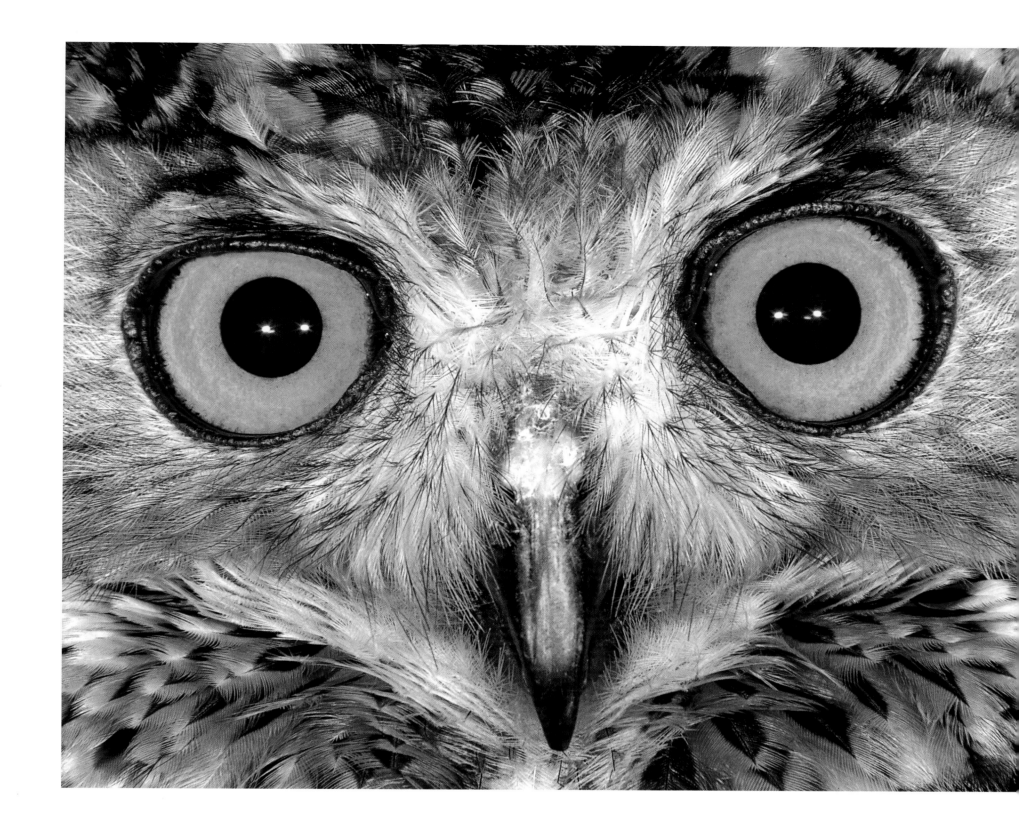

\mathcal{T}he Cape eagle owl *Bubo capensis*, like all others of its family, has superb night vision – though not, surprisingly, as good as that of a cat. This, together with its acute sense of hearing and an ability to fly silently, enables it to locate its prey with uncanny precision. During the day it keeps its eyes hooded to prevent a give-away glint.

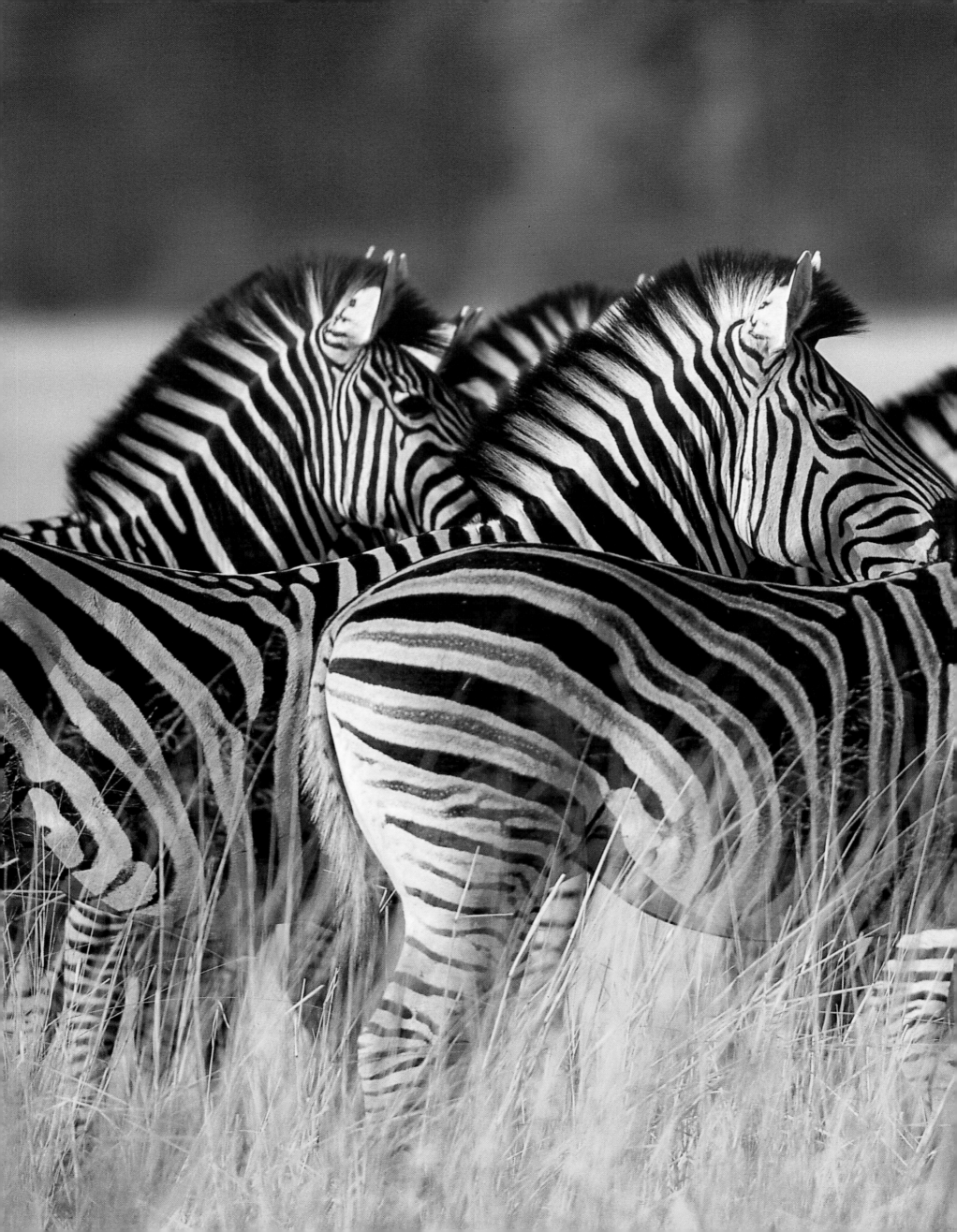

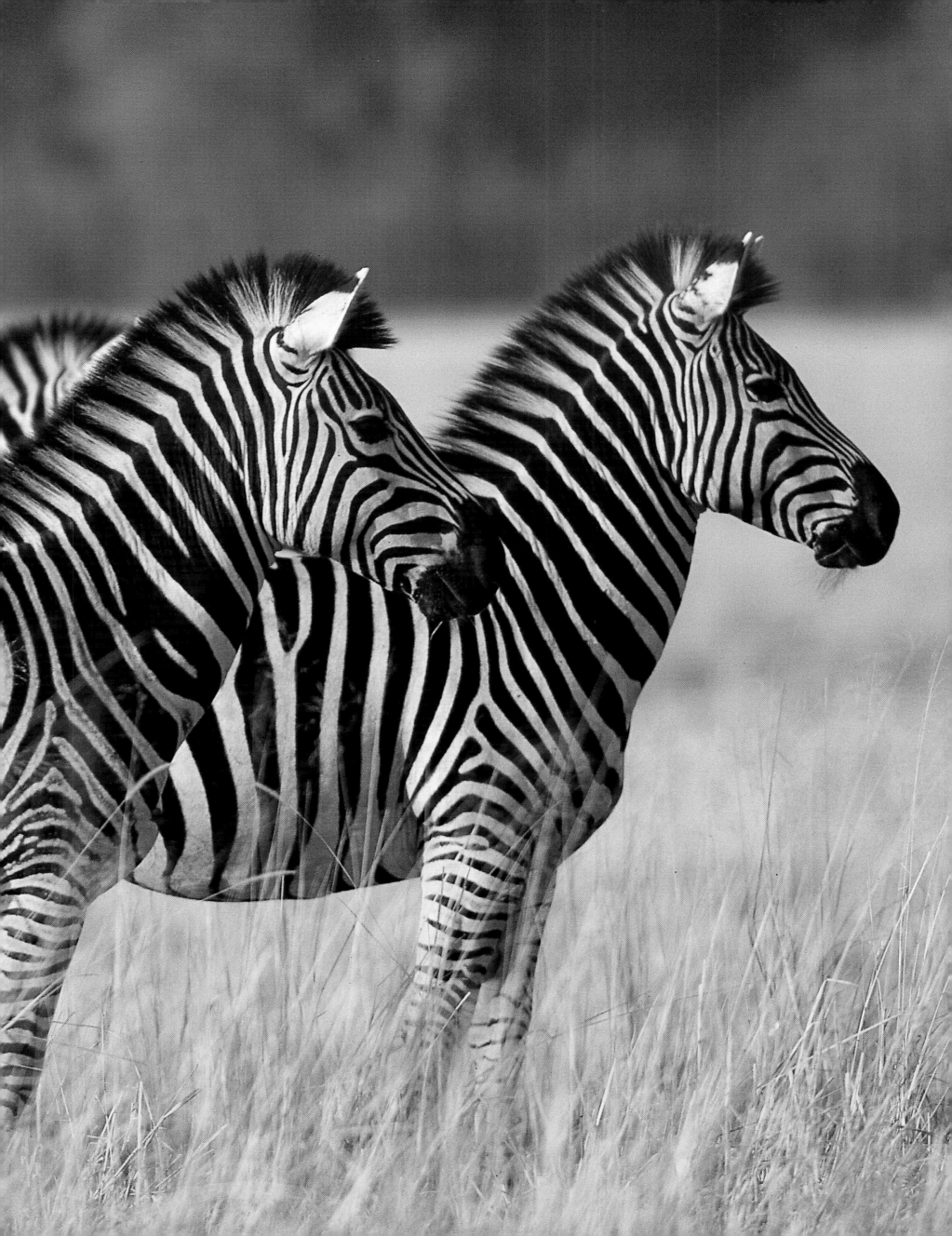

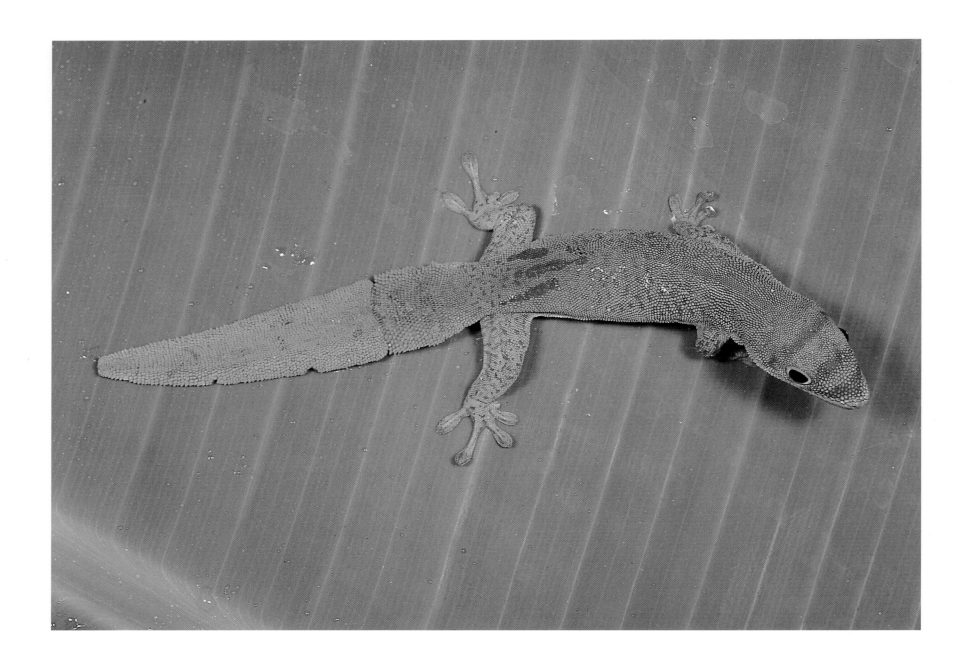

\mathscr{P}revious pages: sharp-eyed Burchell's zebra spot potential danger. The striping, which varies from region to region (and, much less so, between individuals in the same group: no two patterns are exactly the same), does not serve as camouflage. It does, though, tend to confuse predators, who are hard put to single out one animal from the mass. For defence, the zebra relies on eyesight, hearing, speed, stamina, and safety in numbers.

\mathscr{M}adagascar is home to more species of *Phelsuma* day gecko (above) than any other region. Unlike most geckos, these reptiles' self-preservation in the face of a direct threat depends not on camouflage – their colours are gorgeous – but on mock ferocity: when molested they rear up and gape widely to show their bright-red tongues. They are also keen of eye and fleet of foot.

\mathscr{E}ven more richly hued is the larva of the emperor moth (opposite) – family Saturniidae – some of whose members rank among the world's largest moths. Certain species boast a wingspan of nearly 25 centimetres.

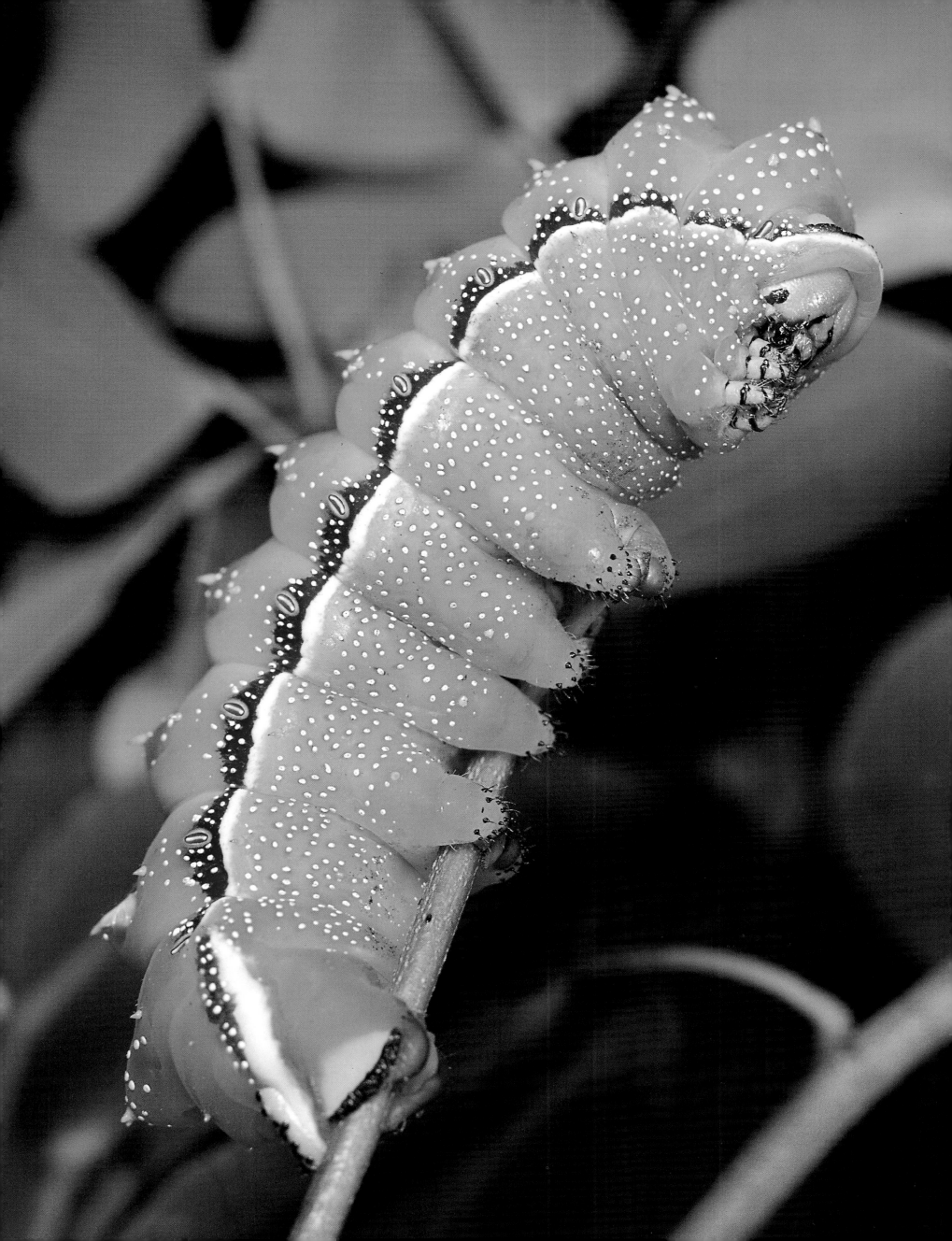

The larger carnivores appear to favour the humble porcupine *Hystrix africaeaustralis* as a prey item, probably because the fat content of its flesh is high. But its quills provide a formidable armament: when molested, it presents its bristling back or side to, and thrusts itself at, the attacker. A lion will invariably come off second best in such encounters; occasionally the needle-sharp quills will pierce the flesh to set up an infection that spreads, weakens the animal, and leads to slow death by starvation.

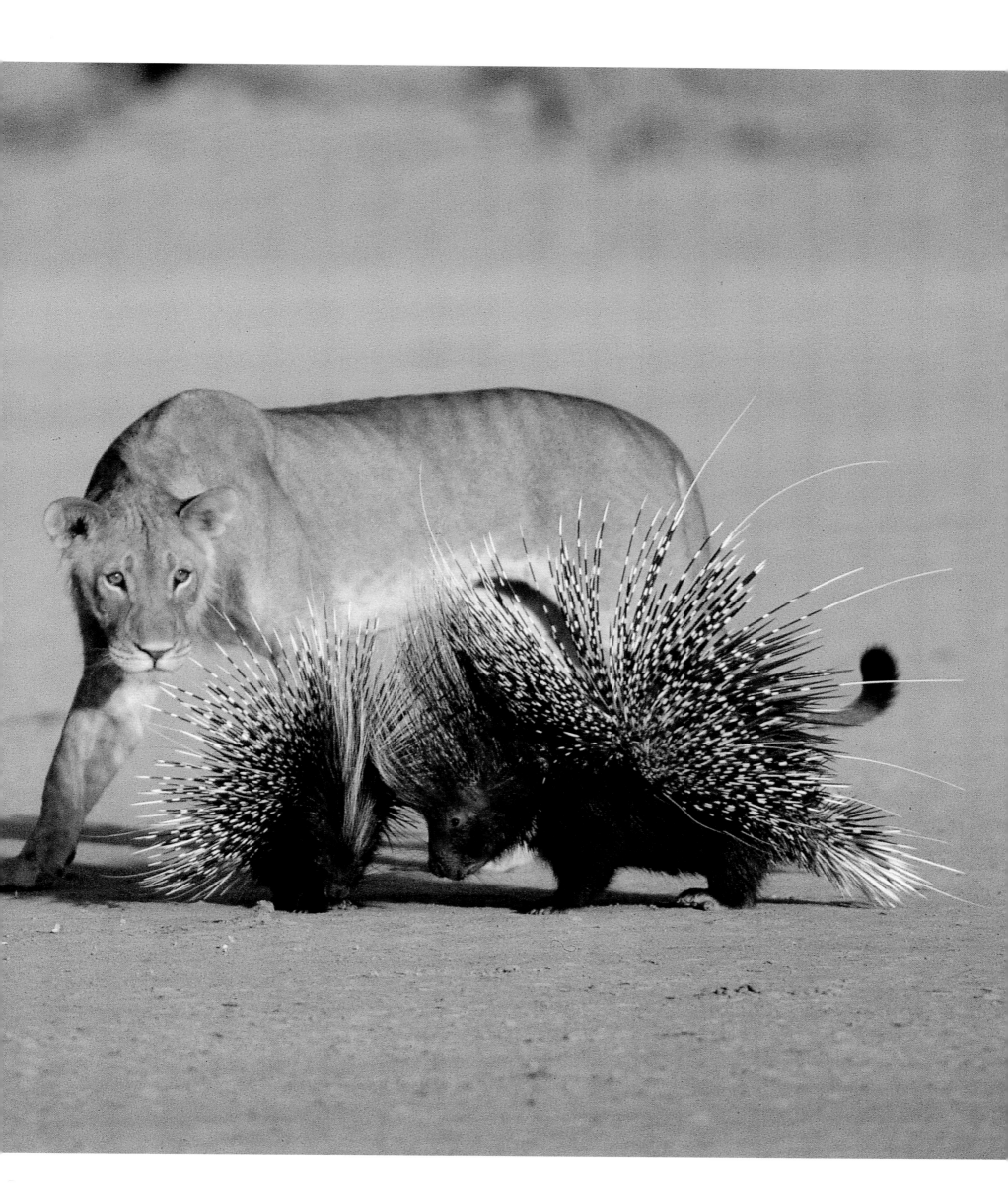

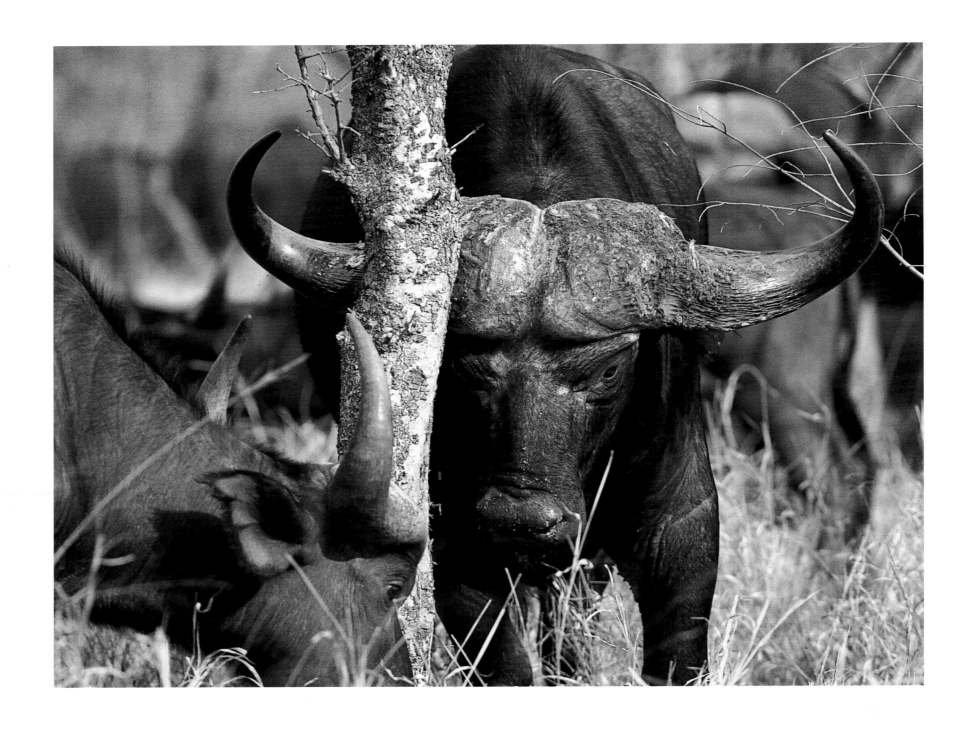

\mathcal{T}he buffalo (above and opposite), Africa's only species of wild cattle, derives protection from its massive bulk, from its great, upward-curving horns, and from co-operative effort: when threatened, a herd will gather in a circle, facing outwards to form a laager. Hunters regard the buffalo as one of the most cunning and dangerous of game species; solitary males, exiled from the herd after losing a mating battle, can be especially aggressive and unpredictable and, if wounded, will hide in ambush.

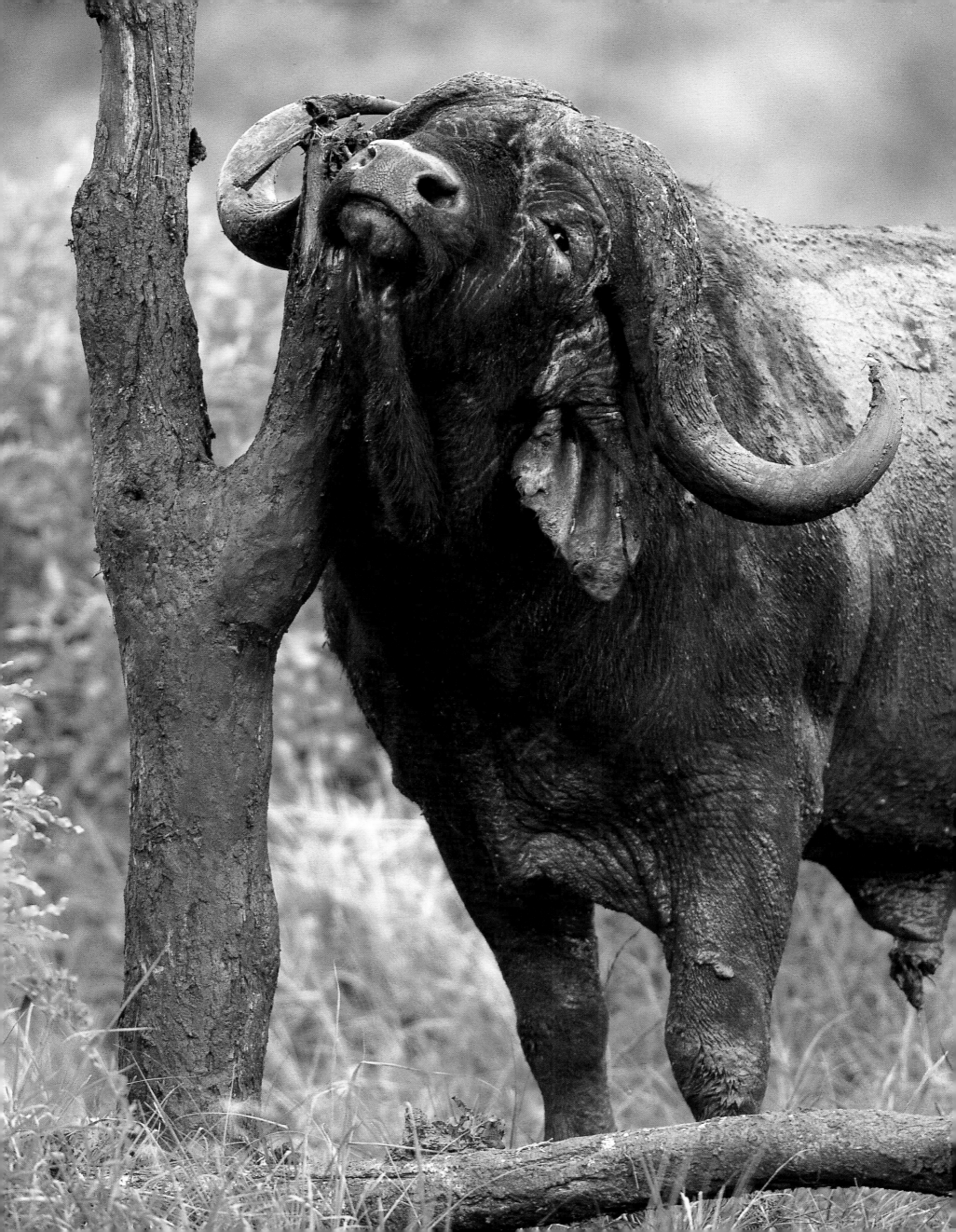

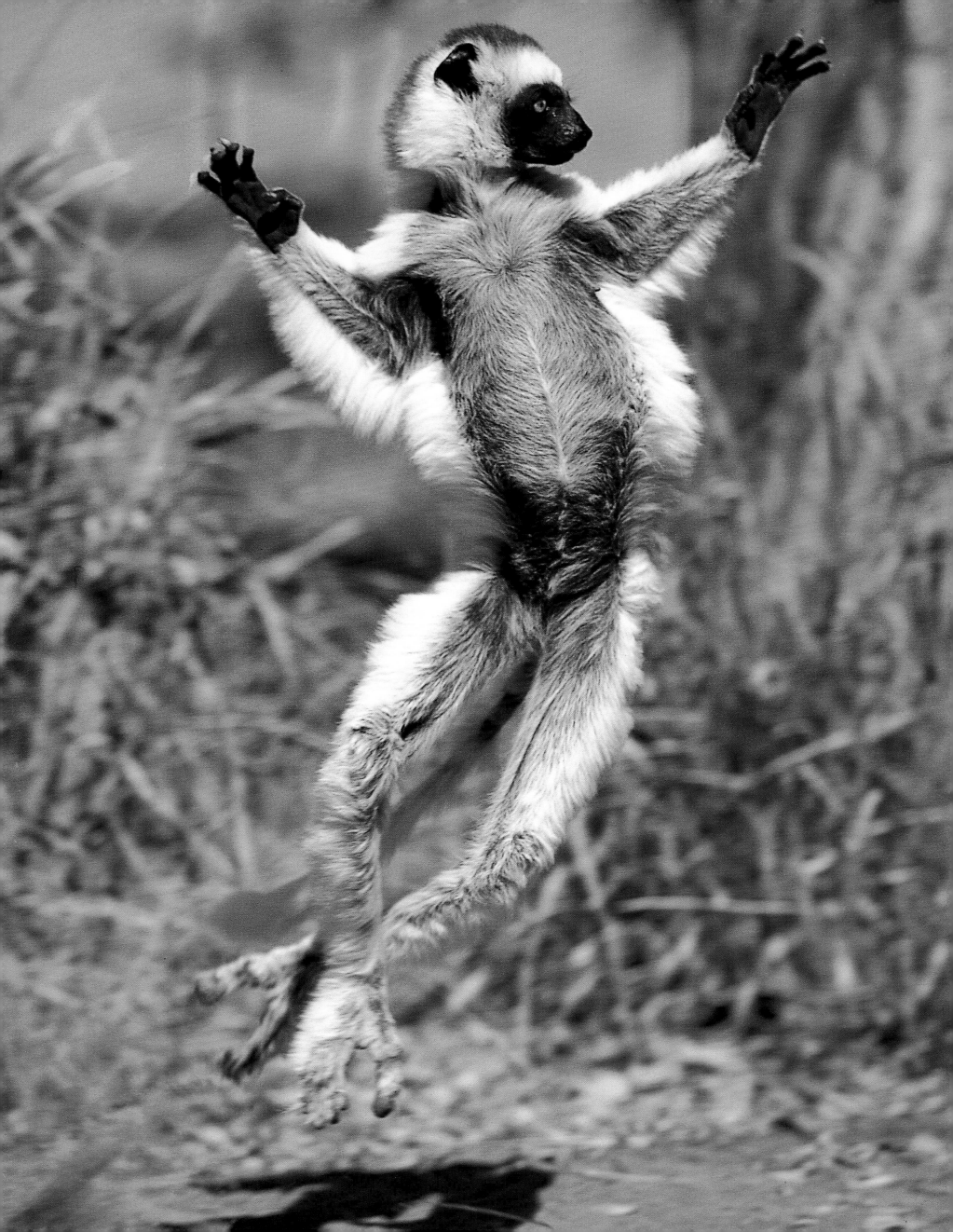

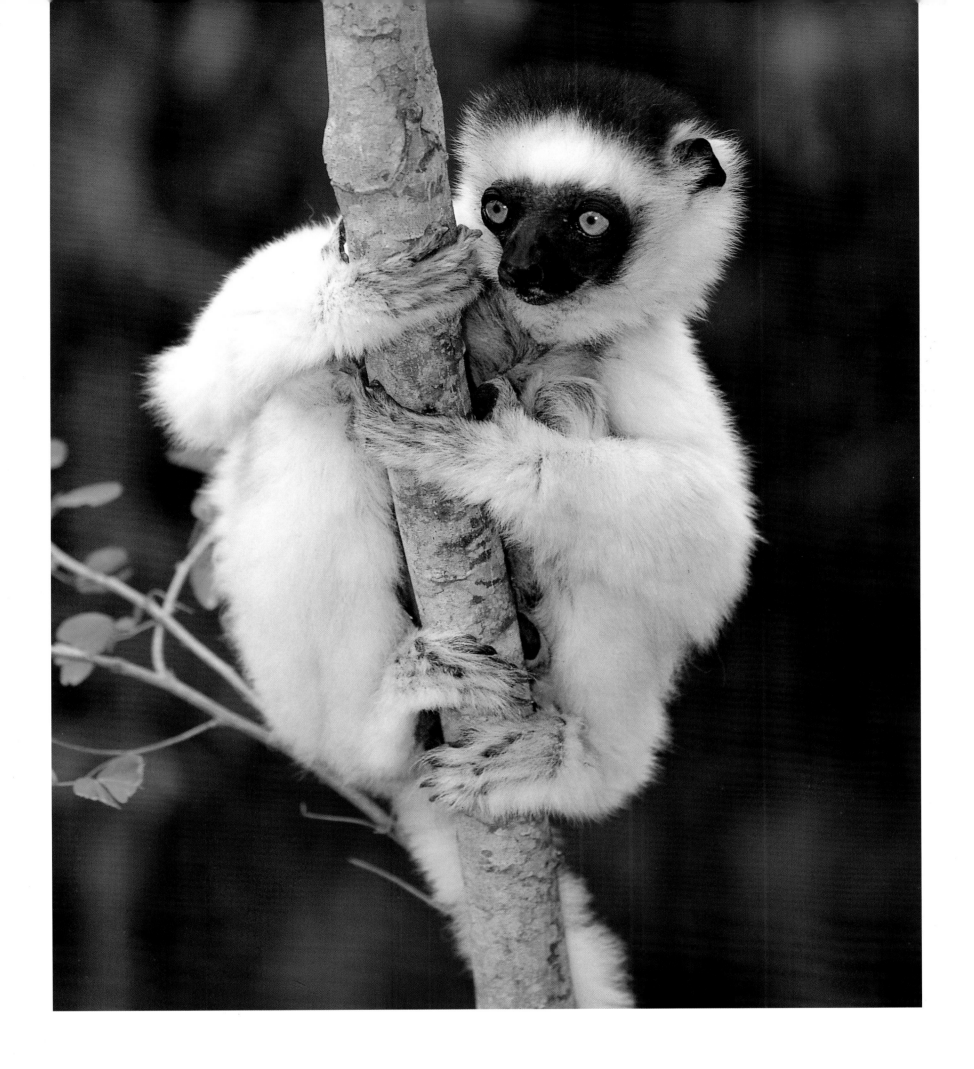

Prominent among Madagascar's lemurs is Verreaux's sifaka *Propithecus verreauxi* (above and opposite), a sprightly little animal renowned for its prodigious leaps. When the trees are too far apart for this means of locomotion, it descends to cover the ground in a peculiar, rather comical gait, a kind of 'dance-step' with arms waving up and down (opposite).

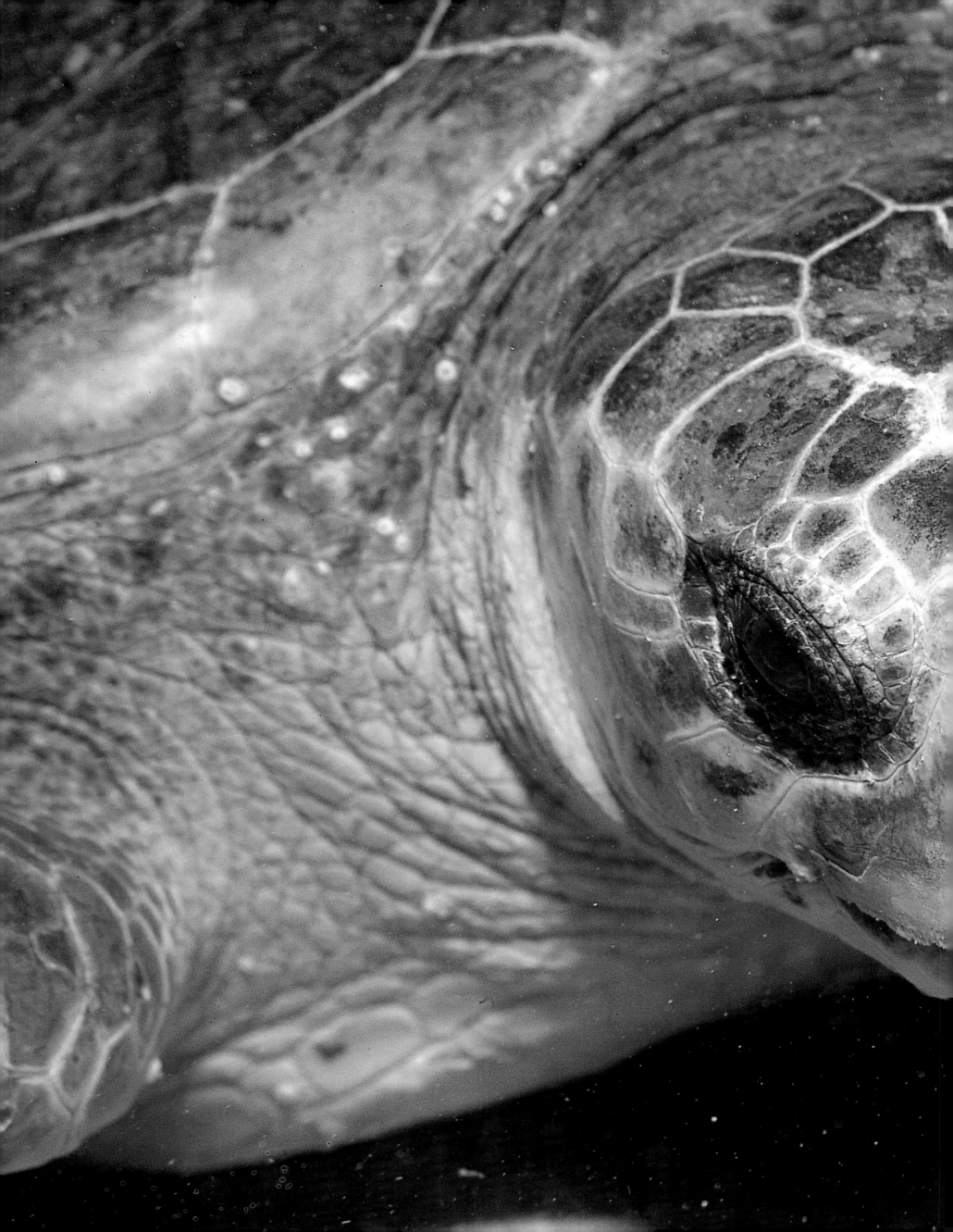

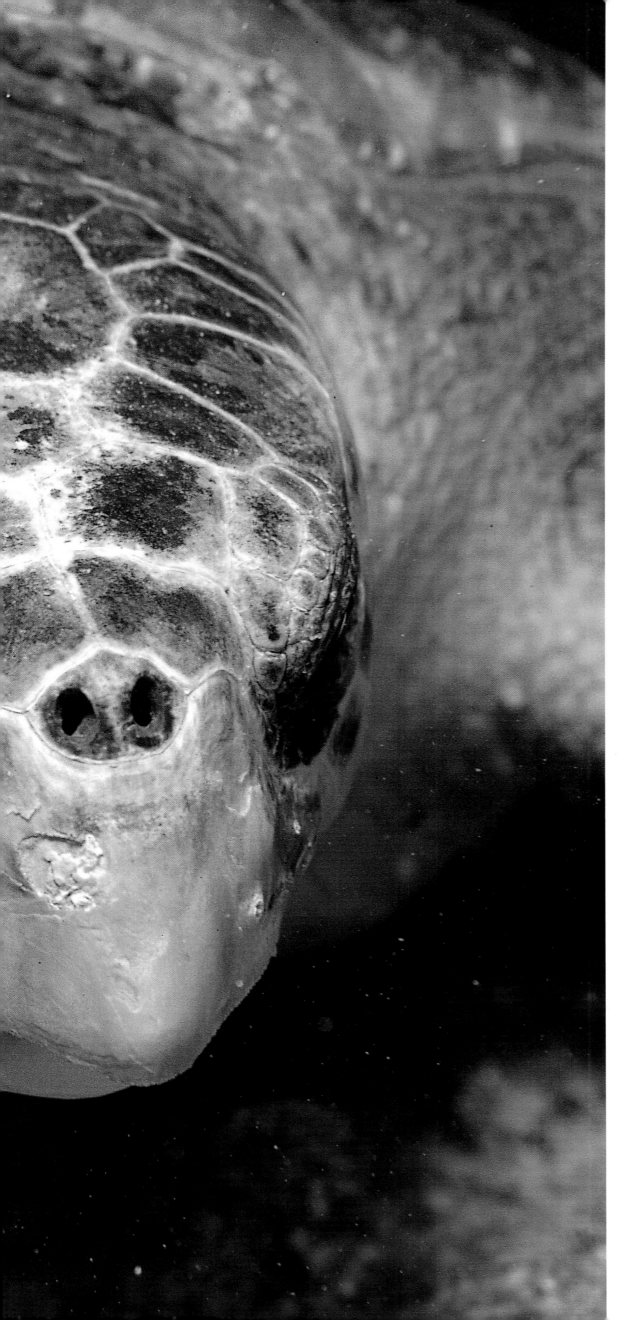

Save for their hard shells, the giant and gentle turtles – the leatherbacks *Dermochelys coriacea* and loggerheads *Caretta caretta* – of Africa's eastern coastal waters have little defence against the myriad predators of shore and ocean. Nevertheless they have survived, virtually unchanged in form and habit, for more than 100 million years. In recent times, however, they were brought to the verge of regional extinction by human vanity and greed: valued for meat, their eggs and the oil in their bodies, and as talismans and ornamentation, they were killed off in their thousands. A rescue programme, launched by the Natal Parks Board in the 1960s, has done much to ensure the future of the two species.

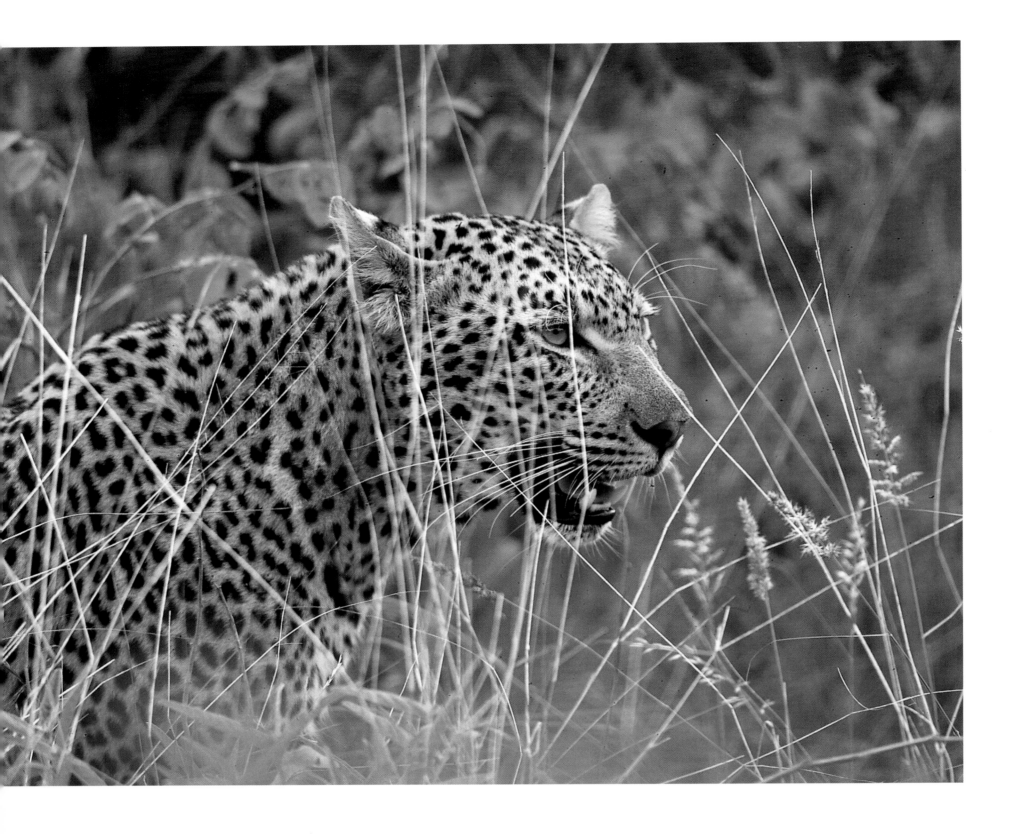

Of all Africa's larger predators, the leopard (above and opposite) is the only one to survive, if not thrive, outside the game parks and other protected areas. It has done so because it is a solitary animal, shy, elusive, wily enough to sidestep the human presence (it is still, occasionally, found on the outskirts of cities). A more important ingredient of its resilience, though, is its varied diet: it will take almost any warm-blooded prey, from field mouse up to young wildebeest. Moreover, its spotted coat provides effective camouflage in its chosen environment. The markings differ from region to region depending on the nature of the environment.

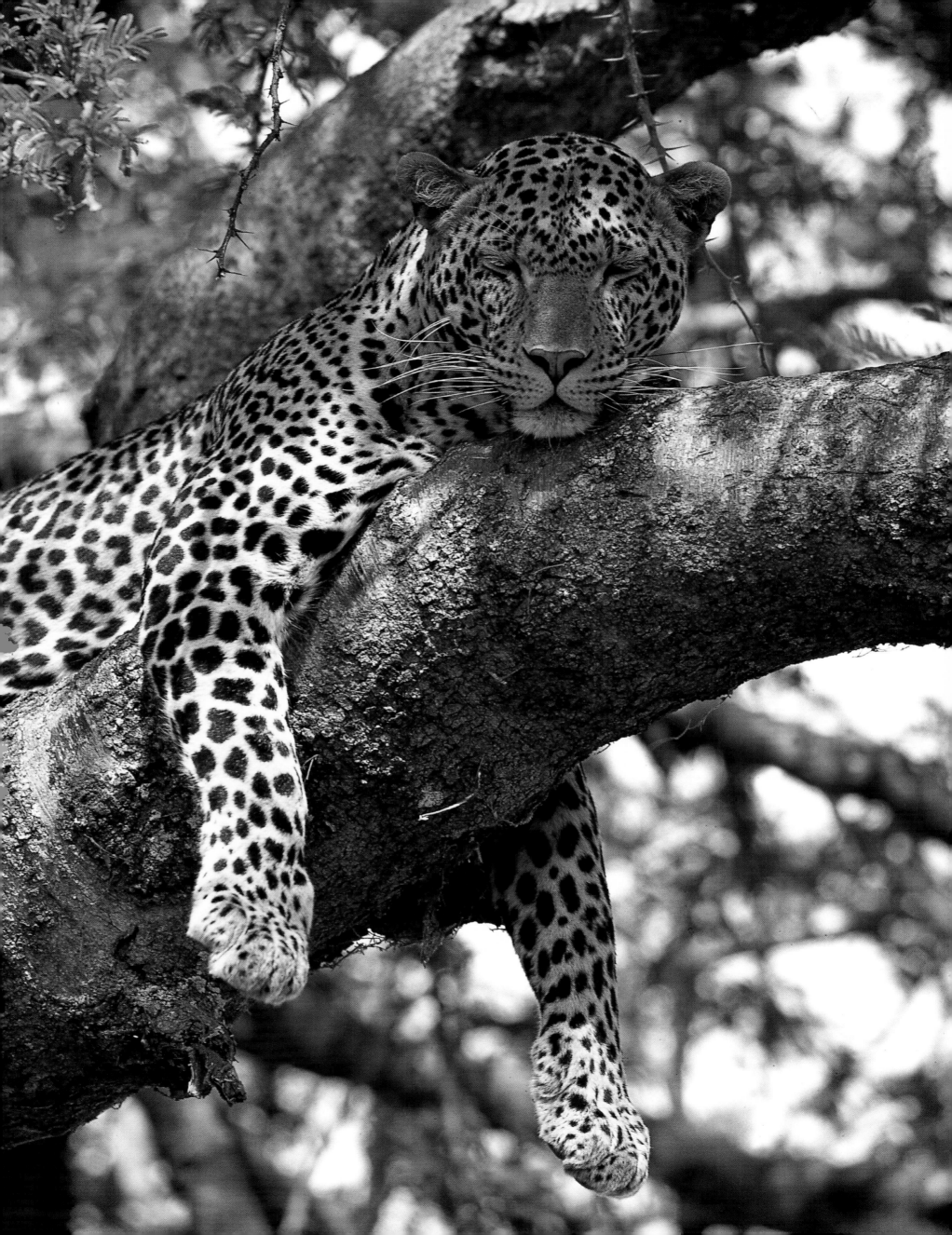

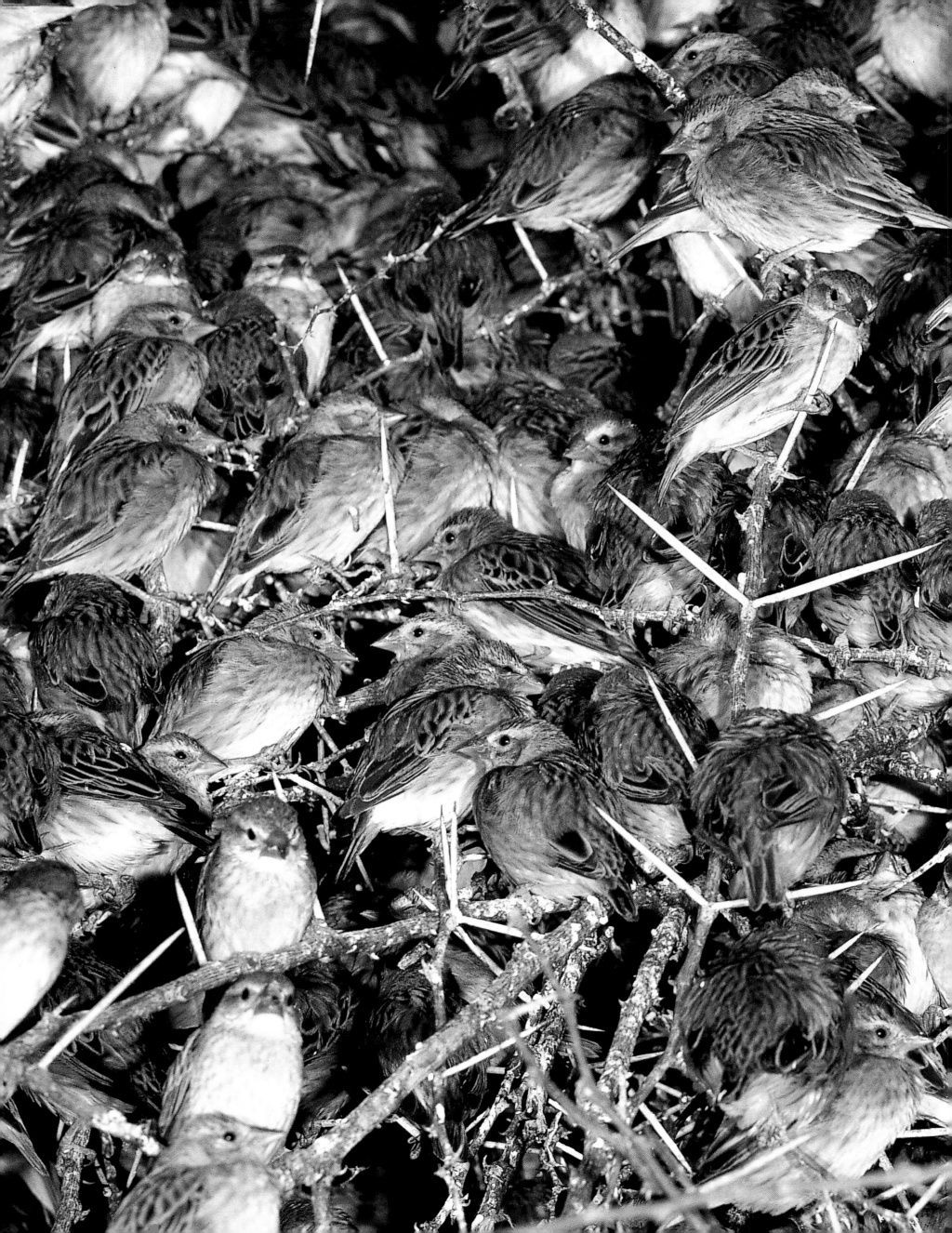

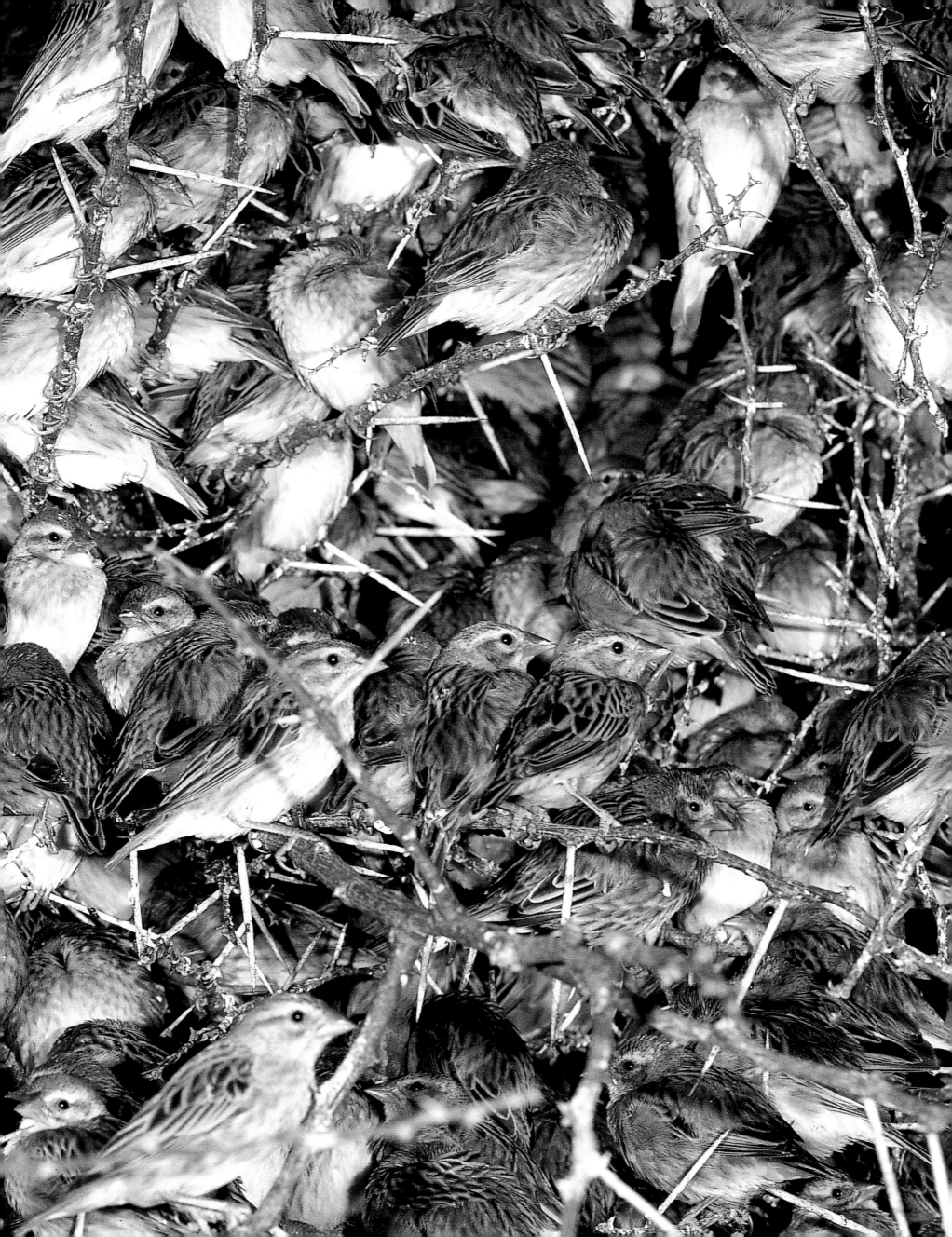

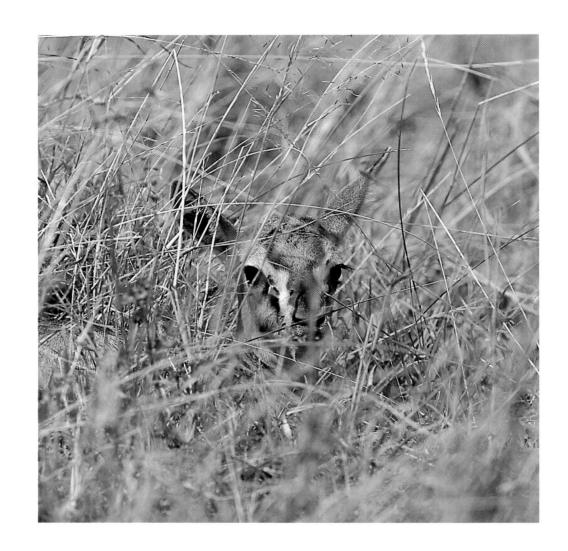

*P*revious pages: sheer numbers ensure the survival of the red-billed quelea *Quelea quelea*. The tiny bird congregates in its hundreds of thousands; from a distance the airborne flock often looks like a drifting cloud of smoke.

*T*aking cover. Right: a newborn Thomson's gazelle *Gazella thomsoni* hidden in the long grass of Kenya's Masai Mara Reserve. Below: a male reedbuck *Redunca arundinum* blends into its wetland surrounds. Opposite: eland *Taurotragus oryx* in the grasslands of KwaZulu-Natal, South Africa.

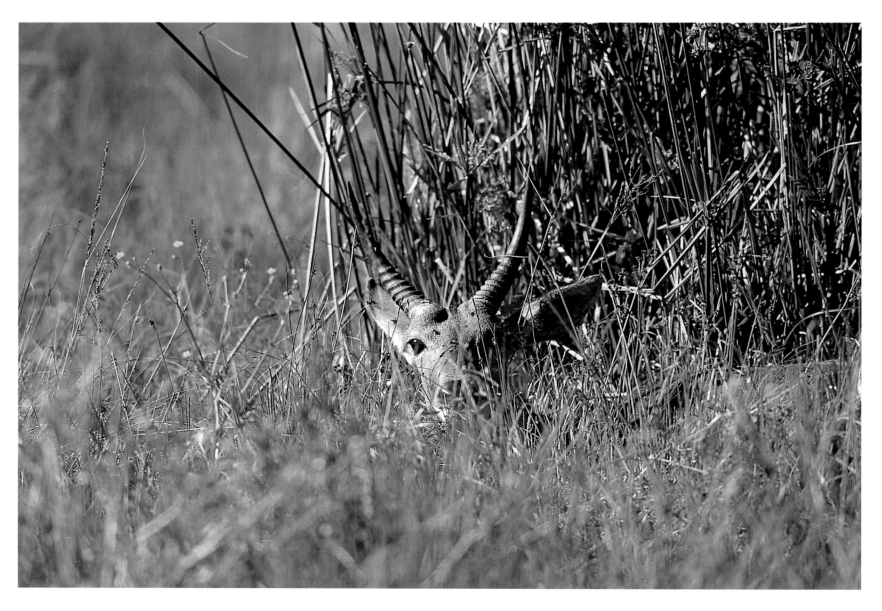

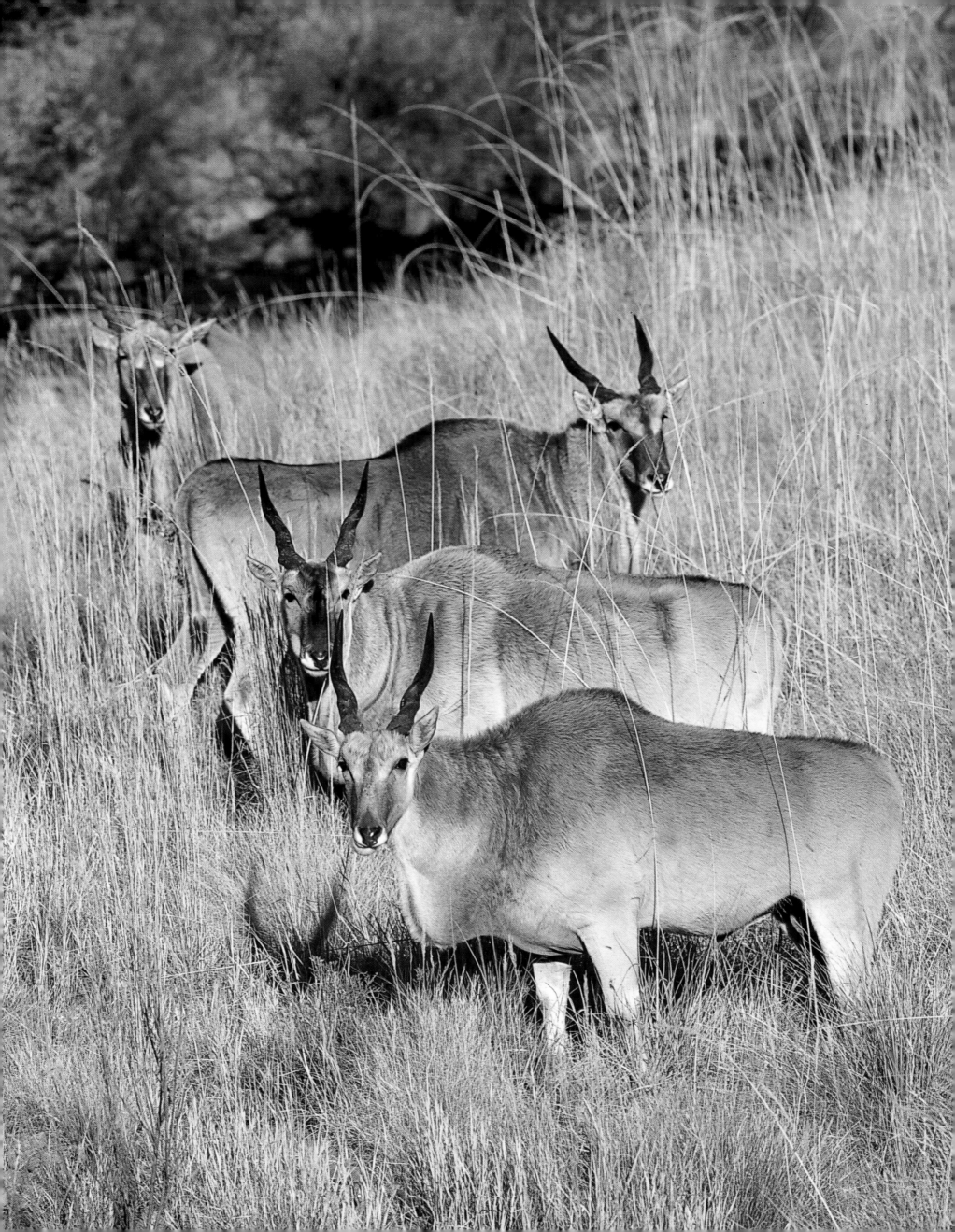

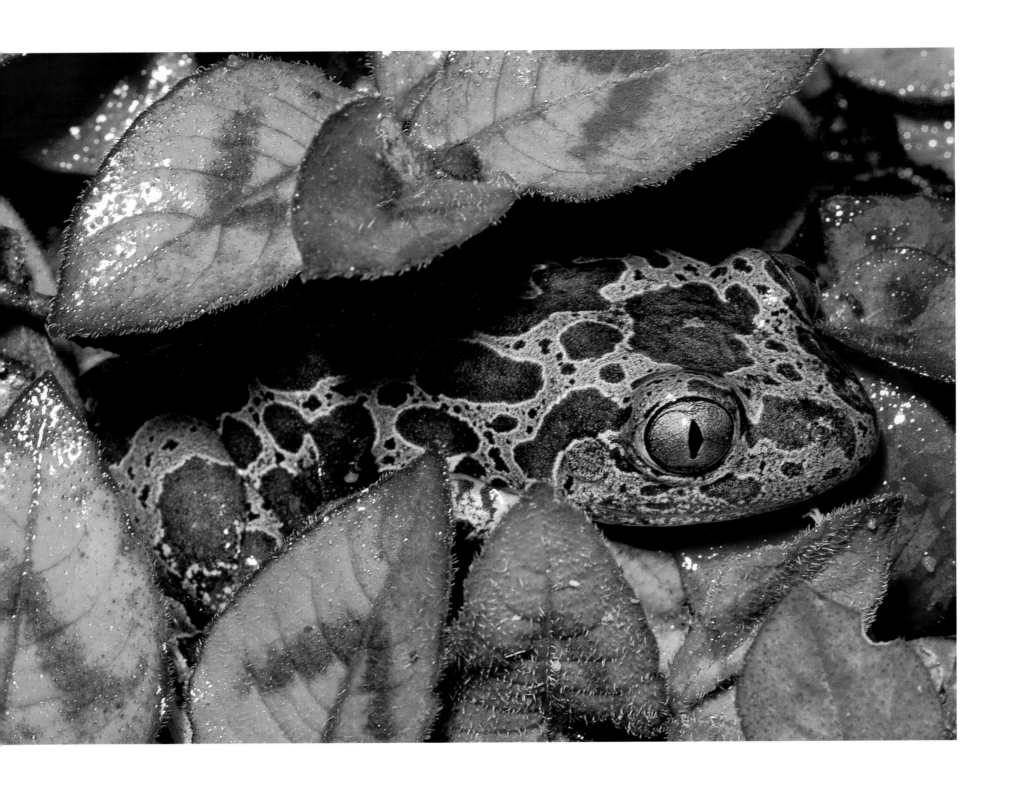

\mathscr{T}he red-legged kassina *Kassina maculata*, one of the often brilliantly coloured Hyperoliidae frog species that occupy a variety of habitats in subSaharan Africa. This one, which hides under the moist ground cover during the daytime, is found in the tropical and subtropical wetlands of southern Africa's eastern parts.

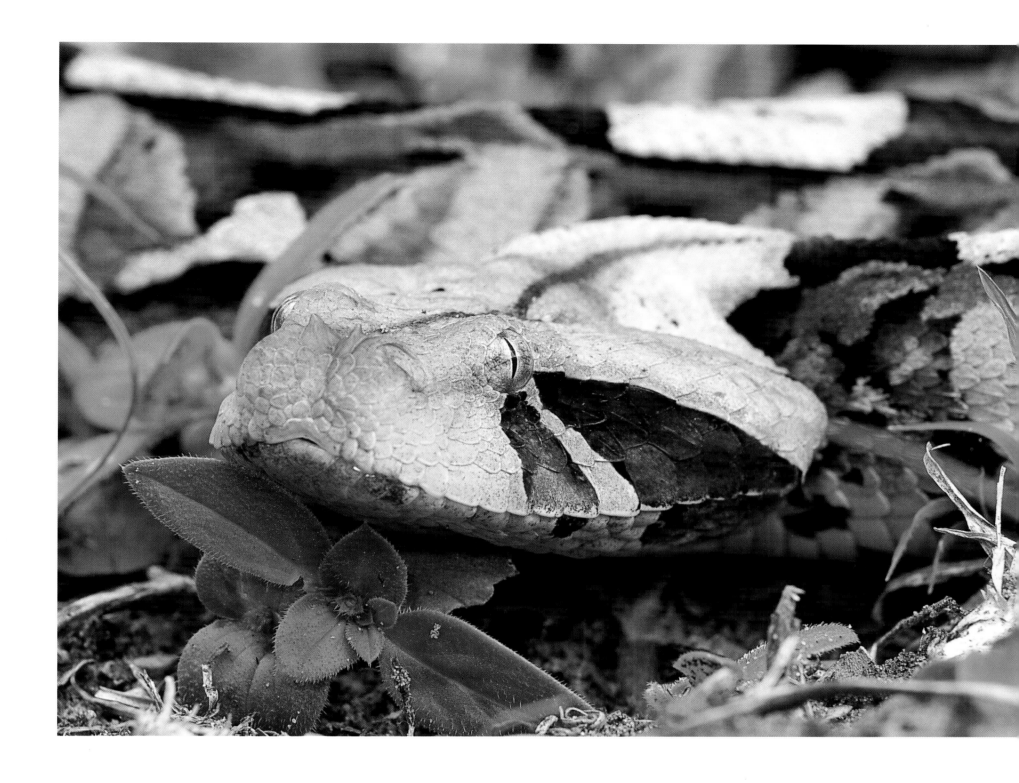

The gaboon adder, distinguished by its complex coloration, its flat, triangular head and two nasal 'horns', is armed with huge fangs filled with a lethal cytotoxin – a poison that destroys the body's cells. The males of the species will fight each other for dominance and the right to mate with the females.

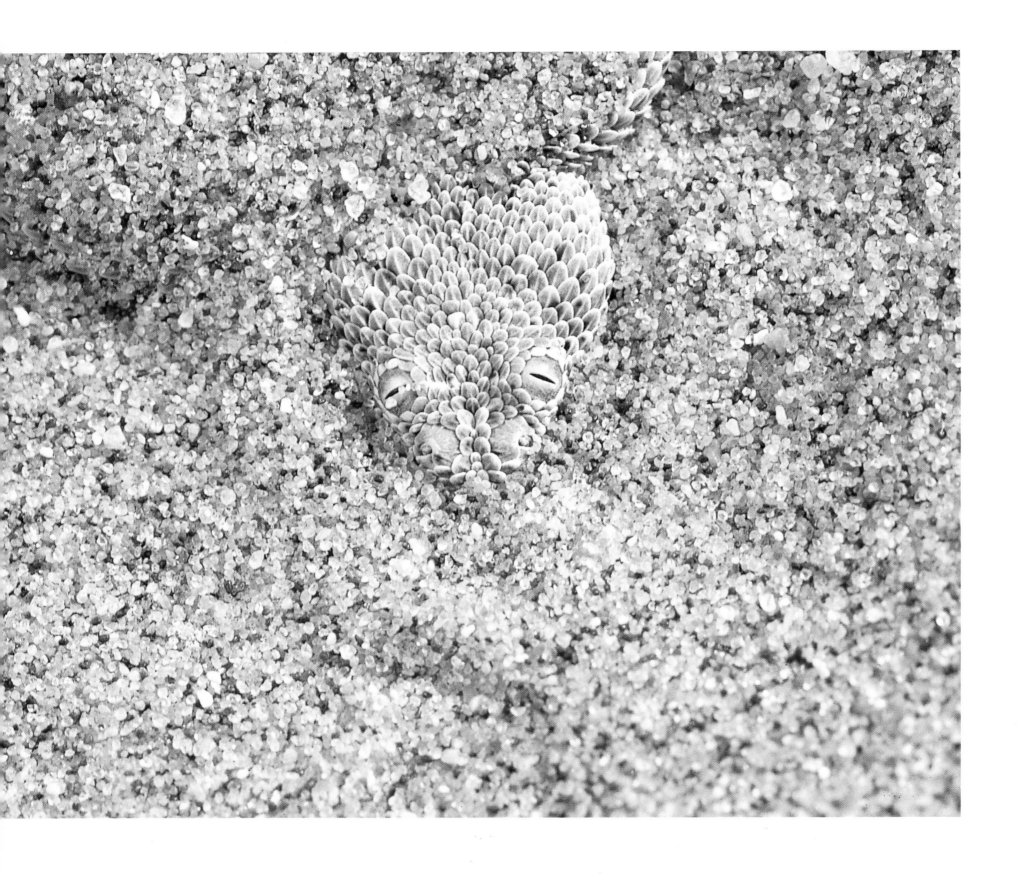

𝒜 side-winding Péringuey's adder (above), half hidden in and almost indistinguishable from the dune-sand of the Namib, lies in ambush for the small vertebrates it feeds on. For moisture, it drinks the droplets formed by desert fogs which roll in from the Atlantic, that condense on and run off its body. Opposite: the large, diurnal hawk- or sphinx-moths, of the family Sphingidae, are masters of disguise, their wing coloration matching that of the tree trunks on which they settle.

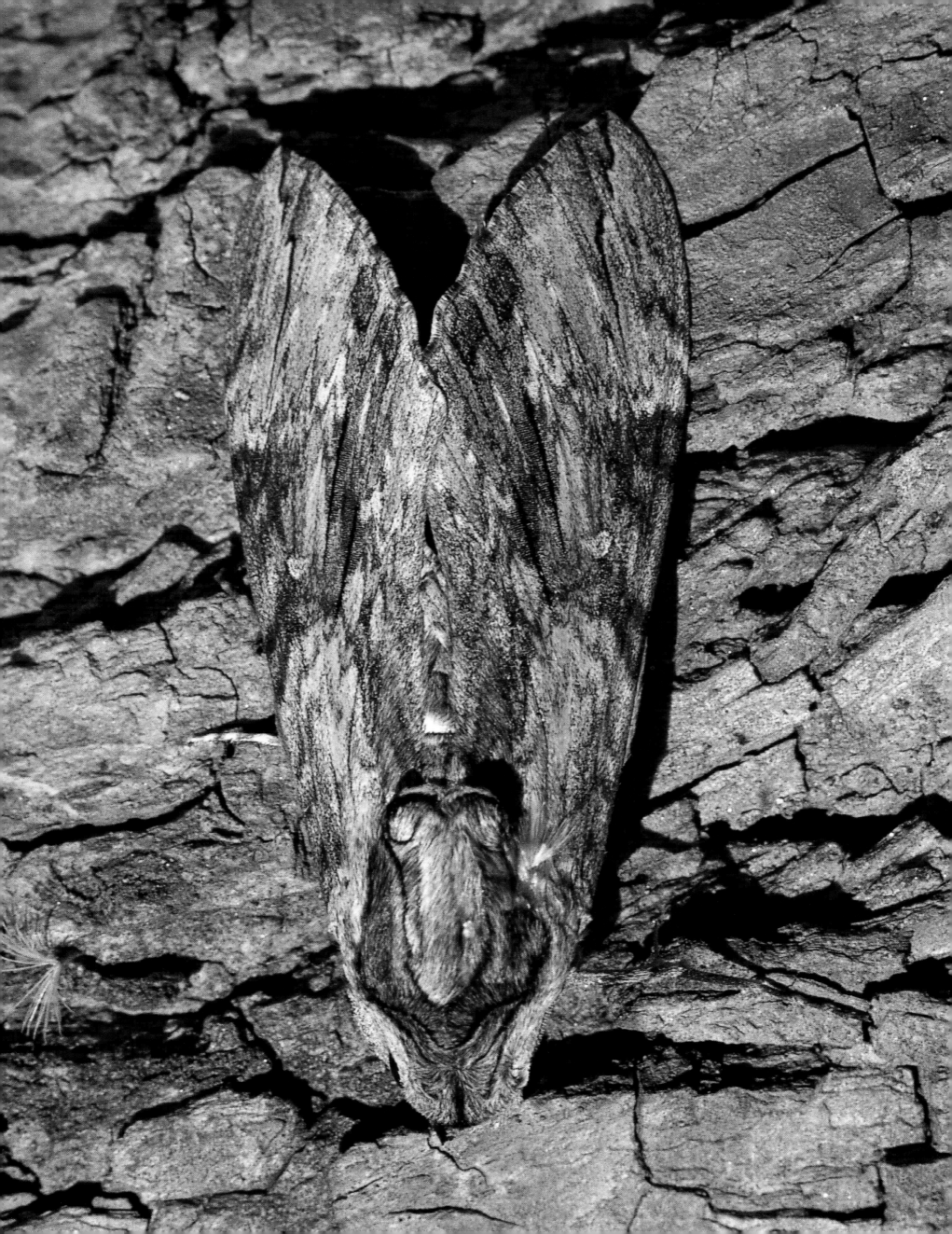

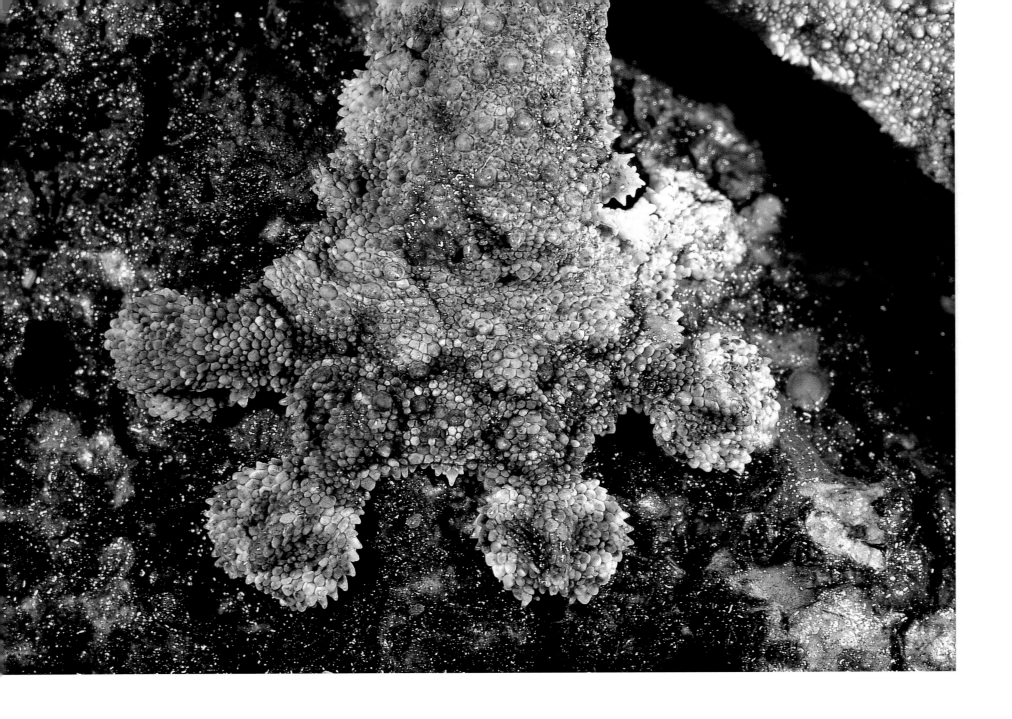

\mathcal{T}he Madagascar leaf-tailed gecko *Uroplatus fimbriatus* (above, and opposite, top), a resident of the island's natural forests, is superbly camouflaged against the tree trunk on which its spends its day. The disguise is enhanced by the ragged, splayed border of skin along the underside of its body, which helps blend its outline into the rough bark. More than that, it is capable of changing colour in a matter of seconds (if, for instance, it is disturbed and has to move) to match a new background. When threatened, it will raise its tail and head, and open wide its scarlet-tongued mouth, to transform itself into a fearsome little dragon.

\mathcal{T}he tree agama *Agama atricollis* (opposite, bottom) is a large arboreal lizard that avoids danger by quickly disappearing to the other side of its tree trunk, but is an inquisitive creature and will soon re-emerge, peering around the corner to see what is happening. It too can take on different hues, though not as dramatically as the leaf-tailed gecko.

\mathcal{A} mud bath cools the elephant (overleaf) and helps protect its hide against the scorching African sun.

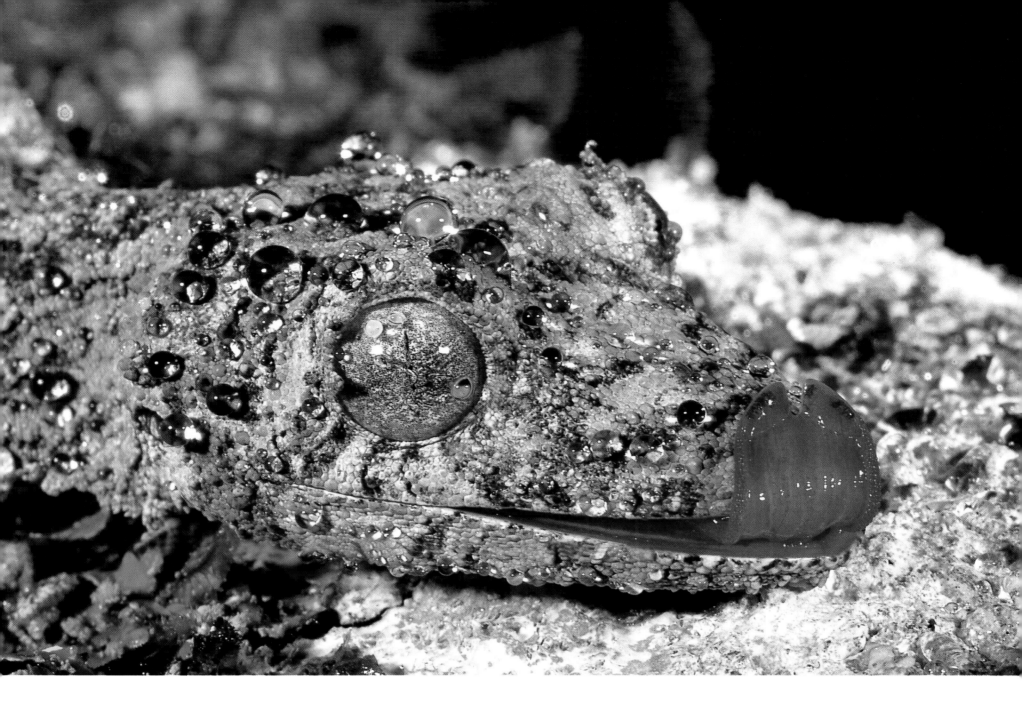
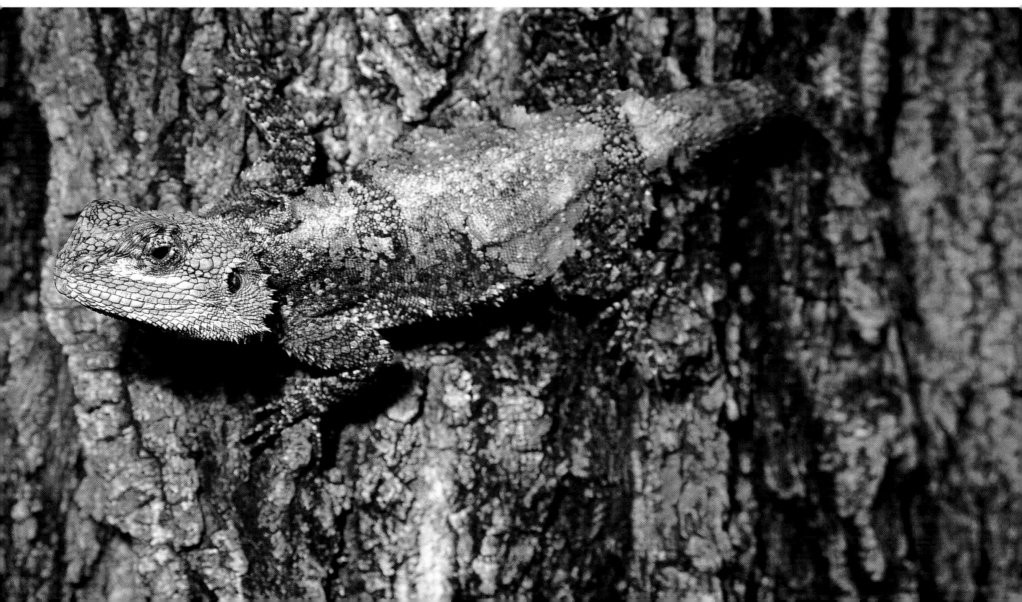

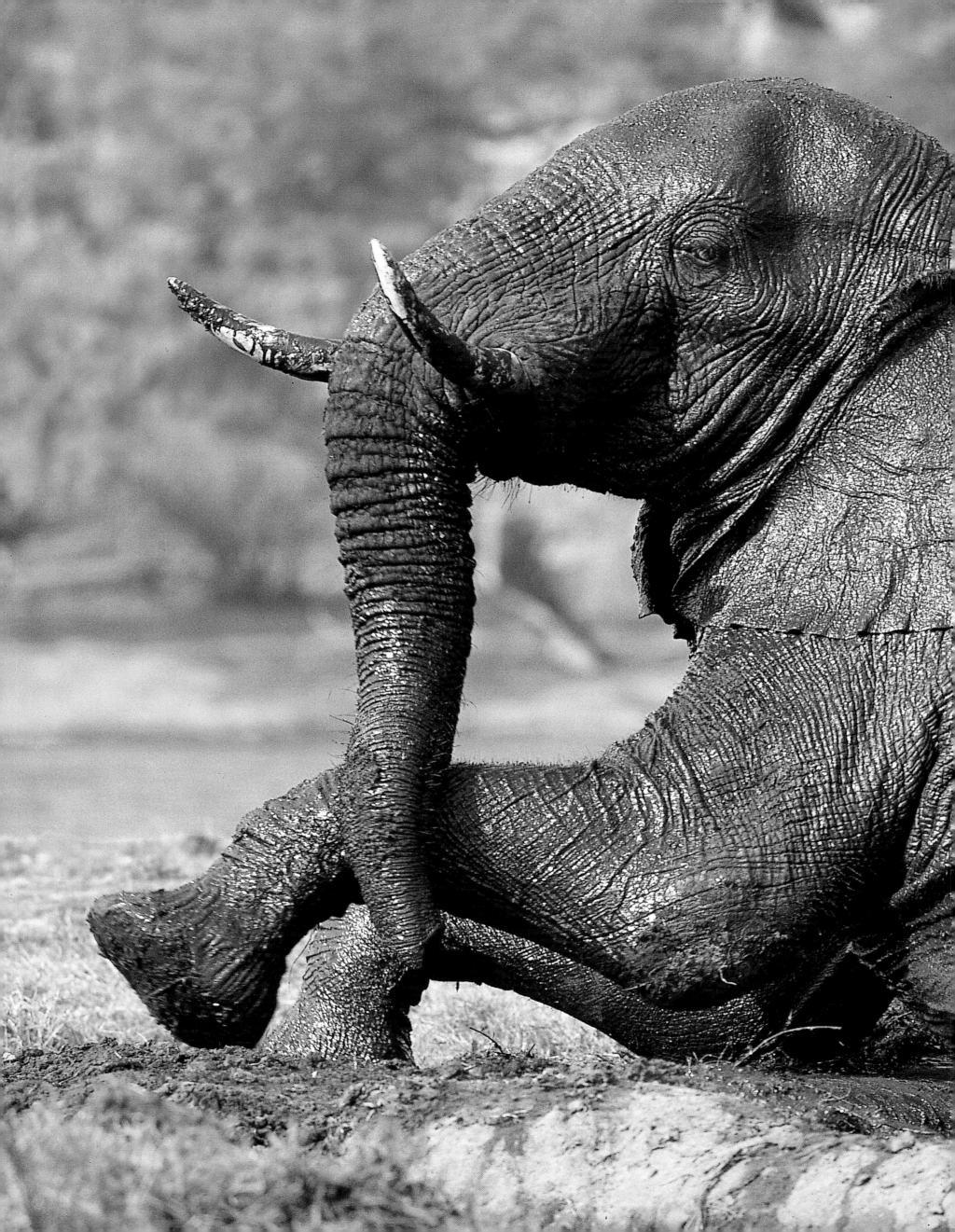

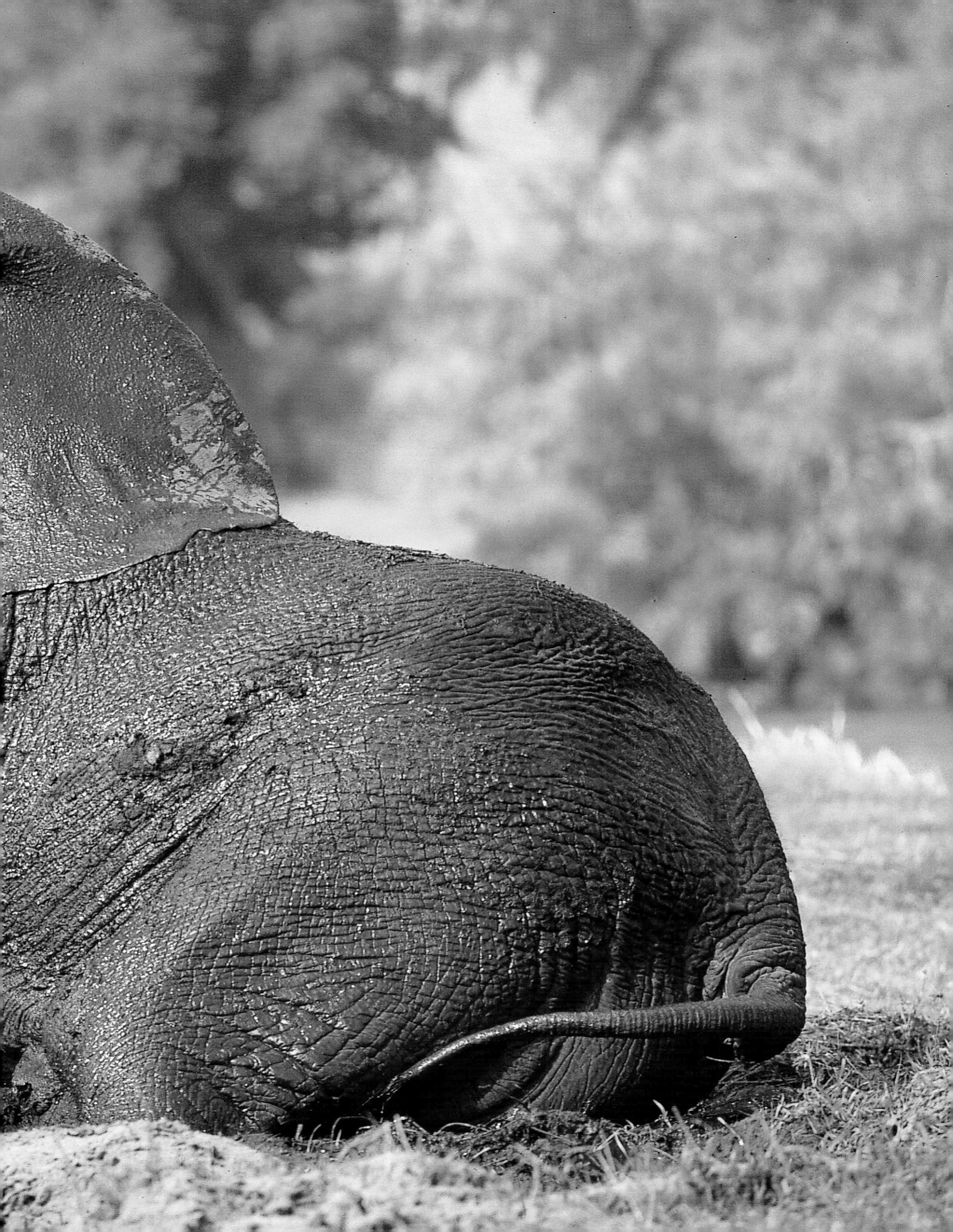

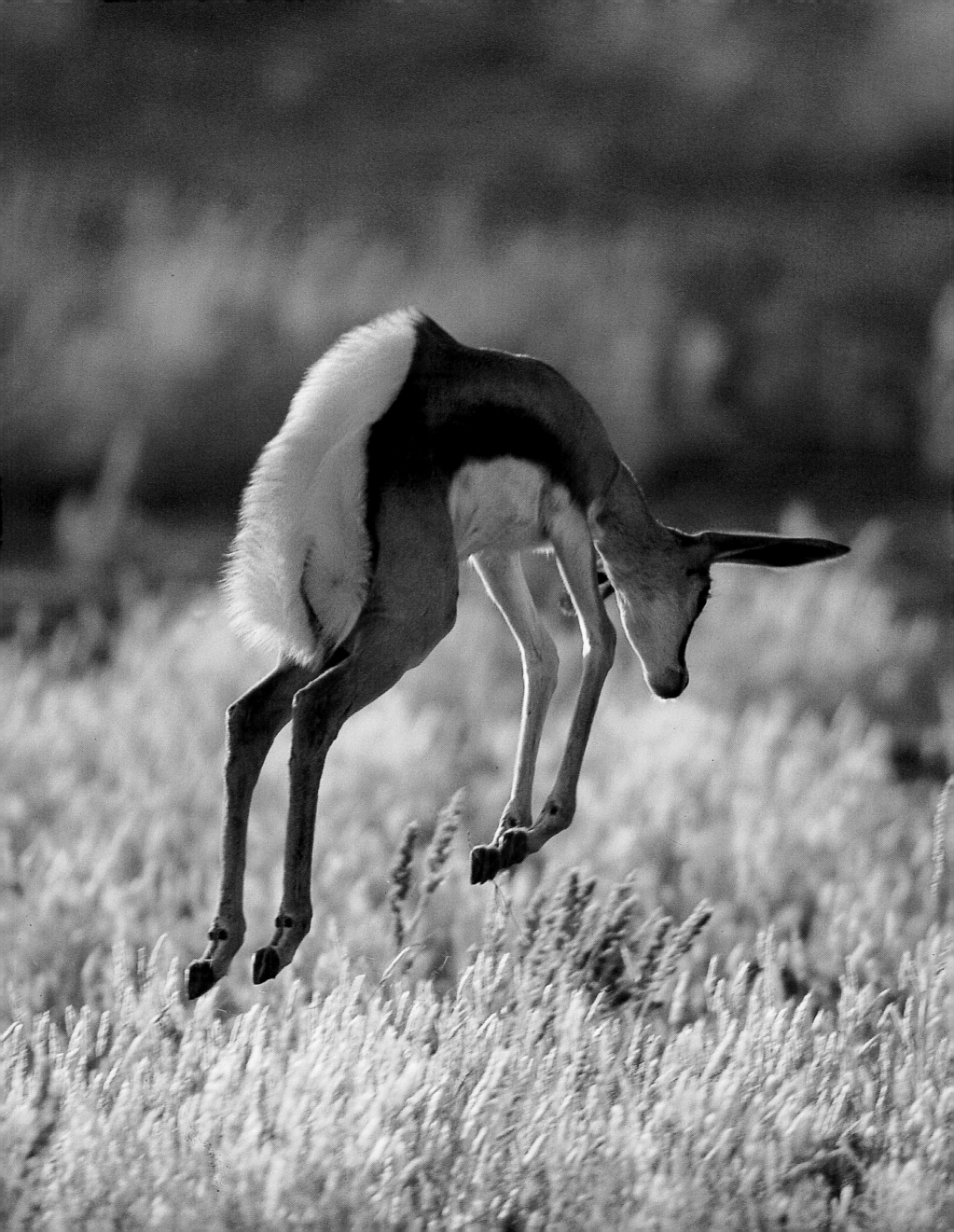

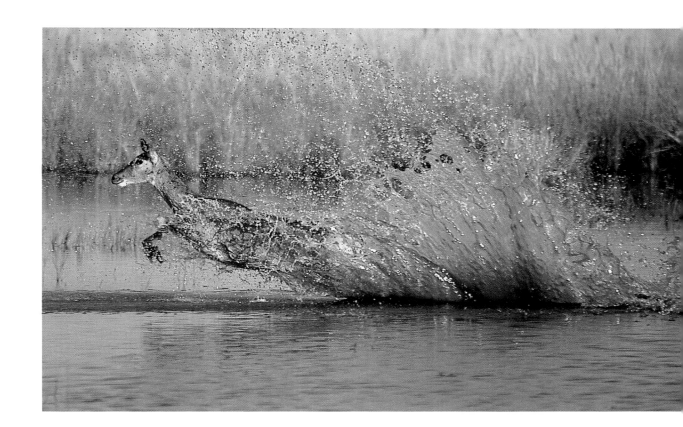

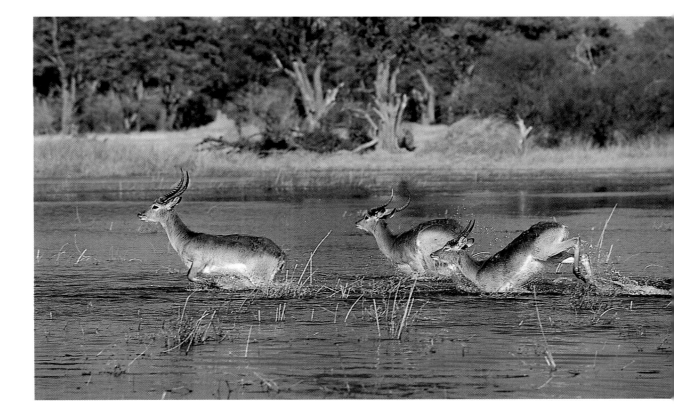

The springbok's most distinctive defensive behaviour is its dance-like 'pronking' (left), in which it springs across the veld, with legs held stiff, head lowered, white rump fluffed out, in a series of high leaps. The dynamic, however, remains something of a mystery. Simple escape can be ruled out, but the leaps could confuse a carnivore used to taking its prey on the ground; and a group of antelope all pronking together might make it difficult for a pursuer to select a single target. The white rump also acts as a warning signal.

Two semi-aquatic antelope of Botswana's Okavango wetlands, the puku *Kobus vardoni* (top) and the red lechwe *Kobus leche* (above), take flight to safety in their natural element.

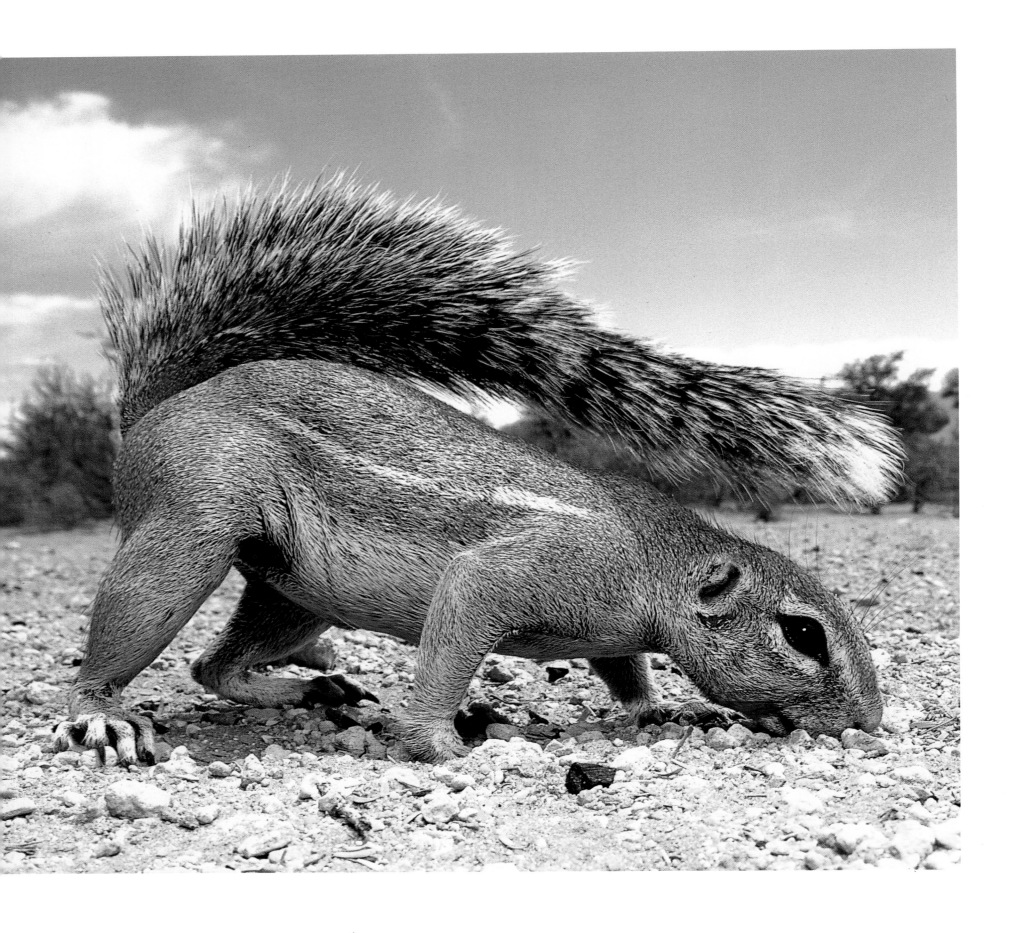

\mathscr{A}mong the ground squirrel's *Xerus inaurus* defences against the burning sun is its bushy tail, which serves as a built-in parasol. The tail is waved in a gentle arc above head and body to provide shade, and this lowers the squirrel's temperature by a couple of degrees, enabling it to forage for longer periods than other animals competing for the same food.

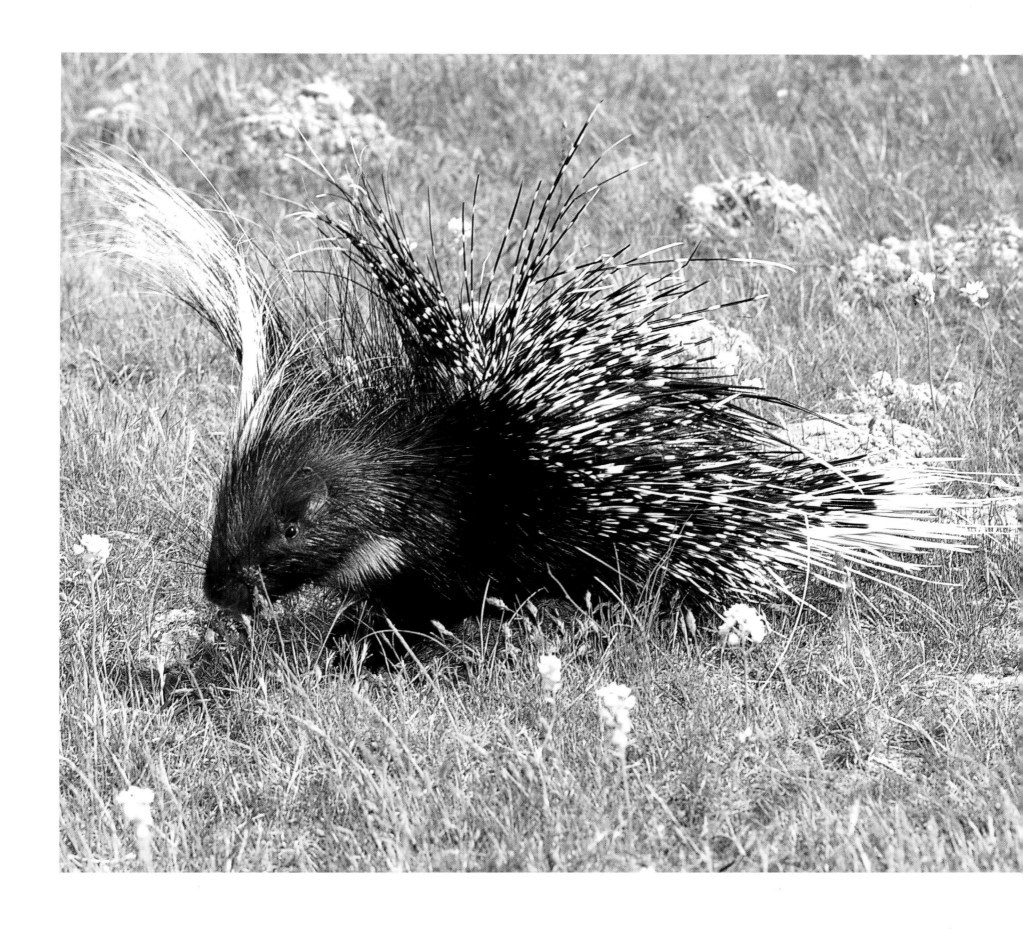

The southern or Cape porcupine's banded quills and spines (above) are in fact modified hairs, which the animal (a rodent) raises when angry or threatened – a reaction that greatly increases its apparent body size. Contrary to popular belief, the quills are neither barbed nor poisonous, and are not ejected.

Overleaf: two Nile crocodiles lie with mouths agape, behaviour designed to help dissipate body heat.

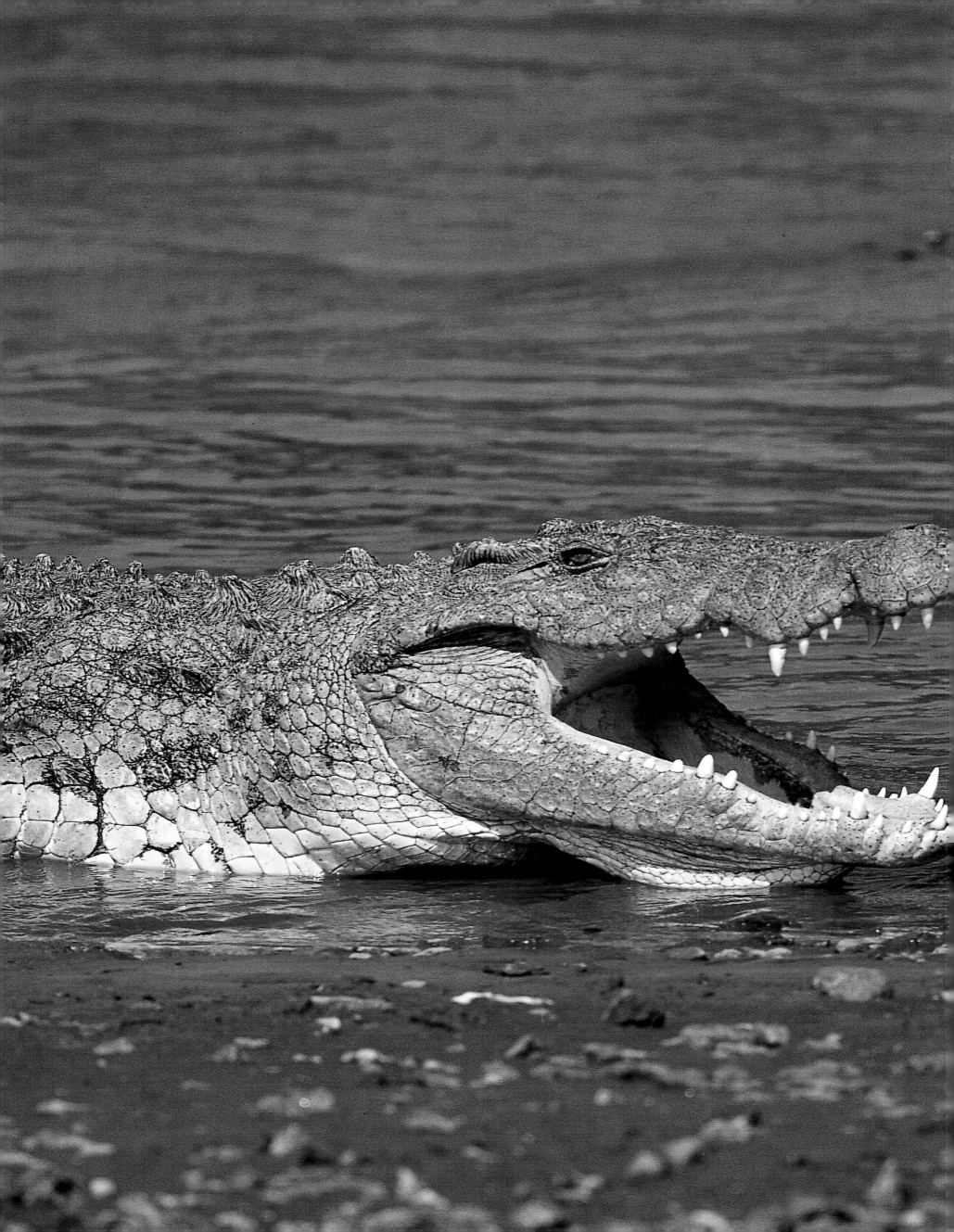

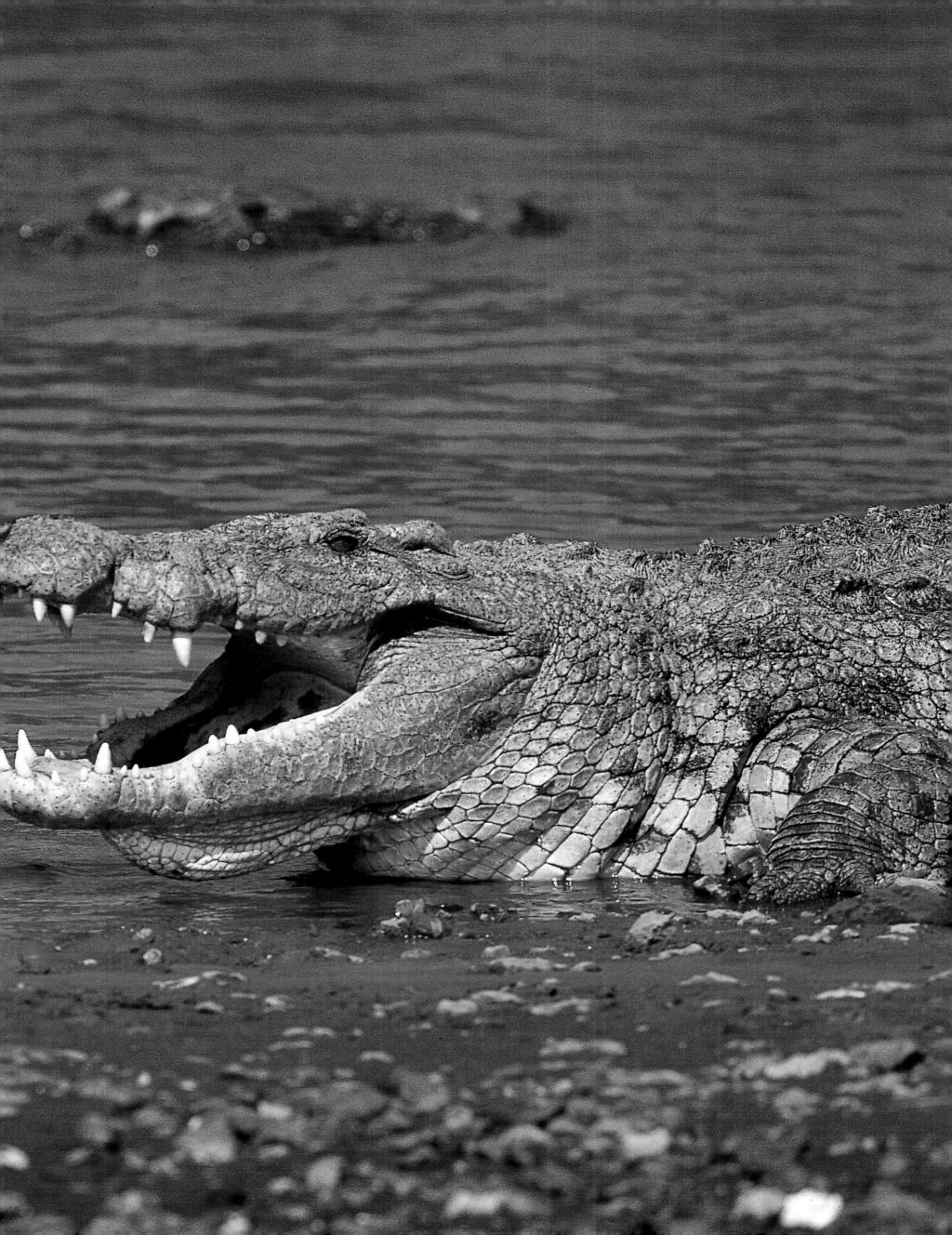

ANIMAL SOCIETY

The African wild dog is among the most social of animals: it lives and hunts as a pack, which embodies an elaborate ranking system defining the seniority of every member from alpha female (who is the only one allowed to mate) down to the lowliest juvenile; individual needs are sacrificed to the wellbeing of the clan as a whole. The species is unusual for its tightly knit group persona, but a great many other creatures congregate and, in their own way, co-operate just as efficiently: antelope, zebra and elephant in herds, lions in prides, birds in flocks and colonies of thousands, ants and termites in communities numbering millions.

The reasons why one life form associates closely with its own kind and another remains solitary, differs from species to species, but generally speaking the degree of sociability depends, first, on the type of food an organism eats and, second, on the kind of enemies it has. Within these two primary dynamics, though, there is huge variation, for each species has developed its own, complex modes and manners to ensure collective survival.

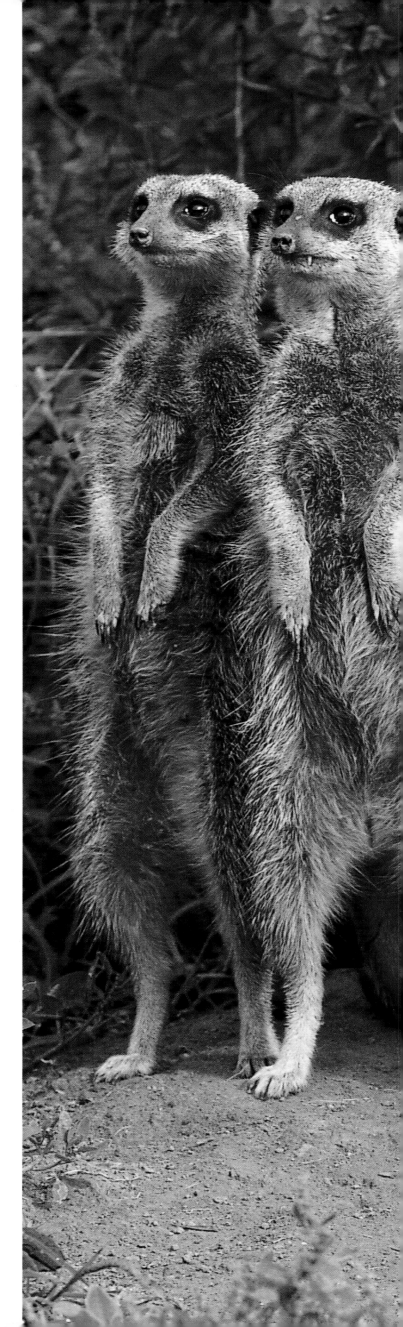

The pixie-faced suricate, or meerkat (right), is a member of the viverrid group that embraces all the mongooses. These little animals live in groups of 30 or so, in underground burrows. Meerkats are remarkably co-operative in all they do. Foraging parties, for example, appoint one of their number as a sentry to keep watch while the others busy themselves gathering food. And when a dominant female gives birth, one of the less important females stays behind to look after the offspring.

132

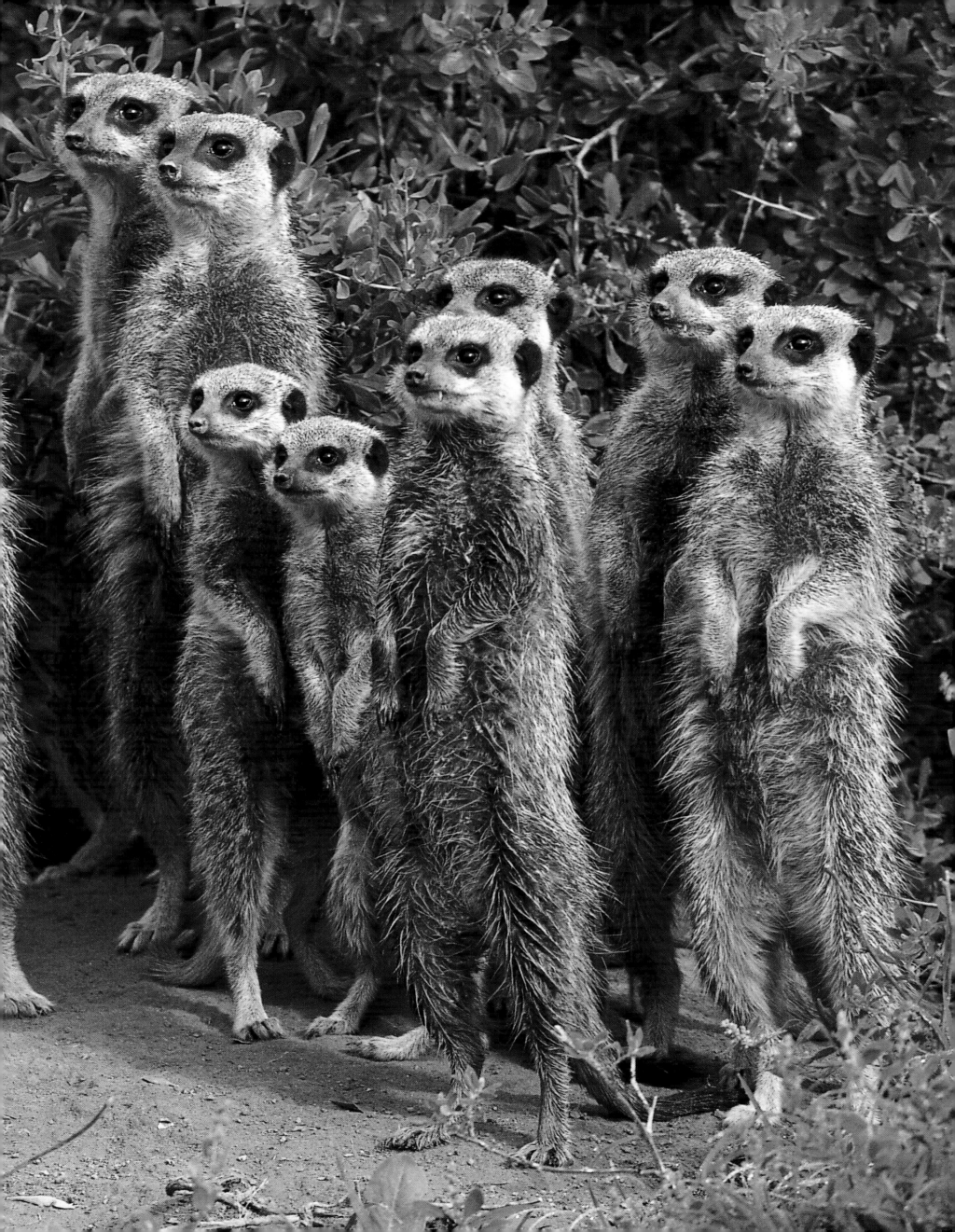

\mathcal{O}utside the breeding season the spurwinged goose *Plectropterus gambensis* (right) is one of Africa's more gregarious birds. It frequents the watery areas – especially floodplains and marshes – that border on grasslands. Rock pigeons *Columba guinea* (below) are commonly found in flocks of up to 20; much larger groups collect at feeding bonanzas.

\mathcal{A} wattled crane *Grus carunculatus* (opposite) preens itself. These elegant birds generally prefer walking to flying; in the northern parts of sub-Saharan Africa they can be seen in flocks of 400 and more.

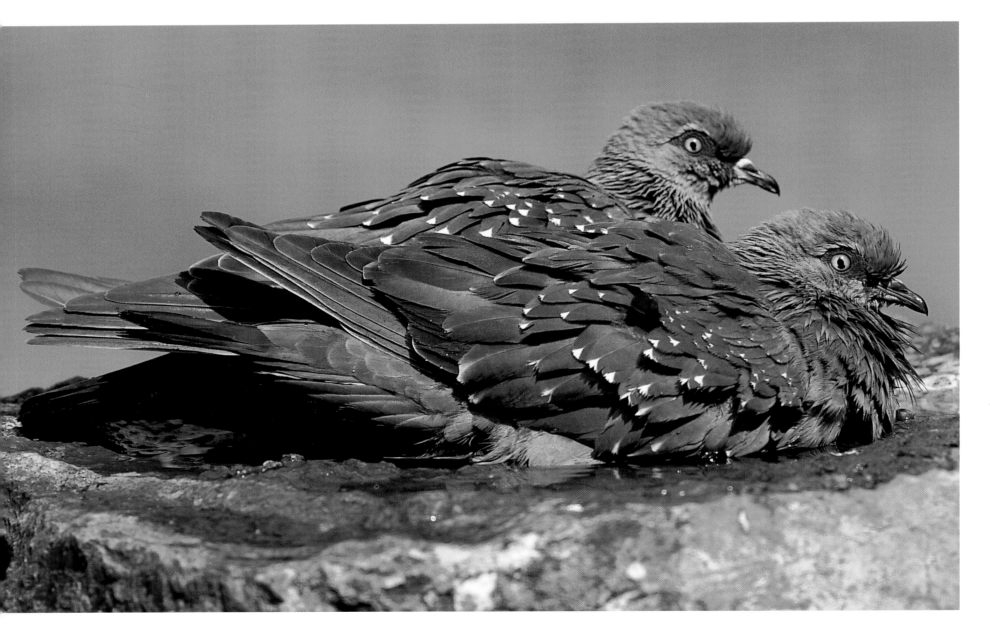

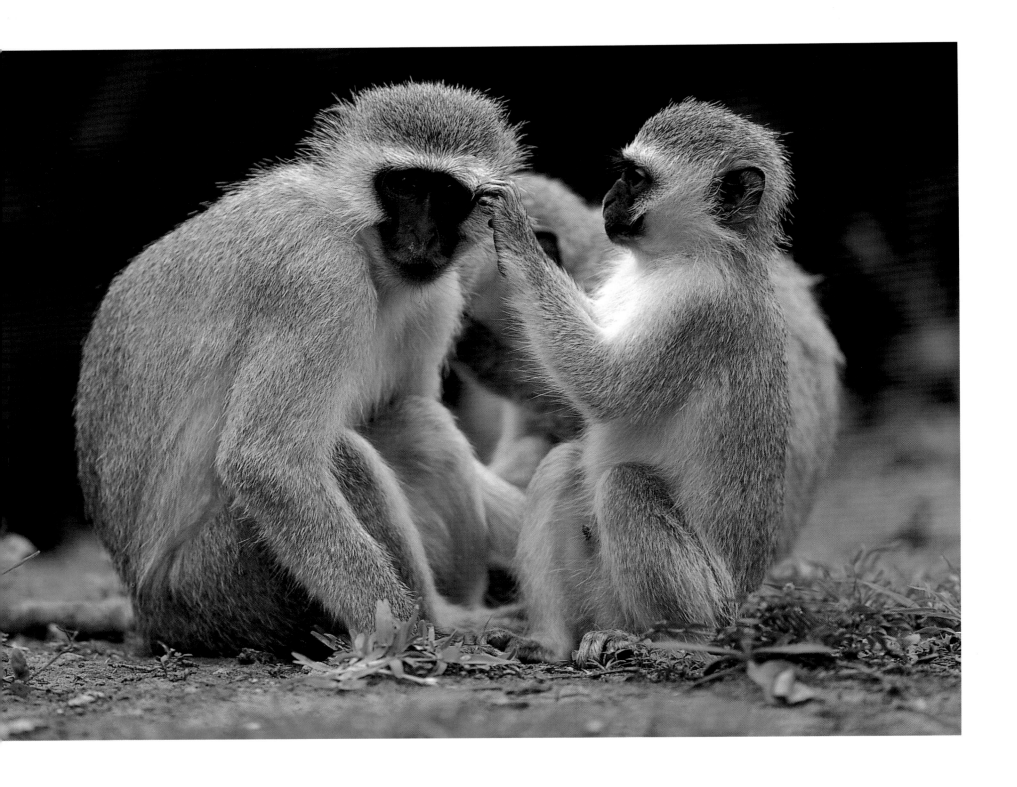

The ubiquitous little vervet or green monkey *Cercopithecus aethiops*, found in the moister areas of Africa south of the Sahara, lives on the forest edges in groups of up to 20, sometimes more. They forage among the trees during the daytime, sleeping in the branches at night. Each group has a well-defined 'pecking order' of dominant and submissive males; females form coalitions to compete with other females and the larger males; grooming (above) is an important element in alliances.

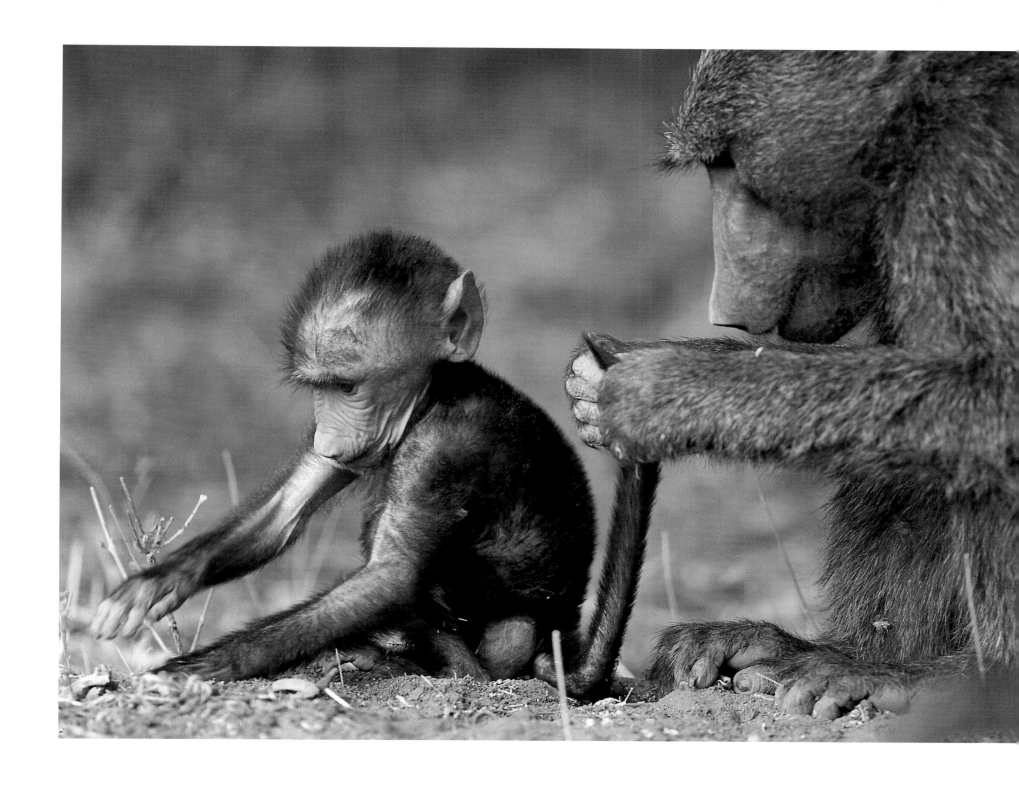

The social order within a troop of chacma baboons is as strictly regulated as, or perhaps even more so than that of the vervet monkeys. The mixed troop averages around 40 members, and all its adult males (those more than five years old) enjoy dominance over all its females. Only the senior male may mate with females who are in oestrus, although the subordinates – sometimes known as 'lieutenants' – will copulate with young and non-oestrus females.

Elephant on the move (overleaf). Free-ranging herds are becoming increasingly rare; most of the animals are restricted to the larger protected areas.

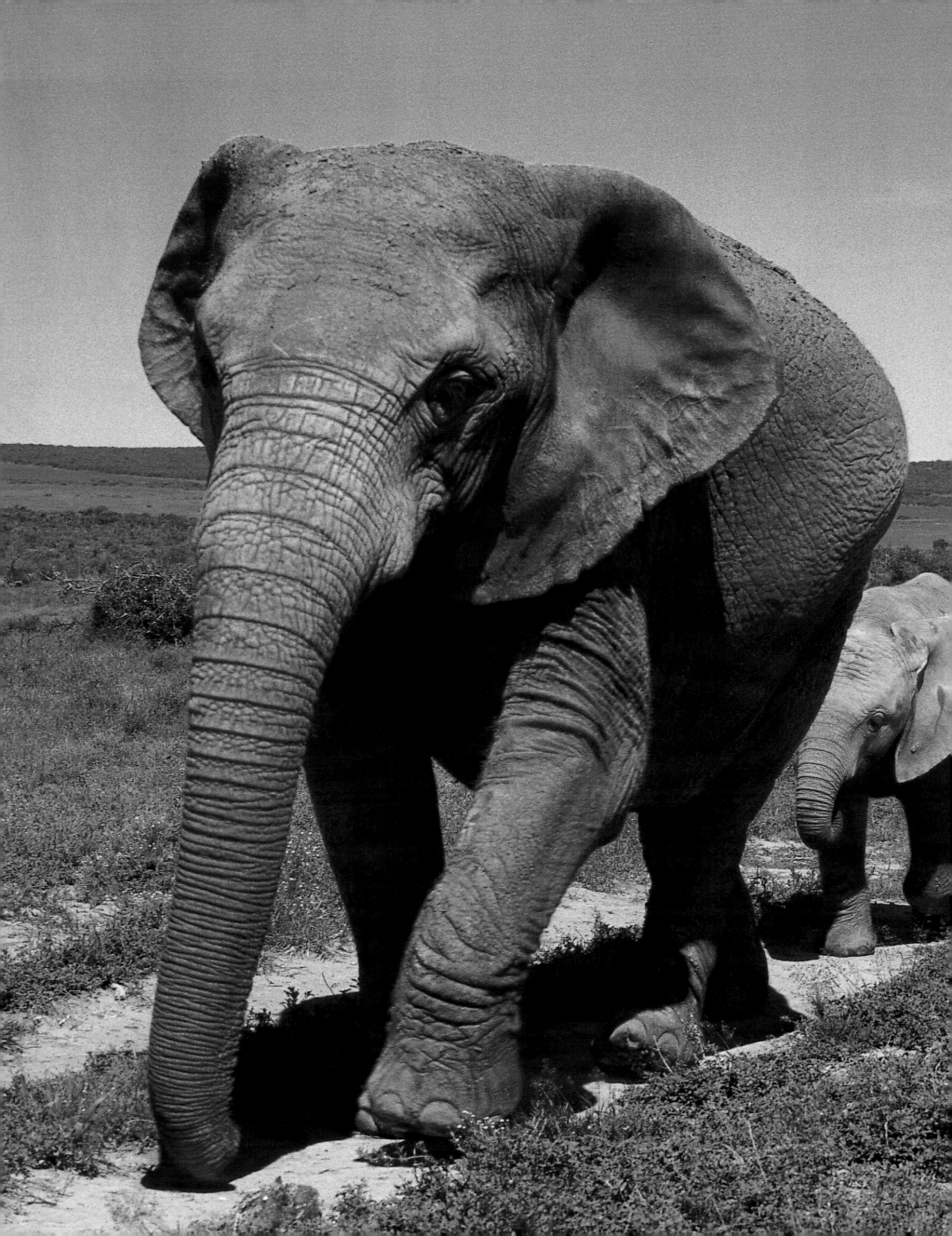

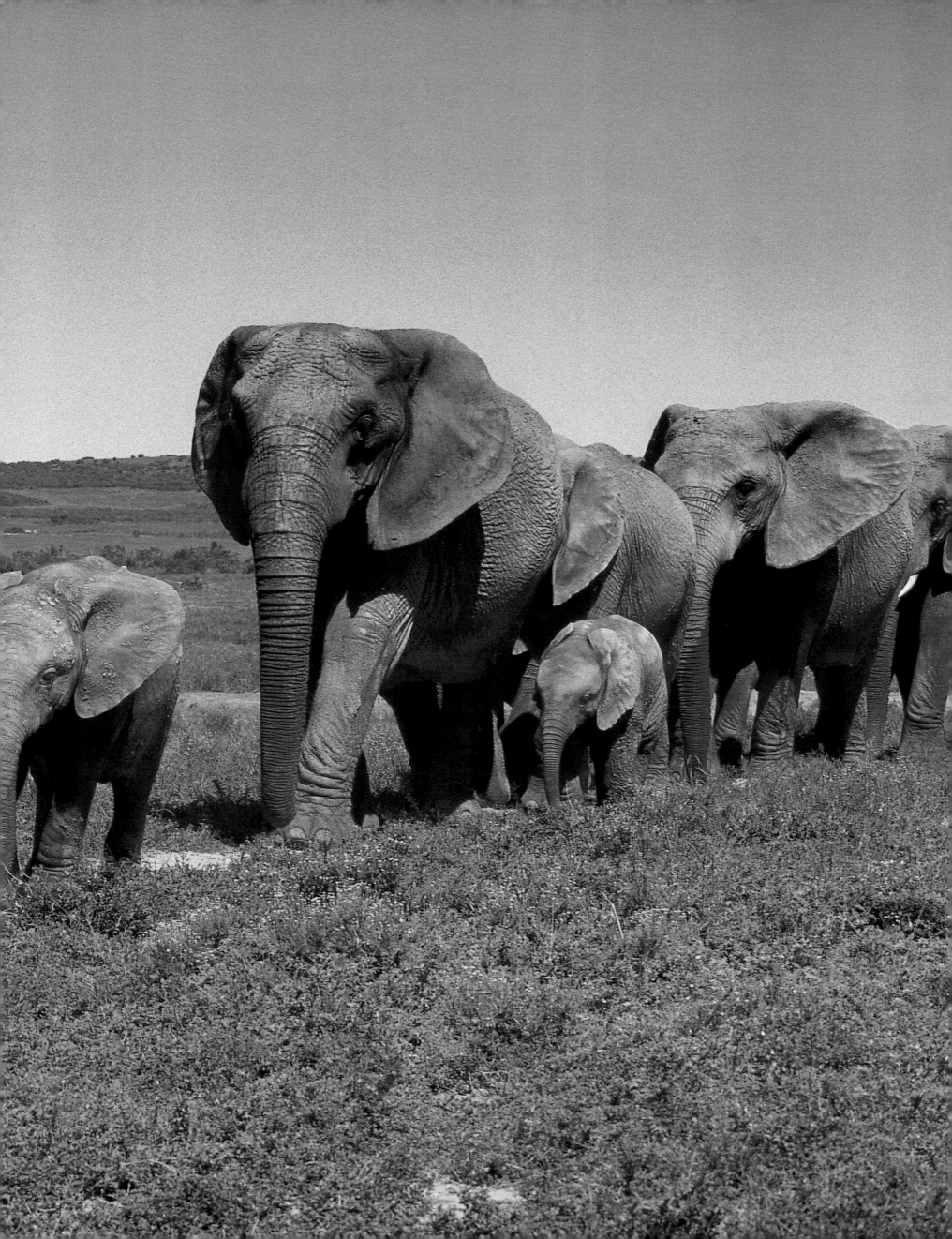

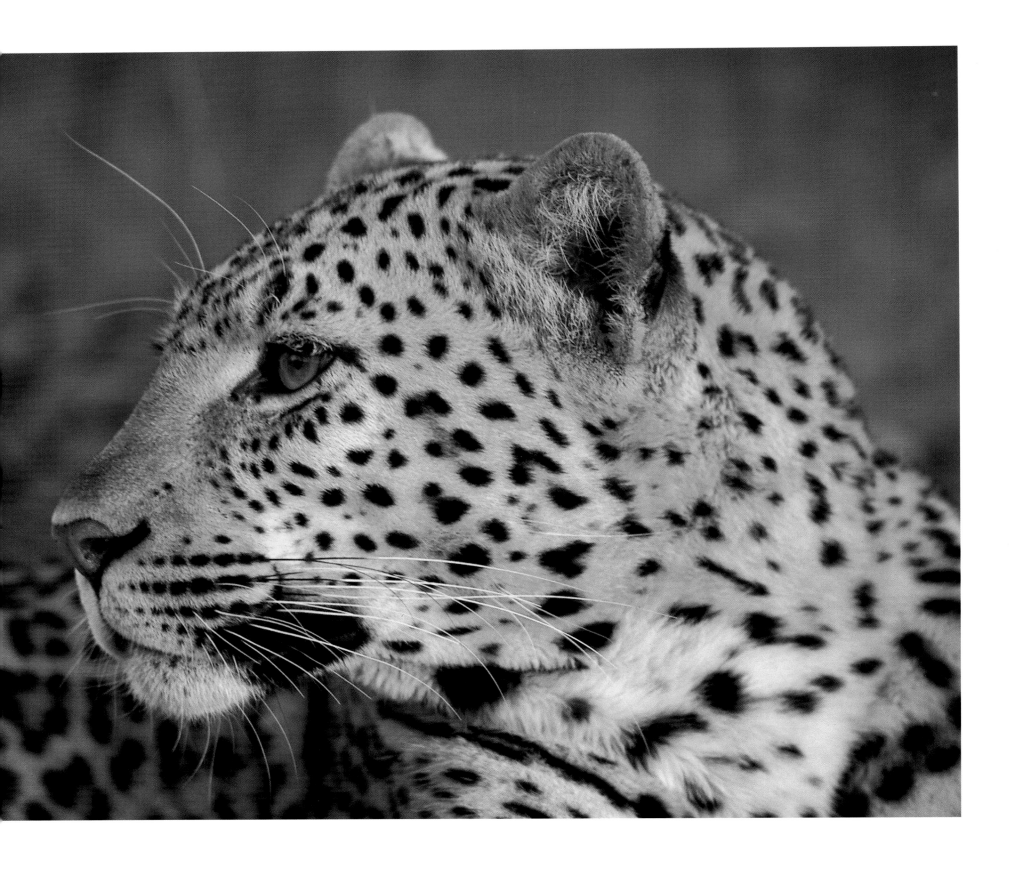

\mathscr{O}ne of the least social of Africa's larger mammals is the leopard, a lone hunter of the night. Contrary to popular perception, it is not an especially arboreal creature, taking to the trees only to escape its predators and to cache its food. The sexes live apart; the male, which is much the larger of the two, has an extensive territory that usually overlaps with those of several females.

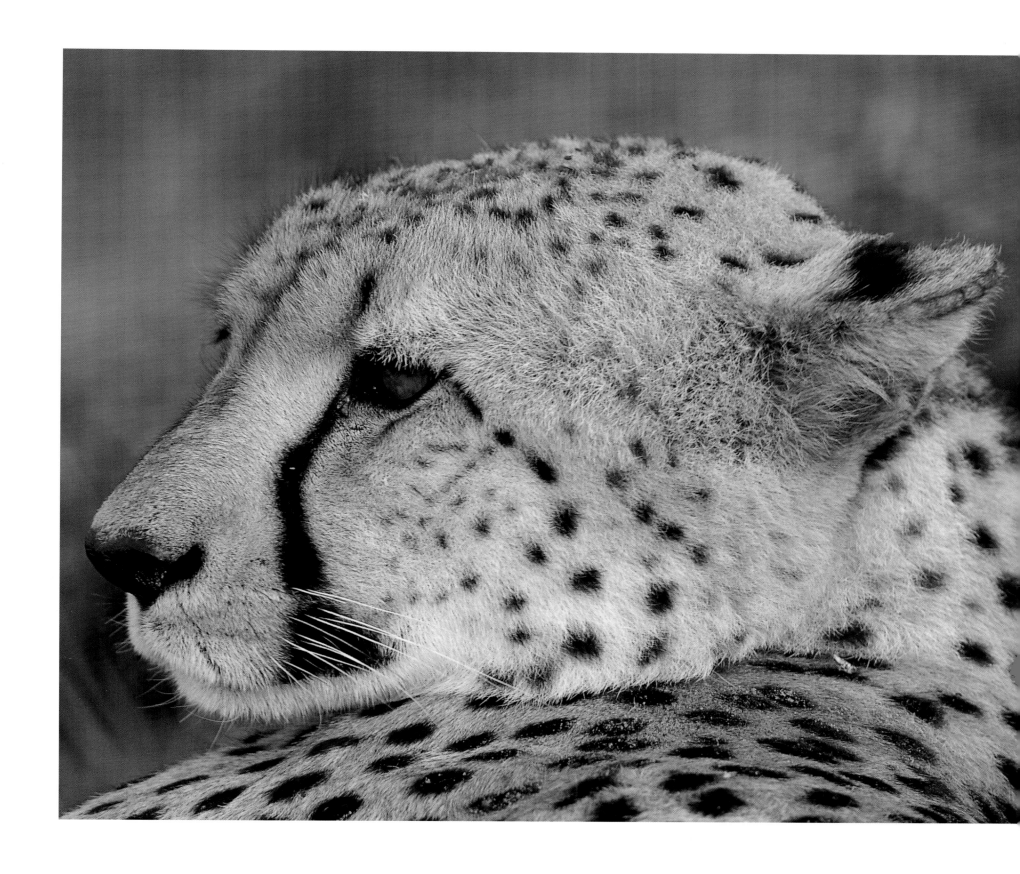

\mathscr{F}emale cheetahs are independent, living in overlapping home ranges but avoiding contact with each other – an unusual social system in the feline world. The animal appears to be unaware of any territorial rights: she will ignore any of her peers who intrude. When they are 18 months old, cubs leave the family circle to wander the veld for a while, in a mixed-sex group, before the males hive off to form pairs or threesomes.

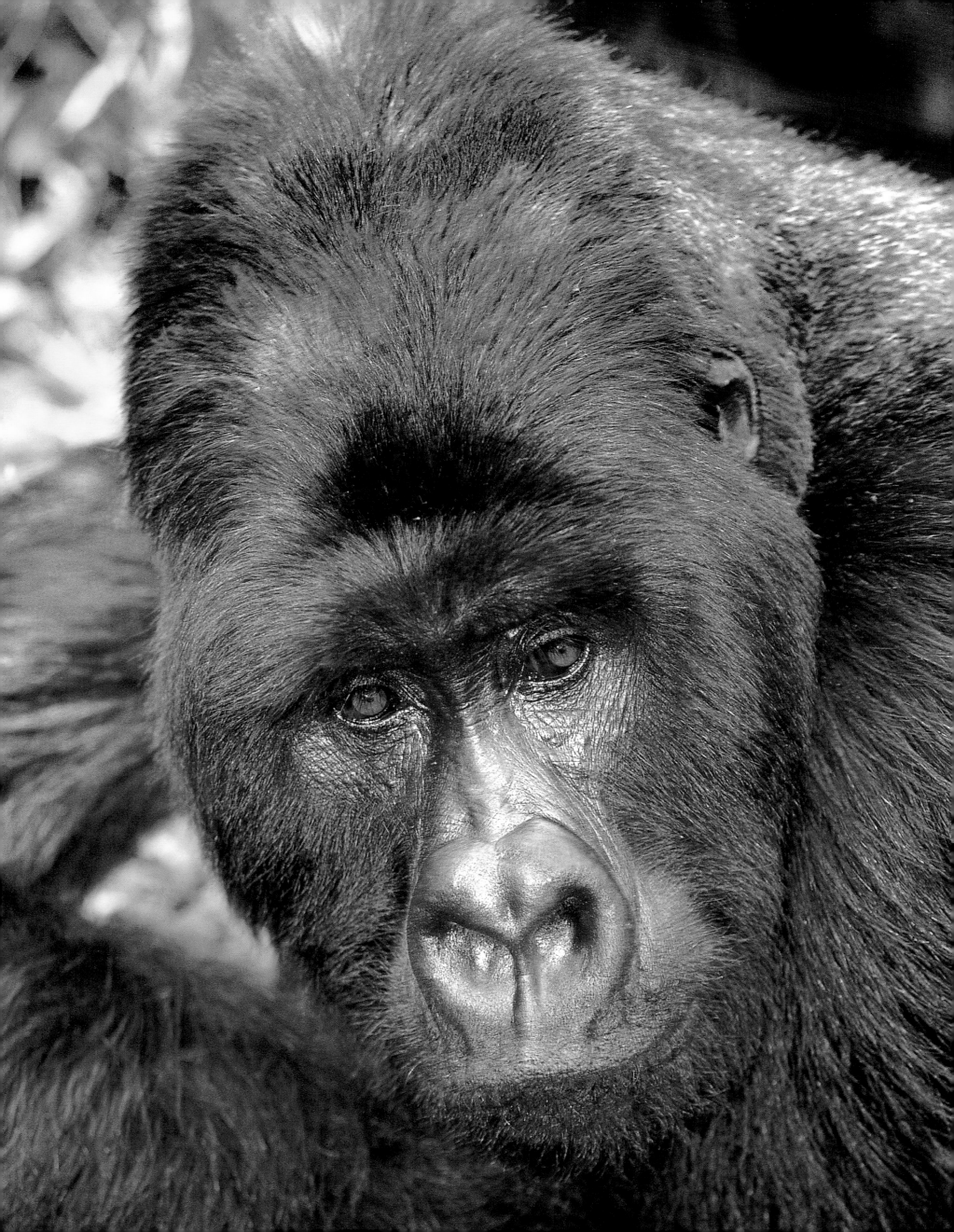

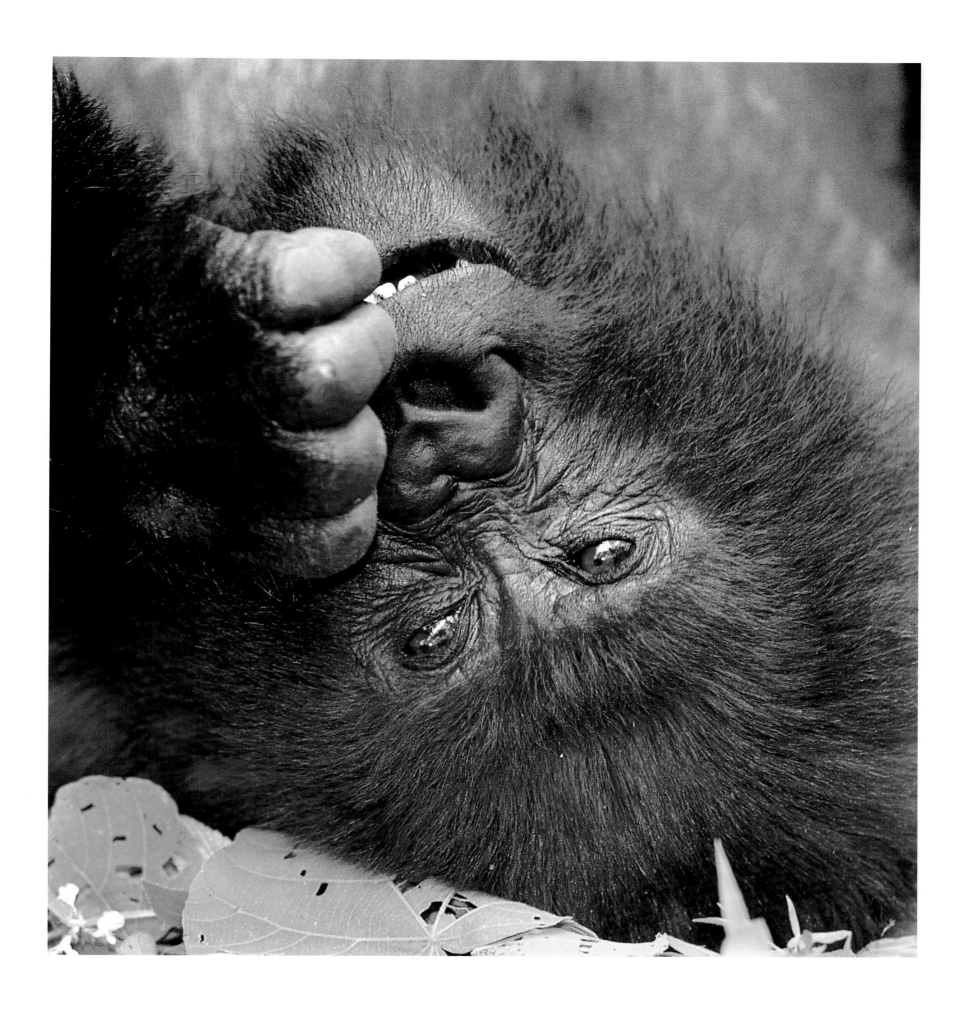

The face of a threatened species: the gorilla's *Gorilla gorilla* habitat is shrinking and, although officially protected, it is still hunted for its meat. Three races of these powerful, but gentle, primates are recognized: the western lowland, the eastern lowland and, around the borders of Uganda, Rwanda and the Democratic Republic of the Congo, the mountain gorilla. Gorillas live in small groups, each led by a dominant male.

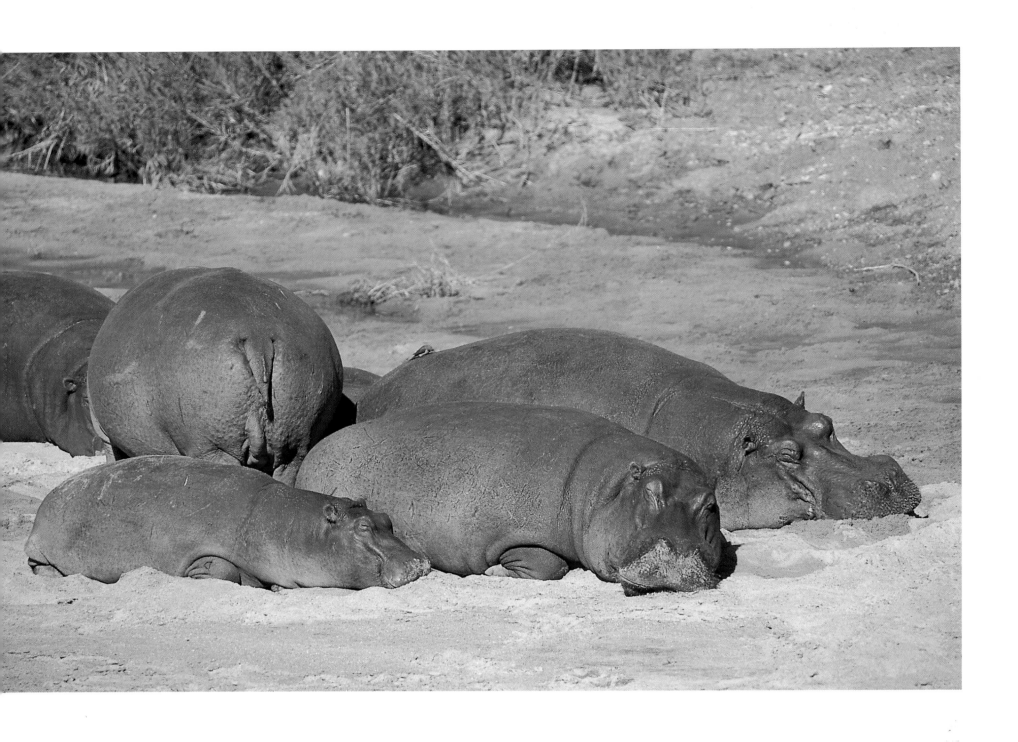

\mathscr{H}ippo males are highly territorial animals, fighting fiercely to defend their turf against challengers in confrontations that can lead to severe injury and even death. The territory occupies a narrow stretch of water (broadening to cover fairly extensive feeding grounds) in which he is joined by females and young to form a school of up to 20 individuals. These animals spend most of their days in the water – emerging often to bask on the sand- and mudbanks – and their nights grazing on land.

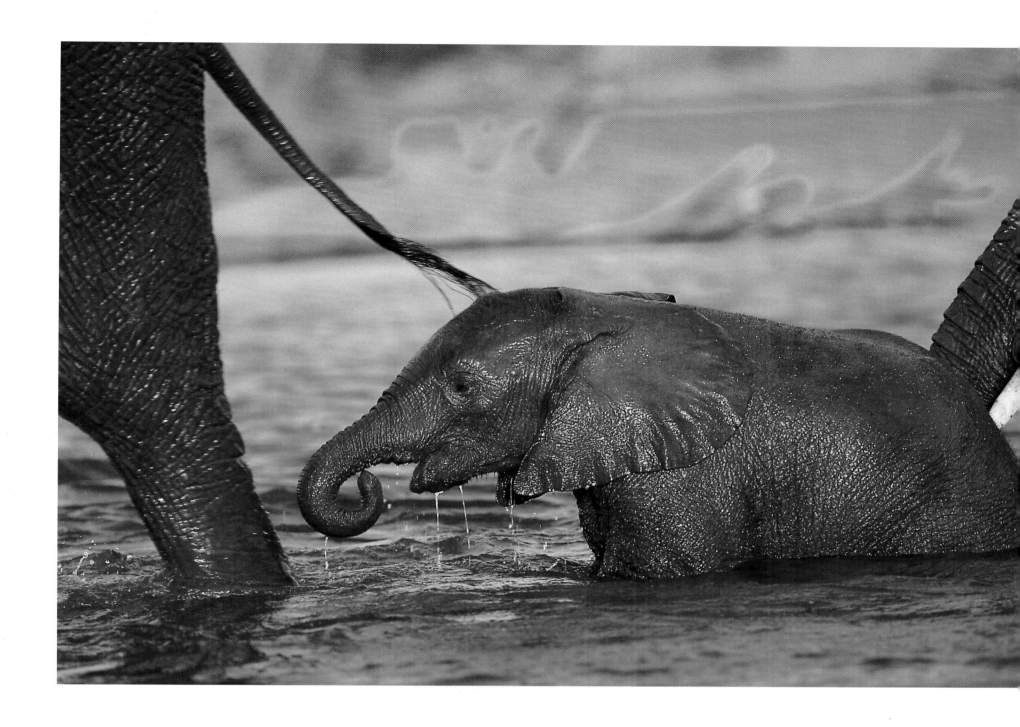

In contrast to the hippo, it is the female who rules the elephant group, which comprises the matriarch, her female relatives and their various offspring. When young males reach puberty they leave to live in bachelor herds; females stay with the birth group but will eventually, as the herd grows, separate as subgroups. Sometimes a number of matriarchal units will get together – at watering points, for instance, or in places where the food is especially abundant – in aggregations of several hundred.

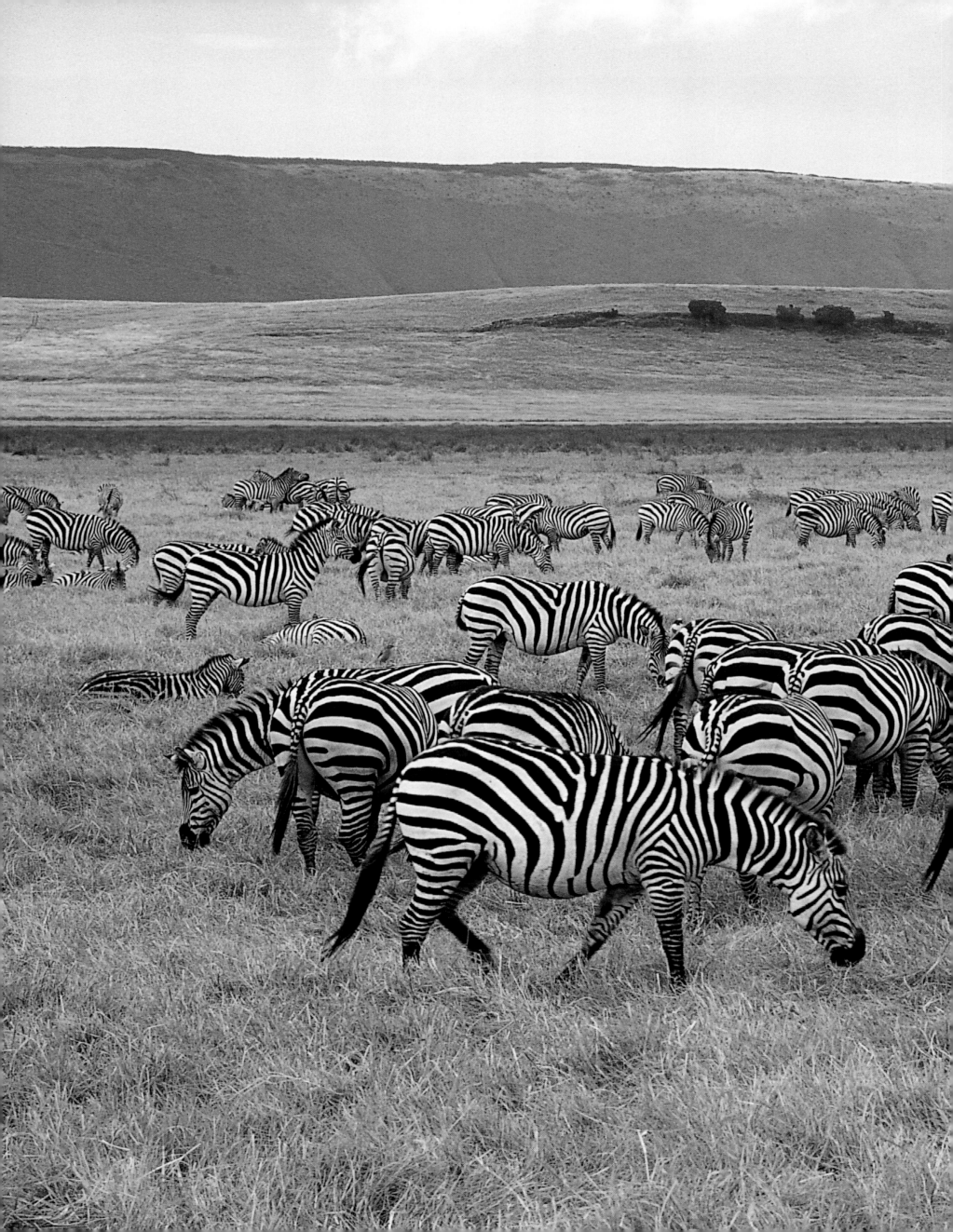

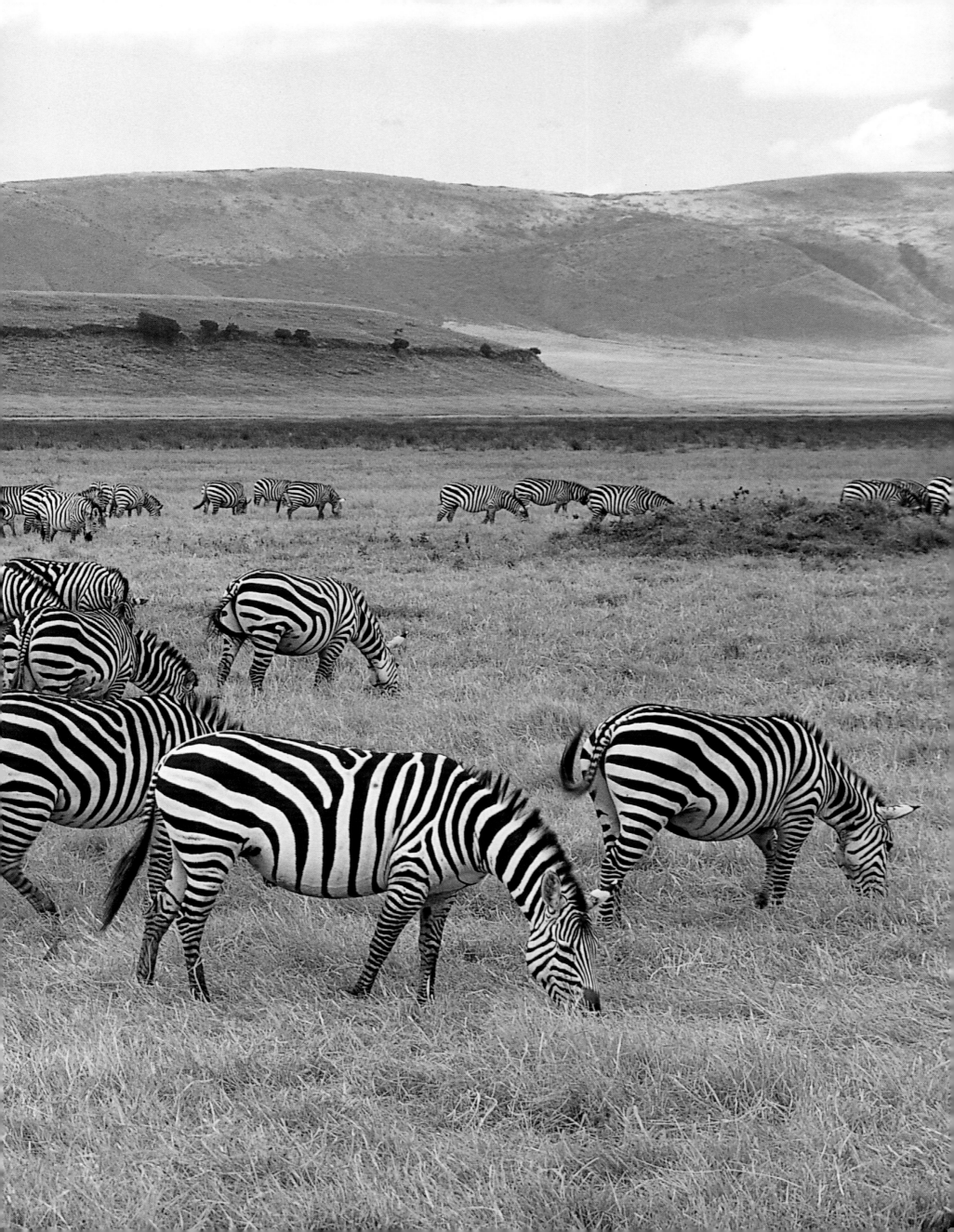

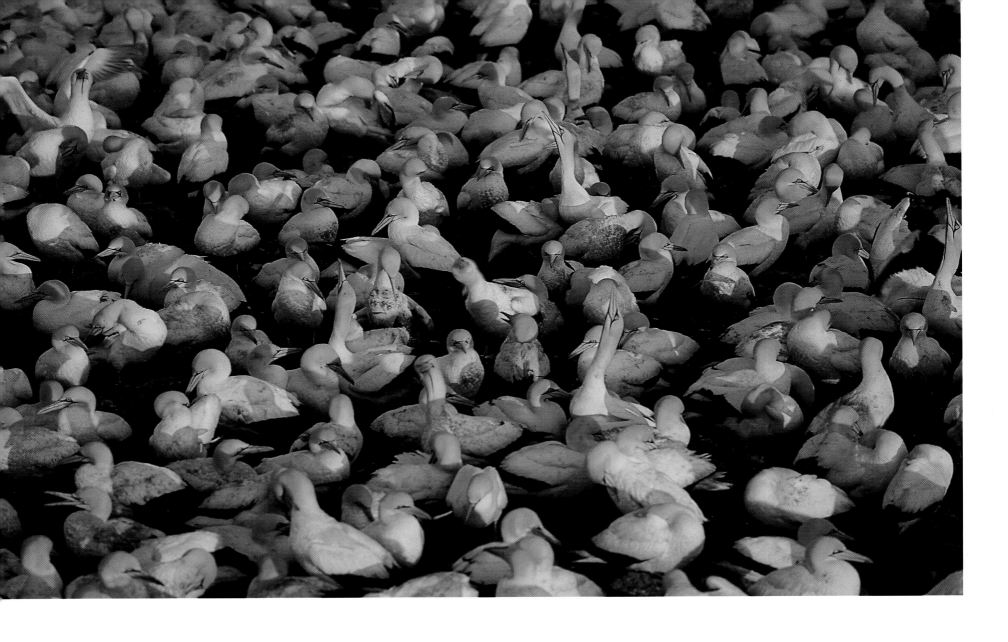

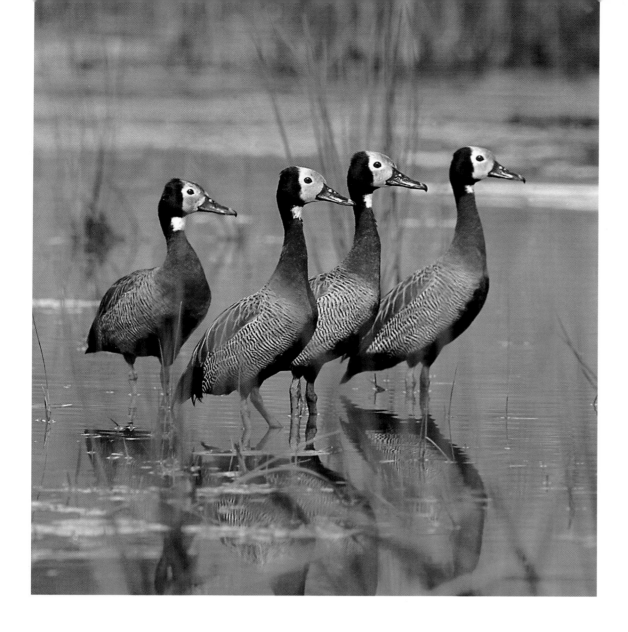

*B*urchell's zebra (previous pages) gather on the lush grass plains of Tanzania's Ngorongoro Crater.

*C*ape gannets *Morus capensis* (opposite, top and bottom) form densely packed breeding colonies on subSaharan Africa's coastal islands, laying their eggs in nests fashioned from twigs and bits of sea-weed placed atop hollowed-out mounds of guano. Left: white-faced ducks *Dendrocygna viduäta*, which prefer the larger inland waters, often flock in their hundreds of thousands. Below: large and hand-some crowned cranes *Balearica regulorum* favour the continent's moister grasslands.

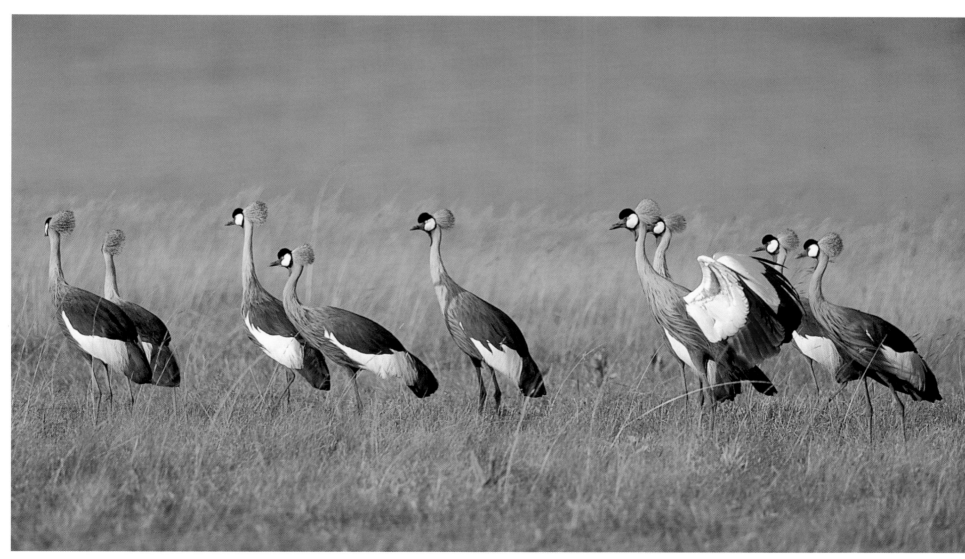

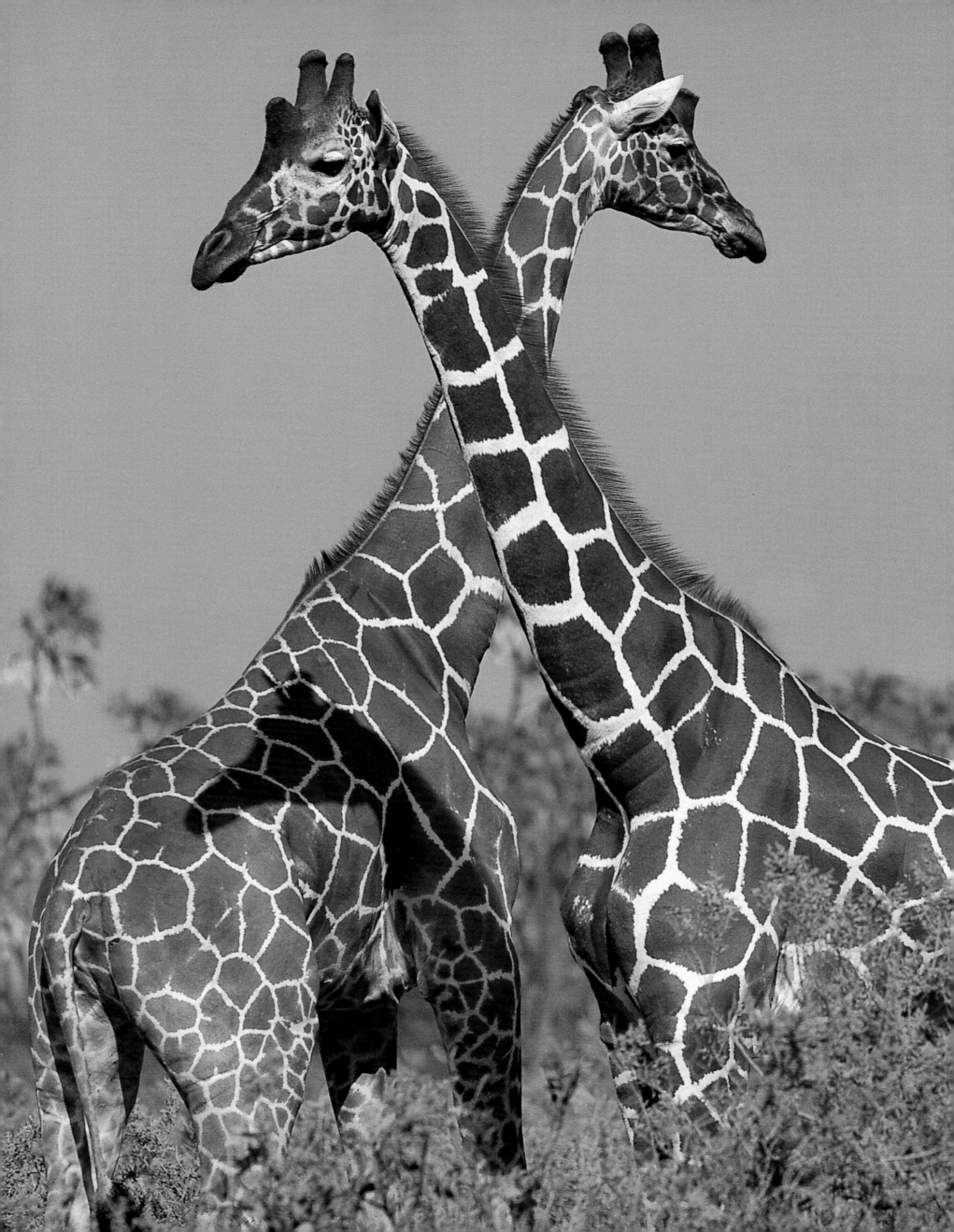

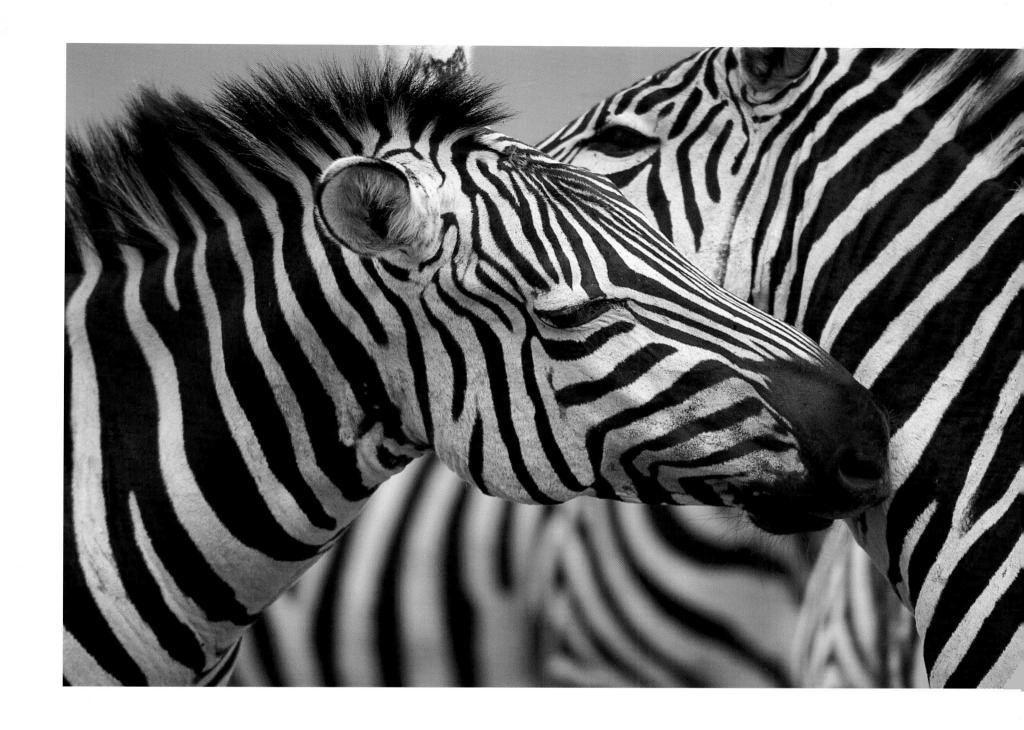

\mathcal{G}iraffe run in herds of from four to 30 individuals, though the groups have little permanency about them. Adult bulls, who spend much of their time on their own, maintain a complicated, non-aggressive ranking structure. These two reticulated giraffes (opposite), a race distinguished by its clearer, darker markings, are residents of Kenya's Samburu Reserve.

\mathcal{T}he plains of East Africa sometimes host aggregations of half a million and more zebra; the Ngorongoro Crater is home to these two (above).

A dolphin *Delphinus delphis* (right) breaks the ocean surface in a distinctive movement known as 'porpoising'. These graceful marine mammals, which are classed with the toothed whales, are famed for their intelligence (though this is entirely different from the human kind), their friendliness and acrobatic playfulness. Special, too, is their skill in 'echolocation': they are able to produce and receive high-frequency sounds – squeaks, whistles, clicks and pops – to navigate, to communicate with each other, and to detect their underwater prey. Some species feed on squid, others on fish, which they hunt in groups, herding the shoals up towards the surface.

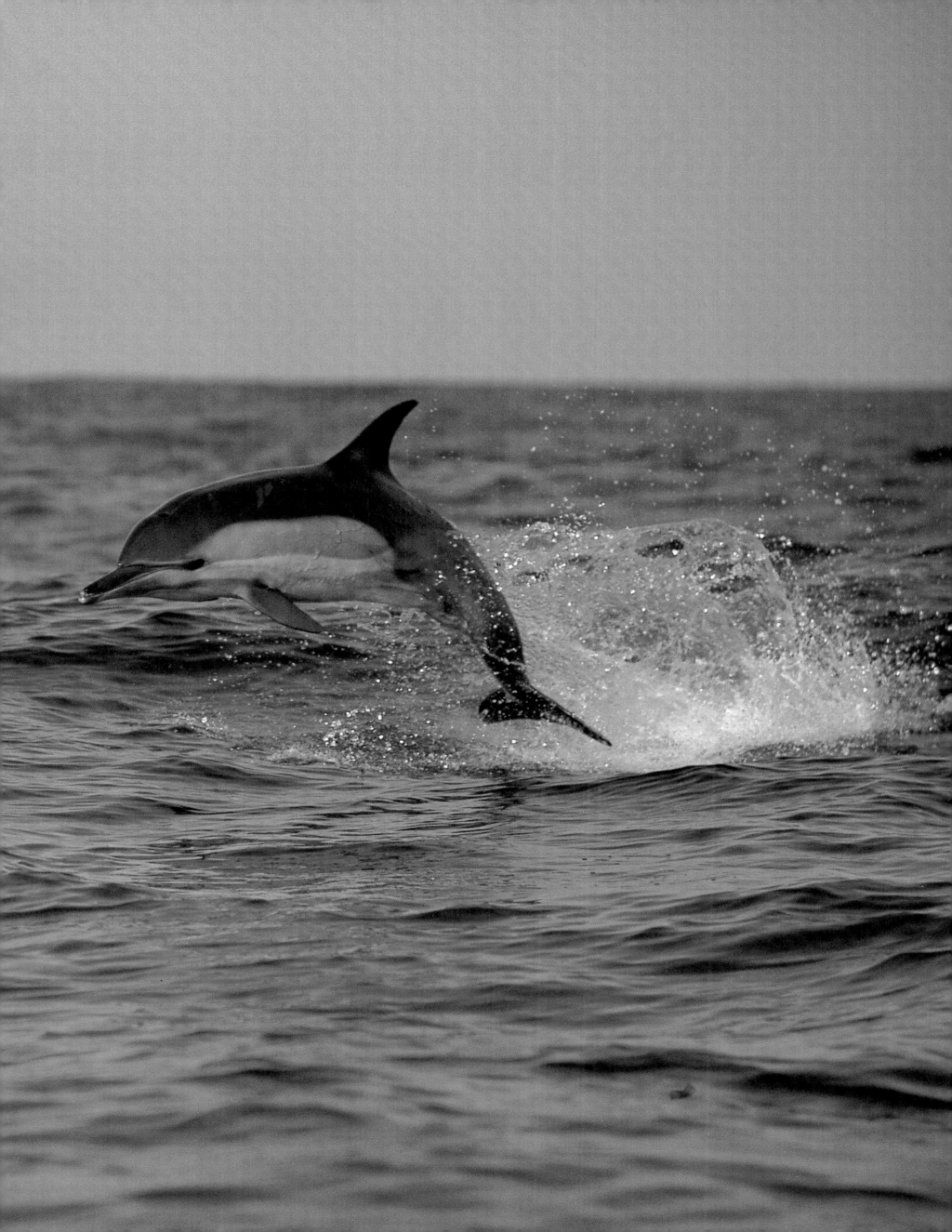

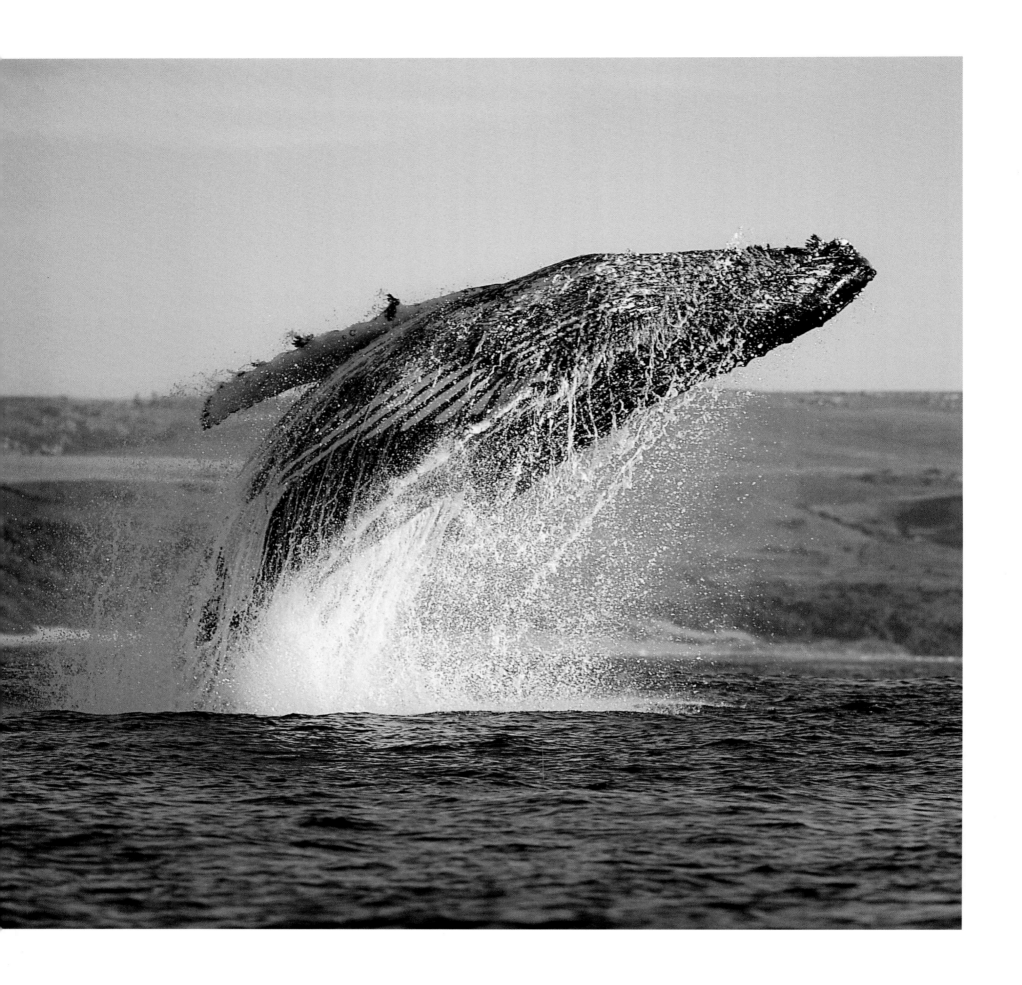

\mathscr{T}he humpback whale *Megaptera novaeangliae,* up to 14 metres in length and found in almost all the world's seas from the polar regions to the tropics, is renowned for its spectacular breaching, often leaping clear of the water to re-enter with a monstrous splash. It is also known for the range of its 'song', a multi-tone series of shrieks and deep moans that lasts for anything up to half an hour, and which is thought to be a means of communication between members of the same stock.

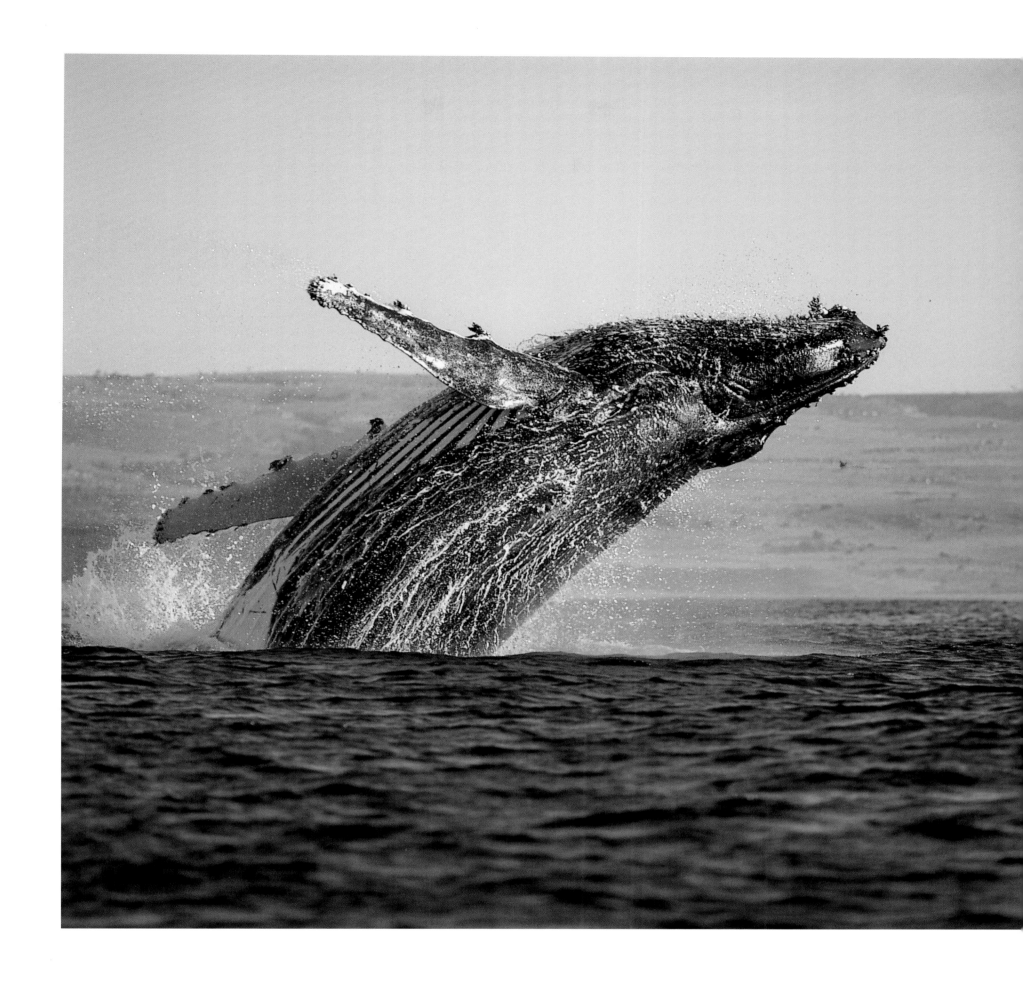

\mathcal{D}uring the southern winter a humpback whale will migrate north from its antarctic feeding grounds to mate and (a year later) give birth in the warmer coastal waters. Little is known of its social system. The species occurs singly or in small groups, and, when feeding, often uses a 'bubble net' to catch fish – a co-operative ploy in which one or more of their number will circle a shoal, blowing a steady stream of bubbles that concentrates the fish into a close-packed mass ready for the taking.

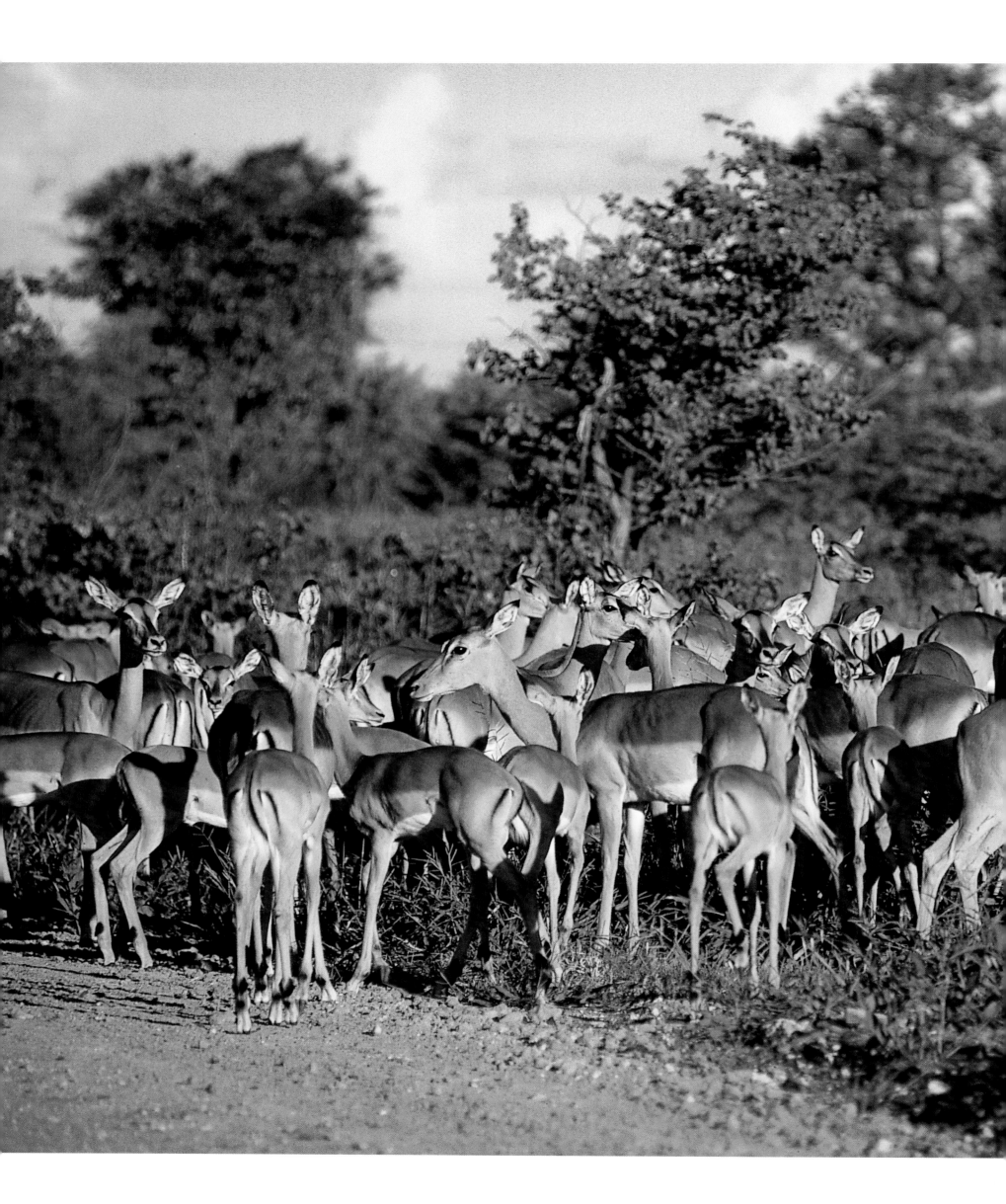

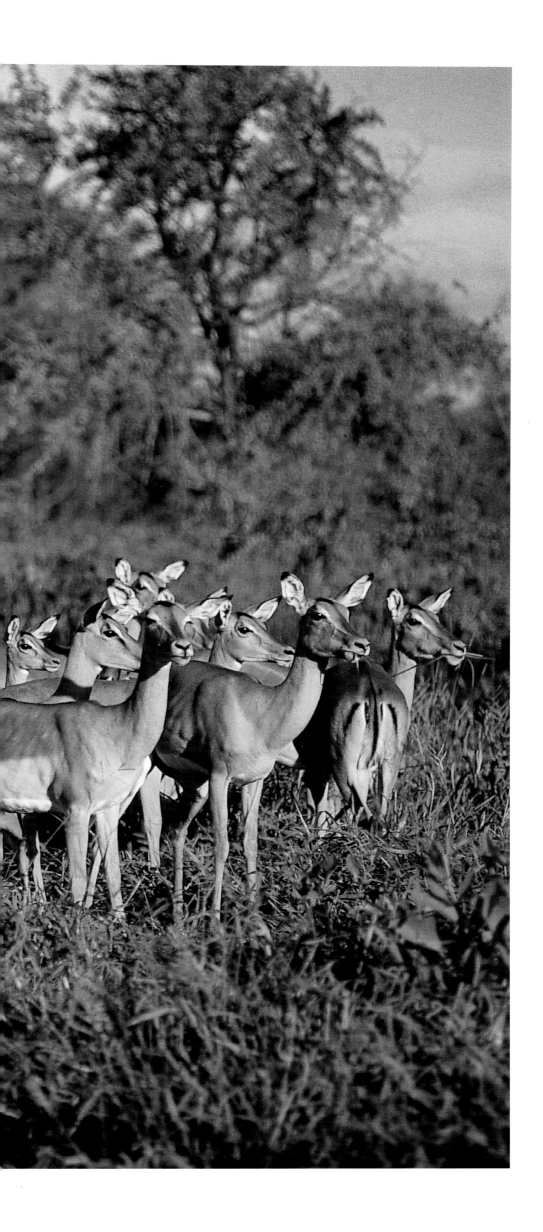

A breeding group of impala (left), the commonest and perhaps the most gracefully agile of all southern African antelope (they are also found in Central and East Africa). The males live in bachelor herds until they are about four years old, when they leave to establish individual territories, which they will defend vigorously against competing rams during the rutting season. Only the males have horns. Below: two red-billed oxpeckers *Buphagus erythrorhynchus* gather strands of hair from an impala's hide to use for nest-building.

Jackass penguins (overleaf) leave their roosting island to hunt for fish in the open sea.

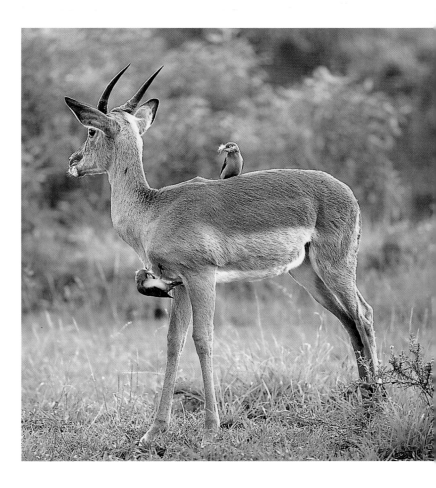

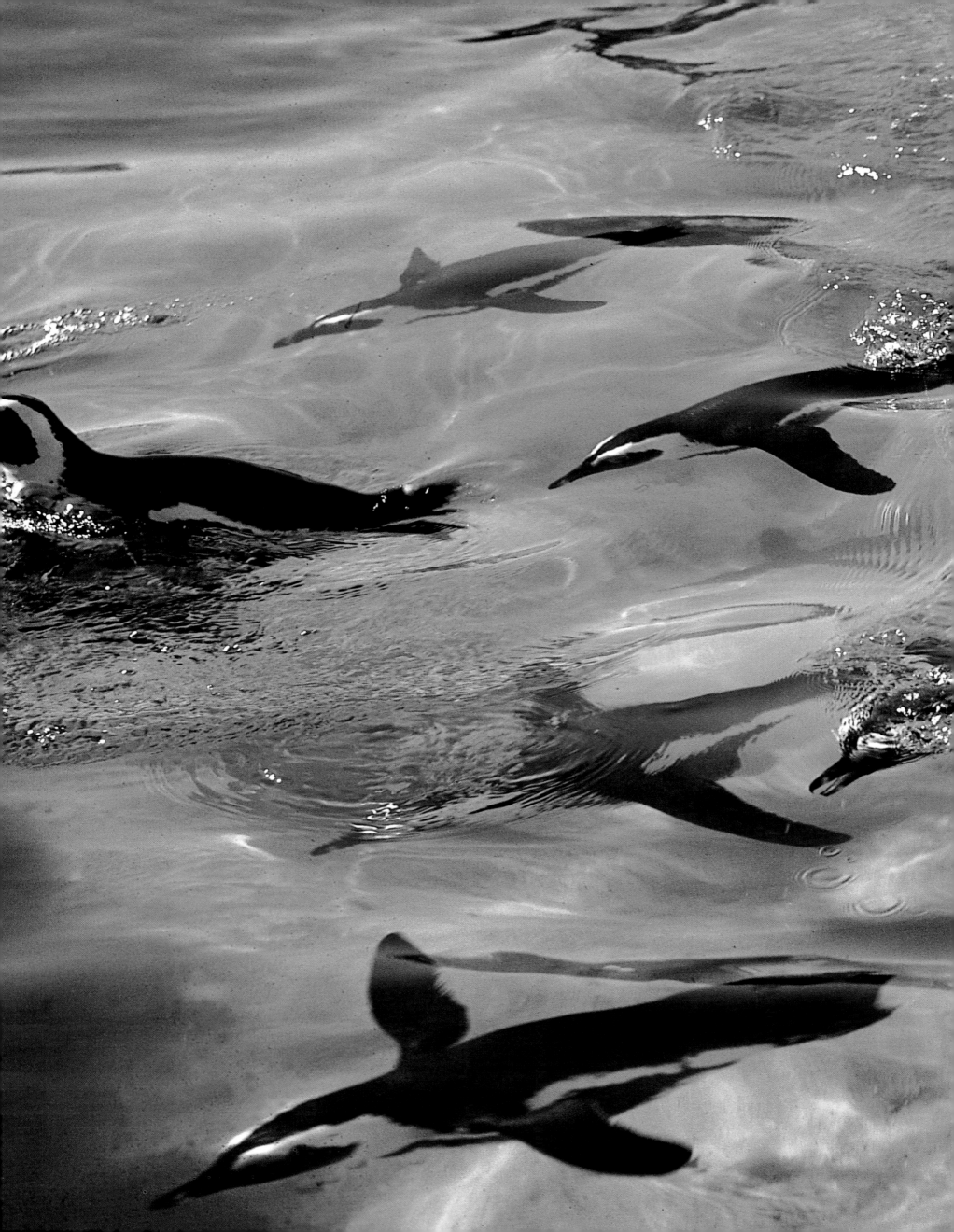

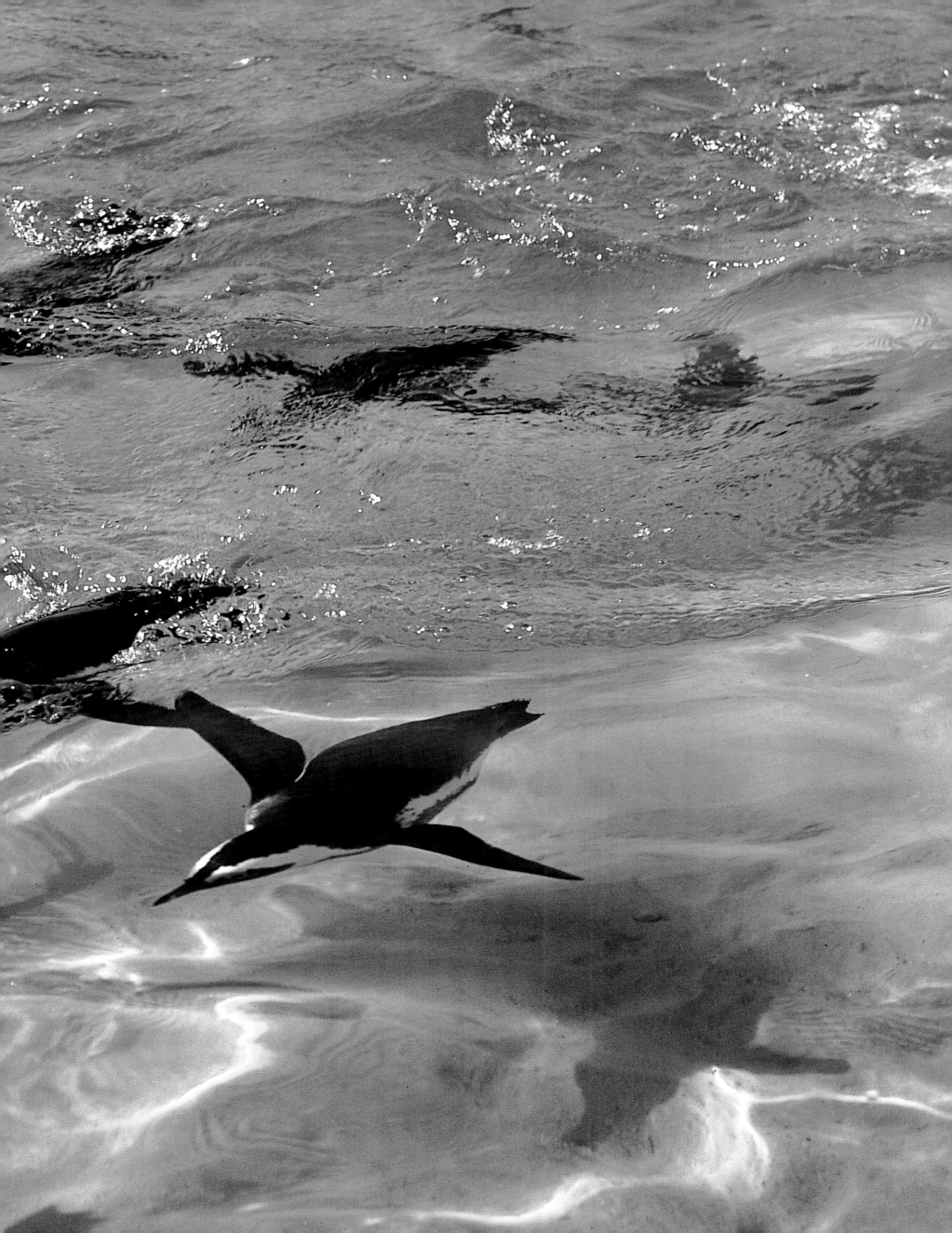

PHOTOGRAPHIC CREDITS

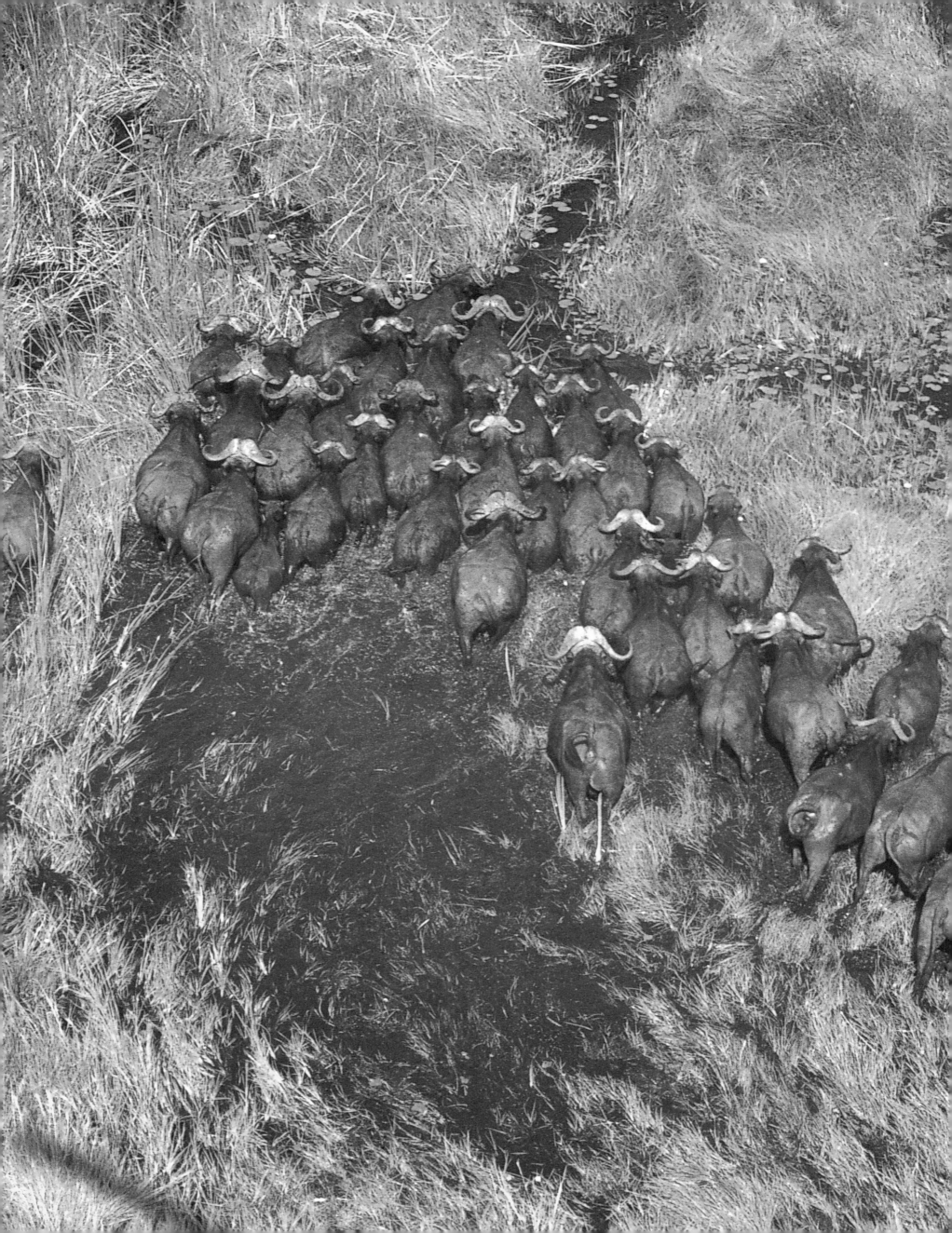